Lecture Notes of the Institute for Computer Sciences, Social Informatics and Telecommunications Engineering 196

More information about this series at http://www.springer.com/series/8197

Anthony L. Brooks · Eva Brooks (Eds.)

Interactivity, Game Creation, Design, Learning, and Innovation

5th International Conference, ArtsIT 2016
and First International Conference, DLI 2016
Esbjerg, Denmark, May 2–3, 2016
Proceedings

 Springer

Editors
Anthony L. Brooks
Department of Architecture, Design
 and Media Technology (CREATE)
Aalborg University
Aalborg/Esbjerg
Denmark

Eva Brooks
The Faculty of Humanities, Department
 of Learning and Philosophy
Aalborg University
Aalborg
Denmark

ISSN 1867-8211 ISSN 1867-822X (electronic)
Lecture Notes of the Institute for Computer Sciences, Social Informatics
and Telecommunications Engineering
ISBN 978-3-319-55833-2 ISBN 978-3-319-55834-9 (eBook)
DOI 10.1007/978-3-319-55834-9

Library of Congress Control Number: 2017934860

Printed on acid-free paper

This Springer imprint is published by Springer Nature
The registered company is Springer International Publishing AG
The registered company address is: Gewerbestrasse 11, 6330 Cham, Switzerland

Preface

ArtsIT (Arts and Technology) has previously been presented on four occasions – see the contribution by Brooks and Brooks in this publication. Reflecting trends in the expanding field of digital art, interactive art, and how game creation is considered an art form, the decision was made to modify the title of ArtsIT to be known as "The International Conference on Arts and Technology, Interactivity and Game Creation," but still with the acronym ArtsIT. Complementing the ongoing series and to expand the European Alliance for Innovation (EAI) portfolio of events, an initiative to establish a new and complementary event to ArtsIT was undertaken and titled "The International Conference on Design, Learning and Innovation (DLI)."

The keynote lecture for ArtsIT was given by Antoni Jaume-i-Capó from Universitat de les Illes Balears, Spain, who enthralled attendees in the first session of the first day. The DLI keynote took place on the second day with Sudarshan Khanna and Surabhi Khanna sharing their focused research on play and toys.

This LNICST book presents the proceedings of the two-day co-located ArtsIT and DLI events of 2016. Sessions were hosted in two adjacent auditoriums – to facilitate delegate ease of access – with coffee and adjacent relaxation areas overlooking University Park where the campus of Aalborg University in Esbjerg is located. The campus is a short distance from downtown where all major hotels, restaurants, shopping and entertainment can be found near the busiest port in Denmark. Also close by is the high-standard youth hostel: all ideal for delegate access. Known as the "Energy Metropolis," Esbjerg is a major supplier to the offshore industries as well as being a key fisheries location. Culture is also a main aspect of the city with it being a regular winner of the Danish City of Culture Award.

The opening contribution in this book is by the editors, who, as authors, detail the strategy behind the initiative of a co-located double conference for the European Alliance for Innovation. The first delegate paper is titled "The Farm Game: A Game Designed to Follow Children's Playing Maturity." The authors are Emmanouil Zidianakis, Kalliopi Stratigi, Danae Ioannidi, Nikolaos Partarakis, Margherita Antona, and Constantine Stephanidis from Forth University, Crete. Following is "A Tangible Augmented Reality Toy Kit: Interactive Solution" by Yujie Zhu and Stephen Jia Wang from Monash University, Australia. From Ulster University, Ireland, Prof. Paul McKevitt and colleagues contributed with their paper titled "SceneMaker: Creative Technology for Digital StoryTelling." "Structuring Design and Evaluation of an Interactive Installation Through Swarms of Light Rays with Human-Artifact Model" is next by Cumhur Erkut from Aalborg University, Copenhagen campus. The next contribution is "Gamify HCI: Device's Human Resolution for Dragging on Touch Screens in a Game with Lab and Crowd Participants" by authors Allan Christensen, Simon Andre Pedersen, and Hendrik Knoche from Aalborg University. Sara Hojjat, Chiaki Ikemoto, and Tomoyuki Sowa's contribution follows, discussing their body of work "Maze and Mirror Game Design for Increasing Motivation in Studying Science in

Elementary School Students." The next paper is titled "Towards a Wearable Interface for Immersive Telepresence in Robotics" by Uriel Martinez-Hernandez from Leeds University and Michael Szollosy, Luke Boorman, Hamideh Kerdegari, and Tony Prescott from Sheffield University. "Designing Digital Tools for Physiotherapy" follows by authors Gabriela Barbu Postolache, Raul Oliveira, and Octavian Postolache. Next is the contribution from Stephanie Nadarajah, Benjamin Overgaard, Peder Pedersen, Camilla Schnatterbeck, and Matthias Rehm, from Aalborg University, with their work titled "Enriching Location-Based Games with Navigational Game Activities." Next is "Pairing Craft-Making with Mandarin eBooks: An Investigation into the Potential Use of Craft for Language Learning by Preschoolers" by authors Wil-Kie Tan, Stephen Jia Wang, and Jeff Janet. "Toward a Decolonizing Approach to Game Studies: Philosophizing Computer Game with BCI" is the next chapter representing the body of work by Hyunkyoung Cho and Joonsung Yoon. Jean Botev, Ralph Marschall, and Steffen Rothkugel authored the contribution titled "CollaTrEx – Collaborative Context-Aware Mobile Training and Exploration." This is followed by Kristoffer Holm, Nicolai Skovhus Lind, and Martin Kraus, with their paper "Increasing the Perceived Camera Velocity in 3D Racing Games by Changing Camera Attributes." Søren Frimodt-Møller's sole-authored paper "Assessment of Stand-Alone Displays for Time Management in a Creativity-Driven Learning Environment" follows. Chulin Yang and Stephen Jia Wang's "Sandtime: A Tangible Interaction Featured Gaming Installation to Encourage Social Interaction Among Children" is next followed by "The Imitation Game to Cultural Heritage: A Human-Like Interaction-Driven Approach for Supporting Art Recreation" by Fiammetta Marulli and Luca Vallifuoco. Ben Challis, Angela Kang, Rachel Rimmer, and Mark Hildred are next with their paper titled "Enhancing the Multisensory Environment with Adaptive Game Audio Techniques." The contribution by Kasper Halkjær Jensen and Martin Kraus is next, titled "Investigating the Effect of Scaffolding in Modern Game Design." The paper following is "Multi-Kinect Skeleton Fusion for Enactive Games" by Nikolaj Marimo Støvring, Esbern Torgard Kaspersen, Jeppe Milling Korsholm, Yousif Ali Hassan Najim, Soraya Makhlouf, Alireza Khani and Cumhur Erkut. Eleanor Mulholland, Paul McKevitt, Tom Lunney, and Karl-Michael Schneider follow with their paper titled "Analyzing Emotional Sentiment in People's YouTube Channel Comments." Szu-Ming Chung and Chun-Tsai Wu are the next authors with "Mobile Device Applications for Head Start Experience in Music." Next is "The Effect of Interacting with Two Devices when Creating the Illusion of Internal State in Passive Tangible Widget" by Andreas Bork, Christoffer Heldbjerg Bech, Jakob Memborg Rosenlund, Lasse Birch Schøne, and Martin Kraus. Following is Georgios Triantafyllidis, Nikolaos Vidakis, and Kostas Kalafatis, who authored "Multimodal Detection of Music Performances for Intelligent Emotion-Based Lighting." "Widening the Experience of Artistic Sketchbooks" is next from Henning Christiansen and Bjørn Laursen. "Considerations and Methods for Usability Testing with Children" follows by Malene Hjortboe Andersen, Saifuddin Khalid, and Eva Brooks.

Sacha Kjærhus Therkildsen, Nanna Cassøe Bunkenborg, and Lasse Juel Larsen introduce their work in a paper titled "An Adaptation Framework for Turning Real-Life Events into Games: The Design Process of the Refugee Game." This is followed by "Emotion Index of Cover Song Music Video Clips Based on Facial Expression

Recognition" by Georgios Triantafyllidis, Georgios Kavalakis, and Nikolaos Vidakis. Next is Denis Stolyarov, Nikolay Borisov, Artem Smolin, Pavel Shcherbakov, and Vasiliy Trushin, whose paper is titled "The Opportunities of Applying the 360° Video Technology to the Presentation of Cultural Events."

Up next is a panel track led by chair Prof. Eva Brooks titled "Design of Interactive Environments for Inclusion." This included: "Learning Together Apart – The Impact on Participation when Using Dialogic Educational Technologies for Kids with Attention and Developmental Deficits" by Elsebeth Korsgaard Sorensen, Andersen, Hanne, Voldborg; "Learning by Designing Interview Methods in Special Education" by Lise Jönsson; "Powerlessness or Omnipotence – The Impact of Structuring Technologies in Learning Processes for Children with Attention and Developmental Deficits" by Andersen Sorensen. Adrià Arbués Sangüesa, Andreea-Daniela Ene, Nicolai Krogh Jørgensen, Christian Larsen, Daniel Aagaard Michelsanti, and Martin Kraus follow with "Pyramid Algorithm Framework for Real-Time Image Effects in Game Engines." "Engaging with the Intangible Cultural Heritage of the City" by Matthias Rehm and Kasper Rodil is next. This is followed by Jeon Myounghoon's paper titled "Aesthetic Computing for Representation of the Computing Process and Expansion of Perceptual Dimensions: Cases for Art, Education, and Interfaces." The final paper is "AcuTable: A Touch-Enabled, Actuated Ṭangible User Interface" by Simon Dibbern, Kasper Vestergaard Rasmussen, Daniel Ortiz-Arroyo, and Michael Boelstoft Holte.

In closing we are happy to report that responses were highly positive about the synching of the complementary co-location of the events such that a similar partnering under EAI will transpire in October 2017 in Crete.

January 2017

A.L. Brooks
E. Brooks

Organization

Steering Committee

Imrich Chlamtac CREATE-NET, Italy
Anthony L. Brooks Department of Architecture, Design and Media
 Technology, School of ICT,
 Aalborg University Esbjerg, Denmark

General Chair

Anthony L. Brooks Aalborg University, Denmark

Organizing Committee

Eva Irene Brooks Aalborg University, Denmark

Technical Program Chair

Matei Mancas University of Mons, Belgium
Ben Challis Manchester Metropolitan University, UK

Web Chair

Cristina Gheorghe Aalborg University, Denmark

Workshops Chair

Nana Borum Aalborg University, Denmark

Local Chair

Janni Baslund Dam Meet & More, Esbjerg, Denmark

Conference Manager

Jana Vlnkova EAI (European Alliance for Innovation)

Technical Program Committee

David Brown
Kristoffer Jensen
Rolf Gehlhaar
Cali Fidopiastis
Cecilia Lanyi
Daniel Thalmann
Scott Palmer
Rikke Ørngreen
Cumhur Erkut
Chris Abbott
Lieselotte Van Leeuwen
Steven Gelineck
Hirokazu Kato
Eva Petersson
Mark Billinghurst
Mel Krokos
Georgios Triantafyllidis
Elizabeth Stokes
Antoni JaumeiCapó
Michel Guglielmi
Line Gad Christiansen
Lars Ole Bonde
Sanne Krogh Groth
Mark Grimshaw
Ceri Williams
Ana Isabel Mota
Daniel Ortiz-Arroy
Søren Frimodt-Møller
Michael Boelstoft Holte
Mikkel Kirkedahl Lysholm Nielsen
Yi Gao
Line Gad Christiansen
Nanna Borum
Cynthia Grund
Rachel McCrindle
Mel Krokos
Tim Marsh

Contents

AstsIT and DLI 2016, Day 2

ArtsIT and DLI 2016, Day 1

ArtsIT + DLI: Invited Paper

Anthony L. Brooks[✉]

Aalborg University, Aalborg, Denmark
tb@create.aau.dk

Abstract. In 2015 the EAI conference series steering board declared that the international conference ArtsIT, which began in 2009, was to be extended for its 5th iteration to reflect contemporary trends of increased activities in interactive and game-based arts and technology and be renamed as *The International Conference ArtsIT, Interactivity and Game Creation*. Hosting would take place in the new auditorium campus buildings of Aalborg University Esbjerg, Denmark where it was also successfully held in 2011.

In 2015 the EAI conference series steering board declared that the international conference ArtsIT, which began in 2009, was to be extended for its 5th iteration to reflect contemporary trends of increased activities in interactive and game-based arts and technology and be renamed as *The International Conference ArtsIT, Interactivity and Game Creation*. Hosting would take place in the new auditorium campus buildings of Aalborg University Esbjerg, Denmark where it was also successfully held in 2011.

To complement and widen the scope of the offered programme, it was also decided to inaugurate *The International Conference on Design, Learning and Innovation* (DLI). Fittingly, the Center for Design, Learning and Innovation was opened at Aalborg University Esbjerg in 2011 coinciding with the second ArtsIT. Founder of DLI is Professor Eva Brooks who appropriately is general chair and steering person of the inaugural DLI conference.

This invited paper overviews the events' integrations and structures with information garnered from the affiliated organization's web sites. The paper is authored from the position as steering person of ArtsIT and initiator of the DLI event as a synched international conference.

1 ArtsIT/DLI/ICST/EAI – History and Alignment

1.1 ArtsIT

ArtsIT has been hosted in the cities of Yi-Lan, Taiwan, in 2009; Esbjerg, Denmark in 2011; Milan, Italy in 2013; Istanbul, Turkey in 2014; and now returns to Esbjerg once again in 2016, where it is expanded and re-titled as *The International Conference ArtsIT, Interactivity and Game Creation*.

© ICST Institute for Computer Sciences, Social Informatics and Telecommunications Engineering 2017
A.L. Brooks and E. Brooks (Eds.): ArtsIT/DLI 2016, LNICST 196, pp. 3–11, 2017.
DOI: 10.1007/978-3-319-55834-9_1

In 2016, 74 authors submitted to the event and 23 papers were accepted and processed for publishing in the proceedings. Previously, in 2009[1] there were 33 papers published; in 2011[2] there were 19 papers published; in 2013[3] there were 19 papers published; and in 2014[4] there were 17 papers published. The links in the footnotes on this page are to the related *Lecture Notes of the Institute for Computer Sciences, Social Informatics and Telecommunications Engineering* (LNICST) series Springer books where the papers can be found.

The scope of the event targets to attract, motivate and promote meetings and discussions between people in arts, with a keen interest in modern IT technologies, and people in IT, having strong ties to arts through their works. Since inauguration in 2009 the event has become a leading scientific forum for dissemination of cutting-edge research results in the area of Arts, Design & Technology – now extended to include the open related topics Interactivity – and all the term may contain (e.g. Interactive music, Interaction Design, Virtual Reality, Augmented Reality etc.,) and Game Creation (e.g. Serious Games, Gamification, Gaming, GamePlay, etc.,).

Alongside the call for papers was a call for posters and gratis exhibition for industry and projects (students, regional educations, interested parties etc.,): The latter being an ideally timed opportunity for students to test prototypes with international delegates to receive "expert" input – as critique and reflection – to supplement and inform via their project reports due for June examinations.

In Aalborg University Esbjerg the Medialogy education, which is under the Media Technology department, links to ArtsIT having a focus on Project Organized Problem Based Learning whereby students work with authentic issues and related problems and challenges via links and activities/collaborations with local, regional and national industries. Thus, senior students are promoted to undertake internships in a growing number of industry partnering companies that typically lead to employment opportunities.

Over the years there have been internationally acknowledged luminaries from the field as keynotes. ArtsIT 2014 featured two keynote speakers, the first was Professor Paul Brown from UK/Australia, pioneered in art, science & technology since the late-1960s and in computational & generative art since the mid 1970s: http://www.paul-brown.com; and the second (in no particular order) was Professor Murat Germen, an artist using photography as an expression/research tool who has an MArch degree from Massachusetts Institute of Technology, where he attended as a Fulbright scholar and graduated receiving the American Institute of Architects (AIA) Henry Adams Gold Medal for academic excellence. Murat now works as a professor of art, photography and new media at Sabanci University in Istanbul: http://muratgermen.com.

Following the above keynotes in their footsteps is the 2016 keynote speaker - and it is a pleasure to welcome - Dr Antoni Jaume-i-Capó. Antoni obtained his Ph.D. in Computer Science at the Balearic Islands University in 2009, where since 2005 he has worked at the Mathematics and Computer Science Department. His main research

[1] http://www.springer.com/us/book/9783642115769.
[2] http://www.springer.com/us/book/9783642333286.
[3] http://www.springer.com/us/book/9783642379819.
[4] http://www.springer.com/us/book/9783319188355.

interests include computational vision, vision-based interfaces, serious games and rehabilitation. His publications are featured in several international journals and he also has participated and led numerous funded research projects (Regional Government, Spanish Government, and European Union). He is also a leader of the international conference titled *AIRtech 2011: Accessibility, Inclusion and Rehabilitation using Information Technologies* – reflecting a collaboration between research groups of the University of the Balearic Islands and the University of Havana, Cuba. This author met Antoni when invited as *AIRtech 2011* plenary speaker/keynote when hosted in December 2011 at the Hotel Parque Central of Havana, Cuba, which resulted in a special collection: Accessibility, Inclusion and Rehabilitation using Information Technologies in the Journal of Research and Practice in Information Technology, Vol. 45, No. 2, May 2013 (JCR indexed, Impact Factor 2010: 0.205)[5], Australian Computer Society.

1.2 DLI (Conference Website[6,7] Extract Included)

The Esbjerg hosting includes the inauguration of the international conference for Design, Learning and Innovation (DLI). This builds upon the opening of the Centre for Design, Learning and Innovation at Aalborg University Esbjerg in 2011 adjacent to when the ArtsIT conference was hosted in Esbjerg for the first time. The steering person and local chair is Professor Eva Brooks who originated and directed the Centre in Esbjerg, which is now established at the main campus in Aalborg under the learning faculty.

Design, learning, and innovation frame the world of ICT, play and playfulness opening doors into an increasingly playful world. Whether it is about developing tools, technologies, environments, as well as content and approaches that can spark and nurture a passion for learning and transforming domains such as education, rehabilitation/therapy, work places, and cultural institutions, design, learning, and innovation is a powerful catalyst in empowering individuals to participate, communicate, and create to be able to exceed their own limits in a playful way: Such is the spirit behind driving the DLI 2016 conference. Making this spirit explicit and visible is crucial to identify how specific tools, technologies, methodologies and solutions shape opportunities for how people can learn and engage with the demands of life. Today, challenges in the fields of design, learning, and innovation are often approached by trans-disciplinary teams and solutions, such that tools, technologies, methods and theories developed for other purposes are mobilized to be utilized in unlocking new frameworks for understanding these fields and thereby opening up to partnerships that can enrich learning in formal and informal learning practices.

Keynotes for the DLI2016 are Sudarshan Khanna and Surabhi Khanna from Delhi, India.

Sudarshan Khanna is a Professor and Design Educator. He was Principal Designer, Chairman of Education & Research, and Head of the Toy Innovation Centre at the National Institute of Design (NID), Ahmedabad, India. He is acknowledged as an

[5] Journal of Research and Practice in Information Technology, Vol. 45, No. 2, May 2013.
[6] http://designlearninginnovation.org.
[7] http://designlearninginnovation.org/2016/show/keynotes.

internationally acclaimed designer and educator, who have established several new courses and programmes, including the Post Graduate Programme in Toy & Game Design. Sudarshan Khanna is a pioneer in the research of interesting facets of indigenous toys and crafts communities all over India. In 1996 he was conferred the National Award for his lifetime work for design-science among children by the Department of Science and Technology. He is recipient of the international BRIO Award 2013 for his lifelong contribution to research and innovation for toy design and development in India. Professor Sudarshan Khanna is the past president of ITRA (International Toy Research Association) and founder Chairperson of "Toys for Tomorrow"- vision-action international forum. As author of three books and many articles on toy design, culture and creative education, he features in many educational TV programmes. He has been conducting workshops in India and other countries all over the world, for teachers, trainers and students, relating the value of design methods and creativity as parts of innovative learning processes.

Surabhi Khanna is a designer, educator and workshop specialist. She has a Master degree in design from the National Institute of Design (NID), Ahmedabad, India, focusing on toy and game design, after her graduation in architecture. She has been working on projects and workshops related to heritage, innovations, and culture-based design. She is associated with several institutions of design and education as a part time and visiting faculty. She was an exchange designer in Germany, invited participant for UNESCO Creativity Workshop on Inclusive Education and Development, and she was co-invitee to Colombia, South America for talks and workshops on design and education. Surabhi Khanna has developed courses and electives related to playful design concepts for students of design and architecture. She conducts design and education workshops for teachers, trainers and children at several organizations and schools.

The title of Sudarshan Khanna and Surabhi Khanna's joint keynote is *Toys & Tales with everyday materials relevance of ingenious, playful ideas for design, learning and innovation*. They describe is as such: -

> "The best thing a child can do with a toy is to break it; the next best is to make it"
> Ingenious toys and tales are innovative tools for holistic learning. Such resource exists in every society. As design educators, we have been involved in the study and documentation of what children play, make and develop. In the presentation, we will discuss how this tangible resource is relevant in today's context of digital environment.
> A good toy would normally integrate aspects of social science, technology, art & aesthetics. Play is a basic and natural instinct and is also an entertaining activity. The process of making and playing innovative toys can make integrated use of 3H: Hands, Heart and Head. Creating products with such a process can provide joy and insights. The sense of curiosity is the starting point of learning. This design medium facilitates interactive, collaborative and creative initiatives.[8]

The Sudarshan Khanna and Surabhi Khanna's joint keynote takes place on the second day of the activities.

All papers are published in the EAI conference proceedings (USB stick) and in the Springer book series run by ICST – namely *Lecture Notes of the Institute for Computer Sciences, Social Informatics and Telecommunications Engineering (LNICST)*. ICST is described next followed by a description of the EAI organization.

[8] http://designlearninginnovation.org/2016/show/keynotes.

1.3 Institute for Computer Sciences, Social Informatics and Telecommunications Engineering (ICST)[9]

ICST is a professional society that sponsors research; innovation and technology transfer to harness and maximize the benefits and impact of ICT in all sectors of human society. ICST views the advancement of ICT as the axis of the next technological and societal revolution and it aims to create a global, grass-roots organization of research communities in diverse technical and geographical areas representing the academic, research, regulatory and business sectors[10].

A wide array of technical and scientific activities falls under the ICST umbrella:

- Over 70 annual scientific events worldwide – summits, conferences, workshops, symposia;
- An extensive publication portfolio – journals, books, proceedings and magazines;
- On-line tools and portals – social networking, multimedia sharing, collaboration;
- Digital libraries – articles, audio-video recordings;
- Recognition mechanisms – awards, lecture and seminar series;
- Technical and functional organizational units.

As a member of the European Alliance for Innovation (EAI), ICST provides the society tools and framework to support EAIs community to achieve its mission to foster innovation in the Information and Communication Technologies (ICT) sector at all levels of the innovation cycle. EAI is described in the following section.

1.4 The European Alliance for Innovation (EAI)[11]

The European Alliance for Innovation (EAI) is a vibrant eco-system for fostering ICT enabled innovation to improve European competitiveness and to benefit society. EAI is unique in its use of open e-platforms to inspire matchmaking, collaboration and to reduce fragmentation among all relevant actors, from organizations to individuals. Through active participation, organizations find ideas and talent, and individuals find organizations for their ingenuity and craft.

EAI's activities are centered on the Innovation Cycle, a framework for classifying the different stages and stakeholders related to the development of innovation. Supported by EAI's platform of online tools, innovation-centered events, and online portals, EAI allows participants to leverage the power of crowd-sourced innovation and engage where and how it is most relevant to them.

EAI's mission is to drive innovation in emerging Information and Communication Technology (ICT) enabled areas by decreasing fragmentation between key participants in the innovation cycle. From education to business to government institutions and Europe itself, EAI provides a bottom-up, grassroots forum for participants to contribute

[9] http://icst.org/about-icst/.
[10] http://icst.org/about-icst/.
[11] http://eai.eu.

knowledge, communicate views, and collaborate together to advance their respective innovation initiatives.[12]

Special Issue journals have also resulted from the events featuring significantly extended and enhanced versions of the work of conference delegates who are invited to submit. These have primarily been under the Inderscience publishing house *International Journal of Arts and Technology*[13]. Additional opportunities to publish are through the introduction of the peer-reviewed research journals EAI Endorsed Transactions that are submitted for inclusion in major indexing services.[14] EAI is linked to CREATE-NET Research Consortium, which is introduced next.

1.5 CREATE-NET: Center for REsearch and Telecommunication Experimentation for NETworked Communities[15]

CREATE-NET is a non-profit association headquartered in Trento, Italy, that was established as an international research center now recognized as one of Europe's leading institutions in ICT and telecommunications technologies. CREATE-NET acts as a promoter of "globalization of knowledge and research", facilitating the cooperation and interaction of research competences around the world to become the focal point in Europe for "engineering of research/innovation", through the promotion and strong participation into the European Alliance for Innovation (EAI).

The above presents the history and dimensions of the two international conferences and the magnitude of the background affiliated organizations that organize and manage the events. In so doing it is fitting to highlight that this will be the final international conference of it type at Esbjerg campus run by Medialogy personnel due to the "dimensioning" that has taken place in the Humanities in Denmark. The result of this is the closure of Medialogy in Esbjerg.

2 Dimensioning

It is appropriate that two international events having creativity, technology and human foci are presented in Esbjerg, Denmark at the time when the Danish Ministry of Education is closing and reducing humanities focused educations under its "Dimensioning" act – originally a resizing plan to cut 4,000 study places from Danish universities[16]. Thus, 2016 will be the final presentation of these events in Esbjerg due to such closures. In welcoming the conferences international delegates to the city, region, and country, the general chairs – including the technical programme committee - and local organizing committee especially will put on a brave face though tinged with anticipation of a

[12] http://icst.org/eai/.
[13] www.inderscience.com/ijart.
[14] http://eai.eu/about-us/organisational-model.
[15] http://www.create-net.org/about-us.
[16] Education 1/12-14 11:03
Title: Dimensioning plans could still be stoppedhttp://universitypost.dk/article/dimensioning-plans-could-still-be-stopped.

regional education profile without a future-oriented state-of-the-art creative industries university education. As campus guests, delegates may note low student numbers. Notably, this relates to the closure of the Medialogy education in Esbjerg and the relocation of the Centre for DLI to the main campus in Aalborg – some 3 hours drive North.

It is fitting to state that since Professor Jens Arnspang founded Medialogy in September 2002, many students in the region have benefitted through graduating and successfully opening their own local business spin-outs (industry start ups) that have achieved international recognition resulting in creating a large number of jobs – often employing Medialogy or other Esbjerg campus students – and attracting significant investment. Other Medialogy graduates have been employed in the region, nationally and internationally, successfully bringing a unique "out-of-the-box" creative edge to their employers' profiles. Evidence points to a 98-percentile employability within one year of graduation for Esbjerg Medialogy students, which confounds the reason for Humanities closures announced at the Education Ministry web site and press[17]. The Dimensioning action has been criticized in the Education Press as "an attack on the open society"[18] where Werner Schäfke, a post doc at the Faculty of Law, University of Copenhagen writes:

> In effect, the Danish government gains the power to decide what kinds of studies Denmark's universities are allowed to offer, and thus what kind of studies Denmark's citizens are allowed to study. This is a degree of centrally planned economy in education and control over education rather known from socialist states like the German Democratic Republic, and even darker comparisons spring to one's mind.
> The message the Danish government sends is, however, easily understood when keeping the prejudice in mind that especially graduates with degrees in the humanities or social sciences are ascribed the ability to think critically, and reflect what the government is doing. The Danish government's message then is: We do not want our citizens to be critical and reflective. We do the thinking, and we shape your opinions for you. We do not want citizens who know how societies work, that is our business, not yours.
> The true message the "dimensioning"-plan sends is easily misunderstood as yet another economically motivated plan to reduce costs for education, and the uproar it causes is easily discarded as the usual whining of scholars from the humanities who fear for their cozy university jobs.
> The true message is: Your government does not want you to reflect upon its decisions. It wants well-behaved citizens who dutifully follow the way they show. This is most easily demonstrated by targeting groups of citizens who are commonly ascribed as the ones most likely to critically reflect what happens in society.
> But the message is directed to all citizens. And the message comes from enemies of an open society.

The action resulted in an outburst by academics in the form of a petition with many thousands of Danish signatures and an international petition against Danish education reforms generated more than 1,700 signatures as well as words of solidarity and support from established academics. One Danish academic, Associate Professor Jan-Ullrich from the University of Copenhagen wrote:

[17] http://politiken.dk/indland/uddannelse/ECE2469128/opposition-vil-presse-ny-plan-for-studier-igennem/.

[18] Education 6/11-14 9:43 4
Title: Comment: 'Dimensioning' – an attack on the open societyURL – http://university-post.dk/article/comment-dimensioning-attack-open-society.

We appeal to our colleagues internationally to voice their concern about this unprecedented, large-scale attack on the humanities in Denmark, he adds. If implemented, the planned cuts would lead to a serious impoverishment of the Danish and Scandinavian academic landscape and to the irreversible disappearance of highly specialized expertise at a time when it is most needed

Professor Richard Gombrich at the University of Oxford in the UK, who is one of the 2,641 + international petitioners who had signed the petition wrote: "I hate to see a civilized country like Denmark committing cultural suicide. If the minister thinks that education is too expensive, has she assessed the cost of ignorance?"

Professor Richard Nance of the Department of Central Eurasian Studies, Bloomington, United States writes that "the threatened loss is not just Denmark's, though that loss would be grave enough. The loss is global. We eliminate the humanities at our collective peril."[19]

Danish university management were subsequently given authority to close and cut back the educations they believed would address the ministry requirements for dimensioning. Despite Esbjerg Medialogy achieving outstanding positive accreditation in a governmental board review, stated as the highest of the three campuses that educate Medialogy, it is being closed thus cutting out the heart of the creative economy in the southwest Jutland region within which such educations exist nowhere else.

3 Conclusion

International conferences offer unique opportunities for networking and learning. Students often get their first experiences of public speaking to amassed academics, scholars and professors at conferences – a challenging but rewarding learning experience. The affiliated organizer of the two events presented, The European Alliance for Innovation (EAI), alongside Create-Net and ICST promote such international conferences as well as supporting resulting networking and publishing in their hosted journals. The foresight and vision behind realizing such a collaborative venture is significant. It exemplifies a core creative industries perspective in supporting across many fields, and in our case over these two days in May, the Arts, Design, ICT, Interactivity, Learning, Game Creation, and Innovation. The pleasure of welcoming delegates is tinged with the sadness of the closing of Medialogy at the host establishment, i.e. the Aalborg University Esbjerg campus. It is especially sad due to the many years of excellent examples of Arts, Design, ICT, Interactivity, Learning, Game Creation, and Innovation at the core of students' Medialogy projects and course work. Aalborg University will move forward yet there will be an empty crater on the south west Jutland coast where Medialogy was established and developed, where a productive student pipeline fed the local creative industries (employed student percentile around 98% within one year of graduation) in a fine manner and where some students realized their dream of an own company with an international media profile.

[19] https://www.change.org/p/minister-sofie-carsten-nielsen-denmark-minister-sofie-carsten-nielsen-preserve-the-humanities-at-copenhagen-university.

 This chapter thus closes as a form of elegy to the Medialogy 'dimensioning': It is written as a tribute to all students and staff that have passed through the doors of Medialogy at Aalborg University Esbjerg. Long may the pioneering efforts be remembered of those in the original team, and I for one anticipate that the legacy of Medialogy founder, Professor Jens Arnspang, will continue onwards through its presence at the other campuses in Aalborg and Copenhagen.

A Tangible Augmented Reality Toy Kit: Interactive Solution for Early Childhood Education

Yujie Zhu[1,2] and Stephen Jia Wang[1,2(✉)]

[1] Department of Design, Faculty of Art Design & Architecture, Monash University,
Melbourne 3145, Australia
stephen.wang@monash.edu
[2] International Tangible Interaction Design lab, Monash University,
Melbourne 3145, Australia

Abstract. Augmented Reality (AR) has been recognized as one of the most promising technologies for the gaming industry. In this study, the designers intend to apply AR technology to developing an educational interactive game. This paper presents an AR featured educational game specifically designed for 4–6 years old pre-school children. The main objective of the game was to teach children knowledge about color mix, mathematics and 2D-3D geometrical shapes. This game allows user to interact with both in-screen and physical objects at same time, and different interaction forms like the touch screen (click) and AR game (rotate) for better interaction with real world and learning. This paper focuses in detail on the design and interactive behavior. Furthermore, beyond the needs of children, this game also serves for parents. Through the Token Economy method, parents can control kids' playing time, and track and modify their everyday behavior.

Keywords: Augmented reality · Tangible interaction · Educational game · Early childhood education

1 Introduction

Children learn from imitation and play before the age of seven, and games provide a fun way of learning serious ideas and important life skills [3]. According to studies, well designed digital educational games can play a significant role in early childhood education, being more efficient and effective than traditional toys [2, 4, 8], also enable 'playful learning' [1]. One of the challenges in recent child education is to enable them to think on an abstract level; such complex knowledge only can be transferred to children through unified/combined methods and manipulating tangible toys [6]. Under such context, augmented reality (AR) technology can significantly enhance early childhood education by providing exciting experiences of 'playful', as it can integrate virtual objects and additional information to real objects.

However, till recently, there are only limited successful cases to support 2D-3D geometrical shape, mathematic and color mix learning, since most of the existing ones are in-screen exercises or pure virtually interactive environments and objects. Also none

© ICST Institute for Computer Sciences, Social Informatics and Telecommunications Engineering 2017
A.L. Brooks and E. Brooks (Eds.): ArtsIT/DLI 2016, LNICST 196, pp. 12–19, 2017.
DOI: 10.1007/978-3-319-55834-9_2

of them focus on bridging theory and abstract concepts with real world feedbacks. In the design of this AR game, the following aspects have been specifically focused:

1. Game design principles based on montessori education theory
2. Physical object interaction with screen
3. Learning and playing method

The following sections describe further details of this study: Sect. 2 illustrates research background information and design concept of the game. Section 3 describes technology and system structure. Section 4 organizes different interactive methods. Sections 5 and 6 detail discussion, future work and conclusions of this project.

2 Design Rationale

The aim of this augmented construction toy kit (AR BLOCK) is to base design on the Montessori education method, which considers that introducing children as young as four or five to mathematics can have long-lasting benefits. Montessori materials are designed to allow for auto-education and self-correction [5].

2.1 Integration of Tangibility and AR

Augmented Reality (AR) technology can enhance 'playfulness' and 'abstract learnability'. In order to recognize the features of AR technology have been applied in children's education, a series existing products have been analyzed. Table 1 presents the advantages and disadvantages of these products. NEOBEAR is a company that specializes in children education and technology. Most of their products use AR technology, such as Pocket Vehicles, Popup AR Paintings and Magnifier NEO. These products allow children to observe virtual 3D models through scanning different animals, vehicles or vocabulary cards. More importantly, NEOBEAR chooses soybean oil ink, which is a safe material for children. Disney Research also presents a texturing process, which uses AR technology. This product can track texture from 2D colored drawing and apply it on virtual 3D models in real time.

Comparing with existing products, AR BLOCK emphasizes on interactivity, playability and methods variations, which could enhance children's experience when exploring the game. This no longer requires a common AR game with display card information but through manipulating tangible 3D objects.

In terms of the ideology of overall system, wide range interactive behaviors have been considered. How to transfer the plane graphics into abstract solid shape is the key of teaching geometrical shapes. Through researching the Montessori methods, we found that touching will be a good solution for bridging abstract concepts with physical objects. So our product will provide some tangible cards and blocks, which helps children observe differences between 2D and 3D shape through touching them. Furthermore, we want to discover a unique method to learn mathematic. And consider our product's feature, we combine the math function with geometrical shape function. In terms of

color mix function, our Color Blocks provide intuitionistic color mixing process. Touching two Color Blocks can become a new color.

Table 1. The existing products analysis

Product name	Advantages	Disadvantages
Pocket vehicles	50 kinds of transportation cards Switch in both Chinese and English Rotatable virtual 3D models Environment friendly ink Safe for children	Lack of interactive mode Single mode of learning Lack of long term attraction
Popup AR paintings	Painting books with different theme Coloring 2D picture and observing 3D animation with users' special colors Learning geography	Lack of further study of color knowledge Children can not create a new color Montessori material through matching the same color cards to train children's sensory ability, this product focuses more on the development of children's creativity

2.2 Design of Tangible Components

The AR BLOCK game consists of tangible construction blocks/cards and intangible application for tablets. The tangible object component contains four main functions:

Through playing with distinctive blocks or cards, children can learn different concepts. For example, when children observe Foundation Cards, they can only see 2D geometrical shapes, but the screen will show the 3D geometrical shapes. These Foundation Cards can help children with 2D and 3D conversion ability. Children can learn mathematics from Number Blocks. Number Blocks have different shapes and numbers; if the Foundation Card shows a house frame with square and triangle shape and number 8, the user should choose a cube and a triangle Number Block. Then they calculate numbers on the cube block and triangle block, letting the result equal 8. Moreover, children can exercise their matching ability through comparing Building Cards with Foundation Cards. Same geometrical shape can complete the house. Lastly, each Color Block has three colors: yellow, red and blue. Children can rotate Color Blocks to change the house's color and two Color Blocks color can mix to a new color.

At current product design process, timber was chosen to manufacture the tangible blocks for our original prototype. Timber comes from nature, and exposure to natural material is good for children. This material can be preserved for a long time, and is widely used in construction blocks toy market. Children are familiar with wooden toys. However, we also consider another material: silica gel, which is wildly used in medicine, toy business and other fields. Silica gel has many advantages, such as non-toxic, no pungent smell, chemical stability. In the future, we will continue to discover the

differences between timber and silica gel. Considering the characteristics of AR BLOCK to finally choose a better solution. For the software, Vuforia-an open source AR platform was used to develop the AR features, also due to it's cross-platform and game engines supporting features. Comparing with other open source platform, functions of Vuforia come closer to my requests, such as objects recognizing and tracking, user-defined images or frame markers, which are ideal for product and game creations.

As shown in Table 2, blocks and cards have different markers' design. These markers will be printed on the timber, so it is very important to choose a safe printed material. Based on current research, we choose soybean oil ink. Soybean oil ink is an environment friendly material. It has many advantages, such as a more reasonable price than other materials, non-toxicity, recyclability, and is already widely used in children's products. Because of the restrictions on the size of Vuforia markers (>30 mm), the size of cards is 55 mm square and blocks have different types, such as 55 mm cube and 55 mm triangle.

Table 2. Different tangible blocks or cards design table

Name	Design	Virtual Objects	Function
Foundation Cards			- First step of game. - Cards show 2D geometrical shape. - Virtual objects show 3D geometrical shape. - Transfer ability between 2D and 3D geometrical shape.
Building Cards			- Training matching ability - Compare Building Cards with Foundation Cards - Same geometrical shape - Prepare for learning color knowledge
Number Blocks			- Training addition ability - Click the yellow number first (On screen)
Color Blocks			- Learn color mix - Combine two colors - Create a new color

2.3 Design of Intangible Components

The intangible/in-screen component is designed for digital media devices, such as an iPad or Android tablet. AR BLOCK application has three modes:

1. Parent Mode
2. Kids' Mode
3. Family Mode

As well known, long period electronic equipment using brings negative impact to both children's physical and mental health. Based on our user studies and demonstrating prototype to parents, the playing time issue has been raised by most of parents. It is important for parents to supervise their kids' playing time. In Parent Mode, parents can choose different behavior medals and each medal has three stars. Bases on children's everyday behavior, parents can provide stars for their kids; one star equals to five minutes playing time. Better behavior can earn longer playing time. This method is called the Token Economy, which is an excellent behavior modification tool. Through Parent Mode service, parents not only can control kids playing time but also can track their everyday behavior, in order to correct behavior problems immediately. Children can play game in Kids' Mode or Family Mode. Kids' Mode has time limited, which needs stars to unlock. Family Mode does not have time limits, but it needs parent's password to unlock.

3 Technology

Though using Unity3D and Vuforia software, we designed an application. As we mentioned before, the system of AR BLOCK divides into three directions: Parent Mode, Kids' Mode and Family Mode.

Figure 1 describes the different interactive behaviors, feedbacks and system of Kids' Mode and Family Mode. If children already get playing stars in the Parent Mode, they can unlock Kids' Mode and play, otherwise users have to go back to home page. When playing times out, users cannot continue to play the game. There are three buttons in the game interface. Clicking 'Home' button can go back to home page and 'Screenshot' button can save children's work to the tablet's gallery. The 'Help' button can help children learning independently, because self-directed learning is an important concept of the Montessori education method. 'Help' has different tips, such as 2D and 3D geometric shapes, the results of mixing two colors, and how to learn mathematics. When the game starts, children will choose a Foundation Card first and the screen will show a 3D frame of house. Next, children should click the yellow number button beside the house on the screen. If users forget to click the button but choose another cards directly, the system will present visual and audio feedbacks, in order to remind users to make the correct behavior. This method can help children to focus on their existing work. After they finish the existing work, they can go to next.

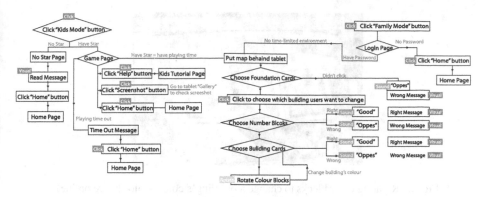

Fig. 1. System architecture of Kids' Mode and Family Mode (Color figure online)

4 Interactivity

The concept of interaction of this project divides into two sections: a visual and auditory interactivity, and an operational interaction aspect. For instance, in terms of parents operation gesture, the main behavior focuses on the screen. The click gesture allows choice of different functions, and swipe choice of different medals. Conversely, in the play environment, the users' main behavior will focus on the physical blocks/cards.

4.1 Visual and Auditory Interactivity

In most cases, the system provides feedback to users when they have operation behavior. These visual or audio feedbacks are crucial for guiding the user's interactive behavior [7]. For example, suppose that after choosing a Foundation Card, instead of clicking the screen to choose the house, children just continue to choose another block. The system will show a visual feedback 'Please click the number to choose which building you want to change' and an audio feedback 'Oops'. If the user chooses a Building Card with a shape different from the Foundation Card, the user will see a message 'Please choose the right card' and hear an audio feedback 'Wrong card'.

4.2 Operational Interactivity

When the user interacts with application, *Click* is the most commonly used operation gesture. However, in the game environment, *Rotate* will become to the mainly gesture. Through rotating blocks, the tablet camera will recognize different markers and the screen will show different feedbacks. For instance, if the user wants to change the house color and learn color mix knowledge, the user can use Color Blocks. Camera recognized No. 1 Color Block marker was yellow and No. 2 Color Block marker was red, so the house's color showed as orange. If the user rotated No. 2 Color Block and changed the marker to blue, the house color will change to green (Fig. 2).

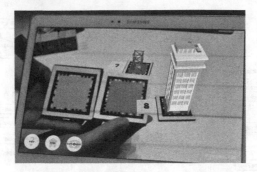

Fig. 2. Rotating color blocks to change a building's color (Color figure online)

5 Discussion and Future Work

This paper provides an overview of the design of AR BLOCK; we start our study with a survey of existing AR products and discover weaknesses of them. Then our prototype was tested in a MADA exhibition in 2015. In the exhibition, researchers, educators and parents have a trial with AR BLOCK. They provide different comments bases on their experiences. Through the observation and conversation with users, some features have been accomplished. For example, most of users consider that the interaction behavior of AR BLOCK is very interesting. Their playing method is no longer limited to the screen but return to the original operation behavior. Instead of Drag, Click or Swipe, they can assemble physical blocks, exactly the same as with traditional construction block toy's operation mode. Moreover, rotating Color Blocks to change colors provide an intuitive and effective method for learning color mix knowledge. However, the prototype is lacking a better way of guidance, despite its tutorial function. The majority of users do not know how to start the game when they play for the first time. We designed a tutorial page in Parent Mode; we hope that after parents understand how to play, they can teach their children by themselves. In fact, children still do not know the game rule.

From these survey and user test, the prototype is different from other existing products in interactive operation methods. AR BLOCK pays more attention to interaction of physical objects with the screen. In terms of learning, AR BLOCK provides a unique color mix method. Users can choose different Color blocks and rotate any of them, which will produce a new color. Children can learn each color's name and observe the result when two colors are combined.

As the next step, the future development of AR BLOCK will focus on building a more effective guidance system, in order to provide a better user experience. For example, in the playing environment, instead of 'Tutorial' function page, using a cartoon character guides users game process and provides visual/audio feedback of users operation. Moreover, the interface design of existing Foundation cards and Building cards are easy to mislead users, they do not know how to pair the right card. We should redesign them and display information more efficiently.

6 Conclusions

To sum up, the main contributions of this project are bonding Montessori education theory with real world feedbacks; allowing user to learn abstract concept through interacting with tangible blocks. According to Montessori theory, blocks and cards of AR BLOCK can transfer abstract information to children, such as addition, 2D or 3D geometrical shape and color mixing. Instead of in-screen exercises, children can assemble or rotate these blocks, and the screen will give feedback based on their operation gestures. AR BLOCK can provide a better interactive experience when children are playing and learning.

References

1. Bundy, A.: Play and playfulness: what to look for. In: Parham, L.D., Fazio, L.S., (eds.) Play in Occupational Therapy for Children, pp. 52–66. Mosby, St. Louis (1997)
2. David, F., González-Ganced, S., Juan, M.-C., Segui, I., Costa, M.: The effects of the size and weight of a mobile device on an educational game. Comput. Educ. **64**, 24–42 (2013)
3. Deborah, P.: Focusing and Calming Games for Children: Mindfulness Strategies and Activities to Help Children to Relax Concentrate and Take Control. Jessica Kingsley Publishers, London (2012)
4. Rui, L., Rodrigues, J.M.F., Aderito, M.: Game-based learning: augmented reality in the teaching of geometric solids. Int. J. Art Cult. Des. Technol. **4**(1), 63–75 (2014)
5. Stephanie, W.: Creating an amazing montessori toddler home environment. Montessori Life **26**(2), 54–59 (2014). A Publication of the American Montessori Society
6. Vygotsky, L.S.: Mind in Society: The Development of Higher Psychological Processes. Harvard University Press, Cambridge (1978)
7. Wang, S.J.: Fields Interaction Design (FID): The Answer to Ubiquitous Computing Supported Environments in the Post-Information Age. Homa & Sekey Books, Paramus (2013)
8. Zaranis, N., Kalogiannakis, M., Papadakis, S.: Using mobile devices for teaching realistic mathematics in kindergarten education. Creative Educ. **04**(07), 1–10 (2013)

The Farm Game: A Game Designed to Follow Children's Playing Maturity

Emmanouil Zidianakis[1]([☒]), Kalliopi Stratigi[1], Danae Ioannidi[1], Nikolaos Partarakis[1], Margherita Antona[1], and Constantine Stephanidis[1,2]

[1] Foundation for Research and Technology – Hellas (FORTH),
Institute of Computer Science, 70013 Heraklion, Greece
{zidian,stratigi,ioanidi,partarak,antona,cs}@ics.forth.gr
[2] Department of Computer Science, University of Crete, Crete, Greece

Abstract. This paper presents the design, implementation and deployment of a new version of the popular farm game as deployed within an Ambient Intelligence (AmI) simulation space. Within this space, an augmented interactive table and a 3D avatar are employed to extend the purpose and objectives of the game, thus also expanding its applicability to the age group of preschool children from 3 to 6 years old. More importantly, through the environment, the game, which builds on knowledge stemming from the processes and theories used in Occupational Therapy and activity analysis, becomes capable of monitoring and following the progress of each young player, adapt accordingly and provide important information regarding the abilities and skills of the child and their development over time.

Keywords: Ambient intelligence · Serious games · Occupational therapy · Virtual assistant · Tabletop interaction

1 Introduction

Play is widely used in therapy to treat children's emotional and behavioral problems because of its responsiveness to their unique and varied developmental needs [3]. Current interactive technologies provide the means to achieve a radical transformation of play much beyond desktop computers games. A large number of products is available to young children that incorporate interactivity such as activity centers, musical keyboards, and radio-controlled toys [4]. This range of toys and devices is part of a move towards pervasive or ubiquitous computing in which technology blends into the environment and is not necessarily visible. AmI environments offer opportunities to support children's playing needs. Designing and creating playing experiences under the perspective of Ambient Intelligence has the potential to provide enhanced gaming experience to all age groups and in particular to children.

The farm game presented in this paper is tailored to the needs of preschool children, aged 3 to 6 years old, and supports playing through tangible interaction with physical objects. In general, the theme of the farm game is considered to be one of the most popular puzzle games for children and at the same time for OT therapists as a mean to

© ICST Institute for Computer Sciences, Social Informatics and Telecommunications Engineering 2017
A.L. Brooks and E. Brooks (Eds.): ArtsIT/DLI 2016, LNICST 196, pp. 20–28, 2017.
DOI: 10.1007/978-3-319-55834-9_3

assess children's developmental issues. Using the employed technological infrastructure (an augmented interactive table and a 3D avatar) and its support for combination of physical and virtual objects, the farm game presented in this paper extends the age range supported by the traditional one. This is achieved by increasing the difficulty and playing demands according to developmental standards for ages up to 6.

2 Background and Related Work

Play is one of the areas of human occupation that OT focuses on, thus appropriate activities for children are widely used in order to evaluate and facilitate the development of their skills and abilities [15]. Therapists proceed with **activity analysis** process to define the numerous demands that a specific activity requires for execution. OT expertise has been employed at the design of the farm game, so as to meet the needs of OT practitioners, and also to provide the knowledge at the basis of interaction monitoring and adaptation logic employed by the game. As a result, the farm game builds upon child development theories and the definition of expected skills and tools to provide the scientific basis for the rationale of the game [6, 13].

Aiming to analyze play performance, a thorough and systematic process needs to be applied in order to address the factors that may affect children's functionality and identify the context related factors as well as the interrelations among them. All factors are interrelated and can be grouped as follows: (a) child factors, (b) performance skills, (c) activity demands and (d) context and environment [1, 5]. Relevant studies in the domain of activity recognition for monitoring children's developmental progress have focused more on the recognition part than on the 'play' aspect [8, 14].

Historically, children have been encouraged to play with physical objects such as building blocks, shape and jigsaw puzzles, in order to enhance a variety of their skills [11]. In general, a growing number of research projects have begun to investigate the usefulness of tangible interfaces because they present a lot of advantages, which have also been validated by many authors [2, 9]. Tangible interfaces aim to open up new possibilities for interaction that blend the physical and digital world together [7], and have the potential to provide innovative ways for children to play and learn through novel forms of interaction [10, 12].

However, little work has been conducted so far that employs developmental theories and AmI technology to offer games capable of monitoring and adapting to child's development in an unobtrusive manner. To this end, this paper presents three main contributions: (a) the novel design of the farm game which has been conducted in collaboration with occupational therapists so as to embed aspects of their work and therapeutic procedures, (b) the adaptation logic of the game relying on OT expertise and activity analysis based on the ICF-CY [16] and Denver II scale [6] together with runtime interaction monitoring and statistical analysis [18], and (c) the game itself was developed using a distributed service architecture were technology is embedded in everyday objects and deployed within the environment thus providing a unique enhanced playing experience to children, while also maintaining and expanding the therapeutic qualities of the game itself.

3 Technological Infrastructure

The design of the game was conducted on the basis of an existing technological infrastructure that includes an augmented interactive table called Beantable [17] and a cross-platform remotely-controlled 3D avatar called Max [19], shown in Fig. 1. Beantable is made up of technological components that offer the child the opportunity to engage in virtual play situations either alone or with the presence of a virtual partner called Max. The "means" that the child can use during interaction include: (a) force-pressure sensitive table surface, (b) physical object recognition, (c) speech recognition, (d) gesture recognition, (e) body movement recognition, (f) force-pressure and orientation sensitive pen, and (g) digital dice [17, 20, 21].

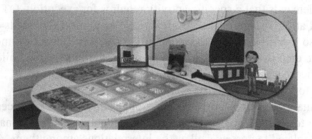

Fig. 1. Beantable: An augmented interactive table accompanied by a cross-platform 3D avatar.

Max can act as a guide, assistant or information presenter for novel, cross-platform Ambient Intelligence (AmI) edutainment scenarios. The role of Max depends on the client-application's requirements. In order to achieve natural communication channels both non-verbal and verbal behavior are essential. Non-verbal communication includes full body animation and facial expressions.

4 The Farm Game

The farm game is organized in 4 levels, each one addressing the developmental needs of a specified age range between 3 to 6 years. Each level targets selected activities from two categories: (a) specific activities related to child's matured abilities (based on the Denver II scale) and (b) general activities related to the activity's prerequisites (e.g. watching, listening). Based on the data stemming from activity analysis and OT expertise, targeted activities were identified along with the adaptation logic and the physical design of the game.

The player has to execute a number of tasks for achieving the game goals. Involved activities include watching, listening, adapting to time demands, communicating with the virtual character Max, etc. Furthermore, the farm game requires various body functions related to the execution of playing actions such as mental functions (discriminating shape, size, color, etc.), problem solving, time management, voice, speech functions, etc. Finally, the farm game targets various performance skills such as (a) remaining seated, (b) listening to spoken messages, (c) matching items, etc.

The game is responsible to monitor and evaluate the play performance and commit a representative score to the adaptation infrastructure mechanism (AIM) which is part of the Bean framework and provides the child's profile [18]. AIM analyzes the play performance of the current level's specific activity and makes appropriate adaptation suggestions back to the game. Through statistical analysis, AIM is able to identify potential activity limitations, extract the current child's capacity in the execution of targeted activities as well as estimate the child's developmental rate. As a result, the adaptation logic is able to identify children whose play performance deviates significantly from the average population of their age using Denver II scale and report the outcomes to parents and caregivers. Additionally, using this information, the game can adapt to the child's evolving skills so as to choose the most appropriate level according to child's estimated abilities.

The design of the game was based on an actual physical puzzle game. The puzzle pieces act as the physical part of the game, while the background is provided digitally on the Beantable's surface. Wooden pieces, including physical objects and the identity card, were scanned in order to create their virtual counterparts employed in the game. Special visual markers were added on the bottom side of the physical pieces (Fig. 2A) which are recognizable by the system. Additionally, in the case of identity cards, lanyards were placed on the top of the physical objects (Fig. 2B). Children store all the physical items in a box called the "Farm Box", which also has a visual marker attached.

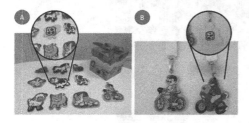

Fig. 2. (A) Physical items and attached visual markers. (B) Tagged identity cards with lanyards.

Fig. 3. Alternative instantiations of virtual animals.

At the beginning of the game, Max asks the child to place his identity card on the surface as shown in Fig. 4A. The system recognizes the identity card and remotely requests child's profile from AIM in order to initialize the game accordingly. Max welcomes the child by announcing his/her name and asks the child to find and place the "Farm Box" on the Beantable's surface as shown in Fig. 4B. Thereafter, the game is started at a level corresponding to the child's maturity profile, while Max explains the relevant instructions.

Fig. 4. (A) Waiting for the identity card. (B) Waiting for the "Farm Box".

At the **1st** level (age 3 to 4), the child has to place each physical object to its corresponding virtual position (Fig. 5A). Each virtual position depicts an animal in the form of black and white. The system recognizes successful matching between the physical object and its virtual position even when its orientation is wrong. Upon successful recognition, the gray-out virtual position is colored (Fig. 3A) and the system rewards the child by the reproduction of the animal's sound.

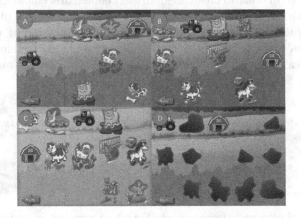

Fig. 5. Indicative game level instances.

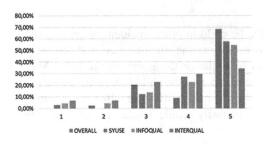

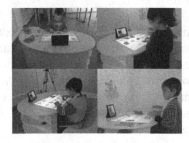

Fig. 6. Usability factors (children). **Fig. 7.** Young children playing the farm game.

The game tracks various interaction data such as the number of invalid placements for each virtual position and submits them to AIM. The latter sends feedback including indications about possible weaknesses regarding child's play activities making the game

to adapt appropriately. For instance, the sound of the virtual animal is produced even when the physical object is placed on it after several misplacements, thus the child is assisted to identify the depicted animal. The game level is completed when every physical object is placed on its corresponding virtual position by activating the **congratulation mode** of the game, where Max congratulates the child by saying a random rewarding message. When AIM reports severe weakness, the **free play mode** is activated allowing the child to interact freely, without any errors signaled, thus keeping him as much as possible engaged.

At the **2nd** level (age 4 to 5), the child has to place more physical items in their virtual positions (Fig. 5B). The game's logic is extended to require properly aligned physical object placement. At the **3rd** level (age 5 to 6), the child has to place every physical object (Fig. 5C) while no feedback is provided even when matching is successful. The system checks for correct matching, proper orientation and reports interaction data to AIM only when every virtual position is covered by a physical object. That functionality remains the same at the **4th** level (age 6 to 7) with the only difference that the virtual positions are created using the mirrored and the normal outline of each physical object (Figs. 3B and 5D).

5 Evaluation

A small scale evaluation of the farm game was conducted in order to explore usability, playability and applicability in the context of OT practice. The participants list of the evaluation consists of: (a) 14 children, (b) their parents, and (c) early intervention professional comprising of two occupational therapists, a psychologist and a special education teacher. Each child played the farm game while the child's parent(s) and professionals were observing. The children were encouraged to play freely without any external interventions by adults (Fig. 7). After each evaluation session, children and parents were required to fill in a questionnaire developed separately for each user group. Early intervention professionals completed their questionnaire after the completion of all the evaluation sessions. The interaction of children with the game was recorded in consensus with their parents. The evaluation results were extracted through an analysis of the recorded sessions and the results of the questionnaires. The recorded sessions were analyzed by usability experts to produce recommendations regarding further improvements of the game, while the questionnaires were used to calculate quality factors. Overall, four factors were calculated, and namely OVERALL (overall satisfaction), SYUSE (satisfaction when using the system), INFOQUAL (information quality) and INTERQUAL (satisfaction regarding the user interface). Figure 6 shows the results for children. Overall, it can be concluded that the young users were satisfied from the game. However, there is a lot of room for improvement such as the interaction quality. In case of parents, the game scored well in all the calculated usability factors with scores for 8 to 10, gathering the majority of their goals for all usability factors. Professionals' rating was also very positive and this was also expressed during the informal interviews conducted after the completion of the evaluation. They commented very positively both the design of the game and the adaptation mechanism.

Regarding playability, children reported a few problems as follows: sometimes Max was unable to understand their answers, the game remained the same between levels (although the virtual positions and the background were randomly selected), and the 4th level was not quite similar to the previous ones. Some parents commented that the game should give feedback every time the child places a physical object to its correct virtual position. For example, a visual or an audio feedback to give the feeling that the item is correctly placed as happening in the actual traditional game. Moreover, parents think that the voice of Max should be louder and less computerized. Professionals commented that the game should demonstrate the "how to play" guidelines only for the first time the child chose to play. Furthermore, they noticed that Max was slow in his reactions while the game's idle time was too short. They also expressed concern about the size of the secondary screen presenting Max that in their opinion should be bigger. Finally, they found that the monitoring and adaptation logic of the 4th level should not be as tolerant as it was. More importantly, both parents and early intervention professionals commented that the game could successfully adapted to children's skills and abilities. In case of a 5.5 years old child, facing learning difficulties, the game efficaciously adjusted the difficulty level due to possible skill immaturities indicated by AIM.

6 Conclusion and Future Work

This paper has presented the design, implementation and deployment of a popular farm game capable of monitoring and following the progress of each young player. The farm game is able to adapt accordingly and provide important information regarding the abilities and skills of the child and the inferred development progress over time. This was achieved by employing OT knowledge during design process and by exploiting existing technological components such as an interactive table for preschool children, a remotely-controlled 3D avatar and an adaptation infrastructure mechanism. The presented game adjusts the difficulty and playing demands according to the measured developmental progress of the young player following the developmental expectations of child's play performance for age related activities.

The produced version of the game was evaluated in the context of a small scale study with children of the aforementioned age groups, their parents, as well as early intervention professionals. The results of the evaluation were positive for all the aforementioned user groups, but also generated feedback regarding possible improvements of the game in the future. In the case of children, the game in general was proven to be suitable for all age groups and this was also mirrored in the way the adaptation mechanism was functioning while playing. Currently, the farm game is hosted in a children's playroom setup within FORTH-ICS's AmI research facility. Regarding future work it is considered crucial to design an evaluation strategy comparing the presented game to the traditional one along with the active contribution of the aforementioned end users.

Acknowledgments. This work is supported by the FORTH-ICS internal RTD Programme 'Ambient Intelligence and Smart Environments'.

References

1. American Occupational Therapy Association. Occupational therapy practice framework: Domain & process. 2nd edition. Amer Occupational Therapy Assn (2009)
2. Ananny, M.: Supporting children's collaborative authoring: practicing written literacy while composing oral texts. In: Proceedings of the Conference on Computer Support for Collaborative Learning, Boulder (2002)
3. Axline, V.M.: Play Therapy. Random House LLC, New York (2012)
4. BECTA. Keyboard Skills in Schools. British Educational Communications and Technology Agency, Covertry (2001). http://www.becta.org.uk/technology/infosheets/index.html
5. Fisher, A.: Overview of performance skills and client factors. In: Pedretti's Occupational Therapy: Practice Skills for Physical Dysfunction, pp. 372–402 (2006)
6. Frankenburg, W.K., Dodds, J., Archer, P., Shapiro, H., Bresnick, B.: The Denver II: a major revision and restandardization of the denver developmental screening test. Pediatrics **89**(1), 91–97 (1992)
7. Ishii, H., Ullmer, B.: Tangible bits: towards seamless interfaces between people, bits and atoms. In: Proceedings of the ACM SIGCHI Conference on Human Factors in Computing Systems, CHI, pp. 234–241 (1997)
8. Kientz, J.A.: Decision support for caregivers through embedded capture and access. Ph.D. thesis, College of Computing, School of Interactive Computing, Georgia Institute of Technology, Atlanta, GA, USA (2008)
9. Marco, J., et al.: Bringing tabletop technologies to kindergarten children. In: Proceedings of the 23rd British HCI Group Annual Conference on People and Computers: Celebrating People and Technology. British Computer Society (2009)
10. Marshall, P.: Do tangible interfaces enhance learning? In: Proceedings of the 1st International Conference on Tangible and Embedded Interaction. ACM (2007)
11. O'Malley, C., Fraser, D.S.: Literature review in learning with tangible technologies (2004)
12. Price, S., Rogers, Y., Scaife, M., Stanton, D., Neale, H.: Using 'tangibles' to promote novel forms of playful learning. Interact. Comput. **15**, 169–185 (2003)
13. Vygotsky, L.S.: Play and its role in the mental development of the child. Sov. Psychol. **5**(3), 6–18 (1967)
14. Wang, P., Westeyn, T., Abowd, G.D., Rehg, J.M.: Automatic classification of parent-infant social games from videos. In: Electronic Proceedings of the International Meeting for Autism Research (2010)
15. WFOT: http://www.wfot.org/AboutUs/AboutOccupationalTherapy/DefinitionofOccupational Therapy.aspx
16. World Health Organization (ed.) International Classification of Functioning, Disability, and Health: Children & Youth Version: ICF-CY (2007)
17. Zidianakis, E., Antona, M., Paparoulis, G., Stephanidis, C.: An augmented interactive table supporting preschool children development through playing. In: Proceedings of the 2012 AHFE International Conference (4th International Conference on Applied Human Factors and Ergonomics), pp. 744–753, San Francisco, California, USA (2012)
18. Zidianakis, E., Ioannidi, D., Antona, M., Stephanidis, C.: Modeling and assessing young children abilities and development in ambient intelligence. In: De Ruyter, B., Kameas, A., Chatzimisios, P., Mavrommati, I. (eds.) Ambient Intelligence. LNCS, vol. 9425, pp. 17–33. Springer, Heidelberg (2015)
19. Zidianakis, E., Papagiannakis, G., Stephanidis, C.: A cross-platform, remotely-controlled mobile avatar simulation framework for AmI environments. In: SIGGRAPH Asia 2014 Mobile Graphics and Interactive Applications, p. 12. ACM (2014)

20. Zidianakis, E., Partarakis, N., Antona, M., Stephanidis, C.: Building a sensory infrastructure to support interaction and monitoring in ambient intelligence environments. In: Streitz, N., Markopoulos, P. (eds.) DAPI 2014. LNCS, vol. 8530, pp. 519–529. Springer, Heidelberg (2015). doi:10.1007/978-3-319-07788-8

21. Zidianakis, E., Zidianaki, I., Ioannidi, D., Partarakis, N., Antona, M., Paparoulis, G., Stephanidis, C.: Employing ambient intelligence technologies to adapt games to children's playing maturity. In: Antona, M., Stephanidis, C. (eds.) UAHCI 2015. LNCS, vol. 9177, pp. 577–589. Springer, Heidelberg (2015). doi:10.1007/978-3-319-20684-4_56

SceneMaker: Creative Technology for Digital StoryTelling

Murat Akser[1], Brian Bridges[1], Giuliano Campo[1], Abbas Cheddad[6],
Kevin Curran[2], Lisa Fitzpatrick[1], Linley Hamilton[1], John Harding[1],
Ted Leath[4], Tom Lunney[2], Frank Lyons[1], Minhua Ma[5], John Macrae[3],
Tom Maguire[1], Aiden McCaughey[2], Eileen McClory[1], Victoria McCollum[1],
Paul Mc Kevitt[1(✉)], Adam Melvin[1], Paul Moore[1], Eleanor Mulholland[1],
Karla Muñoz[7], Greg O'Hanlon[1], and Laurence Roman[1]

[1] School of Creative Arts and Technologies, Ulster University, Magee,
Derry/londonderry BT48 7JL, Northern Ireland
p.mckevitt@ulster.ac.uk
[2] School of Computing and Intelligent Systems, Ulster University, Magee,
Derry/londonderry BT48 7JL, Northern Ireland
[3] Research and Innovation, Ulster University, Jordanstown,
Newtownabbey BT37 OQB, Northern Ireland
[4] Information Services Directorate, Ulster University,
Coleraine BT52 1SA, Northern Ireland
[5] Department of Art and Communication, University of Huddersfield,
Queensgate, Huddersfield HD1 3DH, England
[6] Department of Computer Science and Engineering,
Blekinge Institute of Technology (BTH), 371 79 Karlskrona, Sweden
[7] BijouTech, CoLab, Letterkenny F92 H292, Co. Donegal, Ireland
http://www.paulmckevitt.com

Abstract. The School of Creative Arts & Technologies at Ulster University (Magee) has brought together the subject of computing with creative technologies, cinematic arts (film), drama, dance, music and design in terms of research and education. We propose here the development of a flagship computer software platform, *SceneMaker*, acting as a digital laboratory workbench for integrating and experimenting with the computer processing of new theories and methods in these multidisciplinary fields. We discuss the architecture of SceneMaker and relevant technologies for processing within its component modules. SceneMaker will enable the automated production of multimodal animated scenes from film and drama scripts or screenplays. SceneMaker will highlight affective or emotional content in digital storytelling with particular focus on character body posture, facial expressions, speech, non-speech audio, scene composition, timing, lighting, music and cinematography. Applications of SceneMaker include automated simulation of productions and education and training of actors, screenwriters and directors.

© ICST Institute for Computer Sciences, Social Informatics and Telecommunications Engineering 2017
A.L. Brooks and E. Brooks (Eds.): ArtsIT/DLI 2016, LNICST 196, pp. 29–38, 2017.
DOI: 10.1007/978-3-319-55834-9_4

Keywords: SceneMaker · Natural language processing · Speech processing · Artificial intelligence (AI) · Affective computing · Computer graphics · Cinematography · 3D visualisation · Digital storytelling · Storyboards · Film · Drama · Dance · Music technology · Design

1 Introduction

The School of Creative Arts & Technologies at Ulster University (Magee) has brought together the subject of computing with creative technologies, cinematic arts (film), drama, dance, music and design in terms of research and education. This paper proposes the development of a flagship computer software platform, *SceneMaker*, acting as a digital laboratory workbench for integrating and experimenting with the computer processing of new theories and methods in these multidisciplinary fields. An earlier instantiation of *SceneMaker* has been reported in [1,2]. Drama and movie production is a costly process involving planning, rehearsal, (expensive) actors and technical equipment for lighting, audio and special effects. It is also a creative process which requires experimentation, visualisation and communication of ideas between everyone involved, e.g., playwrights, directors, actors, cameramen, orchestra, costume and set designers and managers. *SceneMaker* will assist with production processes and provide a facility to test and visualise scenes before they are finally implemented. Users will input a natural language text scene description and automatically receive multimodal 3D visualisation output. The aim is to provide directors or animators a draft idea of a scene view. Users will have the ability to refine the automatically created script and 3D output through an editing interface, also accessible over the internet and on mobile devices. Thus, SceneMaker will be a collaborative tool for script writers, animators, directors and actors, where they can share scenes online. SceneMaker could be applied in the training of scene production employees without having to utilise expensive actors and studios.

This work focuses on three research questions: (1) How can affective and emotional information be computationally recognised, represented and reasoned about in screenplays and structured for visualisation purposes?, (2) How can emotional states be synchronised in presenting relevant modalities?, and (3) Can compelling, life-like and believable multimodal animations be achieved? Section 2 of this paper gives an overview of current research on computational, multimodal and affective scene production. In Sect. 3, the design and architecture of SceneMaker is discussed. SceneMaker is compared to related work in Sects. 4 and 5 concludes with future work.

2 Background and Literature Review

Automatic and intelligent production of film/theatre scenes with characters expressing emotional or affective states involves four development stages and this section reviews current work in these areas.

2.1 Modelling Emotions and Personality in Film/Play Scripts

All modalities of human interaction express emotional affective states with personality, such as voice, word choice, gesture, body posture and facial expression. In order to recognise emotions in script text and to create life-like characters, psychological theories for emotion, mood, personality and social status are translated into computable methods, e.g., Ekman's 6 basic emotions [6], the Pleasure-Arousal-Dominance (PAD) model [7] with intensity values or the OCC model (Ortony-Clore-Collins) [8] with cognitive grounding and appraisal rules. Word choice is an indicator of the personality of a story character, their social situation, emotional state and attitude. Different approaches to sensing affect in text are able to recognise explicit emotion words using keyword spotting and lexical affinity [9], machine learning methods [10], hand-crafted rules and fuzzy logic systems [11], and statistical models [10]. Common knowledge-based approaches [12,13] and a cognitive inspired model [14] include emotional context evaluation of non-affective words and concepts.

2.2 Modelling Affective Embodied Characters

Research on automatic modelling and animating virtual humans with natural embodied expressions faces challenges not only in automatic 3D character manipulation/transformation, synchronisation of face expressions, e.g., lips and gestures with speech, path finding and collision detection, but also in the execution of actions. SCREAM (Scripting Emotion-based Agent Minds) [15] is a web-based scripting tool for multiple characters which computes affective states based on the OCC-Model [8] of appraisal and intensity of emotions including social context. ALMA [16] (A Layered Model of Affect) implements AffectML, an XML-based modelling language which incorporates the concept of short-term emotions, medium-term moods and long-term personality profiles. The OCEAN personality model [17], Ekman's basic emotions [6] and a model of story character roles are combined through a fuzzy rule-based system [11] to decode the meaning of scene descriptions and to control the affective state and body language of characters. The high-level control of affective characters in [11] maps personality and emotion output to graphics and animations. Embodied Conversational Agents (ECA) are capable of real-time face-to-face conversations with human users or other agents, understanding and generating natural language and body movement. Greta [18] is a real-time 3D ECA with a 3D female model compliant with the MPEG-4 animation standard. Two standard XML languages, FML-APML (Function Markup Language, Affective Presentation Markup Language) for communicative intentions and BML (Behavior Markup Language) for behaviours enable users to define Greta's communicative intentions and behaviours.

2.3 Visualisation of 3D Scenes and Virtual Theatre

Visual and auditory elements involved in composing a virtual story scene, construction of 3D environments or sets, scene composition, automated

cinematography and the effect of genre styles are explored in complete text-to-visual systems such as WordsEye [19], ScriptViz [21], CONFUCIUS [3] and NewsViz [22], and the scene directing system, CAMEO [24]. WordsEye depicts non-animated 3D scenes with characters, objects, actions and environments. A database of graphical objects contains 3D models and their attributes, poses, kinematics and spatial relations in low-level specifications. ScriptViz renders 3D scenes from natural language screenplays simultaneously during the writing process, extracting verbs and adverbs to interpret events and states in sentences. The time and environment where a story happens, the theme around which the story revolves and the emotional tone of films, plays or literature classify different genres with distinguishable presentation styles. Genre is reflected in the detail of a production, exaggeration and fluency of movements, pace (shot length), lighting, colour and camerawork. Cinematic principles in different genres are investigated in [23]. Dramas and romantic movies are slower paced with longer dialogues, whereas action movies have rapidly changing, shorter shot length. Comedies tend to be presented in a large spectrum of bright colours, whereas horror films adopt mainly darker hues.

CONFUCIUS [3] produces multimodal 3D animations of individual stand-alone sentences. 3D models perform actions, dialogues are synthesised and basic cinematic principles determine camera placement. NewsViz [22] gives numerical emotion ratings to words calculating the emotional impact of words and paragraphs, facilitating the display mood of the author over the course of online football reports and tracks the emotions and moods of the author, aiding reader understanding.

A high-level synchronised Expression Mark-up Language (EML) [20] integrates environmental expressions like cinematography, illumination and music into the emotion synthesis of virtual humans. The automatic 3D animation production system, CAMEO, incorporates direction knowledge, like genre and cinematography, as computer algorithms and data to control camera, light, audio and character motions. A system which automatically recommends music based on emotion is proposed in [25]. Associations between emotions and music features in movies are discovered by extracting chords, rhythm and tempo of songs.

2.4 Multimodal Interfaces and Applications

Technological advances enable multimodal human-computer interaction in the mobile world. System architectures and rendering can be placed on the mobile device itself or distributed from a server via wireless broadband networks. SmartKom Mobile [26] employs the multimodal system, SmartKom, on mobile devices. The user interacts with a virtual character (Smartakus) through spoken dialogue. Modalities supported include language, gesture, facial expression and emotions through speech emphasis. Script writing tools assist the writing process of screenplays or play scripts, like Final Draft [27] for mobile devices.

3 Design and Architecture of SceneMaker

The prototype software platform, SceneMaker will use Natural Language Processing (NLP) methods applied to screenplays to automatically extract and visualise emotions, moods and film/play genre. SceneMaker will augment short 3D scenes with affective takes on the body language of characters and contextual expression, like illumination, timing, camera work, music and speech and non-speech audio automatically directed depending on the genre.

3.1 Architecture of SceneMaker

SceneMaker's architecture is shown in Fig. 1. The key component is the *scene production module* including modules for understanding, reasoning and multimodal visualisation situated on a server. The *understanding module* performs natural language processing, sentiment analysis and text layout analysis of input text utilising algorithms and software from CONFUCIUS [3], NewsViz [22] and 360-MAM-Affect [5]. The *reasoning module* interprets the context based on common, affective and cinematic knowledge bases, updates emotional states and creates plans for actions, their manners and representation of the set environment with algorithms and software from Control-Value Theory emotion models [4] and CONFUCIUS [3]. StoryTelling techniques developed in [28] will also be employed here and gender and affect in performance [29] will also be relevant. The *visualisation module* maps these plans to 3D animation data, selects appropriate 3D models from the graphics database, defines their body motion transitions, instructs speech synthesis, selects non-speech sound and music files from the audio database and assigns values to camera and lighting parameters. The visualisation module synchronises all modalities into an animation manuscript. Techniques for automated multimodal presentation [30], embodied cognition music [31], visual and audio synchronisation [32], and analysing sound in

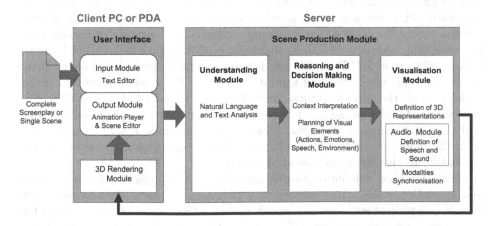

Fig. 1. Architecture of SceneMaker

film [33] will be deployed here. The online *user interface*, available via desktop computers and mobile devices, consists of two parts. The input module provides assistance for film and play script writing and editing and the output module renders the 3D scene according to the manuscript and enables manual scene editing to fine-tune and polish the automatically created animations.

3.2 Implementation of SceneMaker

Multimodal systems automatically mapping text to visual scenes face challenges in interpreting human natural language which is ambiguous, imprecise and relies on shared (and world) knowledge between the communicators. Enabling a machine to understand a natural language text involves loading the machine with grammatical structures, semantic relations and visual descriptions to match appropriate graphics. Existing software tools fulfilling sub-tasks will be modified, combined and extended for the implementation of SceneMaker. For the interpretation of input scripts, SceneMaker will build upon the NLP modules of CONFUCIUS [3] and 360-MAM-Affect [5] with GATE [34], but a pre-processing tool will first deconstruct the layout structure of the input screenplay/play script. The syntactic knowledge base parses input text and identifies parts of speech, e.g., noun, verb, adjective, with the Connexor Part-of-Speech Tagger [35] and determines the constituents in a sentence, e.g., subject, verb and object, with Functional Dependency Grammars [36]. The semantic knowledge base (WordNet [37] and LCS database [39]) and temporal language relations will be extended by an emotional knowledge base, e.g., WordNet-Affect [38], emotion processing with 360-MAM-Affect [5], EmoSenticNet [40] and RapidMiner [41] and Control-Value Theory emotional models [4], and context reasoning with ConceptNet [13] to enable an understanding of the deeper meaning of the context and emotions.

In order to automatically recognise genre, SceneMaker will identify keyword co-occurrences and term frequencies and determine the length of dialogues, sentences and scenes/shots. The visual knowledge of CONFUCIUS, such as object models and event models, will be linked to emotional cues. CONFUCIUS' basic cinematic principles will be extended and classified into expressive and genre-specific categories. EML [20] is a comprehensive XML-based scripting language for modelling expressive modalities including body language and cinematic annotations. Resources for 3D models are H-Anim models [42] which include geometric or physical, functional and spatial properties. For speech generation from dialogue text, the speech synthesis module within CONFUCIUS, FreeTTS [43], will be tested for its suitability in SceneMaker with regard to mobile applications and the effectiveness of emotional prosody. An automatic audio selection tool, as in [25], will be employed for intelligent, affective selection of sound and music in relation to the theme and mood of a scene.

Test scenarios will be developed based on screenplays of different genres and animation styles, e.g., *drama* films, which include precise descriptions of set layout and props versus *comedy*, which employs techniques of exaggeration for expression. The effectiveness and appeal of the scenes created in SceneMaker will be evaluated against hand-animated scenes and existing feature film scenes.

The functionality and usability of SceneMaker's components and the GUI will be tested in cooperation with professional film directors, comparing the traditional process of directing a scene with real actors with virtual (SceneMaker) actors.

4 Relation to Other Work

Research implementing various aspects of modelling affective virtual actors, narrative systems and film-making applications relates to SceneMaker. CONFUCIUS [3] and ScriptViz [21] realise text-to-animation systems from natural language text input, but they do not enhance visualisation through using affective aspects, the agent's personality, emotional cognition or genre specific styling. Their animations are built from well-formed individual stand-alone sentences but not extended texts or scripts. SceneMaker will facilitate animation modelling of sentences, scenes or whole scripts. Individual sentences require more reasoning about default settings due to lack of context and more precision will be achieved from collecting context information from longer passages of text. No previous storytelling system controls agent behaviour through integrating all of personality, social status, narrative roles and emotions. EML [20] combines multimodal character animation with film-making practices based on an emotional model, but it does not consider personality types or genre. CAMEO [24] relates specific cinematic direction, for character animation, lighting and camera work, to the genre or theme of a given story, but genre types are explicitly selected by users. SceneMaker will introduce a new approach to automatically recognise genre from script text with keyword co-occurrence, term frequency and calculation of dialogue and scene length.

5 Conclusion and Future Work

This paper proposes the development of a flagship computer software platform, SceneMaker, acting as a digital laboratory workbench for integrating and experimenting with the computer processing of new theories and methods in multidisciplinary fields. SceneMaker will contribute to believability and aesthetic quality of automatically produced animated multimedia scenes. SceneMaker, which automatically visualises affective expressions of screenplays, aims to advance knowledge in the areas of affective computing, digital storytelling and expressive multimodal systems.

Existing systems already partly address aspects of NLP, emotion modelling and multimodal storytelling and hence we focus on semantic interpretation of screenplays or play scripts, the computational processing of emotions, virtual agents with affective behaviour and expressive scene composition including emotion-based audio selection. SceneMaker's mobile, web-based user interface will assist directors, drama students, writers and animators in the simulation and testing of their ideas. Accuracy of animation content, believability and effectiveness of expression and usability of the interface will be evaluated in empirical tests comparing manual animation, feature film scenes and real-life directing with

SceneMaker. In conclusion, SceneMaker will automatically produce multimodal animations with increased expressiveness and visual quality from screenplay or play script input.

References

1. Hanser, E., Mc Kevitt, P., Lunney, T., Condell, J.: SceneMaker: intelligent multimodal visualisation of natural language scripts. In: Coyle, L., Freyne, J. (eds.) AICS 2009. LNCS (LNAI), vol. 6206, pp. 144–153. Springer, Heidelberg (2010). doi:10.1007/978-3-642-17080-5_17
2. Hanser, E., Mc Kevitt, P., Lunney, T., Condell, J.: SceneMaker: automatic visualisation of screenplays. In: Mertsching, B., Hund, M., Aziz, Z. (eds.) KI 2009. LNCS (LNAI), vol. 5803, pp. 265–272. Springer, Heidelberg (2009). doi:10.1007/978-3-642-04617-9_34
3. Ma, M., McKevitt, P.: Virtual human animation in natural language visualisation. Artif. Intell. Rev. 25(1–2), 37–53 (2006). Special Issue on the 16th Artificial Intelligence and Cognitive Science Conference (AICS 2005)
4. Muñoz, K., Mc Kevitt, P., Lunney, T., Noguez, J., Neri, L.: Designing and evaluating emotional student models for game-based learning. In: Ma, M., Oikonomou, A., Jain, L.C. (eds.) Serious Games and Edutainment Applications, London, England, pp. 245–272. Springer, Heidelberg (2011). Also presented at the First International Workshop on Serious Games Development and Applications (SGDA 2010), School of Computing, University of Derby, England, 8 July 2011
5. Mulholland, E., Mc Kevitt, P., Lunney, T., Farren, J., Wilson, J.: 360-MAM-affect: sentiment analysis with the google prediction API and EmoSenticNet. In: Proceedings of the 7th International Conference on Intelligent Technologies for Interactive Entertainment (INTETAIN-2015), Politecnico di Torino, Turin (Torino), Italy, 10–12, 1–5 June 2015. EUDL EAI Endorsed Transactions on Scalable Information Systems vol. 2, no. 6, p. e5, November 2015
6. Ekman, P., Rosenberg, E.L.: What the Face Reveals: Basic and Applied Studies of Spontaneous Expression Using the Facial Action Coding System. Oxford University Press, England (1997)
7. Mehrabian, A.: Framework for a comprehensive description and measurement of emotional states. Gen. Soc. Gen. Psychol. Monogr. 121(3), 339–361 (1995). Heldref Publishing
8. Ortony, A., Clore, G.L., Collins, A.: The Cognitive Structure of Emotions. Cambridge University Press, Cambridge (1988)
9. Francisco V., Hervás R., Gervás P.: Two different approaches to automated mark up of emotions in text. In: Bramer M., Coenen F., Tuson A. (eds.) Research and Development in Intelligent Systems XXIII. Springer, London (2007)
10. Strapparava, C., Mihalcea, R.: Learning to identify emotions in text. In: Proceedings of the 2008 ACM Symposium on Applied Computing, SAC 2008, pp. 1556–1560. ACM, New York (2008)
11. Su, W.-P., Pham, B., Wardhani, A.: Personality and emotion-based high-level control of affective story characters. IEEE Trans. Vis. Comput. Graph. 13(2), 281–293 (2007)
12. Liu, H., Lieberman, H., Selker, T.: A model of textual affect sensing using real-world knowledge. In: Proceedings of the 8th International Conference on Intelligent User Interfaces, IUI 2003, pp. 125–132. ACM, New York (2003)

13. Liu, H., Singh, P.: ConceptNet: a practical commonsense reasoning toolkit. BT Technol. J. **22**(4), 211–226 (2004). Springer, The Netherlands
14. Shaikh, M.A.M., Prendinger, H., Ishizuka, M.: A linguistic interpretation of the OCC emotion model for affect sensing from text. In: Tao, J., Tan, T. (eds.) Affective Information Processing, pp. 45–73. Springer, London (2009)
15. Prendinger, H., Ishizuka, M.: SCREAM: scripting emotion-based agent minds. In: Proceedings of the First International Joint Conference on Autonomous Agents and Multiagent Systems: Part 1, AAMAS 2002, pp. 350–351. ACM, New York (2002)
16. Gebhard, P.: ALMA - layered model of affect. In: Proceedings of the 4th International Conference on Autonomous Agents and Multiagent Systems (AAMAS 2005), Utrecht University, The Netherlands, pp. 29–36. ACM, New York (2005)
17. De Raad, B.: The big five personality factors. In: The Psycholexical Approach to Personality. Hogrefe & Huber, Cambridge, MA, USA (2000)
18. Mancini, M., Pelachaud, C.: Implementing distinctive behavior for conversational agents. In: Sales Dias, M., Gibet, S., Wanderley, M.M., Bastos, R. (eds.) GW 2007. LNCS, vol. 5085, pp. 163–174. Springer, Heidelberg (2009). doi:10.1007/978-3-540-92865-2_17
19. Coyne, B., Sproat, R.: WordsEye: an automatic text-to-scene conversion system. In: Proceedings of the 28th Annual Conference on Computer Graphics and Interactive Techniques, pp. 487–496. ACM Press, Los Angeles (2001)
20. De Melo, C., Paiva, A.: Multimodal expression in virtual humans. Comput. Animation Virtual Worlds **17**(3–4), 239–348 (2006)
21. Liu, Z., Leung, K.: Script visualization (ScriptViz): a smart system that makes writing fun. Soft Comput. **10**(1), 34–40 (2006)
22. Hanser, E., Mc Kevitt, P., Lunney, T., Condell, J.: NewsViz: emotional visualization of news stories. In: Inkpen, D., Strapparava, C. (eds.) Proceedings of the NAACL-HLT Workshop on Computational Approaches to Analysis and Generation of Emotion in Text, Millennium Biltmore Hotel, Los Angeles, CA, USA, pp. 125–130, 5 June 2010
23. Rasheed, Z., Sheikh, Y., Shah, M.: On the use of computable features for film classification. IEEE Trans. Circ. Syst. Video Technol. **15**(1), 52–64 (2005). IEEE Circuits and Systems Society
24. Shim, H., Kang, B.G.: CAMEO - camera, audio and motion with emotion orchestration for immersive cinematography. In: Proceedings of the 2008 International Conference on Advances in Computer Entertainment Technology, ACE 2008, vol. 352, pp. 115–118. ACM, New York (2008)
25. Kuo, F., Chiang, M., Shan, M., Lee, S.: Emotion-based music recommendation by association discovery from film music. In: Proceedings of the 13th Annual ACM International Conference on Multimedia, MULTIMEDIA 2005, pp. 507–510. ACM, New York (2005)
26. Wahlster, W.: Smartkom: Foundations of Multimodal Dialogue Systems. Springer, Berlin/Heidelberg (2006)
27. Final Draft (2016). http://www.finaldraft.com. Accessed 11 Apr 2016
28. Maguire, T.: Performing Story on the Contemporary Stage. Palgrave MacMillan, Basingstoke (2015)
29. Fitzpatrick, L.: Gender and affect in testimonial performance. Irish Univ. Rev. **45**(1), 126–140 (2015)

30. Solon, A.J., Mc Kevitt, P., Curran, K.: TeleMorph: a fuzzy logic approach to network-aware transmoding in mobile intelligent multimedia presentation systems. In: Dumitras, A., Radha, H., Apostolopoulos, J., Altunbasak, Y. (eds.) Special issue on Network-Aware Multimedia Processing and Communications (2007). IEEE Journal of Selected Topics in Signal Processing vol. 1, no. 2, pp. 254–263, August 2007

31. Bridges, B., Graham, R.: Electroacoustic music as embodied cognitive praxis: Denis Smalley's theory of spectromorphology as an implicit theory of embodied cognition. In: Proceedings of the Electroacoustic Music Studies Network Conference, The Art of Electroaoustic Music (EMS 2015), University of Sheffield, England

32. Moore, P., Lyons, F., O'Hanlon, G.: The river still sings. In: Digital Arts and Humanities Conference, Ulster University, Magee, Derry/Londonderry, Northern Ireland, 10–13 September. Digital Humanities Ireland, 20 pp. (2013)

33. Melvin, A.: Sonic motifs, structure and identity in Steve McQueen's hunger. Soundtrack 4(1), 23–32 (2011)

34. Cunningham, H.: General Architecture for Text Engineering (GATE) (2016). http://www.gate.ac.uk. Accessed 11 Apr 2016

35. Connexor (2016). http://www.connexor.com/nlplib. Accessed 11 Apr 2016

36. Tesniere, L.: Elements de syntaxe structurale. Klincksieck, Paris (1959)

37. Fellbaum, C.: WordNet: An Electronic Lexical Database. MIT Press, Cambridge (1998)

38. Strapparava, C., Valitutti, A.: WordNet-affect: an affective extension of WordNet. In: Proceedings of the 4th International Conference on Language Resources and Evaluation (LREC 2004), Lisbon, Portugal, pp. 1083–1086, 26–28 May 2004

39. Lexical Conceptual Structure (LCS) Database (2016). http://www.umiacs.umd.edu/~bonnie/LCS_Database_Documentation.html. Accessed 11 Apr 2016

40. Gelbukh, A.: EmoSenticNet (2014). http://www.gelbukh.com/emosenticnet/. Accessed 20 Feb 2014

41. RapidMiner: RapidMiner (2015). https://rapidminer.com/. Accessed 4 May 2015

42. Humanoid Animation Working Group (2016). http://www.h-anim.org. Accessed 11 Apr 2016

43. FreeTTS 1.2 - A speech synthesizer written entirely in the JavaTM programming language (2016). http://freetts.sourceforge.net/docs/index.php. Accessed 11 Apr 2016

Structuring Design and Evaluation of an Interactive Installation Through Swarms of Light Rays with Human-Artifact Model

Cumhur Erkut[1(✉)] and Jonas Fehr[2]

[1] Department of Architecture, Design and Media Technology, Aalborg University Copenhagen, Copenhagen, Denmark
cer@create.aau.dk
[2] Media Artist, Copenhagen, Denmark
mail@jonasfehr.ch

Abstract. We present the design and evaluation of an interactive installation to be explored by movement and sound under Human-Activity Model. In the installation, movement qualities that are extracted from the motion tracking data excite a dynamical system (a synthetic flock of agents), which responds to the movement qualities and indirectly controls the visual and sonic feedback of the interface. In other words, the relationship between gesture and sound are mediated by synthetic swarms of light rays. A test session was conducted with eleven subjects, who were asked to investigate the installation and to fill out a questionnaire afterwards. In this paper, we report our preliminary work on the analysis of the tensions of interaction with the installation under the Human-Artifact Model. Our results indicate exploration and discovery as the main motives of the interaction. This is different than utilitarian HCI artifacts, where the instrumental aspects are typically in the foreground.

Keywords: Interactive installation · Multi-agent systems · HCI · Activity Theory

1 Introduction

Evaluation of interactive artwork faces new challenges in the digital age [1]. New methods for testing user experience and artistic qualities of interactive art are in high demand, while case studies and best practices contribute to the body of knowledge of the field. A promising direction in the evaluation of interactive digital art is to borrow and adapt theories and techniques from Human-Computer Interaction (HCI) [1, 2]. In this transfer, one possibility is a framework to identify and describe the dialectics and potential tensions between the visitors and the artifact, namely the Human-Artifact Model [3].

This paper presents the evaluation of an interactive sound and light installation that is explored by movement. The movement aspects of the installation have been previously reported in [4], and the sound aspects (especially the mapping between movement and sound, sound synthesis, and dynamic generation of control) in [5]. Here, we focus on the evaluation of the installation.

© ICST Institute for Computer Sciences, Social Informatics and Telecommunications Engineering 2017
A.L. Brooks and E. Brooks (Eds.): ArtsIT/DLI 2016, LNICST 196, pp. 39–46, 2017.
DOI: 10.1007/978-3-319-55834-9_5

Previously, direct manipulation of three *tangible* interfaces equipped with sensors was controlling the sounds and colors of the installation [6]. With collaboration and embodied metaphors [7] in mind, the installation was designed as three tangible interfaces (*fruits*) mounted on *branches* coming from a central trunk. The original design was big; the fruits could only be grasped by both hands. Figure 1 depicts a smaller iteration with 5 blue fruits (leftmost), which can be moved with single hand. An evaluation of the original installation indicated issues on control: the participants did not seem to understand the underlying embodied and conceptual metaphors [7, 8].

Fig. 1. Different phases in the design refinement of a previous tangible installation. (Color figure online)

More recently, we have implemented an indirection between motion and sound through a dynamic, *intangible* interface, movement qualities (MQ), and a virtual ecosystem (Fig. 2). A test session was conducted with 11 subjects, in a room at the university over a time period of 3 days. The subjects were asked to investigate the installation and to fill out a questionnaire afterwards. The gathered data was qualitatively evaluated, and a summary of results was reported [5]. However, an interpretation of the results under the human-artifact model remained unpublished.

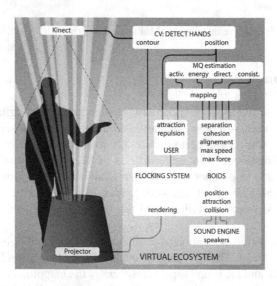

Fig. 2. The Installation: interaction with light-rays.

In both accounts, user associations indicated strong themes, such as "*Very romantic; Hot summer night and bugs flying. Quiet space in a not polluted nature by water*" or "*I tried to play a wizard, waving his hands to shoot out fireballs*". There were also recurring references to play (especially children's), magnetism, fantasy, and sci-fi. These themes, together with the history of the tangible artifacts depicted on Fig. 1 indicate an ecology of the installations. In this paper, we report on our preliminary work on the analysis of this ecology during interaction with the Installation. Our analysis is grounded on the Human-Artifact Model [3], and some of the findings will have direct impact on the design of a future work that will make use of specific gestures.

2 Background

2.1 The Human-Artifact Model

Human activity is mediated. Bødker and Klokmose developed and used the Human-Artifact Model [3] as means to analyze the use of artifacts within an ecology. The analytical scheme of the Human-Artifact Model combines analyses of human experiences and artifacts, and addresses the tensions between human skills and capacity on the one hand, and the action possibilities and affordances offered by the artifact on the other [9]. This is done on three levels reflecting the activity hierarchy: *activity, action* and *operation*. The activity level concerns *why* the user is motivated to interact, the action level with *what* the user does, and finally the operation level *how* the user performs the actions, together with the aspects and attributes of the artifact which support the corresponding level. The focus of an analysis with the Human-Artifact Model is on tensions between the experiences of a user and the assumptions of use embodied in the artifact on all three levels of activity.

Bødker and Klokmose [9] discuss how artifact ecologies evolve dynamically over time. Based on a study of iPhone users, they summarize this dynamism as three states that artifact ecologies iterate through: *unsatisfactory, excited, and stable states*. We note this approach as a future possibility to structure the continuity in history of the installation artifacts depicted on Figs. 1 and 2. Bødker and Klokmose also discuss [10] how the model can be used in design education as a conceptual and generative tool without going to deep into the Activity Theory behind the model. This is also our point of departure in this contribution. To our knowledge, the human-artifact model has not been used in design and evaluation of interactive art before.

2.2 Gestures, Movement Qualities, and Conceptual Metaphors

With the help of machine learning, interactive systems are able to learn and recognize gestures, which are subsequently used to control sound. A good overview of different techniques is provided by [11]. Machine learning can also be used to classify different intentions of a movement [12]. Instead of focusing on a complete gesture, the *quality of the movement* can be extracted. The Laban Movement Analysis (LMA), after the dance theorist and analyst Rudolf Laban, is a promising starting point in movement quality extraction. LMA is based on four main qualities: Body, Effort, Shape, and Space. Mentis

and Johansson provide a good summary on the LMA, especially on the effort, and present an approach using movement analysis to control sound [13]. The authors of [13], however, consider the use of LMA as a too high level of classification for an untrained observer.

2.3 The Artifact Ecology: Interactive Multi-agent Systems

The term *ecology* is related to organisms within an environment, and how they interact with each other and their surroundings. An artifact ecology consists of multiple artifacts built for similar purposes but with slight variations and no clear delineation of when to use which artifact [9] –e.g. the installations on Figs. 1 and 2.

A *software agent* is an autonomous entity that observes and acts upon an environment and directs its activity towards achieving goals. Agents, for instance, enhance the musical performance possibilities: different approaches where some of musical parameters are controlled by agents in parallel to the user have been described in [14]. With the use of agents as procedures, the instrument takes on a life of its own and enhances the possibilities of the player. The installation *Room #81* is a good example, where an agent is used to create both a soundscape and light changes to frame the users interaction [15]. Shacher and his colleagues recently suggested a classification of fundamental mapping relationships with the help of swarm simulations [16]. These include a number of strategies in making the mapping relationships less predictable and more organic. Other studies on agents and interactive sound include [17, 18]. However, none of these works facilitate the Human-Artifact model, to our knowledge.

3 Concept and Interaction Design

In our installation, we consider an audio-visual composition as a complex virtual ecosystem embedded in its enactive landscape (c.f., Fig. 2). The user, as a part of the enactive landscape is able to directly manipulate this ecosystem. The ecosystem is based on a flocking algorithm by Reynolds [19], which is represented in space through light-rays thrown by a projector. When the user enters the space of the ecosystem, he becomes a part of it, and the boids react towards him as a physical object. In parallel, the movement quality (MQ) is estimated in order to change the flocking behavior and therewith the way the user interacts with it. The details of the MQ estimation have been presented in [4].

Currently, the reaction of boids is considered as one of the three main conditions: *hunted, passive* and *curious*: *hunted* is a basic reaction towards fast and directed movements of the user. The boids start to organize in swarms, and seek distance to the user. *Passive*: when nothing of importance happens, the boids act independent (similar to a heard of wildebeests grazing). They move slowly, and seek distance to each other. The user has to move randomly and not to fast. *Curious*: when moving very slowly, the boids become interested in the user and come closer (similar to insects seeking a light source). These states seem to be well perceived with the help of audio-visual feedback. To create the aural feedback, the position and acceleration of each boid is forwarded to a

Max/Msp patch using OSC. After updating the flocking system, the boids are rendered and projected, which closes the circle (see Fig. 2). Currently, all simulation and visual computing is done in C++ on openFrameworks, including the add-on openCV. The sound is generated in the environment of Max/MSP.

For simplicity, here we consider a case where the installation is placed in a room akin to a large digital musical instrument. This is to shorten the process of audience interactions with generic artworks [20]. Because of the intangibility of the light rays, however, the generated sound in the installation should be very directly coupled to the visual representation. The user should get an idea when a sound occurs and what is generating it. As a first design, we have considered three simplistic sound sources to experiment with the dimensionality of mapping, as suggested in [16]. Currently, not all of their parameters are used.

The tree conditions of swarm behavior outlined above serve as basic starting point in interaction design. While hunted was hinting towards a climax, the other two conditions are considered as calmer soundscapes. In the hunting part, the boids organize in flocks. A computer vision based evaluation was programmed estimate the flock formation, together and with their density and group velocity. Additionally, a temporal approach was implemented by the detection of collisions. Collisions happen from time to time and by distinction of different actors (boid/boid; boid/wall; boid/user) different sound qualities can be mapped towards them. So far, we have discussed the density coupling between three swarm behaviors and three sound sources. The first of these sound sources correspond to the swarms and implemented as a classical AM Synthesizer [21]. The other two correspond to collisions and implemented by physical models from the PeRColate library in Max/MSP: user/boid collusions trigger a marimba tone, whereas other collusions trigger a bowed bar tone.

4 Evaluation

A test session was conducted with 11 subjects, in a room at the university over a time period of 3 days. During this test session, the subjects were asked to investigate the installation and to fill out a questionnaire afterwards. In order to determine how consciously the subjects could control the installation, the subjects were asked to reproduce specific reactions. The gathered data was qualitatively evaluated. The three stages of the test procedure are described below.

1. **Investigation of the installation**: The subjects entered the room and were asked to explore the installation. They were left to explore freely, until they stopped by themselves or seemed to run out of ideas, repeating the same movements. The subjects were observed in terms of where they looked and which reactions the installation produced upon their actions. The observations were captured with a standardized form. This stage was planned to inform the operational level of the human-artifact model.

2. **Questionnaire about the experience**: After the investigation the test subjects were asked to fill out a questionnaire, which included personal questions (knowledge and background relevant to the evaluation), a question about how the different reactions

were perceived, questions towards the sound and the connection towards to the light rays, and how the touch of the light rays was experienced, a question about the control experience, a question about the associations (to shift the focus towards the aesthetics), and questions regarding the installation's sound aesthetics and visual appearance, plus personal engagement and general impression. Seven of the questions, especially those regarding aesthetics and interests, were posed with a Likert psychometric scale model, to provide a common measure. The subject was asked to rate within a range of 1 to 10; 1 standing for *not at all*, while 10 meant *quite a lot/ very*. The Likert-scale answers were followed by a text-field with the request to comment. This stage was planned to inform the activity (why) level of the human-artifact model.

3. **Performance session**: The performance test was an experimental approach to see if the subjects were able to reproduce requested reactions. This was attempted, due to the fact that the vocabulary, which describes one's experience, is often difficult to find. With the performance session, a specific reaction could be addressed and the result directly be observed. The requested tasks were designed after specific characteristics of the three conditions, *hunted*, *passive* and *curious*. This stage was planned to inform the action (what) level of the human-artifact model.

5 Results

Seven of the eleven participants reported some kind of technical background or have had some previous experience with interactive installations. Their age spanned 21 to 56 with an average age of 36 years. Three of the participants have heard about the installation before, while just one of them had some closer knowledge about the system. However, their results show no significant difference to the other participants. Their data are therefore evaluated equally with the others. The approximate duration of each session was about 30 min, most of the time taken by the questionnaire.

All qualitative data obtained has been coded by the second author, and complemented with his observations during the investigation and performance. The quantitative results are meant to complement the coding, by themselves they not reliable due to small sample size; nor it was the aim to gather statistics for interaction with an experiential installation. A qualitative evaluation of the results, was reported in [5]. The evaluation has highlighted the potential of the system to engage the user in all three levels of the human-artifact model.

5.1 Interpretation of the Results with the Human-Activity Model

The second author interpreted the answers provided by the test subjects according to the model described in Sect. 2.1. Sentences like, *"I was looking forward to see how they would response"* and *"I would like to understand how it works and what it represents"*, for instance, were interpreted as motivation for *Exploration* and *Discovery*. The pie diagram in Fig. 3, gives an overview over the occurrence of the ten categories extracted from the answers.

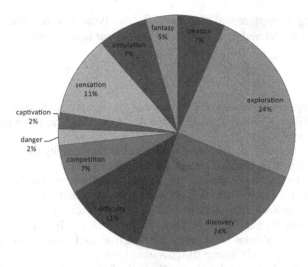

Fig. 3. Categories and factors in the evaluation.

The two factors mentioned above seem to apply for all participants and tend to be the strength of the installation: *Exploration,* and *Discovery.* Other categories indicate orienteering aspects and qualities in addition to the motivation. Examples include *Difficulty, Competition, Fantasy, Sensation,* and *Danger. Competition* was considered for them who felt challenged by the autonomy the system provides and *Fantasy* by those who liked the openness of the abstract expression like mentioned in: *"It was subtle but gives me imagination"* or the fantasy of being a wizard. The possible tension mentioned by several subjects in understanding what to do is interpreted as *Difficulty.* The coding categorized mentions of musical actions or playing as a *Sensation,* which also inform the action level of the model. A rather unexpected result for the *Danger* example was: *"... and I liked the sound that scared me at some point - that was funny".*

We are currently investigating how these categories interact with the performance and experience sections of the evaluation. Unlike any other utilitarian artifact, however, the primary engagement with our interactive installation seem to happen directly at the *activity* level, instead of the *action (instrumental)* level (c.f., [3, 9]).

6 Conclusions and Future Work

We presented an evaluation of a new interactive sound installation to be explored by movement via a synthetic flock of agents. In the installation, the relationship between gesture and sound are *mediated* by synthetic swarms of light rays. The system, as a running installation has been tested on 11 subjects. The results of the analysis by the human-artifact model [3] are encouraging, as the installation seems to provide many facets. The identification of *Exploration* and *Discovery* as main motivations is uplifting, considering our intention to create an installation allowing audience to explore experimental music. The evaluation highlights the potential of the system to engage users, as

it seems pleasing to explore and discover different dynamic reactions. Finalizing the analysis with the model and its dynamics constitute our future work.

References

1. Candy, L., Ferguson, S.: Interactive Experience in the Digital Age. Springer, Cham (2014)
2. Holland, S., Wilkie, K., Mulholland, P., Seago, A.: Music and Human-Computer Interaction. Springer, London (2013)
3. Bødker, S., Klokmose, C.N.: The human-artifact model: an activity theoretical approach to artifact ecologies. Hum. Comput. Interact. **26**, 315–371 (2011)
4. Fehr, J.: LichtGestalt. Master's thesis, Aalborg University Copenhagen (2015)
5. Fehr, J., Erkut, C.: LichtGestalt: interaction with sound through swarms of light rays. In: Proceedings of the Sound and Music Computing Conference, Maynooth (2015)
6. Erkut, C., Serafin, S., Fehr, J., Figueira, H.M.R.F., Hansen, T.B., Kirwan, N.J., Zakarian, M.R.: Design and evaluation of interactive musical fruit. In: Proceedings of the Conference on Interaction Design and Children (IDC), Aarhus (2014)
7. Bakker, S., Antle, A.N., van den Hoven, E.: Embodied metaphors in tangible interaction design. Pers. Ubiquitous Comput. **16**, 433–449 (2012)
8. Wilkie, K., Holland, S., Mulholland, P.: What can the language of musicians tell us about music interaction design? Comput. Music J. **34**, 34–48 (2011)
9. Bødker, S., Klokmose, C.N.: Dynamics in artifact ecologies. In: Proceedings of the Nordic Conference on Human-Computer Interaction (NordiCHI), Copenhagen, October 2012
10. Bødker, S., Klokmose, C.N.: Preparing students for (inter-) action with activity theory. Int. J. Des. **6**(3), 99–101 (2012)
11. Caramiaux, B., Tanaka, A.: Machine learning of musical gestures. In: Proceedings of the New Interfaces for Musical Expression (NIME), pp. 513–518, Daejeon (2013)
12. Maranan, D.S., Alaoui, S.F., Schiphorst, T., Subyen, P., Bartram, L., Pasquier, P.: Designing for movement. In: Proceedings of the Conference on Human Factors in Computing Systems (CHI), Toronto (2014)
13. Mentis, H., Johansson, C.: Seeing movement qualities. In: Proceedings of the Conference on Human Factors in Computing Systems (CHI), Paris (2013)
14. Schroeder, B., Ainger, M., Parent, R.: A physically based sound space for procedural agents. In: Proceedings of the New Interfaces for Musical Expression (NIME), Oslo (2011)
15. d'Alessandro, N., Calderon, R., Muller, S.: ROOM #81 - agent-based instrument for experiencing architectural and vocal cues. In: Proceedings of the New Interfaces for Musical Expression (NIME), Oslo (2011)
16. Schacher, J.C., Bisig, D., Kocher, P.: The map and the flock: emergence in mapping with swarm algorithms. Comput. Music J. **38**(3), 49–63 (2014)
17. Blackwell, T.: Swarming and Music. In: Miranda, E.R. (ed.) Evolutionary Computer Music. Springer, London (2007)
18. Eigenfeldt, A., Pasquier, P.: A sonic eco-system of self-organising musical agents. In: Chio, C., et al. (eds.) EvoApplications 2011. LNCS, vol. 6625, pp. 283–292. Springer, Heidelberg (2011). doi:10.1007/978-3-642-20520-0_29
19. Reynolds, C.W.: Flocks, herds and schools: a distributed behavioral model. SIGGRAPH Comput. Graph. **21**, 25–34 (1987)
20. Edmonds, E.A.: Human computer interaction, art and experience. In: Candy, L., Ferguson, S. (eds.) Interactive Experience in the Digital Age. Springer, Cham (2014)
21. Cook, P.R.: Real Sound Synthesis for Interactive Applications. AK Peters, Natick (2002)

Gamify HCI: Device's Human Resolution for Dragging on Touch Screens in a Game with Lab and Crowd Participants

Allan Christensen, Simon André Pedersen, and Hendrik Knoche(✉)

Department of Media Technology, Aalborg University, 9000 Aalborg, Denmark
allanchr@hotmail.com, simon@dk-designer.dk, hk@create.aau.dk

Abstract. We compared a game-based experiment carried out in a lab study to crowdsourced set ups (both uninformed and informed). We investigated the device's human resolution - the minimum size for dragging the finger onto a target on a touch screen. Participants in the lab consistently produced fewer errors than those from the crowd. For lab participants, errors significantly increased between targets of 4 mm and 2 mm in width. The uninformed crowd had too many errors to determine significant differences but the informed crowd yielded useful data and performance declined already for targets between 8 mm and 4 mm width. The smallest selectable target width for dragging for all three groups combined, was between 2 mm and 4 mm on mobile touch devices.

Keywords: Crowdsourcing · Gamification · Device human resolution · Touch-interaction · Dragging · HCI

1 Introduction

Running experiments with human participants drawn from student populations has seen criticism for its poor external validity [5] and crowdsourcing has gained momentum to draw from a wider population that is either monetarily or otherwise incentivized, e.g. by collecting data through games [7] to participate in studies. This paper compares results from crowdsourcing a gamified user study to its lab counterpart with participants from a campus population. One potential strength of crowdscourcing user studies lies in reducing or eliminating acquiescence bias. To this end we compared the performance of naive crowd, informed crowd, and lab participants. The latter two groups knew their game performance was collected for scientific purposes.

2 Background

In this paper, we focus on crowdsourcing with unpaid participants motivated by curiosity or interest in a study, reciprocal altruism towards the experimenter, or motivation to play a game. While improving both population and ecological

© ICST Institute for Computer Sciences, Social Informatics and Telecommunications Engineering 2017
A.L. Brooks and E. Brooks (Eds.): ArtsIT/DLI 2016, LNICST 196, pp. 47–54, 2017.
DOI: 10.1007/978-3-319-55834-9_6

validity over lab-based test, crowdsourcing studies raise concerns about internal validity. For example, Henze et al. found implausible results from a game that included rapid touch interactions, which seemed ideal for modelling with Fitts' law [6]. This could have been due to multi-finger entry or other tricks violating how the task was supposed to be carried out.

As a case, we used a study on the unknown limits in precision when dragging a finger onto small targets on a touch screen. We draw on Fitts' Law [4] and the concept of Device Human Resolution (DHR) [2]. Fitts' law predicts the required time for a human to perform a movement over a distance (*amplitude*) from point 'A' to point 'B' with a given a size (*width*). The Index of Difficulty (ID) quantifies the difficulty this task with higher IDs resulting in a harder task and yielding a larger time requirement. We used MacKenzie's extended version of Fitts' ID [9]:

$$Index\ of\ Difficulty\ (ID) = log_2(\frac{amplitude}{width} + 1) \tag{1}$$

Bérard et al. used Fitts' law to determine a Device's Human Resolution (DHR) for mouse, stylus and a free-space device. They defined the DHR as *the smallest target size that a user can acquire with the device, given an ordinary amount of effort*, i.e. without a major decrease in performance in time or accuracy (percentage of successful acquisitions). For mouse input they found a DHR for time (0.036 mm) and error (0.018 mm). Participants were able to maintain a low error rate from 0.036 mm downwards only at the expense of increased time and below 0.018 mm errors increased drastically.

Cockburn et al. compared finger, stylus, and mouse in target acquisition (5, 12.5, and 20 mm width columns) tasks with tapping and dragging [3]. Tapping on 5 mm wide targets with a finger yielded a roughly seven times higher error rate (14%) for acquisition compared to the other devices. Dragging (~0.92 s.) had a significantly higher overall selection time when compared to tapping (~0.57 s.) onto targets mainly attributed to the higher friction when dragging across the screen. But dragging (1% errors) had a significantly higher accuracy than tapping (6.8% errors). The authors attributed this to the offset cursor, which assisted target acquisition while dragging. Tapping had no equivalent feedback on the location of the finger and the 'fat finger' occluded the target. Holz et al. provided two reasons for inaccurate target selections with fingers: (1) users do not know the exact finger surface interaction point - the pixel accurate screen position taken from the skin's contact area with the screen and (2) the imperfect memory of the location of small targets once the finger occludes them [8]. Benko et al. found that users perceive the finger surface interaction point (1) differently [1]. Various design solutions address these problems, e.g. using offsetting the cursor or zooming.

3 Study

The purpose of this study was to compare three different user groups playing a game to investigate DHR for dragging on touch screens. The first consisted

of 16 male participants (average age 24, $SD = 1.5$) from the local university who participated in a lab study including a demographic questionnaire. The uninformed group consisted of 19 participants (crowd), who thought they were merely playing a game and not participating in a study. The third group (crowd-plus) 14 participants (4 female, average age 28, $SD = 9.5$) knew they were participating in a study. After having completed the game, 86% of them chose to fill in a questionnaire including control variables such as age, environment, and touch device usage. The lab participants used an LG Nexus 4 smart phone running Android 5.1, with a 4.7-inch display and 768×1280 resolution, which they held as they pleased.

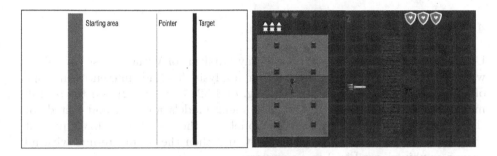

Fig. 1. Design of the standard DHR test (left) and the gamified version (right)

As much as possible we replicated Bérard et al.'s DHR test setup with a game called Wall Destroyer. The user had to tap anywhere within a green starting area (see Fig. 1) and then drag their finger onto a target (wall) that appeared 47 mm away in seven descending widths (32, 24, 16, 8, 4, 2, 1 mm) per round resulting in the following Fitts IDs: 1.32, 1.58, 2, 2.81, 3.7, 4.64, and 5.61. Successful completion of a drag required lifting off the finger when on top of the target. The completion time ran from the touch down event of the dragging finger in the green area to the lift off event on or near the target. Unlike other DHR studies we did not use the second hand to validate target acquisition. The lift-off part of the dragging gesture is essential in understanding the DHR of dragging since the touch area and position at lift off can be different from when the dragged finger comes to a halt on top of the target. If the lift-off occurred on the target a missile appeared and fired as feedback for hits. On misses the missile did not appear. The game provided auditory feedback for both hits and misses but none on the current touch position of the finger input. But given the wall's length the participants were aware of the targets location. To encourage repetitions of these rounds, participants had five lives and a life was only lost on three successive target misses. Even if you missed a target repeatedly you would proceed to the next target. This approach did not enforce an equal number of repetitions, but encouraged most participants to complete multiple game rounds to provide more data.

After the introduction, participants received the smart phone, were prompted to start the game, and watched the ca. 30 s introductory video illustrating how to play and complete the game. The game started on completion of the video. For better between group comparisons, we did not provide any additional assistance to the lab participants in case of questions.

Both crowd groups downloaded the app from the Google Play Store but the crowd-plus participants saw a consent page at start-up. On pressing 'okay' they were redirected to the main menu and from this point on crowd, crowd-plus and lab participants followed an identical procedure. After completion of the game, all saw their own high score. The crowd-plus group further received a pop-up message prompting them to answer a questionnaire.

4 Results

Unless noted otherwise, we used a one-way Analysis of Variance test (ANOVA) with a TukeyHSD as a post-hoc test for analysis. To find differences in slope of all subsets of three successive IDs (e.g. of 1.32, 1.58, and 2) and the overall model slope containing all IDs we ran linear models for each and tested for significant differences between subset model and the overall model. We present the results for the individual groups first and then the overall results with all groups combined, see Fig. 2 as a summary.

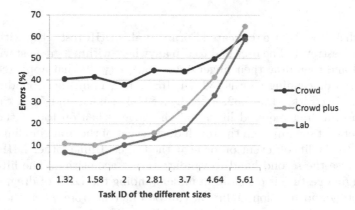

Fig. 2. Target acquisition error rate by target size (in Fitts' ID) for the three groups

For lab participants we found an effect of size on completion time ($F_{6,1767} =$ 156.16, $p \ll 0.001$). However, analyzing the mean slopes for the time data revealed that no subset slope significantly deviated from the overall slope (0.09). For error, a Friedman Ranked Sum test revealed an overall significant difference between the seven sizes ($\chi^2(6) = 63.98$, $p \ll 0.001$) and a post-hoc Friedman test showed significant increases in errors between an ID of 3.7 and 4.64 (4 and 2 mm) and between an ID of 4.64 and 5.61.

For the crowd, we found an overall significant difference for the completion time between the seven sizes ($F_{6,962} = 3.58$, $p < 0.01$) but no significant deviation from the overall slope (-0.00004). A Friedman Ranked Sum test showed no overall significant difference in errors between the sizes ($\chi^2(6) = 10.80$, $p = 0.09$). We found a spike between an ID of 2 and 2.81, however, it was not enough of an increase to be significant.

The time data for the crowd-plus showed an overall significant difference between the sizes ($F_{6,840} = 27.46$, $p \ll 0.001$). But the mean slopes for time showed that no subset slope was significantly different from the overall slope (0.09). However, the Friedman Ranked Sum test revealed an overall significant difference for error rates between the sizes ($\chi^2(6) = 23.47$, $p < 0.01$) and the post-hoc Friedman test showed significant increase in errors between target widths of 8 mm and 4 mm (ID of 2.81 and 3.7).

All data. Several participants in the crowd performed very poorly during the experiment. Therefore, we examined the average number rounds the participants in lab (16.6, SD $= 10.4$), crowd-plus (9.43, SD $= 9.34$), and crowd (7.7, SD $= 9.9$) had played. We removed all participants below the average amount of repetitions for each of the participant groups to examine if this change would provide more comparable results. When only including participants performing above average in the number of rounds we retained 7 out of 19 crowd, 6/14 crowd-plus, and 8/16 lab participants.

Group Comparisons. For the time data on the filtered dataset, we found an overall significant difference between the participant groups ($F_{2,2856} = 92.21$, $p \ll 0.001$) and the TukeyHSD found a significant difference between all groups.

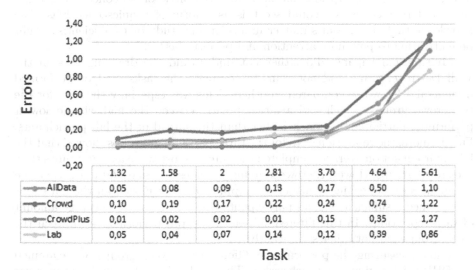

	1.32	1.58	2	2.81	3.70	4.64	5.61
AllData	0,05	0,08	0,09	0,13	0,17	0,50	1,10
Crowd	0,10	0,19	0,17	0,22	0,24	0,74	1,22
CrowdPlus	0,01	0,02	0,02	0,01	0,15	0,35	1,27
Lab	0,05	0,04	0,07	0,14	0,12	0,39	0,86

Task

Fig. 3. Error mean per repetition by size (in Fitts' ID) for the three filtered groups and their combined average (AllData)

But when examining the mean slopes no subset slope deviated significantly from the overall slope (0.09) for the time data. We found no significant difference in errors between the participant groups ($F_{2,144} = 0.79$, $p = 0.45$).

Overall DHR for Touch. For the participants with above the average amount of repetitions we found an overall DHR for touch. We found an overall significant difference between the seven tasks ($F_{6,140} = 26.29$, $p \ll 0.001$) in terms of errors. Its TukeyHSD showed a significant difference between an ID of 5.61 and all other tasks. An ID of 4.64 was also significantly different from the other tasks, except for an ID of 1.32. This showed that a significant increase in errors happened between an ID of 3.7 and 4.64 for the overall data. The overall distribution of the error data for each task, after the participants below the average amount of repetitions had been removed, can be seen in Fig. 3 that includes the pooled data from all groups (AllData) after filtering.

5 Discussion

The results confirmed that participants drawn from a campus population playing in a controlled lab environment with no environmental disturbances outperformed crowd participants playing in their own environment for touch tasks. We do not know how performance was affected by the uncontrolled factors: 1. crowd participants' demographics, 2. the environment and setting that they were playing in, 3. differences in task understanding, or 4. a combination of these. But the performance of informed crowd participants who consented to participating in a scientific study was significantly higher than those of naive crowd participants who might have played the game normally with little or no concern regarding their performance. So we could see this as a form of acquiescence bias. The knowledge that their results matter in a scientific study or to a scientist might be motivating to pay more attention and perform better.

Multiple participants did either not understand the dragging task in the Wall Destroyer game, did not want to complete the tasks, and/or performed in general a lot worse compared to others. This was especially the case for the two crowd groups, which had a large spread between the highest and lowest performing participants - much higher than the spread of the lab participants. Furthermore, the repetition data for the three participant groups showed that the lab environment on average completed the game almost twice as many times than the crowd groups. However, crowdsourcing provides access to data at little to no marginal cost. Following Henze et al.'s approach, we removed all the data that was deemed insufficient, i.e. all participants who had below the average amount of task repetitions. In this filtered subset the overall performance between the three groups did not differ significantly.

While measuring the performance differences between groups, we examined the DHR for dragging on a touch screen. The results showed a significant increase in errors between 4 mm and 2 mm target width. This DHR was achieved by the lab participants with all data included, and for the above average performance

subset of participants from the two crowd groups. This means that for all participant groups combined, the smallest achievable target width a user can select · with a drag on touch screens with little effort is between 2 mm and 4 mm much smaller than average index finger width. We used a target with substantial height which provided cues in terms of the location of the target. Square targets that get completely occluded by the touching finger the DHR might larger in size.

We did not find any differences in completion times. We believe there were two contributing factors. First, the game did not provide any incentives for fast in-game performance. This could be changed in future versions by adding time limits or scores sensitive to time performance, e.g. faster hits yielding higher scores. The average target (wall) acquisition delay across all participants was 0.5 s and the Fitts' law coefficients from MacKenzie's model indicated that most of the movement time was due to the constant ($a = 0.38$) rather than the slope ($b = 0.05$) that depends on the index of difficulty. Furthermore, the fit of Fitts' model even when averaging the time performance of all participants by the different Fitts' IDs was low ($R^2 = 0.23$). We compared this to modeling our data with the ID in Fitts' original model: $log_2(2 \times Distance/Size)$. This approach averaged acquisition delays better ($R^2 = 0.78$) but the coefficients ($a = 0.34, b = 0.07$) were similar to MacKenzie's model. Both MacKenzie's (20.3 bit/s) and Fitts' original model (14.2 bits/s) yielded unrealistically high indices of performance (the inverse of b) that typically lie between 8 and 12 bits/s. In summary, the game in its current design did not yield time performance data that was specific to Fitts' law.

Second, the player did not get any feedback about the actual touch position and could therefore not optimize or correct their finger positions beyond their mental model. This repositioning should yield higher movement times for targets with higher index of difficulty. A setup with positional feedback in a DHR dragging task on touch screens might yield different results in terms of both time and error.

Gamifying existing tests may quickly become tedious for the users, as in our case game elements, scores, lives, animations etc. were insufficient to make the game fun as became clear from our observations during the lab trials and remarks from the lab participants after the experiment. From the lab participants' responses, we believe that adding an overall story for the game in future iterations, may not change the fact that it was neither fun nor very engaging, but rather felt like forcing the participants to do something for an extended period of time, which they did not feel like doing.

6 Conclusion

We found the device's human resolution for dragging with a finger on a touch screen to be between 2 mm and 4 mm. This is comparable to the DHRs for positioning a cursor on targets with in-air interactions (2.4 mm) found by Berard et al. and Bjerre et al. (between 1.2 and 2.4 mm), and much worse than with a mouse (between 0.036 mm for time and 0.018 mm for error). We found significant

differences in performance between participants from the crowd (informed and uninformed) and the lab, with lab participants performing best. However, when analysing only participants with above average performance of their respective population, crowd participants performed just as well lab participants. Therefore, using crowdsourcing for HCI user studies should be a feasible solution to get both more participants and acting in their real environment resulting in higher external validity. Informed crowd participants had significantly better performance in the tasks compared to their naive counterparts - another good reason to openly disclose the scientific purpose.

Games or tasks used in crowd studies need to be very easy to understand and engaging. We found high drop-out rates (people ending the game before having lost all their lives) in the crowd compared to the lab, as the participants did not feel as obliged to complete the game. Our response rate in terms of people downloading the game was much lower than what Henze et al. achieved five years earlier. We assume this to be due to a more highly saturated market place for games and entertainment on mobile devices.

References

1. Benko, H., Wilson, A.D., Baudisch, P.: precise selection techniques for multi-touch screens. In: Proceedings of the SIGCHI Conference on Human Factors in Computing Systems, pp. 1263–1272 (2006)
2. Bérard, F., Wang, G., Cooperstock, J.R.: On the limits of the human motor control precision: the search for a device's human resolution. In: Campos, P., Graham, N., Jorge, J., Nunes, N., Palanque, P., Winckler, M. (eds.) INTERACT 2011. LNCS, vol. 6947, pp. 107–122. Springer, Heidelberg (2011). doi:10.1007/978-3-642-23771-3_10
3. Cockburn, A., Ahlström, D., Gutwin, C.: Understanding performance in touch selections: tap, drag and radial pointing drag with finger, stylus and mouse. Int. J. Hum.-Comput. Stud. **70**(3), 218–233 (2012)
4. Fitts, P.M.: The information capacity of the human motor system in controlling the amplitude of movement. J. Exp. Psychol. **47**, 381–391 (1954)
5. Henrich, J., Heine, S.J., Norenzayan, A.: The weirdest people in the world? Behav. Brain Sci. **33**, 61–83 (2010)
6. Henze, N., Boll, S.: It does not fitts my data! Analysing large amounts of mobile touch data. In: Campos, P., Graham, N., Jorge, J., Nunes, N., Palanque, P., Winckler, M. (eds.) INTERACT 2011. LNCS, vol. 6949, pp. 564–567. Springer, Heidelberg (2011). doi:10.1007/978-3-642-23768-3_83
7. Henze, N., Rukzio, E., Boll, S.: 100,000,000 taps: analysis and improvement of touch performance in the large. In: Proceedings of the 13th International Conference on Human Computer Interaction with Mobile Devices and Services, pp. 133–142 (2011)
8. Holz, C., Baudisch, P.: The generalized perceived input point model and how to double touch accuracy by extracting fingerprints. In: Proceedings of the SIGCHI Conference on Human Factors in Computing Systems, pp. 581–590 (2010)
9. MacKenzie, I.S.: Fitts' law as a research and design tool in human-computer interaction. In: Human-Computer Interaction, pp. 91–139 (1992)

Maze and Mirror Game Design for Increasing Motivation in Studying Science in Elementary School Students

The case of Maze and Mirror Workshop in Shimada elementary school of Japan

Sara Hojjat[✉], Chiaki Fukuzaki, and Tomoyuki Sowa

Kobe Design University, 8-1-1, Gakuen-nishi-machi Nishi-ku, Kobe City 6512196, Japan
sara_hojjat@yahoo.com

Abstract. The research project discussed here, examines attempts to increase the motivation of elementary school students in basic science by the means of designing a science game. To realize this goal, the maze and mirror game was designed and a workshop was held based on the game which teaches the concepts of light and reflection during joyful group play. The game was initially designed for this research consisted of a maze pattern, mirrors and bases, a buzzer and a laser. The results of the game were evaluated by three types of questionnaires and showed improvement in all aspects. The questionnaires revealed that 91% of students liked the game very much and 81% favored having these kinds of games in their science classes. The main achievement of this game for students can be categorized into four main areas: Creating thinking and independent learning, playful learning atmosphere, a chance to learn in group activities, and a feeling of accomplishment.

Keywords: Game design · Maze and mirror game · Science workshop · Playful learning · Real time video

1 Introduction

Love for and/or interest in science begins in elementary schools (Spencer and Walker 2012). Younger children tend to be more curious and motivated to learn. The pipeline for increasing the number of people interested in science fields begins in these formative years. Efforts on designing games and combining them with science workshops will provide a unique chance for children to enjoy these games broadly, while their motivation and enthusiasm for learning science may increase and help them to face the challenges or learning sciences such as physics in high school and later.

In this research, by designing a game and a game-based science workshop including reflection by RTV, we prepare a situation for students to enter a game, and enjoy, learn and share their experiences while they're studying about light, mirror and reflection. One of the steps of this workshop is preparing Real Time Video (RTV) which is taken simultaneously during the workshop. During the workshop two camera men take photos and videos, and at the same time make a 4-minute video of the game. At the end of the

© ICST Institute for Computer Sciences, Social Informatics and Telecommunications Engineering 2017
A.L. Brooks and E. Brooks (Eds.): ArtsIT/DLI 2016, LNICST 196, pp. 55–64, 2017.
DOI: 10.1007/978-3-319-55834-9_7

workshop, this clip is shown to participants which reflects the students, their group and the other groups' activities. In this game, the RTV allowed children to understand their strong and weak points and consider them in the possible next steps, giving them a good chance to improve their learning of science achieved in the game and for the researchers to study their reaction to the designed game.

2 Method

2.1 Maze and Mirror Game Concept

Children at birth are natural scientists, engineers, and problem-solvers (Tony 2011). They consider the world around them and try to make sense of it the best way they know how: touching, tasting, building, dismantling, creating, discovering, and exploring. For kids, this isn't education. It's fun. Children's play is not "supplemental" to their learning. It is their learning. (Renee 2011). According to Einstein "Play is the highest form of research". Fred Rogers said "Play is often talked about as if it were a relief from serious learning, while for children, play is serious learning. Play is really the work of child-hood".

Resnick (2007) in "All I really need to know (about creative thinking)" argues that the kindergarten approach to learning - characterized by a spiraling cycle of Imagine, Create, Play, Share, Reflect, and back to Imagine - is ideally suited to the needs of the 21st century, helping learners develop the creative-thinking skills that are critical to success and satisfaction in today's society. The materials and the creations vary, but the core process is the same." He thinks of it as a spiraling process in which children imagine what they want to do, create a project based on their ideas, play with their creations, share their ideas and creations with others, and reflect on their experiences – all of which leads them to imagine new ideas and new projects (Fig. 1). Considering these aspects, an indirect educational atmosphere based on a designed game can allow children to think, play and discover actively. Children will be motivated if they have the chance to do something by themselves and feel that they did it! In this research, two methods were considered for sharing. One involved sharing through consultation time in group work, and the other sharing through reflection by RTV. The case of light, mirror and reflection were considered and a Maze and Mirror Game was designed to be used with the research subjects.

This Maze and Mirror Game creates a unique possibility for students to communicate in groups, share and strengthen their ideas, and experience playful learning. There is the possibility of direct, hands-on learning and self-evaluation by seeing their interactions in their own groups and by seeing how other groups interact through reflection by RTV, integrating better learning with fun. It is expected that the learning procedure will increase their interest, activate their minds, and what they have learned will be retained longer (Fig. 2).

Fig. 1. The kindergarten approach to learning (Mitchel 2007)

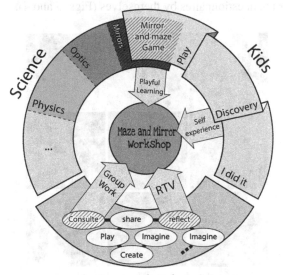

An approach to learning

Fig. 2. Maze and Mirror Game design

2.2 The Steps of Maze and Mirror Workshop

Following the inspiration of Mitchel Resnick's spiraling process, the workshop steps
were designed as seen in Fig. 4. In the preparatory step, the workshop and what students
will do are explained to students. Then a questionnaire about light and mirror is distrib-
uted among the students to collect information about their basic knowledge of the science
that will be presented. After that, students gather in the workshop area for about 15 min

for an ice-breaker that helps them to warm up mentally and become prepared for the main part of the workshop. The next step is the first round of the game in which the first two groups of students start to play the Maze and Mirror Game, competing with each other. The group which finishes first is the winner of the game. Each round of the game takes about 20 min. After the first round, the students fill in the same questionnaire to check their knowledge progress. Then a time is allocated to groups for consultation about what they have done, their experiences and ideas about how they should continue in order to win the game. This is followed by the second round of the game in which the other two groups of students participate and the first two groups are spectators. A third round follows in which all four groups enter the game and compete with each other to check on students' progress compared to their first rounds. After that, the RTV which reflects what students did during two hours of activity is shown for about five minutes. In the RTV students will see their own and other groups' experiences. The last step is answering a questionnaire about the game, the workshop and RTV which asks about students' feelings and understanding. In this workshop, there were two facilitators to help the students know what to do in each step, to motivate them, to help them to understand their feelings, and to ask them questions during question time as it is difficult for children to answer the questionnaires by themselves (Figs. 3 and 4).

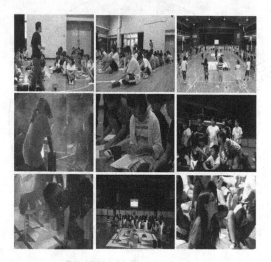

Fig. 3. Workshop's steps

2.3 Maze and Mirror Game Design

This game was initially developed for this research as an educational aid product in 2012 (Fig. 5). It is basically a conventional maze which is solved with light instead of a pen on paper. It is designed to teach students about light and reflection while playing an enjoyable game.

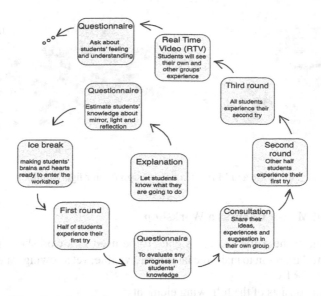

Fig. 4. The spiral of workshop steps inspired from Mitchel Resnick's approach

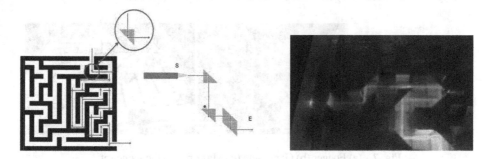

Fig. 5. Maze and Mirror Game's concept

A laser beam emits from the starting point and players direct it toward the correct path by using a mirror or prism, putting the reflective devices at the correct point with the proper orientation to divert the Laser beam to the right path and continue this manipulation until they reach the final goal.

This set is made of a wooden board covered with 3 × 3 cm flat cubes used to construct a passage (Fig. 6). By fixing the flat cube pieces at different points along the passages, it is possible to make different maze patterns on the board. The board is colored silver and the pieces are dark grey and pink. There is also a laser as the light source, small mirrors with wooden stands and a fog producer (fogger or recurrence) that makes the laser beam visible.

Fig. 6. Maze and Mirror Game's design (Color figure online)

2.4 Maze and Mirror Game as a Workshop

A larger version of the game was redesigned to be used as a workshop. The game is played in a semi-dark room to make the laser beam visible, yet allowing for enough light to take videos for RTV.

This version consists of the following elements:

(1) Fogger (American DJ) to make the laser beam visible (Fig. 7a)

Fig. 7. (a) Fogger (b) Game sets (c) Maze pad in the game set

(2) Maze pad, which is a 3 × 3 m printed sheet of a maze pattern (Figs. 7b, c). A maze pattern was downloaded from a maze generator website with ten turns. The pattern was redrawn in the illustrator at a resolution quality that enabled printing the design on a 3 × 3 m plastic sheet. The maze pattern was divided into three parts and each 1 × 3 m part was printed and connected from the backside.
(3) High power laser pointers (to meet the need of multiple reflections)
(4) Mirrors, A4 size (size considered necessary to make the reflection in ten mirrors in one game set reach its best usability.)
(5) Innovative mirror bases made of cardboard sheets designed to allow the mirrors to rotate around a horizontal axis ten centimeters from the ground, as well as rotate around the central vertical axis allowing the students to adjust the laser beam freely (Fig. 8).

Fig. 8. Mirrors and sensor's base and their rotations and the set's function

(6) An optical buzzer assembled as a goal which beeps when a laser beam is detected and announces the successful end of the game. It is located on an A4 size sheet and its base is the same as the base used with the mirrors. A tetrahedron passage placed around the sensor on the board prevents other lights from triggering the sensor, thus preventing a continuous beep from the buzzer (Fig. 8).

2.5 Implementation of the Game in Shimada Elementary School

This game was implemented in the Shimada Elementary School, (Osaka, Japan) on September 2013. A total of 44 students from two 6th grade classes attended. 6 graders were considered because they matched to the game usability best as an elementary school students. They were divided into four groups. Two groups, A1 and B1, competed in the first round, the other two groups, A2 and B2, competed in the second round, and all four groups competed in the third round. In each group, one person was responsible for fixing the laser pointer, one for the fogger and the others for placing the mirrors (10 mirrors had been prepared for each group). The workshop consisted of explanation, questioner time (1), break, first round, questioner time (2), consultation time, second round, third round, reflection by RTV and questioner time (3). Students' prior formal exposure to light and mirrors before the workshop was in third grade of elementary when they had a lesson named the nature of light (let's investigate the sunlight).

3 Result

3.1 Students' Interactions with the Game and Contents

The game set was successful and students could accomplish the game through three rounds of the game. Despite of uncomplicated theory of the game, practically transferring light through mirrors and fixing mirrors' angles was challenging for students and let them to be familiar with the concept of light and reflection as they revealed in their questioners. The performance of laser, maze sheet, mirrors, sensor and fogger was convenient. Music sound of the sensor that was played right after light reached to the end point was resulted in children's excitement about the game's accomplishment. Just there was a need for a base for laser to be fixed on and move up and down freely. This will be helpful for more accuracy considering that light getting to the end point of the maze through several mirrors, and millimeter movement of laser can disrupt everything.

An analysis of student answers to the questionnaires about light and reflection, as well as to the general questionnaires, yielded the following results. Eighty-one percent of students expressed interest in having these kinds of workshops in their science classes, as one of them expressed that "It would be a good chance to have workshops like this once a month". Analyzing students' answers in the questioners generally revealed that what was motivating them in this research can be summarized in some main areas. One of them indicated as hands-on experiences. Students enjoyed moving their bodies while studying and being engaged in some tasks like changing mirrors' position. The other one can be presented as self-confidence. They enjoyed expressing their ideas and watching that they worked, they had the possibility to cope with their responsibilities in their groups, and they could find some new capabilities in themselves. Group-work is another case students enjoyed and benefited quite much of it. Thinking together, learning while cooperating and winning all together were some of their beliefs on benefits of group-work through this game. Also the feeling of accomplishment like as when they had been trying their best and with excitement were arranging the last mirror of the game was another achievement of this game in students' point of view. Having fun and atmosphere related items such as wide space and teacher's tension also helped them to increase their motivation. These finding demonstrate the success of the game in motivating students' interest in science (Fig. 9).

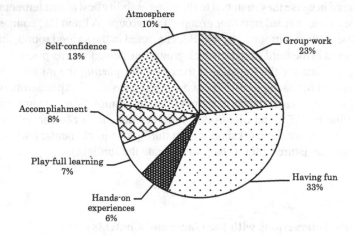

Fig. 9. Motivating factors through students' answers in the questioner

3.2 Real Time Video (RTV) Questionnaire

Regarding to the questions related to the RTV, students when they requested to describe their facial expressions through the RTV, 26% answered happy, 26% answered serious, and others answered with other replies like normal and I couldn't understand. Their feelings about themselves were mostly a combination of happy and serious. Through the RTV, they could see which part they did well and where they could try harder. Also they could study interactions in both their own groups and the other groups while the positive points in themselves and their own groups will increase their self-confidence

and positive points in other groups will help them to learn new aspects of learning, feeling and interacting, which may help them in their future interactions (Fig. 10).

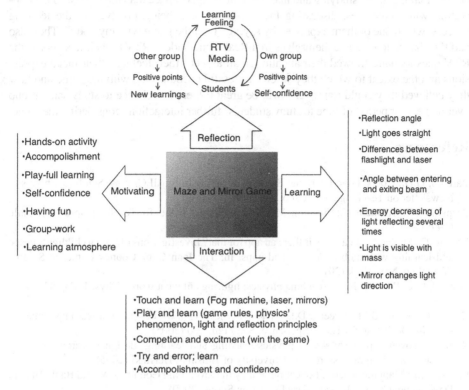

Fig. 10. Maze and Mirror game and concluding factors considering students' interaction with the game

4 Conclusion

The Maze and Mirror Game was initially designed for this research in 2012 with the purpose of motivating elementary school students in science, specifically physics. This game was redesigned in 2013 on a bigger scale to be held as a workshop for students to study its effect on student motivation for science leaning. The game in the Shimada elementary school in Japan was studied and the results revealed that students were impressed by the game as a new atmosphere in which to learn while they are playing. They learned more than what was expected from this game in terms of both theoretical physics and its practical application. For example, students learned that a laser beam enters and exits a mirror at the same angle. They also learned that when a laser beam is reflected by several mirrors, the beam becomes thinner. This is something that can only be learned through practical or hands-on experience. They enjoyed working with their hands with new things in a new learning atmosphere as much as they enjoyed working together, doing something by themselves and watching themselves through the RTV. They had useful suggestions to create a better game

and believed that advantages of the game-based workshop over their normal science classes are the possibilities of learning while having fun, learning in person rather than studying books or taking notes, studying and interacting in a bigger space than their classroom, cooperating with classmates, discussing their opinions and, being involved in the learning process, which one of them expressed by saying "I felt the game with my body". They also had the chance to evaluate themselves in a Real Time Video (RTV). Their answers to the RTV questionnaire showed their attention in all aspects, their feelings, their facial expressions and the extent to which they where successful encountering with the game and how they believed they could improve. It will be great if there is a chance to study same group over a one-year period of time to study students' further interactions considering the game.

References

Barbara, G.D.: Cooperative Learning: Students Working in Small Groups. Stanford University Newsletter on Teaching, vol. 10, no. 2 (1999)

Bernsrdini, C., Tarsitani, C., Vicentini, M. (eds.): Thinking Physics for Teaching. Springer, Seattle (1995)

Chiong, C., Shuler, C.: Learning: is there an app for that? Investigations of young children's usage and learning with mobile devices and apps. In: The Joan Ganz Cooney Center at Sesame Workshop, New York (2010)

Edward, F.R., Richard, N.S.: Teaching physics: figuring out what works. Phys. Today **52**, 24–30 (1999)

Heeter, C., Winn, B.M., Greene, D.D.: Theories meet realities: designing a learning game for girls. In: Designing for User eXperience, San Francisco (2005)

Kalle, J.: Towards primary school physics teaching and learning: design research approach. Unpublished doctoral dissertation, University of Helsinki, Helsinki (2005)

Lewin K.M.: Mapping Science Education: Policy in Developing Countries. World Bank, Human Development Network, Secondary Education Series (2000)

Martin, F.: Kids learning engineering science using LEGO and the programmable brick. In: Proceeding of AERA (1996)

Mitchel, R.: All i really need to know (about creative thinking) i learned (by studying how children learn) in Kindergarten. In: C&C 2007 Proceedings of the 6th ACM SIGCHI conference on Creativity & Cognition, pp. 1–6. ACM, New york (2007)

Mitchel, R.: Computer as paintbrush: technology, play, and the creative society. In: Singer, D., Golikoff, R., Hirsh-Pasek, K. (eds.) Play = Learning: How Play Motivates and Enhances Children's Cognitive and Social-Emotional Growth. Oxford University Press (2006)

Laws, P., College, D., Sokoloff, D., Thornton, R.: Promoting Active Learning Using the Results of Physics Education Research. UniServe Science News, vol. 13 (1999)

Renee, T.: 4 Simple Methods for Teaching Elementary Science. Methods & Philosophies (2011) http://simplehomeschool.net/elementary-science/

Spencer, T.L., Walker, T.M.: Creating a love for science for elementary students through inquiry-based learning. J. Virginia Sci. Educ. **4**(2), 18–25 (2012)

Squire, K.D.: Video games in education. J. Intell. Simul. Gaming, **2**(1) (2003)

Tony, M.: STEM Education–It's Elementary. U.S. News & World Report (2011). http://www.usnews.com/news/articles/2011/08/29/stem-education–its-elementary

Yasmin, B.K.: The Educational Potential of Electronic Games: From Games-to-Teach to Games-to-learn. Playing by the Rules. Cultural Policy Center, University of Chicago (2001)

Towards a Wearable Interface for Immersive Telepresence in Robotics

Uriel Martinez-Hernandez[1,2]([✉]), Michael Szollosy[2], Luke W. Boorman[2],
Hamideh Kerdegari[2], and Tony J. Prescott[2]

[1] Institute of Design, Robotics and Optimisation, University of Leeds, Leeds, UK
u.martinez@leeds.ac.uk
[2] Sheffield Robotics Laboratory, University of Sheffield, Sheffield, UK

Abstract. In this paper we present an architecture for the study of telepresence, immersion and human-robot interaction. The architecture is built around a wearable interface that provides the human user with visual, audio and tactile feedback from a remote location. We have chosen to interface the system with the iCub humanoid robot, as it mimics many human sensory modalities, including vision (with gaze control) and tactile feedback, which offers a richly immersive experience for the human user. Our wearable interface allows human participants to observe and explore a remote location, while also being able to communicate verbally with others located in the remote environment. Our approach has been tested from a variety of distances, including university and business premises, and using wired, wireless and Internet based connections, using data compression to maintain the quality of the experience for the user. Initial testing has shown the wearable interface to be a robust system of immersive teleoperation, with a myriad of potential applications, particularly in social networking, gaming and entertainment.

Keywords: Telepresence · Immersion · Wearable computing · Human-robot interaction · Virtual reality

1 Introduction

Recent decades have seen great advances in technology for the development of wearable devices and their application in robotics. Teleoperation, telemanipulation and telepresence are research areas that benefit from the wide repertoire of opportunities offered by sophisticated, intelligent and robust wearable devices. Researches have paid special attention on telepresence in robotics, systems that allow humans to feel physically present in a robot at remote locations [1,2]. Sufficient, accurate, multi-modal sensory information from the remote operator and the environment are required to create a sense of presence, so that the human user feels immersed in the remote environment.

The virtual reality (VR) games industry is also a driving force behind the increased interest in telepresence, though the development of sophisticated devices for the study and implementation of telepresence. Telepresence and teleoperation are now being employed in office settings, education, aerospace, and

© ICST Institute for Computer Sciences, Social Informatics and Telecommunications Engineering 2017
A.L. Brooks and E. Brooks (Eds.): ArtsIT/DLI 2016, LNICST 196, pp. 65–73, 2017.
DOI: 10.1007/978-3-319-55834-9_8

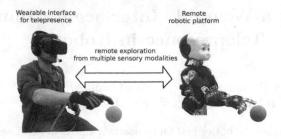

Fig. 1. Wearable interface for telepresence composed of multiple sensory modalities such as vision, touch and audio available in the iCub humanoid robot platform.

rehabilitation, as well as gaming and entertainment [3]. Space research and military markets have also seen an opportunity to influence the development of applications making use of teleoperation and telepresence [4,5].

Despite advances in technology, robust systems that offer a natural experience of human-robot interaction are still a challenge [6]. This is due, at least in part, to the complexity of perceptive information that needs to be transferred to the user in order to create a feeling of presence, of being in a remote location [7]. The lack of multisensory feedback have been identified as major problems in the study of telepresence [8,9]. Vision, tactile and proprioceptive information, depth perception, facial expressions and audio (including spoken language) need to be delivered to the human user with minimal delays (or lag') [10].

Here, we extend our previous work on telepresence [11] with the development of a wearable interface and architecture to immerse the human in a remote environment through the use of a robotic platform and multiple sensory modalities. Specifically, we have developed a wearable bi-directional interface for telepresence (Fig. 1). The system provides visual, tactile and audio feedback to the human participant from the remote location through a humanoid robot. At the same time, the system allows for the remote control of the robot's vision, through the robot's head movements, allowing for the visual exploration of the remote environment. The user can also provide and receive audio, enabling interaction between the human user and other humans present in the remote location.

2 Methods

2.1 ICub Humanoid Robot

The iCub humanoid robot was chosen for integration with the telepresence system because it mirrors many human functions and sensing modalities. The iCub is an open robotic platform that resembles a four year old child. This robot, composed of a large number of articulated joints, is capable to perform complex movements, which make the iCub one of the most advanced open robotic systems, and suitable for the study of cognitive development, control and interaction with humans [12,13]. The design of its limbs and hands allow it to perform

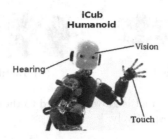

Fig. 2. iCub humanoid robot and its multiple sensory modalities used for the development of the wearable interface for telepresence.

natural, complex and dexterous movements, whilst its head and eyes are fully articulated for smooth and precise head and saccadic movements. The robotic platform also provided with multiple sensory modalities, such as vision, hearing, touch and vestibular modalities (Fig. 2).

The iCub is also capable of producing facial expressions, e.g. sad, angry, happy, which are essential to natural, realistic communications with humans. These facial expressions are generated by LED arrays located on the robot's face. The type of emotion displayed can be altered depending on the feedback from both the sensing modalities and the interactions with other humans [14]. The use of a humanoid, more 'life-like', robot, it is hoped, would not only increase the levels of immersion for the remote operator, but also the receptiveness of other human engaging with the robot.

2.2 Visual Feedback

Visual feedback from the remote environment is achieved with the Oculus Rift (DK2) coupled to the eyes of the iCub. The Oculus Rift is a light-weight headset developed by Oculus VR that allows humans to be immersed in a virtual environment (Fig. 3a). The headset, composed of two lenses with high resolution display each, was primarily developed for gaming and displaying other virtual environments. The dual-display feature of the Oculus Rift provides the user with the sensation of depth, through stereo-vision, and offers immersion in a 3D world, which increases the feeling of being present in the remote environment.

A multi-axis head tracking system, based on a gyroscope and an accelerometer, is integrated into the Oculus Rift, which allows the user to explore the virtual environment in a manner akin to that of exploring the real world [15]. Here, we use these features to allow the human to observe and explore the iCub's environment by remotely controlling the gaze and head movements of the robot.

2.3 Tactile Feedback

The high accuracy of the iCub tactile sensory system has been demonstrated with multiple perception and exploration experiments [16–20]. Then, to take advantage of this rich source of information, a pair of gloves were developed to provide the human with tactile feedback from the hands of the iCub (Fig. 3b) [21].

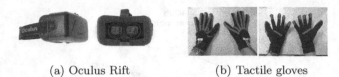

(a) Oculus Rift (b) Tactile gloves

Fig. 3. (a) Oculus Rift and (b) tactile gloves coupled to the iCub's eyes and hands, for visual and tactile feedback, respectively.

The gloves remotely connect the fingertips and palms of the user to those of the robot. Tactile feedback, based on vibrations, is proportionally controlled by applied pressure to the hands of the iCub.

The vibrations within the gloves are generated by a set of small and precise coin vibrating motors from Precision Microdrives. These motors are attached to the five fingertips and palm of each glove. A module for the activation, communication, control and synchronisation of the vibrating motors has been developed and implemented in an embedded system based on the Arduino Mega 2560 microcontroller (Fig. 3b). The vibrations are generated by taking tactile pressure measurements from the capacitive sensors on the iCub's hands. The pressure measurements are encoded and controlled using a PWM (Pulse-Width Modulation) technique. Our system is capable of generating smooth and accurate vibrations, by converting the range of pressure values from the robot (0 to 255) into volts (0 to 3) that are used to drive the motors located in the tactile gloves worn by the human user.

2.4 Audio Feedback

Audio feedback is implemented through the integration of two omnidirectional Hama LM-09 microphones, one placed on either side of the iCub, and a Creative HS800 audio headset (headphones and microphone) from Creative Labs Inc worn by the user (Fig. 4a). The dual microphones located around the robot provide a stereo sound effect, which create a more immersive experience for the user. Our module was designed with the option to enable and disable the audio feedback from the iCub, in order to test the relative importance of audio in levels of immersion.

2.5 Control Architecture

The integration of the multi-sensory modalities, the bidirectional transfer of data and the need for low-latencies in transmission require a robust control architecture. We have developed an architecture that offers modularised functionality, with precise control of timings between modules for local and wide-area networks (e.g. the Internet), whether these be public or private (Fig. 4b).

The architecture has two main components: the human side, which consists of the wearable interface (the Oculus Rift, gloves and headset) and the robot

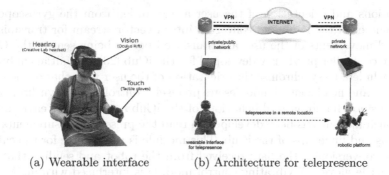

(a) Wearable interface (b) Architecture for telepresence

Fig. 4. Wearable interface for telepresence and immersion in robotics. The interface is composed of different subsystems that provide the human with multiple sensory inputs from a humanoid robot in a remote location.

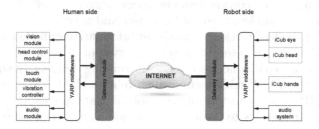

Fig. 5. Low level description of the modules that compose the proposed architecture for telepresence with the iCub humanoid robot.

side (at the remote location), which is composed of the neck and eye motors, cameras, tactile sensors and microphones. The communication channel between both environments is established through Internet. The communication is maintained through a Virtual Private Network (VPN) as this offers a secure and reliable communication channel.

The modules for our proposed architecture for telepresence have been developed using the C++ language and the YARP middleware (Yet Another Robot Platform), which has been designed for robust communication in robotic platforms [22]. The low level description of the modules is shown in Fig. 5.

The visual module uses two-way communication. An image stream is captured from each eye of the iCub and is sent to the displays of the Oculus Rift. These images need to arrive with minimal latency and optimal quality. Initially, raw image data was passed between the robot and user, however this produced very low frame rates (∼4 Hz) and greatly reduced the quality of the experience. We therefore introduced Motion Joint Photographic Experts Group (MJPEG) encoding and decoding that vastly reduced the data volume and the amount of bandwidth required to send the data. This compression increases the image display frame rates (∼25 Hz) and the computational overhead is now minimal.

The motions and orientation of the user are recorded from the gyroscope and accelerometer of the iCub and converted into a vector stream for transmission. The head movements of the user are translated before being sent to the Cartesian gaze controller previously developed for the iCub [23]. An initial calibration is also included, to synchronise the orientation of the user with that of the robot. The vision and head control modules are precisely controlled and synchronised to achieve a smooth and natural behaviour of the iCub in the remote environment.

A touch module has been developed to read the pressure measurements from the palms and fingertips of the iCub. This module is responsible for the calibration and conversion of the data received from the robot and sending that data to the tactile gloves. A vibrating control module is interfaced with an Arduino Mega 2560 microcontroller, in order to control the vibration intensity of the motors based on a PWM technique.

An audio module has been constructed, based on the PortAudio library [24], to provide two-way communication between the user and the remote environment. For sending and receiving audio feedback, server and client modules have been developed and implemented for both user and robot.

To allow for the bi-directional transfer of information outside local area networks, e.g. through the Internet, a gateway system is required to provide a virtual bridge between distinct networks (e.g. running different IP subnets); this is essential for the YARP middleware, which relies on IP based communication. By specifying IP sockets and only allowing specific data to pass, the gateway also provides added robustness to the system, and some additional security features.

3 Results

Our wearable interface and architecture for telepresence and immersion of the human with the iCub humanoid robot was tested from different physical locations. Because it is not easily portable, the iCub was always located at the Sheffield Robotics Laboratory at the University of Sheffield. However, the lightweight and compact nature of the wearable interfaced allows it to be tested from multiple remote locations. These included a location within the same building as the robot, domestic residences and public venues in the city of Sheffield, the University of Oxford and the Arts institute of London.

To provide flexibility, the telepresence modules have been developed for a wide range of computer platforms with Microsoft Windows or Linux operating systems. Our system was tested in a mobile computer with the following specifications: Core i5 Processor, 4 GB RAM, NVS 3100 M NVidia Graphic processor. The iCub was controlled by a dedicated computer system with the following features: Xeon E5-1620 Processor, 16 GB RAM, Nvidia Quadro K2200 Graphic processor, 4 GB RAM for CUDA. These systems provided appropriate computational power to minimise temporal delays in data processing from vision, touch and hearing sensing modalities, and control of head movements; such levels of operation are vital for creating an effective sense of presence, and levels of immersion necessary for the successful teleoperation of a robot, in any applicaiton.

The wearable interface for teleprescence allows a human user to explore visually a remote environment through the eyes of the iCub. The neck of the robot, and thus its visual field, can be controlled simply by moving the user's own head while wearing the Oculus, creating a natural, immersive experience. The human user is also able to feel remote contacts with objects, based on the controlled intensity of vibrations, through the haptic gloves. This feature also allows the human to perceive object properties, such as texture, shape and roughness. It is already known that adding multiple sensory inputs has a greater effect in creating feelings of presence and immersion than focussing on improving a single sensation; for example, adding accurate auditory and tactile feedback is more effective than increasing the photorealism of the visual feedback alone in creating a heightened sense of immersion [25, 26]. Combining tactile, auditory and visual feedback tremendously improves the experience of immersion with the iCub at a remote environment. The auditory system, furthermore, permits effective verbal communication between the user and those present in the remote environment.

For the current study, the delays in receiving tactile and audio feedback, and between natural movements of the human head and the response of the iCub, are imperceptible for the user. These results show that our wearable interface offers a robust and suitable system for immersion, and an effective experience for the teleoperation of robotics.

4 Conclusion and Future Work

In this work we presented a wearable interface and architecture for the study of telepresence and immersion in robotics. Our system is composed of different modules able to receive inputs from multiple sensory modalities, including vision, touch and hearing, and can transmit information such as audio and head orientation. These features allow human users to experience a more natural teleoperation of a robot in a remote environment. In the future we plan to enhance the experience by including a system to track the user's limbs, making it possible to manipulate objects in the remote environment. This will make the teleoperation of robots much more effective in, for example, cleaning dangerous wastes or exploring inhospitable environments. In addition, we will also track the user's facial expressions and reflect these in the robot, allowing for more realistic, natural communication between users and those in the remote environment. This will greatly enhance the possibilities for the teleoperation of robots in social applications, such as teleconferencing, gaming and entertainment.

References

1. Sheridan, T.B.: Telerobotics. Automatica **4**, 487–507 (1989). Elsevier
2. Sheridan, T.B.: Teleoperation, telerobotics and telepresence: a progress report. Control Eng. Pract. **2**, 205–214 (1995). Elsevier
3. Rae, I., Venolia, G., Tang, J.C., Molnar, D.: A framework for understanding and designing telepresence. In: 18th ACM Conference on Computer Supported Cooperative Work & Social Computing, pp. 1552–1566. ACM (2015)

4. Li, L., Cox, B., Diftler, M., Shelton, S., Rogers, B.: Development of a telepresence controlled ambidextrous robot for space applications. IEEE Int. Conf. Robot. Autom. **1**, 58–63 (1996)
5. Fisher, S.S., Wenzel, E.M., Coler, C., McGreevy, M.W.: Virtual interface environment workstations. In: Annual Meeting of the Human Factors and Ergonomics Society, vol. 2, pp. 91–95. SAGE (1988)
6. Stone, R.J.: Haptic feedback: a brief history from telepresence to virtual reality. In: Brewster, S., Murray-Smith, R. (eds.) Haptic HCI 2000. LNCS, vol. 2058, pp. 1–16. Springer, Heidelberg (2001). doi:10.1007/3-540-44589-7_1
7. Gibert, G., Petit, M., Lance, F., Pointeau, G., Dominey, P.F.: What makes human so different? Analysis of human-humanoid robot interaction with a super Wizard of Oz platform. In: International Conference on Intelligent Robots and Systems (2013)
8. Akamatsu, M., Sato, S., MacKenzie, I.S.: Multimodal mouse: a mouse-type device with tactile and force display. Presence Teleoperators Virtual Environ. **1**, 73–80 (1994). MIT Press
9. Stassen, H.G.: The rehabilitation of severely disabled persons. A man-machine system approach. Adv. Man-Mach. Syst. Res. **5**, 153–227 (1989)
10. Stassen, H.G., Smets, G.J.F.: Telemanipulation and telepresence. Control Eng. Pract. **3**, 363–374 (1997). Elsevier
11. Martinez-Hernandez, U., Boorman, L.W., Prescott, Tony J.: Telepresence: immersion with the iCub humanoid robot and the oculus rift. In: Wilson, Stuart P., Verschure, Paul F.M.J., Mura, Anna, Prescott, Tony J. (eds.) LIVINGMACHINES 2015. LNCS (LNAI), vol. 9222, pp. 461–464. Springer, Cham (2015). doi:10.1007/978-3-319-22979-9_46
12. Martinez-Hernandez, U., Damianou, A., Camilleri, D., Boorman, L.W., Lawrence, N., Prescott, T.J.: An integrated probabilistic framework for robot perception, learning and memory. In: IEEE International ROBIO Conference (2016, in press)
13. Metta, G., Natale, L., Nori, F., Sandini, G., Vernon, D., Fadiga, L., Von-Hofsten, C., Rosander, K., Lopes, M., Santos-Victor, J., Bernardino, A., Montesano, L.: The iCub humanoid robot an open-systems platform for research in cognitive development. Neural Netw. **8**, 1125–1134 (2010). Elsevier
14. Martinez-Hernandez, U., Rubio-Solis, A., Prescott, T.J.: Bayesian perception of touch for control of robot emotion. In: IEEE International Joint Conference on Neural Networks (2016)
15. Desai, P.R., Desai, P.N., Ajmera, K.D., Mehta, K.: A review paper on oculus rift-a virtual reality headset. arXiv preprint arXiv:1408.1173 (2014)
16. Martinez-Hernandez, U., Dodd, T.J., Evans, M.H., Prescott, T.J., Lepora, N.F.: Active sensorimotor control for tactile exploration. In: Robotics and Autonomous Systems, vol. 87, pp. 15–27. Elsevier (2017)
17. Martinez-Hernandez, U., Dodd, T.J., Natale, L., Metta, G., Prescott, T.J., Lepora, N.F.: Active contour following to explore object shape with robot touch. In: IEEE World Haptics Conference, pp. 341–346 (2013)
18. Martinez-Hernandez, U., Dodd, T.J., Prescott, T.J., Lepora, N.F.: Active Bayesian perception for angle and position discrimination with a biomimetic fingertip. In: International Conference on Intelligent Robots and Systems, pp. 5968–5973 (2013)
19. Martinez-Hernandez, U., Dodd, T.J., Prescott, T.J., Lepora, N.F.: Angle and position perception for exploration with active touch. In: Lepora, N.F., Mura, A., Krapp, H.G., Verschure, P.F.M.J., Prescott, T.J. (eds.) Living Machines 2013. LNCS (LNAI), vol. 8064, pp. 405–408. Springer, Heidelberg (2013). doi:10.1007/978-3-642-39802-5_49

20. Martinez-Hernandez, U., Lepora, N.F., Prescott, T.J.: Active haptic shape recognition by intrinsic motivation with a robot hand. In: World Haptics Conference (WHC), pp. 299–304. IEEE (2015)
21. Martinez-Hernandez, U.: Tactile sensors. In: Scholarpedia of Touch, pp. 783–796. Atlantis Press (2016)
22. Yet another robot platform. http://eris.liralab.it/yarpdoc/index.html
23. Pattacini, U.: Modular cartesian controllers for humanoid robots: design and implementation on the iCub. Ph.D. dissertation. RBCS, IIT, Genova (2011)
24. PortAudio Portable Real-Time Audio Library. http://www.portaudio.com
25. Kim, H., Giacomo, T., Egges, A., Lyard, L., Garchery, S., Magnenat-Thalmann, N.: Believable virtual environment: sensory and perceptual believability (2008)
26. Luciani, A.: Dynamics as common criterion to enhance the sense of presence in virtual environments. In: 7th International Workshop on Presence, pp. 96–103. ISPR (2004)

Designing Digital Tools for Physiotherapy

Gabriela Postolache[1], Raul Oliveira[2], and Octavian Postolache[3(✉)]

[1] Instituto de Medicina Molecular, Instituto de Telecomunicacoes, Lisbon, Portugal
opostolache@lx.it.pt
[2] Faculdade de Motricidade Humana, Lisbon, Portugal
[3] Instituto de Telecomunicações, ISCTE-IUL, Lisbon, Portugal
octavian.postolache@gmail.com

Abstract. With advances in information and communication technologies (ICT), dramatic changes have been produced in physiotherapy provision. However, low adoption of the developed technologies calls attention for better theoretical model and methods for ICT design, which may fulfill the needs of physiotherapists and their patients. In this work we discuss the framework of designing ICT for physiotherapy based on some results obtained from the perspectives of physiotherapists and patients on electronic health records for physiotherapy. We underscore the importance of considering the context - the conditions in social and physical environment as well as end-users internal conditions to be in place - for a specific physiotherapy process.

Keywords: Context based design · Online training · Serious games

1 Introduction

Ageing populations, change of illness pattern into an increase prevalence of non-communicable diseases in all population age groups, technological developments and new patterns of practice and funding techniques in healthcare systems, are altering the way healthcare is delivered by providers and accessed by service users. The quality of life and wellness are the main goals of healthcare systems in the 21st century medicine. Healthcare system reforms are promoted worldwide, leading to a medicine that is preventive, predictive, personalized and participatory [1].

Given that each individual's circumstances are varied, a fixed, and/or standardized pattern of provision by each healthcare organization does not fit well. More tailoring to the individual is necessary to match technologies for different unmet support needs. The paternalistic model that has prevailed in the past health care, in which the provider is often depicted as the guardian of the service user's best interests and is given the role of determining the approach to treatment [2, 3] is being changed. Deliberative and partnering model of healthcare, model based on collaboration for co-production of health between user, their families and health care professionals, model that is more responsive to individual needs, model that incorporates individual perspectives and preferences in the care process, model that provide educational and psychosocial supports for an effective care partnership [4–6] are nowadays promoted worldwide.

© ICST Institute for Computer Sciences, Social Informatics and Telecommunications Engineering 2017
A.L. Brooks and E. Brooks (Eds.): ArtsIT/DLI 2016, LNICST 196, pp. 74–88, 2017.
DOI: 10.1007/978-3-319-55834-9_9

Nowadays, dramatic changes are produced worldwide in health care provision through the instrumentality of information and communication technologies (ICT). A wealth of evidence suggests great potential of ICT to meet healthcare aspirations of patients and citizens [7]. In the last two decades various ICT were designed and implemented for improving health care services, for tailored and cost effective treatments. Our team had been involved in various projects related designing and development of the technologies for low-cost, non-invasive, long term monitoring of functional state. Particularly, in the last years the team had investigated: international knowledge and experiences on physiotherapists and patients expectancies, perceived benefits and risks of electronic health records (EHRs); and the perspectives of Portuguese physiotherapists and their patients, on needs, requirements, and barriers for adoption of EHRs. The aim of the present work is to discuss some potential ways of designing new tools for physiotherapy process based on some of the results of the survey on the perspectives of physiotherapists and patients, related ICT for physiotherapy.

Physiotherapy, also known as physical therapy, or kinesitherapy, has different definition [8] and physiotherapists have various professionals' status worldwide. However, it is recognized that the core of expertise, practice, education and research in the physiotherapy is the assessment, prevention and treatment of movement disorders. In Portugal, physiotherapists promote and in some cases also prescribe physical activity programs in the area of prevention, maintenance, and treatment. They provide care for the premature babies; care for the children with impaired motor functionalities; rehabilitation of cardiac and respiratory system; therapy for musculo-skeletal disorders; programs for preventions of functional decline in older adults, etc. Physiotherapists can practice in hospital, primary health centers, private clinics, community centers, etc., either alone or in different teams. Designing information system for physiotherapy services is a very complex work due not only to the diversity of environments in which physiotherapists provide healthcare services, and the complexity of competencies, skills and knowledge of physiotherapists - some overlapping with those of others health professionals (e.g. professionals for wound care, alternative therapy, occupational therapy) - but also to great diversity of the subjects receiving physiotherapy. Individuals having physiotherapy differ in terms of geographical locations, age, health, clinical history, functioning, disabilities and socioeconomic status.

In the Methods section of the paper a brief description of methods that our team used for designing electronic EHRs for physiotherapy is presented, and in section of Results and Discussion we discuss potential framework for ICT design for physiotherapy based on some results of our work.

2 Methods

Development of tools for improving healthcare services can draw on theory, evidence and/or practical issues. The team of the project EHR PHYSIO organized the work in three phases, aiming:

1. synthesis of international knowledge and experiences on physiotherapists and patients expectancies, perceived benefits and risks of EHRs;

2. evaluation of the perspectives of physiotherapists and their patients on needs, requirements, and barriers for adoption of EHRs for physiotherapy Patient – Physiotherapists – Designer Framework;
3. physiotherapists and patients perspectives survey on EHRs for physiotherapy.

2.1 Phase One: Systematic Review of International Knowledge and Experience on Physiotherapists and Patients Perspectives on EHRs

A systematic review of the scientific literature (qualitative, quantitative and mixed-methods studies) and other published documentation (technical or grey literature) was carried out to document international experiences regarding physiotherapists and their patients perspectives on EHRs and ICT for healthcare systems in order to synthesize knowledge on perceptions of physiotherapists and patients related: availability and use of ICT to support care delivery; features and performance expectancy of ICT for EHRs in physiotherapy; perceived benefits and barriers of adoption; behavioral intentions related electronic health records. Standardized literature was conducted in all relevant databases. Meta-analysis of the published documents on the status, success and documented problem, achievement of goals, strengths and weaknesses of the implemented EHRs and ICT for physiotherapy was conducted. The detailed problems were abstracted as far as possible, for the purpose of summarizing them into categories. This was done by using consensual guidelines for narrative synthesis and meta-analytical techniques. Findings were organized using frameworks that propose conceptual model of physiotherapists and patients perceptions and needs related EHRs. Categories related to each other, in terms of content, were grouped into critical areas. The critical areas were then arranged according to the frequency of the underlying detailed problems.

2.2 Phase Two: Patient-Physiotherapists-Designer Framework

Focus groups, brainstorming, semi-structured questionnaire, mind mapping were carried out during six workshops and three special sessions at international conferences. At every workshop participated physiotherapists, engineers specialized in biomedical instrumentation and measurements, and informatics. In each workshop the general goals of the EHRs for Physiotherapy from both clinical and technical perspectives were presented. The key members of the project coordinate each 4–5 h workshop by facilitating discussion about particular design goals and issues; system features and functionality. Tutorials and demonstration of ICT with potential application in physiotherapy were also organized during workshops/special sessions. Physiotherapists networking activity was also promoted. A semi-structured style of interview was realized with open questions, in order to stimulate the interviews for providing detailed opinions, experiences, and descriptions of needs related with the daily living/work routine. Participants were included in focus group using snowball sampling, based on referrals from physiotherapists and caregivers. Interviewers used a semi-structured interview guide to ensure that similar questions and themes were addressed in all interviews. However, interviewers were free to adapt the questions, probe responses, and follow respondent-driven topics. Questions were developed before conducting interviews using a conceptual

model of patients perspectives derived from review of the literature (phase one). Interviews lasted 30–120 min. Content analysis was conducted on the transcriptions. Mindmaps were created, by using method described by Buzan [9] and iMindMap software, until information on requirements and barriers for adoption of EHRs in physiotherapy were easily described using imagine of relationships between information from content of the notes, photographs, drawings and transcripts of the interviews. Interviews transcripts were analyzed thematically by three researchers using the immersion/crystallization approach, which emphasizes gaining an in-depth knowledge of the data to identify key themes. Data collection and analysis were conducted sequentially. The analysis team drafted a coding scheme based on the conceptual model, discussion of findings, and initial impressions from the data. Four pilot tests for validation of the *Inventory of Physiotherapists Perspectives related with EHRs* were realized, one using experts in physiotherapy (n = 7), physiatry (n = 1), and psychology (n = 2). Two tests for validation were realized for the questionnaire for *Inventory of the Patients Perspectives on Information and Communication Technology*.

2.3 Phase Three: Survey of Physiotherapists and Patients Related EHRs for Physiotherapy

Convenience sampling was used to analyze the perspective of physiotherapists and patients on EHRs for physiotherapy.

The questionnaire designed to study physiotherapists' perspectives on electronic health records for physiotherapy, which consist of 27 questions, was self-administered and accessible online from December 2014 and September 2015.

The questionnaire designed to evaluate the perspectives of patients of ICT for physiotherapy, have 42 questions, and can be administered with support of other person (in our study with the help of psychologists that worked in EHR PHYSIO team) or self-administered. Research concerning the ways for increasing patients' participation in this study was carried out. Vouchers, flyers with information on projects, and online link to the questionnaire were distributed. The questionnaire was also available online from December 2014 to September 2015. For some patients functional status of the patients was measured by using Health Utilities Index (HUI). The HUI3 attributes include vision, hearing, speech, ambulation, dexterity, emotion, cognition, pain and discomfort. Statistical analysis was conducted using SPSS to account for the complex sample design of the survey.

2.4 Developing and Pilot Testing of a System for EHRs for Physiotherapy

Scenarios on workflow of physiotherapists' interventions were discussed and system architecture for EHRs for physiotherapists based on mobile technologies, wireless sensors networks, M2M, Serious Game and natural user interface have been designed, particularly for movement deficiency diagnosis and monitoring, for remote monitoring of physiotherapy interventions and in-home exercises training.

3 Results and Discussion

A wealth of information was extracted from physiotherapists that participated at 6 workshops (180 physiotherapists in total), more 180 physiotherapists that responded at our developed questionnaire that was online administered, and from interviews with 20 patients for testing the questionnaire developed for assessment of patients perspectives on ICT for physiotherapy, and 366 patients participants at survey.

As can be shown in Fig. 1 the physiotherapists' main domain of intervention is related with movement disorders.

Fig. 1. Domains of interventions and percentage of physiotherapists who participated at survey, in each domain.

They can act in hospital or clinics but also in other healthcare institutions, social institutions, sports club, beauty office, etc. (see Fig. 2). Therefore the information that they would like to store, to process or to share with their patients or other professionals is very diverse.

Although a lot of information was collected during workshops and surveys, the general feeling of researchers of the project EHR PHYSIO is that requirements elicitation for information system for physiotherapy may lead to technologies with missing important and necessary functions for some physiotherapists and for other physiotherapists to many, unnecessary features, depending on their area of intervention, their skills, their patients needs and workplace environments.

Fig. 2. Workplace and percentage of physiotherapists who participated at survey, in each workplace.

Based on our research work we suggest that for better requirements elicitations discussions in groups of physiotherapists with high level of similarity in practice shall be organized. Low time availability for organization of meetings for discussion of the needs, requirements and barriers of implementation of EHRs for physiotherapy, geographical distance and lack of financial support were the main reasons for low physiotherapists' participation in requirements elicitation. Moreover, difficulty of physiotherapists and their patients to comprehensively describe their needs and the process of interventions as well as properly understanding of physiotherapy process by the engineers and informatics had induced a high level of uncertainty in defining system boundaries and in producing a consistent and complete set of software requirements to be implemented. Data from the interviews realized during the research project, as well as evidence from the social research from Portugal [10–12] had underscored that low health and digital literacy of patients could be important factors that might reduce comprehensive drawing of requirements for information system for physiotherapy. In our view, software tools developed and available for free or at very low pricing could be used for better ITC for physiotherapy requirements elicitation. For instance, applications that allow sharing documents and messages as Evernote, Google Drive, Slack, Ryver might facilitate: heavy documentation, wikis, videoconferencing, etc.; collaboration, knowledge transfer between stakeholders; effective informal communications between physiotherapists with similarity in practice and ITC developers; identification and addition of more requirements in the following discussion; and more effective identifications of needs and expectations. A method for improving requirements elicitation, particularly for the groups working in diverse and complex environments, was described recently [13]. The work suggests that serious games developed by Innovation Games® might be used for practicing teamwork, improving interaction between participants, and increase

quantity and quality of requirements for ICT development. For example, in the game *Prune the Product Tree* the participants should collaborate to shape the desired product in the form of a tree (i.e. system functionalities – as limbs; system features – as fruits; the root system as trunk). A short description for each feature should be written on an index card, which represents a fruit or a leaf, and the card should be placed on the tree. The leaves or fruits closer to the trunk indicate requirements with higher priorities, which should be delivered as soon as possible. The online version of the game consists of the game area, a chat and whisper facility, and a palette of items (e.g., fruit, leaves, index cards). While participants are describing their expectations, other players have the opportunity to ask questions and discuss features and their priorities. The requirements can be reformulated and the development team can analyze the requirements of the system to be developed based on the descriptions provided for each feature and the discussions recorded between the participants. The participation to online serious game for requirements elicitation for developing ICT for physiotherapy might engage physiotherapists and their patients in developing ICT tailored to their needs and expectation. Moreover, online serious games enable the development teams to collaborate with physiotherapists and their patients from diverse workplace, without limitations of time and geography and to easily collect new ideas and quick feedback for creating precise project roadmaps. Furthermore, serious game might be used as a catalyst for discussion and negotiation between end-users and developers, and a playful method for drawing and resolving requirements conflicts.

In selection of theory and practice informed requirements, the mapping of present infrastructure into its' theoretical determinant' should be carried out in order to identify potential levers for change. This assessment should also take into account the likelihood of resulting a product and service from a combinations of any of the components or the behaviors of the system. In our research project we investigate the ICT that physiotherapists or patients already have, frequency of use, as well as determinants of their use. At the question on importance that is given to use of technologies for their physiotherapy process, the patients indicate as more important for future development the personal computer, internet, and technologies that allow in home physiotherapy through online training with physiotherapists (see Fig. 3, scale 4–5). These data should be analyzed in the context of present use and frequency of use of these technologies. At the questions 'what technologies you have or had' and 'in the last year, what the frequency of use of technologies' the patients indicate TV and Internet with more frequency of use (Figs. 4 and 5).

The more use of devices for vital signs monitoring (i.e. device for heart rate or blood pressure monitoring) in comparison with those for physical activity assessment and monitoring suggests the influence of social determinants such as: social validation – individuals are more likely to engage in behaviors who they perceived others are also engaged, and signal their conformity, in that they have also engaged in some behaviors [14–16]; social comparison - individuals evaluate their own opinions and abilities by comparing themselves to others in order to reduce uncertainty in these domains, and learn how to define the self [17]; health literacy – at least in Portugal, various educational and health preventive programs were organized in order to raise awareness on potential of using devices for vital signs monitoring for prevention and disease management of

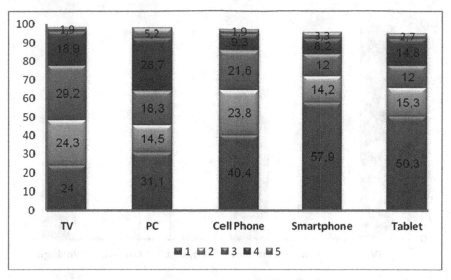

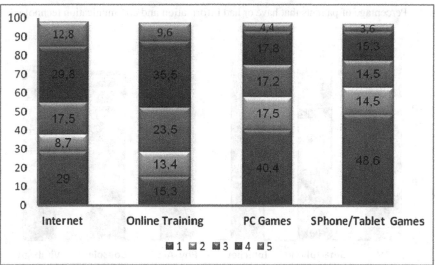

Fig. 3. Perceived importance of technologies in future development of physiotherapy. Assessment was made by using Likert scale (1 to 5; 1-no importance; 5-very important). Percentage were calculated for all sample (the difference between sum of respondents and 100% are represented by missing data, as respondents were able to choose the items for each they wanted to give an input).

cardiovascular disorders. Therefore, for increased adoption of devices for physical activity monitoring, and for effective design and implementation of the physiotherapy intervention based on developed ICT, the key should be incorporation of the conditions from social and physical environment as well as the end-user internal conditions that are needed to be in place for a specific physiotherapy process.

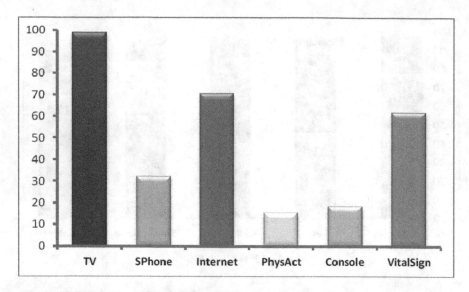

Fig. 4. Percentage of patients that have or had information and communication technologies.

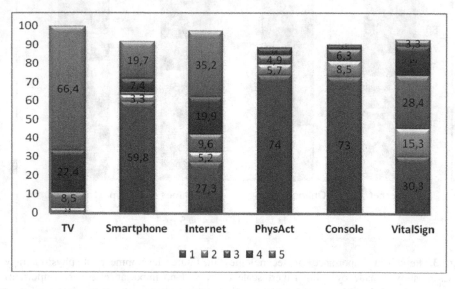

Fig. 5. Percentage of patients that reported use of technologies and perceived frequency of use. Assessment was made by using Likert scale (1 to 5; 1-no use; 5-always use). Percentage were calculated for all sample (the difference between sum of respondents and 100% are represented by missing data, as respondents were able to choose the items for each they wanted to give an input).

The physiotherapists that participated in our survey reported using as main source of information based on ICT, for physiotherapy process, the software for administrative management and information from Web sites (see Fig. 6). However, they reported that

they would like to have access to technologies for clinical process and electronical devices that should improve assessment and monitoring of physiotherapy intervention (see Fig. 7).

Fig. 6. Percentage of physiotherapists that reported use of technologies. Assessment was made by using Likert scale (1 to 5; 1-no use; 5-always use). Percentage were calculated for all sample (the difference between sum of respondents and 100% are represented by missing data, as respondents were able to choose the items for each they wanted to give an input).

Fig. 7. Percentage of physiotherapists that indicate what they would like to use in physiotherapy practice.

Physiotherapists are aware on increasing evidence that electronic devices in combination with virtual reality may improve physiotherapy intervention (i.e. balance training, posture and coordination training, biofeedback, stroke rehabilitation, cardiac rehabilitation, etc.) [18]. In the last years, electronic devices were developed to be integrated in Internet of Things (IoT) technologies with potential for improving physiotherapy process. Technology for exergame with near-realistic motions based on body-wearable sensors was described [19]. An innovative, computer-based gaming platform based on instrumentation with a motion-sense mouse which should transform broad range of common objects into therapeutic input devices was designed and it is being evaluated [20]. By using this technology, algorithm based on acquired movements that replicate common situation in everyday living, can be used for designing serious games.

Many software for rehabilitation management including virtual reality, augmented reality or serious games were developed and some are commercially available (i.e. MIRARehab, BioGaming, exergames based on Nintendo Wii ™ technology, Xbox Kinect technology, applications for smartphone, tablet or TV from GooglePlay, iTunes or APTOiDE). Visual, and/or audio, and/or haptic (interaction involving touch) interaction, and/or immersive (providing information or stimulation for a number of senses, not only sight and sound, that deeply involve one's senses and may change mental state) simulation of real, imaginary or symbolic environment was developed, with objective of improving rehabilitation or other physiotherapy processes. Examples of ICT tools used or with potential use for physiotherapy are BioGaming apps, MIRARehab apps, YouRehab apps, CoRehab apps, I Am a Dolphin apps developed by John Hopkins Hospital, PocketPhysio, Hand Rehab, Button Board apps for smartphone, apps/games based on Nintendo Wii, Xbox Kinect, PlayStation technologies. The developed software for Augmedix healthcare service, or Kinesio Capture apps for smartphone use augmented reality. Windows Holographyc developed by Microsoft that use mixed reality (a mix of the physical and virtual reality, by merging the real and virtual worlds to produce new environments and visualizations, where physical and digital objects co-exist and interact in real time) might also be used in physiotherapy. Various interfaces were developed for interaction with virtual reality – Leap Motion, Microsoft Kinect, Nimble from Intugine Technologies, Wii Remote, Wii Balance Board, iKids Interactive Zone, Gloveone, Fit Interactive's fitness system 3 Kick, Virtuix Omni, Oculos Rift, Samsung Gear VR, ZSpace, Google Cardboard, Epson Moverio BT-200, Microsoft Hololens).

With developing ICT a new category of patients is also developed. e-Patients, coined by Tom Ferguson in 2007, are those patients equipped, enabled, empowered and engaged in their health and health care decisions. PatientLikeMe, BrainTalk Communities, NeuroTalk are e-Patients social networks. The importance of e-Patients as consumer, curators and creators of information, are recently recognized and investigated. e-Patient potential for improving quality of care is also presently analyzed and should be considered in ICT tools for physiotherapy.

An increase in the gap between development of ICT and healthcare services progress are often reported in the last years. In many studies low adoption of these technologies in healthcare services are reported, and in physiotherapy processes in a lower degree. The physiotherapists indicate various barriers of the adoption of ICT in physiotherapy,

mainly those related to: lack of financial incentive for ICT implementation; lack of information system developers knowledge on physiotherapy processes and workflow; not acceptable technological performance; costs of implementation and maintenance; not addressing tangible and practical needs; regulatory policy; lack of public institutions' support for implementation; lack of cooperation between physiotherapists and ICT developers [21]. These results suggests the necessity for better theoretical model for designing and for ICT implementation, in which policy interventions – service provision, regulation, legislation, environmental and social planning, communication/ marketing, guidelines, fiscal measures - should be considered together with motivation, and capability of all stakeholders, as well as opportunities created by training, education and incentivisation. In our view training of health professionals for active involvement in designing and implementation of ICT tools should be an important goal of healthcare service providers and universities. In the last decade increase number of evidence indicate that stakeholders' training and education are key to successful adoption of ICT [22]. Moreover, it was suggested that health professional (i.e. physiotherapists) with expertise in informatics can help design systems that meet the needs of physiotherapy, and rigorously evaluate the extent to which they actually improve care [23]. Majority of the physiotherapists that participated in our survey reported low and very low level of knowledge on ICT (see Fig. 8). One solution for this would be organization of online database similar to HELM Open data base developed by University of Nottingham, in which free to use high quality interactive peer-reviewed learning and teaching resources related with ICT for physiotherapy may be found.

Fig. 8. Percentage of physiotherapists that reported level of information and communication tecnologies knowledge. Assessment was made by using Likert scale (1 to 5; 1-very low level; 5-very good level).

Also, activities that incentive the physiotherapists to work with software for story-boarding (i.e. StoryBoardThat, Google SketchUp), software for ease creation of mobile apps (i.e. AppInventor), software for easy serious game design (i.e. Scratch, Game-Maker, GameGuru, ItyStudio, Unreal Engine, Unity – Game Engine) might contribute for better design of ICT tools for physiotherapy. The presence of a champion, someone who is the leader for an information technology project, was also identified as a critical factor in successful implementation of ICT - *"Health care providers' readiness is connected to baseline levels of computer knowledge"* [24]. In their very informative study Kaye et al. [25] has shown *"When health IT was in its early stages, we needed doctors who had a knack for computers to help the IT people build 'doctor-friendly' systems. Today, we have a growing cadre of doctors who have made medical informatics their profession. These professionals are an important bridge between the practicing physician who is not equipped to explain to the technician what he really needs; the manager, with his concerns and system objectives; and the technological people with their ever-expanding bag of IT goodies. We need to encourage increased professional leadership in this area to help systems make intelligent decisions about continued innovation"*.

4 Conclusions

There is a trend toward physiotherapy interventions combined with emerging ICT. The conceptual framework of requirements elicitations developed in project EHR PHYSIO research project, together with suggestions derived from our results and ICT progress might be used for tailored ICT tools for physiotherapists practice and patients needs. Rigorous and tailored design of the physiotherapy service incorporating ICT may lead to operational improvement and positive program outcome, augmented physiotherapist-patient relationships, autonomy and engagement of patients in regards to their health-care, better quality of service and cost-effectiveness of intervention. Training physio-therapists, informal caregivers and patients, to raise awareness and knowledge on ICT would greatly contribute for better physiotherapy services and improve quality of life of patients. Collaboration is needed (between public authorities, ICT providers, associ-ations of physiotherapists and other health professionals, patient organizations, reim-bursement scheme providers, insurer, medical devices and information technology regulatory organizations) for integration of ICT in physiotherapy practice.

Acknowledgments. Work was supported by Fundação para a Ciência e Tecnologia and Instituto de Telecomunicações, project: PTDC/DTP-DES/1661/2012– Electronic Health Records: Needs, Requirements and Barriers for Adoption in Physiotherapy and project: PTDC/DTP-DES/6776/2014.

References

1. Hood, L., Friend, S.H.: Predictive, personalized, preventive, participatory (p4) cancer medicine. Nat. Rev. Clin. Oncol. **8**, 184–187 (2011)
2. Szasz, T., Hollender, M.: A contribution to the philosophy of medicine: the basic model of the doctor-patient relationship. Arch. Int. Med. **97**, 585–592 (1956)
3. Emanuel, E.J., Emanuel, L.L.: Four model of the physician-patient relationship. JAMA **267**, 2221–2226 (1992)
4. Clark, N.M., Nothwehr, F., Gong, M., et al.: Physician-patient partnership in managing chronic illness. Acad. Med. **70**, 957–959 (1995)
5. Laine, C., Davidoff, F.: Patient-centered medicine. A professional evolution. JAMA **275**, 152–156 (1996)
6. Quill, T.E., Brody, H.: Physician recommendations and patient autonomy: finding a balance between physician power and patient choice. Ann. Int. Med. **125**, 763–769 (1996)
7. Coulter, A.: What do patients and the public want from primary care? BMJ **331**, 1199–1201 (2005)
8. Jull, G., Moore, A.: Physiotherapy's identity. Manual Ther. **18**, 447–448 (2013)
9. Buzan, T.: Mind Map Tutor Handbook. http://www.usingmindmaps.com/support-files/mind-map-tutor-handbook.pdf
10. e-Skills in Europe. Portugal Country Report. http://ec.europa.eu/DocsRoom/documents/4581
11. Cavaco, A., Santos, A.L.: Evaluation of health literacy and the readability of information leaflets. Revista Saude Publica **46**, 918–922 (2012)
12. Santos, O., Lunet, N., do Carmo, O., Ferreira, P.: Prevalence of low health literacy. In: 27th Conference of the European Health Psychology Society, Bordeaux, vol. 28, no. sup. 1, pp. 1–335 (2013)
13. Ghanbari, H., Simila, J., Markkula, J.: Utilizing online serious games to facilitate distributed requirements elicitations. J. Syst. Softw. **109**, 32–49 (2015)
14. Cialdini, R.: Harnessing the science of persuasion. Harv. Bus. Rev. **79**, 72–79 (2001)
15. Goldstein, N., Cialdini, R., Griskevicius, V.: A room with a viewpoint: using social norms to motivate environmental conservation in hotels. J. Cons. Res. **35**, 472–482 (2008)
16. Van de Ven, N., Zeelenberg, M., Pieters, R.: The envy premium in product evaluation. J. Cons. Res. **37**, 984–998 (2011)
17. Festinger, L.: A theory of social comparison processes. Hum. Relat. **7**, 117–140 (1954)
18. Postolache, G., Oliveira, R., Moreira., I, Postolache, O.: Why, what and when in-home physiotherapy? In: Graffigna, G., (eds.) Transformative Healthcare Practice through Patient Engagement, pp. 215–246. IGI Global, Hershey (2016)
19. Mortazavi, B., Nyamathi, S., Lee, S.I., Wilkerson, T., Ghasemzadeh, H., Sarrafzadeh, M.: Near-realistic mobile exergames with wireless wearable sensors. IEEE J. Biomed. Health Inf. **18**, 449–456 (2014)
20. Srikesavan, C.S., Shay, B., Robinson, D.B., Szturm, T.: Task-oriented training with computer gaming in people with rheumatoid arthritisor osteoarthritis of the hand: study protocol of a randomized controlled pilot trial. Trials **14**, 69 (2013)
21. Postolache, G., Moreira, I., Pedro, L., Oliveira, R.: Implementation of electronic health records in physical therapy. In: 1st Asia-Oceanian Congress for NeuroRehabilitation, Seoul (2015)
22. Lorenzi, N.M., Kourobali, A., Detmer, D.E., Bloomrosen, M.: How to successfully select and implement electronic health records in small ambulatory practice settings. BMC Med. Inf. Decis. Mak. **9**, 15 (2009)
23. Vreeman, L.J., Taggard, S.L., Rhine, M.D., Worgell, T.W.: Evidence for electronic health record systems in physical therapy association. Phys. Ther. **86**, 434–446 (2006)

24. Terry, A.L., Thorpe, C.F., Giles, G., Brown, J.B., Harris, S.B., Reid, G.J., Thind, A., Stewart, M.: Implementing electronic health records key factors in primary care. Can. Fam. Phys. **54**, 730–736 (2008)
25. Kaye, R., Kokia, E., Shalev, V., Idar, D., Chinitz, D.: Barriers and success factors in health information technology: a practitioner perspectives. J. Manag. Market. Healthc. **3**, 163–175 (2010)

Enriching Location-Based Games
with Navigational Game Activities

Stephanie Githa Nadarajah, Benjamin Nicholas Overgaard,
Peder Walz Pedersen, Camilla Gisela Hansen Schnatterbeck,
and Matthias Rehm[✉]

Department of Architecture, Design, and Media Technology,
Aalborg University, Aalborg, Denmark
matthias@create.aau.dk

Abstract. Mobile location-based games are experiences that entertain its players by requiring interactions mainly at points of interest (POIs). Navigation between POIs often involve the use of either a physical or digital map, not taking advantage of the opportunity available to engage users in activities between POIs. The present paper examines, how riddle solving as a navigational method affects enjoyability, flow, and spatial presence.

1 Introduction

It is our conviction that the city can become the key element in creating smart learning environments that transcend traditional institutionalized learning by bringing learning back to where it originally belonged: everywhere. Our vision of smart city learning is to create a public space for learning experiences that transcend into all areas of life while at the same time establishing traditional institutions (like schools, libraries, museums, etc.) as hubs for information gathering and collaborative interactions. The city itself, becomes an enchanted place allowing for discovering hidden knowledge in a playful manner. The StreetArt project is based on previous work that realizes an exploration game that is supported by a virtual tour guide in the form of a monster and situated in a museum context [16]. As the application is targeting younger children between 6–10, the playful back story for the guide is that it has eaten some of the artworks and – as we all know – "you become what you eat". This is taken literally here, where the monster's body is textured by the artworks it has eaten and the task is now to find these artworks. Scaling up the museum experience to the city level revealed a big challenge – travel time between points of interest. In standard location-based games (LBG) this is lost time because interactions only happen at POIs. In this project we aim at integrating travel between POIs with the enfolding narrative of the LBG.

2 Background

Based on [1], LBGs are defined as *game experiences* that connect the *physical space with the virtual space* and make use of an underlying *narrative* element.

© ICST Institute for Computer Sciences, Social Informatics and Telecommunications Engineering 2017
A.L. Brooks and E. Brooks (Eds.): ArtsIT/DLI 2016, LNICST 196, pp. 89–96, 2017.
DOI: 10.1007/978-3-319-55834-9_10

Location-based games (LBGs) utilize points of interest (POIs) in their gameplay, which requires navigating between POIs, when the games take place in cities. This opens opportunities for gaining additional knowledge about the surroundings during navigation. This potential has not been fully utilized yet. Several LBGs have used maps with GPS technology in a city context, in order to guide their participants to POIs [2,3,5,6,10,14,19]. To the best of our knowledge, none of these have integrated game activities, such as those that are found at the POIs into the navigation.

In [4], players navigate freely in a restricted area. However, the design of the game may only be appropriate in a bounded areas due to the extended freedom of exploration, and could be problematic if transferred to a wider context (e.g. an entire city) due to longer distances between POIs. In a similar study about a walking tour in the Venice, the narrative space incorporated the navigation, but kept a linear narrative structure [8]. A narrator in the application verbally explained where to make turns, and at the same time made comments on the physical environment. The outcome of the study did not reveal the users' experiences concerning the navigation. Both in [4,8], the user is encouraged to explore the physical space, but only on an individual basis. A LBG for tourists is presented in [7] that utilizes a sightseeing navigation system to promote enjoyability and awareness of the physical surroundings. Augmented reality (AR) is used to display descriptive information and upon arrival at the POI, users have to seek out a character in the surroundings. The concept does makes use of a map for leading the users to the area requiring AR for navigating. No evaluation has been done and therefore the outcome is unknown. Other LBGs have looked into using AR combined with physical props for navigation. Maplens displays location information on a physical map using augmented reality [12]. In a comparative study, flow, presence and intrinsic motivation have been compared to DigiMap, a map with incorporated accessibility to read about locations. MapLens scored significantly lower on most dimensions but its potential was revealed in terms of social interaction, since it encouraged collaborative behaviour.

Wayfinding using landmarks is a navigational method in which objects or structures are used as points of reference. This is typically used for route directions [15]. Route directions provide procedures and descriptions that help people build mental representations of the environment they are about to traverse. When following a route, landmarks can be used for re-orientation at decision points such as road intersections and are known as *local* landmarks. Landmarks can also be used for confirming if people are on the right path, known as *route marks*. Finally, landmarks can be used for overall navigation, known as *distant* landmarks. Landmarks can be described by their *saliency*, which defines how much a landmark stands out from the surrounding objects in its environment. Different types of landmarks have different types of saliency. Sorrows and Hirtle categorize landmarks as either *visual, cognitive,* or *structural* [17]. The saliency of visual landmarks can be characterized by their visual contrast to surrounding objects, e.g. based on the size, shape, position or age of a landmark. For *Cognitive* landmarks, the saliency depends on the meaning of the landmark, e.g. due to

the landmark being culturally or historically important. The saliency for structural landmarks depends on the accessibility of the landmark, e.g. the amount of locations a landmark is visible from. Wayfinding using landmarks opens up for integrating game activities between POIs due to its inclusion of objects in the physical space. This could result in a stronger interplay between the physical and virtual spaces during navigation between POIs in LBGs. Furthermore, using landmarks is based on vision instead of sound, indicating that it might be suitable for a group experience. To the best of our knowledge, no LBGs have used landmarks for navigation between POIs so far.

3 Lost on Earth

Lost on Earth scales the museum-based Monsters Eat Art [16] to a city level. Monsters Eat Art is an interactive exploration game, where children find specific artworks based on certain details given. When children find the specific artwork, they get feedback from the monster. Furthermore, Monsters Eat Art has a narrative where a monster eats artworks. The children now have to find all artworks that the monster has eaten. When the children show an artwork to the monster, it gives feedback and when it is one of the artworks they have to find, the monster conveys information in a humorous way.

In Lost on Earth, the players assist the monster character (see Fig. 1 – left) in reaching a specific goal, using streetart found in the city as POIs. The narrative is built around the monster being stranded on Earth. It needs to find fuel for its spaceship to fly home. However, the monster is also looking for its friends, who are also stranded on Earth.

Due to the importance of choice in interactive narratives and games, players have to choose for each route (see Fig. 1 – right) whether the monster should look for fuel or friends, which will affect the outcome of the game. These choices are made at the street art paintings. Ideally, different routes should be used for

Fig. 1. Left: Riddle-based navigation showing the monster character with points in the form of fuels and friends. Right: The route between the three street art paintings during the experiment.

Fig. 2. Child in charge of the iPad (left) and parent assisting the child (right)

different choices, however to minimize the amount of bias in the experiment, the illusion of choice is given, as the choice will only influence the outcome of the game, not the route to be taken. To incorporate pedagogic elements, information about the painting itself is given through a dialogue with the monster. Additionally, players unlock access to an info screen about the particular painting. This was included, in order to incorporate the element of saving information about places visited, mentioned previously by Gentes et al. [9] and Peitzl et al. [13], giving the user a sense of progression and feedback (Fig. 2).

Players use riddle solving based on *I Spy* [18] for navigating between POIs. When players start their first riddle, a tutorial introduces how the system works. To incorporate a feedback system, players are given points as they answer correctly on the control questions for the riddles. These points are dependant on the choice made at the previous POI, so for instance in the case that players have chosen to look for fuel, fuel points will be given to the players and vice versa. Whether the monster will get home or have any friends in the end of the game, will rely on these choices. For the purpose of the experiment, a 2D map has been implemented. The map has the primary objective of resembling maps used in other LBGs. It shows the user's position on a 2D digital map provided by Google Maps. As seen in the LBG *Team Exploration*, incorporating limitations in the game such as time, can cause the focus of the game to be more on the hunt itself and not the exploration that takes place in the physical space. For this reason, the limitations used in Lost on Earth are primarily found in the act of navigating itself, where using riddles to navigate is a cumbersome, but also enjoyable way of navigating, as it makes use of the physical space.

4 Experiment

The experiment took place over two weekends in central Aalborg, Denmark. Participants used an iPad 2 3G + WiFi running the Lost on Earth application, which was developed using the Unity3D game engine. To investigate the effects of riddle solving as the navigation method in a location-based game, we conducted

a comparative study between navigating by riddle solving and navigating by a 2D map with GPS. The experiment was guided by the following hypothesis:

H1: Riddle solving as navigational method is more enjoyable than map navigation (due to game elements).
H2: Riddle solving as navigational method results in a higher feeling of flow than map navigation (due to game challenges).
H3: Riddle solving as navigational method creates a larger sense of spatial presence than map navigation (due to increased interaction with physical surroundings).

The experiment was designed as a within-subjects design with two conditions. (1) A navigational method, where the participants navigated by solving riddles (R) and (2) a navigational method in which the participants used a digital map (M). These two conditions were counterbalanced with the purpose of reducing the environmental effects met on the route on the results. Participants would either begin with map or riddles, and would end with the navigational method different from the one met in the beginning.

Participants. Ten families of 2–6 persons participated. As the narrative of the game is targeting children, it was a requirement that the families had at least one child in the age range 9–11 years old. 17 children participated with ages ranging between 7 and 13 (mean = 10.1, SD = 1.6), 9 females and 8 males. 14 adults participated with ages ranging between 36 and 62 (mean = 42.3, SD = 6.4), 4 females and 10 males. All participants lived in Aalborg or nearby, and were familiar with the city as well as with using tablets or mobile devices.

Materials and Procedure. Three street arts, A, B and C, were a part of the experience (see Fig. 1 – right). The distance from A to B was 0,9 km and the distance from B to C was 0,9 km. Each condition also had approximately the same amount of turns, respectively 8 and 7 turns. For each session, one of the parents was instructed to wear a GoPro with a harness for recording video, while one of the children carried a bluetooth microphone for recording audio. All parents signed consent forms and filled out demographic questionnaires prior to the experience. We gave the child in the age range 9–11 years old the iPad, but they were not forced to handle it the whole session.

The questionnaires in this study contain questions from the Short Flow State Scale Questionnaire (S-FSS 2), which measures the degree to which flow dimensions characterize the complete experience [11]. The questionnaire also contains questions from the Intrinsic Motivation Inventory (IMI), which measures enjoyability, tension, effort and perceived competence as well as from a Spatial Presence Questionnaire (MEC-SPQ) for measuring spatial presence, allocated attention and suspension of disbelief. Only adults received this questionnaire due to the level of complexity, while children received a simplified questionnaire measuring enjoyability using IMI. Both questionnaires were measuring on a five point Likert scale, going from 1 (strongly disagree) to 5 (strongly agree).

Table 1. General results

Dimension	R	M
Intrinsic Motivation total (**)	4.31	3.64
Enjoyment (**)	4.49	3.46
Pressure	2.11	1.78
Effort (*)	4.30	3.68
Perc. Comp	4.13	3.68
Flow total (*)	3.85	3.60
Presence total	3.07	2.95

Table 2. Item specific results

Item	R	M
Intrinsic Motivation		
I thought navigating was fun (**)	4.48	3.42
I thought navigating was boring (**)	1.41	2.14
I enjoyed navigating (*)	4.29	3.46
I was pretty good at navigating (*)	4.41	3.73
Flow		
I was focused on navigating (*)	4.16	3.66
The experience highly rewarding (*)	3.93	3.15
I felt like time went by quickly (*)	4.54	3.69

Note: (*) = p < .05 and (**) = p < .01

4.1 Results

Tables 1 and 2 show the results for the Wilcoxon Signed-Rank test. Table 1 gives the general results for intrinsic motivation, flow and presence. Significant effect for intrinsic motivation esp. on the dimensions of enjoyment and effort shows that riddles were more motivating and enjoyable. Riddles also received a significantly higher score than maps concerning total flow. No significant difference was found for presence, but riddles was still favoured in terms of its score. Table 2 gives results for specific items from the intrinsic motivation and flow questionnaires that showed significant differences between the ratings for riddle- and map-based navigation. Riddles were significantly more fun and less boring. Adults found the riddles significantly more rewarding and had the feeling of time moving faster compared to the map version. These two questions specifically assess the dimension of having an autotellic experience and the sense of time transformation. As flow involves nine dimensions, these two were the only dimensions to reveal a significant difference. Additionally, children thought they were significantly better at navigating with riddles than maps. A multiple ordinal regression analysis was performed in order to investigate, whether age, gender, condition order or group size served as predictors for the results. In all cases, the results stayed significant, but the condition order had a significant impact on several of the questions concerning enjoyability in IMI. Due to the condition order, the selection of riddles was different for each condition, as well as the route described on the map. Participants met different landmarks on the route based on the condition order, which eventually provided a different experience between conditions.

4.2 Discussion

Based on the results H1 (enjoyability) and H2 (flow) are retained while H3 (spatial presence) has to be rejected. Results from our study clearly shows that riddle solving is a more enjoyable way of navigating than a digital map. Children were

challenged using the map as well as, perhaps because they are not used to any of the navigational methods. We found that children thought they were better at navigating with riddles than maps. Similarly, parents were significantly more in flow with riddle-based navigation. One of the explanations could be that parents were less challenged by using maps, as they are used to navigate with maps, while riddle-based navigation was just as novel an experience for the parents as for the children. We assume that maps were less challenging and therefore that challenge was one of the reasons why riddle-based navigation scored higher on enjoyment. Furthermore, we also found that children enjoyed answering questions and getting feedback. This supports that incorporating game activities into the navigation makes it more enjoyable for the players. We found no significant results about presence, though riddle-based navigation scored higher on making the participants aware of their surroundings. Despite not being the main focus of this study, we observed some interesting elements in terms of social interaction among participants. Even though we did not find any statistically significant results supporting that participants helped each other more during riddle-based navigation, we found in the post-interviews that riddle-based navigation has potential in motivating groups of people, making it a enjoyable group experience rather just a matter of getting from A to B. We observed that participants discussed more and that topics revolved around solving the riddles and discussing the landmarks. Though this requires a more thorough analysis of the interaction among the participants, we hypothesize that riddle-based navigation has potential in supporting learning e.g. about landmarks or developing skills in terms of exploration, particularly in a group context.

5 Conclusion

In this study, we investigated the effects of riddle solving as a navigational method in a location-based game experience for families. We compared this method with map navigation and found significant results indicating that riddle solving is more enjoyable. Though perhaps not being more intuitive, riddle-solving clearly suits the scope of location-based game experiences, as it makes use of the physical space to navigate from one POI to another, while also adding more enjoyment as well as learning possibilities to the experience.

Acknowledgements. We would like to thank Martin Lynge Jensen for support in adapting the Monsters Eat Art project and VisitAalborg for their kind collaboration.

References

1. Avouris, N., Yiannoutsou, N.: A review of mobile location-based games for learning across physical and virtual spaces. J. Univ. Comput. Sci. **18**(15), 2120–2142 (2012)
2. Ballagas, R., Kuntze, A., Walz, S.P.: Gaming tourism: lessons from evaluating rexplorer, a pervasive game for tourists. In: Indulska, J., Patterson, D.J., Rodden, T., Ott, M. (eds.) Pervasive 2008. LNCS, vol. 5013, pp. 244–261. Springer, Heidelberg (2008). doi:10.1007/978-3-540-79576-6_15

3. Bell, M., Reeves, S., Brown, B., Sherwood, S., MacMillan, D., Ferguson, J., Chalmers, M.: EyeSpy: supporting navigation through play. In: Proceedings Human Factors in Computing Systems, pp. 123–132. ACM (2009)
4. Blythe, M., Reid, J., Wright, P., Geelhoed, E.: Interdisciplinary criticism: analysing the experience of riot! a location-sensitive digital narrative. Behav. Inf. Technol. **25**(2), 127–139 (2006)
5. Carrigy, T., Naliuka, K., Paterson, N., Haahr, M.: Design and evaluation of player experience of a location-based mobile game. In: Proceedings of NordiCHI, pp. 92–101. ACM (2010)
6. Diamantaki, K., Dizopoulos, C., Charitos, D., Tsianos, N.: Theoretical and methodological implications of designing and implementing multiuser location-based games. Pers. Ubiquit. Comput. **15**(1), 37–49 (2011)
7. Eguma, H., Izumi, T., Nakatani, Y.: A tourist navigation system in which a historical character guides to related spots by hide-and-seek. In: Proceedings Technologies and Applications of AI, pp. 337–342 (2013)
8. Epstein, M., Vergani, S.: Mobile technologies and creative tourism: the history unwired pilot project in Venice Italy. In: Rodriguez-Abitia, G., Ania, B.I., (eds.) AMCIS, p. 178. AIS (2006)
9. Gentes, A., Guyot-Mbodji, A., Demeure, I.: Gaming on the move: urban experience as a new paradigm for mobile pervasive game design. Multimed. Syst. **16**(1), 43–55 (2010)
10. Gordillo, A., Gallego, D., Barra, E., Quemada, J.: The city as a learning gamified platform. In: IEEE Frontiers in Education Conference, pp. 372–378 (2013)
11. Moneta, G.B.: On the measurement and conceptualization of flow. In: Engeser, S. (ed.) Advances in Flow Research, pp. 23–50. Springer, Heidelberg (2012)
12. Morrison, A., Oulasvirta, A., Peltonen, P., Lemmela, S., Jacucci, G., Reitmayr, G., Näsänen, J., Juustila, A.: Like bees around the hive: a comparative study of a mobile augmented reality map. In: Proceedings of CHI, pp. 1889–1898. ACM (2009)
13. Peitz, J., Saarenpaeae, H., Bjoerk, S.: Insectopia - exploring pervasive games through technology already pervasively available. In: Proceedings of ACE, pp. 107–114 (2007)
14. Procyk, J., Neustaedter, C.: GEMS: a location-based game for supporting family storytelling. In: CHI 2013 Extended Abstracts, pp. 1083–1088. ACM (2013)
15. Raubal, M., Winter, S.: Enriching wayfinding instructions with local landmarks. In: Egenhofer, M.J., Mark, D.M. (eds.) GIScience 2002. LNCS, vol. 2478, pp. 243–259. Springer, Heidelberg (2002). doi:10.1007/3-540-45799-2_17
16. Rehm, M., Jensen, M.L.: Accessing cultural artifacts through digital companions: the effects on childrens engagement. In: Culture and Computing. IEEE Computer Society Press (2015)
17. Sorrows, M.E., Hirtle, S.C.: The nature of landmarks for real and electronic spaces. In: Freksa, C., Mark, D.M. (eds.) COSIT 1999. LNCS, vol. 1661, pp. 37–50. Springer, Heidelberg (1999). doi:10.1007/3-540-48384-5_3
18. Wise, D.: Great Big Book of Children's Games. McGraw-Hill, New York (2003)
19. Wu, B., Wang, A.I.: A pervasive game to know your city better. In: IEEE Games Innovation Conference, pp. 117–120 (2011)

Pairing Craft-Making with Mandarin eBooks: An Investigation into the Potential Use of Craft for Language Learning by Preschoolers

Wil-Kie Tan[✉], Stephen Jia Wang, and Jeffrey Janet

Department of Design, Faculty of Art Design & Architecture, Monash University,
Melbourne VIC 3145, Australia
wilkie.tan@gmail.com

Abstract. Bilingual ethnic Chinese parents are concerned about their preschoolers' learning of their mother tongue. Many allow their children to learn Mandarin by accessing Mandarin language applications on mobile devices. However the effectiveness of solely using mobile devices as a learning tool for preschoolers is debatable. This paper presents a field investigation on how adult-facilitated craft-making promotes interaction between the adults and their children, generates greater interest the reading of Mandarin eBooks and retention of the stories. The data suggests pairing of activities may be useful to children of across language abilities. This also highlights a need for designers and educators to formulate a holistic design approach in the development of preschool mobile learning content.

Keywords: Craft · Design · eBooks · Education · Mandarin learning · Mobile devices · Preschool · Reading · Tangible interaction

1 Introduction

In Singapore, despite an academic emphasis in the learning of both English and Mother Tongue, many families struggle with the use of their Mother Tongue both at home and in school [1]. While Mother Tongue might be spoken prior to preschool, there would be an increase in the use of English once the child starts formal schooling. Bilingual families' cultural hybridity [2] sparks a negotiation of meaning and representation [3] on their perceived value of Mother Tongue. For a child from a bilingual family, home, where two or more cultures interact readily, is an ambiguous area to grow up in.

Many bilingual ethnic Chinese parents use "edutainment" (blend of educational and entertaining) Mandarin language applications to engage their children's interest, in hope of retaining of Mandarin as their Mother Tongue. But the effect of mobile devices usage within their home space or when coupled with another activity such as craft-making is much less understood, as much of present research on language learning and technology pertains to technological and curricular integration of devices for literacy learning [4] or with references drawn from studies of more than 40 years of educational television programs [5].

© ICST Institute for Computer Sciences, Social Informatics and Telecommunications Engineering 2017
A.L. Brooks and E. Brooks (Eds.): ArtsIT/DLI 2016, LNICST 196, pp. 97–104, 2017.
DOI: 10.1007/978-3-319-55834-9_11

This paper presents an investigation of the researchers' hypothesis that a more structured adult involvement in shared reading of Mandarin eBooks and complementary craft-making, with its materiality, tangibility and interaction; and within the child's familiar context of home, can help foster the learning of Mandarin. It will include the theoretical considerations, methodology, data from 15 preschoolers and correlations of collated findings.

2 Theoretical Considerations

The researchers take the view that an adult-child interaction is central to preschoolers' learning. Familiarity and trust of the child towards his/her attached parent helps build confidence in learning from his/her immediate environment and reaching out to others [6]. Traditionally home is the primary space for transmission of knowledge, where the child also learns to make meanings from a setting that offers a cultural context to who he/she is, especially for one growing up in a bilingual family.

Unlike Piaget who placed language as only as a form of symbolic representation and its development as a result of the child's cognitive development, Vygotsky opined that the child learner is not a blank slate [7] but is seen to be constructing his/her own knowledge with the amalgamation of previous experiences and cultural influences to every new situation. Hence, Vygotsky placed learning within social situations and the role of language and cultural transmission is core to his notion of social constructivism perspective. His notion of "scaffolding" proposed that a child learns from a more experienced person and it occurs within a "zone of proximal development (ZPD)" [8]. He also saw ZPD as being formed through play in the early childhood as it is an internalization of social rules, formation of real-life plans and intentions on the part of the child [9]. However for ZPD to be effective, the child has to be an active rather than a passive learner and it is often the quality of interpersonal relationships between the child and the adult, that creates a more fruitful interaction and hence better learning outcomes [10].

EBooks' popularity means that stories continue to be an essential part of cultural and language transmission and storytelling is still important to language acquisition milestones. But there are some researchers who are unsure that shared book reading between adults and children would contribute to the development of children's literacy skills [11]. There are also concerns that adults now have a diminished role to share read once automated media-rich reading features are enabled in the eBooks, leading to comparisons made between adult–child interaction when they share a paper-based or eBook [12].

On the other hand, craft-making is recognized to be beneficial for the development of visual-processing skills, fine motor skills and building executive function, such as concentration, in young children [13]. This coupling of the craft-making with the eBooks also provides the contextualization necessary within the child in his/her learning process [14]. Adult-facilitated craft-making, while not spontaneous or self-directed by the child, when elaborated with age appropriate resources, may become sustained play episodes [15]. However, craft-making is regarded more as qualitative expression than in economic objectives [16] these days, and adults tend to dismiss it to be activities done in day care centres or that they do not have time for it at home.

3 Research Methodology

The methodology for this investigation included collaboration with an e-learning resource publisher, selection of suitable eBooks from them, and designing complementary craft activities with different levels of difficulties, before packaging them for the participants. These were then made accessible to them on a secure test site online. The adult volunteers facilitated the activities and assisted with the logging of observations and photo/video documentation of the prescribed activities with their children.

3.1 External Collaboration and Design of Craft Activities

Collaboration was sought with Commontown[1], an e-learning service provider from Singapore, in early 2015. They had developed *Dudu Town*[2], a subscriber-based portal, offering browser-based Mandarin eBooks to primary schools and preschools. When approached, they expressed an interest to know how subscribers can better understand their stories, and maintain or improve their motivation to read and learn.

A proposal was made to integrate craft making as a means to extend the currency of their eBooks. 4 preschool-level titles (Fig. 1), were shortlisted by the researchers from *Dudu Town*'s repository. The selection criteria included diversity in themes, illustration style and potential for integration of craft activities. Commontown offered technical assistance in hosting the test site with the 4 craft-eBook packages. Subsequent activities and data collation were conducted without their further involvement, but they were briefed on the data collated at the end of the investigation.

| Friends and the Bear | Goldfish is Asleep | The Rain Drop | Rabbit & Snail |

Fig. 1. Top 4 screenshots of eBooks show title pages with designated tabs (bottom right of each title page) for downloading craft activities. First and third screenshots from second row show mid-story prompts for craft activities.

[1] http://www.commontown.com.

[2] *Dudu Town* was designed for self-paced reading and incorporates an Automated Reading Programme (ARP) that provides adaptive learning and matching of the reader's ability to appropriate leveled changes in the readers' content. http://dudu.town/.

The eBooks selected were:

1. Friends and the Bear, a story about being true to your friends in the face of danger.
2. Goldfish is Asleep, a story about why fishes do not close their eyes when sleeping.
3. The Rain Drop, a story about the water cycle.
4. Rabbit & Snail, a story about the importance of keeping promises.

4 story-specific craft activities were then designed for the investigation (Fig. 2). Their visual elements were inspired from the stories so that the children can relate to what they read. They were also designed with ascending levels of technical difficulties:

1. For Friends and the Bear, a memory flip-card game, to simulate Bear hunting Friends (Level 1).
2. For Goldfish is Asleep, a cardboard aquarium with mobile goldfish (Level 2).
3. For The Rain Drop, a PVC bottle mini simulation of 'water cycle tank' (Level 4).
4. For Rabbit & Snail, a date-matching card game, to simulate counting down the days to a week (Level 3).

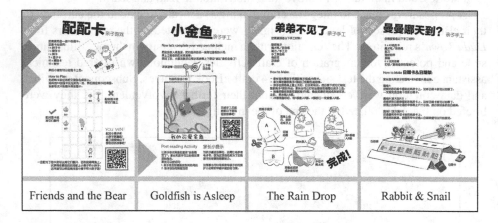

| Friends and the Bear | Goldfish is Asleep | The Rain Drop | Rabbit & Snail |

Fig. 2. Sample pages of craft instructions in Mandarin.

These were then packaged as PDF files, accessible from the books' title pages.

The adults were to prepare the material prior to the shared reading and the children were to start on the craft activities midway, when they were prompted by audio-visual cues in the eBooks. Upon completion of the craft objects, the adults could scan designated QRcodes on the instructions sheets to return to the stories, if they had printed them out prior to the activities.

3.2 Field Activities

Adults were sought as facilitators and documenters. Being 'gatekeepers' to the 'field' [17] provided both familiarity to the children and also a degree of control and participation that an external researcher would take a while to cultivate. Before starting on the activities, they provided background information on their use of Mandarin at home. They

stated their children's exposure to craft-making and use of Mandarin at home and with immediate family members. They also logged down the time taken to complete each activity and documented their observations of the children during the sessions, from reading, craft making to post-reading activities.

The shared reading of eBooks on mobile devices and all 4 craft activities were compulsory. Then the children attempted the post-reading activities, by answering simple questions in the eBooks and retelling the stories, with the aid of their craft objects. The adults were advised that their children's comfort take precedence and some completed the activities over a few sessions. Most importantly, the children were allowed to respond comfortably by code switching - alternating of Mandarin and English. Even when a child could not fully remember the stories, they were encouraged to string together fragments of the stories, with the aid of the craft objects. A stylistically different retelling meant the child grasped what was read.

Upon completion, each child answered a simple questionnaire with a series of 5 Yes/ No answers regarding his/her experiences in reading, crafting and retelling, and was given a "Certificate of Completion" to encourage further reading and crafting.

4 Data Collation and Analysis

A total of 15 children aged 3 to 5 from bilingual (English & Mandarin-speaking) Singaporean families based in Singapore and Melbourne participated in the activity.

When the respondents' answers from 2 key background questions: *The child responds in Mandarin when spoken to* and *The child needs me to encourage him/her to speak in Mandarin* were correlated, it showed that most adults still saw the need to encourage their children to speak in Mandarin despite that they were already responding in Mandarin when spoken to. This implies that the adults in this sample group must have felt the same anxiety towards the maintenance of Mandarin (Fig. 3).

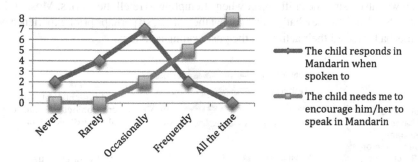

Fig. 3. Correlation between adults' encouragement and children's response in Mandarin

The children who were noted to "never"/"rarely" respond in Mandarin were compared to those who responded "occasionally" and "frequently" (no adults indicated "all the time"), in their interest to start reading the eBooks (Fig. 4). Almost all the children, regardless of their willingness to respond in Mandarin, were keen to start reading

the Mandarin eBooks, possibly due to the visual appeal of the characters in the stories and/or the opportunity to access or "play" with the mobile devices.

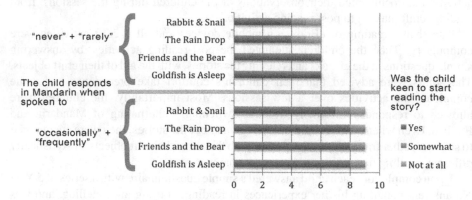

Fig. 4. Correlation between whether the children were keen to start reading the respective stories and their willingness to respond in Mandarin.

Next, the focus is on adults who said they spent time on craft-making with their children. Children of adults who indicated "rarely" and "frequently" to spending time on craft-making, are investigated to see if they related the craft object with the eBooks, and if they used the craft object to aid in their retelling of stories. The correlated result of the children with the adults who quoted "rarely" was too small to be read effectively. However, children of the 7 adults who cited "frequently" gave interesting results (Fig. 5) about their choice of craft. *Goldfish is Asleep* topped their list for being the most relatable craft object to the eBooks, followed by *Friends and Bear*, *The Rain Drop* and *Rabbit & Snail*. This matches the difficulty level of the craft activities designed. *Goldfish is Asleep*, despite being slightly more difficult, could have topped due to its whimsical factor. This same group of children was also using the craft object when attempting to retell the stories. Most of them indicated "yes" and "somewhat" to using what they made, so perhaps prior experience with the adults had affected their actions in the post reading activities.

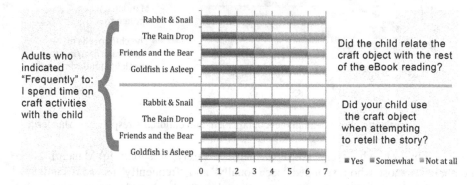

Fig. 5. Correlation between whether the children were keen to start reading the respective stories and their willingness to respond in Mandarin.

At the end, 4 out of 6 of the children who "never"/"rarely" respond in Mandarin at home were noted to be "somewhat" able to engage in the retelling of the story in Mandarin. All other children who "occasionally"/"frequently" respond in Mandarin at home, expectedly were able to ("yes" and "somewhat") engage in Mandarin retelling. While it was not conclusive that the children warmed up to the use Mandarin after going through the activities, it was helpful to know that the children were not adverse to the experience. These sentiments were also captured in the final children questionnaire, with 13–15 of them noted that they liked reading and retelling the stories (with the craft objects), playing the toys they made and liked making them with the adults (Fig. 6).

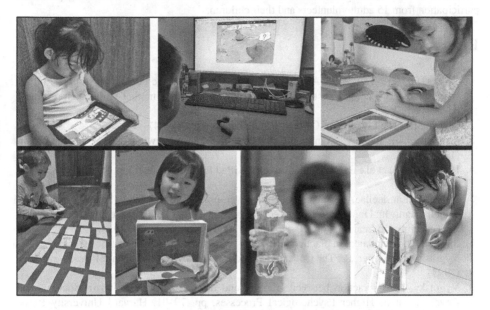

Fig. 6. Participants accessing the eBooks and playing with their craft objects.

5 Limitations and Strengths of the Investigation

The results are not definitive that a structured adult involvement in shared reading and craft-making, can help foster the children's interest in the learning and use of Mandarin. The differences or limitations of individual adults' approach when facilitating the activities might have affected how the children responded or went about their activities. Neither was there a consistent use of Mandarin in the communication between the adults and children from some of the video documentation submitted. However, this may be seen as adults using code-switching to engage rather than to negate the efforts of the children.

Future in-depth investigations, with a larger pool of participants, different family demographics, more varied stories and a control group exercising without craft-making activities, would provide a better picture on how the role of adults, adult-child interaction and craft-making's materiality and tangibility, can help retain interest and knowledge. The documentation from this investigation did however shed light on how the children were

injecting their own individuality into the craft objects, and that they were at ease when reading and crafting within their homes. From the perspective of design research, this indicates that the development of screen-based edutainment preschool resources requires more than just better narratives and audiovisual content. The understanding of child development, play, the recognition of their creativity, the engagement of adults and even site specificity should be key considerations for any designer, developer and manufacturer.

Acknowledgments. This investigation is part of the 1st author's PhD study at Monash University, Australia. It was made possible with the collaboration of Commontown Singapore and participation from 15 adult volunteers and their children.

References

1. VoicesTODAY: VoicesTODAY asks: mother tongue - can the decline be stopped? http://www.todayonline.com/voicestoday/episodes/voicestoday-asks-mother-tongue-can-decline-be-stopped
2. Bhabha, H.: The Location of Culture. Routledge, London (1994)
3. Rutherford, J.: Identity: Community, Culture, Difference. Lawrence & Wishart, London (1990)
4. Hutchison, A., et al.: Exploring the use of the iPad for literacy learning. Read Teach. **66**(1), 15–23 (2012)
5. Robb, M., Lauricella, A.: Connecting child development and technology: what we know and what it means. In: Donohue, C. (ed.) Technology and Digital Media in the Early Years: Tools for Teaching and Learning, pp. 70–85. Taylor and Francis, Florence (2014)
6. SirenFilms: Attachment in practice (2014)
7. Vygotskij, L., Rieber, R.: The Collected Works of L.S. Vygotsky. Plenum Press, New York (1993)
8. Vygotsky, L.: Interaction between learning and development. In: Mind in Society: The Development of Higher Psychological Processes, pp. 79–91. Harvard University Press, Cambridge (1978)
9. Vygotsky, L.: Play and its role in the mental development of the child. J. Russ. East Eur. Psychol. **5**, 6–18 (1967)
10. Stone, C.: Should we salvage the scaffolding metaphor? J. Learn. Disabil. **31**, 409–413 (1998)
11. Scarborough, H., Dobrich, W.: On the efficacy of reading to preschoolers. Dev. Rev. **14**(3), 245–302 (1994)
12. Kim, J.E., Anderson, J.: Mother–child shared reading with print and digital texts. J. Early Child. Lit. **8**(2), 213–245 (2008)
13. Rende, R.: Research shows parent/child craft time has lifelong benefits. http://www.parenting.com/parenting-advice/tips-tricks/research-shows-parent-child-craft-time-has-lifelong-benefits
14. Pöllänen, S.: Contextualising craft: pedagogical models for craft education. Int. J. Art Des. Educ. **28**(3), 249–260 (2009)
15. Moyles, J.: A–Z of play in early childhood (2012)
16. Aerila, J., Rönkkö, M.: Integrating literature with craft in a learning process with creative elements. Early Child. Educ. J. **43**(2), 89–98 (2013)
17. Barley, R., Bath, C.: The importance of familiarisation when doing research with young children. Ethnogr. Educ. **9**(2), 182–195 (2013)

Toward a Decolonizing Approach to Game Studies: Philosophizing Computer Game with BCI

Hyunkyoung Cho[1(✉)] and Joonsung Yoon[2,3]

[1] Design Institute, Inje University, Gimhae, Korea
hkcho.vt.edu@gmail.com
[2] Tianjin Normal University, Tianjin, China
[3] Global School of Media, Soongsil University, Seoul, Korea
dryoon@maat.kr

Abstract. This study presents that the computer game is being philosophized as an object of thoughts that generates a number of philosophical discourses. In order to define the concept of philosophizing computer game, my paper examines *Racing Car Game* with BCI (Brain-Computer Interaction) and reconsiders the rule of the game in the conflict between the game and the narrative. It proposes that the philosophizing computer game with BCI contributes to the decolonizing knowledge enabling new forms of collaborations between sciences, engineering, arts, and design.

Keywords: Decolonizing knowledge · Philosophizing computer game · Brain-Computer Interaction · Rule

1 Introduction

Decolonizing knowledge is an awakening of disciplines. Knowledge is acquired through complex cognitive processes and conducting by correcting and training disciplines. It is justified by a power of theoretical or practical understanding system and can be more or less formal or systematic. To decolonize knowledge of computer game is to invaginate game studies into the ecology of networked knowledge enabling new forms of collaboration between sciences, engineering, arts, and design. It is concerned with both conceptual and methodological strategies aimed at understanding and enhancing the processes and outcomes of collaborative, team-based research.

According to Hannah Arendt's action theory, the knowledge is the way in which we humans produce our means of life. It articulates itself in the mode of performing our life beyond the material and physical one. The knowledge condition is a whole from the perspective of the idea of social relations embodied in the real movement of life [1]. Max Horkheimer and Theodor W. Adorno also meditated the knowledge as the intertwinement of reason and experience in the actual life-process. They point out a paradox of knowledge embracing both enlightenment and myth. The knowledge has the twofold character of enlightenment traversing the universal movement of mind and a nihilistic,

© ICST Institute for Computer Sciences, Social Informatics and Telecommunications Engineering 2017
A.L. Brooks and E. Brooks (Eds.): ArtsIT/DLI 2016, LNICST 196, pp. 105–112, 2017.
DOI: 10.1007/978-3-319-55834-9_12

life-denying power [2].[1] On the one hand, we humans create our own knowledge condition, and on the other, everything we create turns immediately into a condition. This presents that the knowledge condition can be transformed by the performing of the action. Here's the problematic of knowledge of computer game.[2]

Like human-human communication, technology and humans act and react. In particular, computational technology is endowed with highly intelligent and perceptive qualities; has its own laws; and the system itself evolves. With the ability of autonomy and emergence, technology performs the autonomous and emergent action beyond human control. It becomes 'a performer (a collaborator)' collaborating with humans [3]. Technology as a performer (collaborator) transforms the knowledge condition. The transformation, the expanded knowledge conditions by the collaborative action of we humans and technology can be called as "We" human-and-technology [4].[3] The word of "We" human-and-technology indicates that knowledge of we humans is organized by collaborative actions between we humans and technology. "We" human-and-technology is a response to the need for alternative frames of reference to inter-active systems design and alternative ways of understanding the relationships and collaborative actions between humans and new digital technologies [5]. The concept provides a chance to study a growing interest in the philosophizing computer game with interactive technologies.

2 What the Computer Game is Philosophizing

Human-Computer interaction (HCI) techniques evolve from conscious or direct inputs. Especially, the computer game with Brain-Computer Interaction (BCI) shows that the collaborative action of "We" human-and-technology involves both conscious and nonconscious inputs. It expands the collaborative action into a kind of biofeedback. It suggests the brain signal processing as a new way for the collaborative action of "We" human-and-technology.

For example, *Racing Car Game* as an ongoing research-led practice about the computer game design with BCI is constituted by the concentration between human and computer as collaborators (Fig. 1).[4] The brain-computer collaborative action changes the car's velocity; it can improve the attention state; when the collaboration between

[1] Max Horkheimer and Theodor W. Adorno, Dialectic of Enlightenment (California, Standford: Standford University Press, 2002), p. 36.

[2] In this paper, the problem of knowledge reframed by Human-Computer Interaction was originated from my paper. See, Cho, H.K., Yoon, J.S.: Toward a New Design Philosophy of HCI: Knowledge of Collaborative Action of "We" Human-and-Technology, In: Human-Computer Interaction. Human-Centred Design Approaches, Methods, Tools, and Environments. LNCS 8004, pp. 32–40. Springer, Heidelberg (2013).

[3] The concept of "We" human-and-technology was first presented in Cho, H.K.: Aesthetics of "We" human-and-technology. In: ArtsIT 2013. LNICST, vol. 116, pp. 97–104. Springer, Heidelberg (2013).

[4] Game Design with BCI, Brain-Computer Collaborative Action: *Racing Car Game* designed by Bio-Computing Laboratory at GIST, Korea.

human and computer gets stronger, the concentration level goes higher. In *Racing Car Game*, brainwave is the key measure. It represents the concentration as the degree of collaborative action of "We" human-and-technology. Car's velocity shows the concentration level using electroencephalography (EEG).[5]

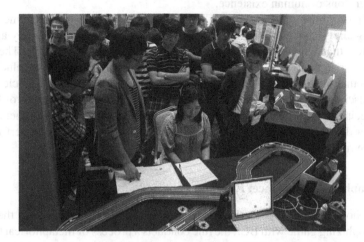

Fig. 1. *BCI* Game of "We" human-and-technology: Communication without physical and visible movement (*Racing Car Game* Exhibition. EPOC (14-channel wireless EEG system developed by Emotiv Systems) and Carrera Slot Car.).

As a new way of computer game design for "We" human-and-technology, the collaborative action through brain activities allows us a communication without physical and visible movement between human and computer. Brain signals create a new philosophical dimension of computer game design constituted by the collaborative action of "We" human-and-technology.[6]

2.1 Philosophizing Computer Game: Philosophy and Computer Game

Philosophy is not a theory but an activity. Bertrand Russell meditates that the object of philosophy is the logical clarification of thoughts. The result of philosophy is not a number of 'philosophical propositions', but to make propositions clear. It should make clear and delimit sharply the thoughts which otherwise are, as it were, opaque and blurred [6].[7]

[5] As a research project, *Racing Car Game* is concerning on the aesthetic of art with BCI. See, Cho, H.K., Paik, J.K.: Well-Being of Decolonizing Aesthetics: New Environment of Art with BCI in HCI. In: Human Interface and the Management of Information: Applications and Service, LNCS, vol. 9735, pp. 244–255. Springer, Heidelberg (2016).

[6] The design of HCI with BCI is a part of my research project, "Decolonizing Knowledge: the aesthetic reconstruction of technological experiments." This multi-disciplinary project is to contribute on the networked knowledge between art, design, engineering, and humanity.

[7] Ludwig Wittgenstein, Tractatus Logico-Philosophicus (New York: Routledge, 2005), p. 4.

Today the computer game with BCI is not only as a major media but also as an object of philosophy that generates a number of discourses. It shakes the tradition of Cartesian coordinating system, through the traversing body and mind, reason and sense, the real and the virtual. It asserts the multiplicity of human existence. It maintains that there are other dimensions of human existence.

The philosophizing game with BCI is to define the ontological newness of the computer game. It catches the eloquence missing both fields of philosophy and game studies. More than what it means beyond the philosophy of computer game. The concept indicates that the game is an object of thoughts and consists essentially of elucidations. It involves the rule in order to conduct everything can be thought and said clearly. The rule is a discipline intended to produce a specific characteristic or pattern of behavior and is especially a training that produces moral, physical or mental development towards a particular direction. It implies that the game is philosophizing on two performances making the rule and simultaneously obeying the rule.

2.2 Metaphor Performance: Rule and Use

The metaphor is a crucial point that prescribes the double performance of the rule. In the philosophizing game with BCI, the rule conducts a process of metaphorical thinking. The metaphor comes from the Greek 'metaphora,' in which 'meta' is a tenor (or moving) and 'phora' is a vehicle (or vans). It is a rhetorical trope defined as a comparison (or analogy) for an unrelated object. The tenor is an object being described, and a vehicle is an object borrowing a description. In "Juliet is the sun," Juliet is a tenor and the sun becomes a vehicle. The rule of the game follows the rule of metaphor in which both objects (the user and the game or the user and the selected character) simultaneously must be considered. When a user is playing a game, the user and the game or the user and the selected character also have a mapping of the concepts as a tenor and a vehicle. The rule of the game becomes a metaphor performing an interaction between rules and establishes similarity and difference of objects.

The narrative of the game with BCI is imported by this metaphorical performance of the rule. As a moving van, the metaphor must be found out in a performance of thoughts and events. In other words, the performance of the rule can be considered as the narrative in which series of thoughts and events are involved. For example, the word 'game' is an ambiguous term that the narrative remains inactive. When someone uses the word 'game' as a noun or a verb, it becomes a metaphor that contains a rule of 'similarity and difference' in the performance of thought and events. At this moment, we are locked up in the obscuring story of the word 'game' that needs to be overcome, and the narrative is generated in the performance. In the philosophizing game with BCI, the performance of the rule shows that there is an apparent ontological difference (or a method of existence) between the narrative of the game and the narrative of the literary.

In the case of *Racing Car Game,* the narrative is replaced by the processing of the signal. *Racing Car Game*'s system is implemented under BCI2000 platform (general purpose software in BCI research) (Fig. 2). Graphical software visualizes concentration

index, and hardware module controls the velocity of a racing car. BCI2000 is a general-purpose system for BCI research and development.[8] It can also be used for data acquisition, stimulus presentation, or brain observation applications. BCI2000 consists of a Signal Acquisition module that acquires brain signals from g.USBamp or g.MOBIlab + devices. These raw signals are visualized and stored to disks and submitted to the Signal Processing module. The Signal Processing module extracts signal features and translates them into the device command. Its commands are used by the Applications module to generate collaborative action of human and technology.

Fig. 2. BCI2000 platform (general purpose software in BCI research) in *Racing Car Game*

As a case of the philosophizing game, *Racing Car Game* presents that the computer game is the moving. The literary work has a fixed story that is written by the author, and the reader reads it. The computer game, however, surely requires the user's action, and the collaborative action of humans and computer even constructs the game itself. Here the interesting point of the philosophizing game with BCI is that we do not just see that things move in the game, but we see them moving in it, and this is because we ourselves move it. In other words, the computer game using BCI technologies is not the still of moving things, but the moving of moving things. It shows that there is no coherent and inherent relevance in the game. Thus, it challenges the way of knowing and decolonizes the power of knowledge system.

Arthur Danto said that "We refer to Voltaire only with reference to why we see the cloud as we do, not with reference to why the cloud is the way we see it." [7][9] The ontological difference (or the existence) is caused by the experience of reality, but causality and reference are in front of undetermined (or being determined) experience. It is not undetermined causality and reference, but veridical experience. The

[8] BCI2000 has been used to replicate or extend current BCI methods in humans and has recently been used in a number of groundbreaking BCI studies. BCI2000 has been in development since 2000 in a collaborative effort led by the Wadsworth Center. BCI2000 is available free of charge for research purposes to academic and educational institutions.

[9] Arthur Danto, "Moving Pictures," Philosophizing Art (California: California University Press, 2001), p. 216.

philosophizing game with BCI presents that we have to question the way of knowing, that is, the rule of the knowledge game.

3 More Than What It Means

3.1 Context

The philosophizing game with BCI reconsiders the conflict between the game and the narrative. What is a real game? What is the narrative of the game? Is it agreed to obey the theory of the literary narrative? For a long time, these questions have been controversial. Especially, in the relationship between the game and the narrative, Narratology and Ludology have different perspectives. The former is based on the traditional narrative theory of the literary while the latter is claimed that the game should not be viewed as an extension of the traditional narrative.

The philosophizing game with BCI reconciles two theoretical frames. On the one hand, it embraces Narratology that is interested in the shows (or traces) of the game. According to Mieke Bal, the narrative contains both an actor and a narrator; it also should contain three distinct levels consisting of the 'text', the 'story', and the 'fabula'; its contents should be a series of connected events caused or experienced by actors [8].[10] As a level of the narrative, the 'text' is a totality of structures with language signs, the 'story' represents the 'fabula,' and the 'fabula' is continuous events with a logical, temporal and historical connection that is caused or experienced by the actor. In short, the narrative of the philosophizing game is a 'series of connected events' caused or experienced by actors' and it requires both an 'actor and a narrator' as a narrative condition.

On the other hand, the philosophizing game concerns Ludology focusing on the rule as a cause and an experience, and the game itself that defines a winner and a loser as the result of it. Hence, the philosophizing game presents that the game produces a sequence of events, but it is not just the narrative that makes a continuous story or a formal development. It has the simulation as a representational and rhetorical tool, which is a way of portraying reality.

The philosophizing game with BCI is an inevitable risk in trying to clarify the potential and synergistic effects of Narratology and Ludology. It reveals that the conflict between the game and the narrative depends upon a 'political pedagogy'; it challenges an academic, scholastic and scientific meaning. Thomas S. Kuhn distinguishes 'context of discovery' from 'context of justification.' How is this distinction mystified? He calls it the "context of pedagogy." [9][11] It is similar to the fact that the Foucault's Pendulum itself represents the scientific and rational reason of human, but the moving earth as an exploring object is full of endless mysteries. It recalls that the knowledge of the game is useful in the classification, but the game always transcends it.

[10] Mieke Bal, Narratology: Introduction to the Theory of Narrative (Toronto: Toronto University Press, 1985), p. 8.

[11] Thomas S. Kuhn, "Objectivity, Value Judgment, and Theory Choice." In: Arguing about Science. Routledge, New York (2013), p. 74.

3.2 Interpretation

The philosophizing game with BCI presents that there is no distinction between a random and a systematic. The understanding itself is a state using the rule. The problem is not the meaning, but how to use the rule. The correct use of the rule is an important term in Ludwig Wittgenstein's philosophy [10].[12]

Let's consider that a user A and a user B are playing a game of numbers. A has written down numbers 1, 5, 11, 19. After A writes the number 19, B finds out a formula $an = n^2 + n - 1$, and says, "Yes, I know the next number." This process is a perfect imagination. It may be thought to have the narrative and to get hold of the mental process of understanding that seems to be hidden behind the visible accomplishment. We, however, do not succeed in getting the narrative and the mental process. Since, it surely doesn't mean a simple understanding that 'B understands the rule of the series,' and we would have endless questions as a chain of reason that comes to the end; what is the understanding? Why should it be understood?

If there has to be something behind the utterance of a formula, it is a 'particular circumstance' that we are trained to do so. There is no understanding with a mental process that is originated from a pure operation of the body like the sickness. When we are obeying the rule of the philosophizing computer game with BCI, we can have a special experience. But it is also the circumstance under which we had such an experience that justifies us in such a case that we understand and that we know how to go on. This is the reason why we have to call us not the player or the gamer but the 'user'!

Obeying the rule, giving the order and playing the game are merely customs as we are trained to do so. Therefore, there is no place for the narrative in it. If there, however, is something remained, it is not the narrative, but an 'interpretation of the rule.' When we should comment on the situation that someone is playing the game with BCI, the game is translated into a series of actions according to certain rules. In other words, the BCI game procedure is translatable by the rule, since every action of the user is determined by the rule. Thus, the narrative of BCI game is a merely 'surplus of this interpretation.'

Unlike narrative of the literary narrative, the interpretation of the philosophizing game with BCI is endless, and it just merely defines a winner and a loser. Thus, Wittgenstein said that "if we dwell upon the rule, and do try to get beyond it, the difficulty here is: to stop" [11][13].

4 Invagination

The philosophizing computer game with BCI is a 'Don Quixote.' Like Miguel de Cervantes's "Don Quixote De La Mancha" that is the first modern work of literature, the computer game shows us that the rule of similarity and difference makes sport of

[12] Ludwig Wittgenstein, Philosophical Investigations, trans. G. E. M. Anscombe (Oxford: Blackwell, 1953, 2005), pp. 145–155.

[13] Ludwig Wittgenstein, "Following a Rule," In: The Wittgenstein Reader, ed. Anthony Kenny (Oxford: Blackwell, 2006), pp. 99–100.

our reason endless. Today, the computer game breaks off its old kinship with the literary narrative and it exactly marks the point converging madness and imagination. Michel Foucault defines that "The madman brings similitude to the signs that speak it, whereas the poet loads all signs with a resemblance that ultimately erases them." [12][14] The madman and the poet share the rule of the extreme point of our reason.

The philosophizing game with BCI also has an ambivalence of the philosophy and game. The collaborative action of humans and computer involves the decolonizing knowledge. In the philosophizing computer game design with BCI practices, *Racing Car Game*, the collaborative action of "We" human-and-technology becomes an imagination itself. It considers the collaborative action of "We" human-and-technology as both knowledge of practical arts and practical arts themselves. Thus, BCI game constituted by the collaborative action of "We" human-and-technology stimulates a network of conceptual relations rather than merely perceptions of the haptic and sensory aspects of interactive game design.

Acknowledgments. This work was supported by the National Research Foundation of Korea Grant funded by the Korean Government (NRF-2014S1A5B8044097).

References

1. Cho, H., Yoon, J.: Toward a new design philosophy of HCI: knowledge of collaborative action of "We" human-and-technology. In: Kurosu, M. (ed.) HCI 2013. LNCS, vol. 8004, pp. 32–40. Springer, Heidelberg (2013). doi:10.1007/978-3-642-39232-0_4
2. Horkheimer, M., Adorno, W.T.: Dialectic of Enlightenment. Standford University, California (2002)
3. Cho, H.K., Yoon, J.S.: The performative art: the politics of doubleness. In: LEONARDO, vol. 42:3, pp. 282–283. MIT Press, New York (2009)
4. Cho, H., Park, C.-S.: Aesthetics of 'We' human-and-technology. In: Michelis, G., Tisato, F., Bene, A., Bernini, D. (eds.) ArtsIT 2013. LNICSSITE, vol. 116, pp. 97–104. Springer, Heidelberg (2013). doi:10.1007/978-3-642-37982-6_13
5. Cho, H., Paik, J.-k.: Well-being of decolonizing aesthetics: new environment of art with BCI in HCI. In: Yamamoto, S. (ed.) HIMI 2016. LNCS, vol. 9735, pp. 244–255. Springer, Heidelberg (2016). doi:10.1007/978-3-319-40397-7_24
6. Wittgenstein, L.: Tractatus Logico-Philosophicus. Routledge, New York (2005)
7. Danto, A.: Moving pictures. In: Philosophizing Art. California University Press, California (2001)
8. Bal, M.: Narratology: Introduction to the Theory of Narrative. Toronto University Press, Toronto (1985)
9. Kuhn, S.T.: Objectivity, value judgment, and theory choice. In: Arguing about Science. Routledge, New York (2013)
10. Wittgenstein, L.: Philosophical Investigations, Blackwell, Oxford (2005). trans. Anscombe, G.E.M.
11. Wittgenstein, L.: Following a rule. In: Kenny, A. (ed.) The Wittgenstein Reader. Blackwell, Oxford (2006)
12. Foucault, M.: The Order of Things. Routledge, New York (2002)

[14] Michel Foucault, The Order of Things (New York: Routledge, 2002), p. 55.

CollaTrEx – Collaborative Context-Aware Mobile Training and Exploration

Jean Botev$^{(\boxtimes)}$, Ralph Marschall, and Steffen Rothkugel

Computer Science and Communications Research Unit, Faculty of Science,
Technology and Communication, University of Luxembourg,
6, rue Richard Coudenhove-Kalergi, 1359 Luxembourg, Luxembourg
{jean.botev,ralph.marschall,steffen.rothkugel}@uni.lu

Abstract. This paper introduces the CollaTrEx framework for collaborative context-aware mobile exploration and training. It is particularly designed for the in-situ collaboration within groups of learners performing together diverse educational activities to explore their environment in a fun and intuitive way.

Aside from employing both absolute and relative spatio-temporal context for determining the available activities, different buffering levels are an important conceptual feature supporting seamless collaboration in spite of temporary connection losses or when in remote areas.

CollaTrEx comprises a prototypical front-end implementation for tablet devices, as well as a web-based back-end solution for the creation and management of activities which can be easily extended to accommodate both future technologies and novel activity types.

Keywords: Collaborative learning · Context-awareness · Mobile learning · Location-based learning

1 Introduction

The proliferation of mobile devices equipped with a multitude of sensors as well as advanced recording and networking capabilities offers an enormous potential for educational applications. The advantages and opportunities of context-aware mobile learning are widely recognized [1], but modern smartphones, tablets or wearables with their GPS antennas, magnetometers and gyroscopes, not only allow for establishing precise spatio-temporal context. Their multi-touch screens, high-resolution cameras and microphones, together with the support of various long- and short-range network protocols, call for increased interactivity and collaboration. However, instead of harnessing these capabilities to full effect for a genuinely collaborative and interactive mobile learning experience, they are often left unexploited.

In this paper we introduce CollaTrEx, an integrated framework for collaborative context-aware mobile exploration and training with a focus on the in-situ

© ICST Institute for Computer Sciences, Social Informatics and Telecommunications Engineering 2017
A.L. Brooks and E. Brooks (Eds.): ArtsIT/DLI 2016, LNICST 196, pp. 113–120, 2017.
DOI: 10.1007/978-3-319-55834-9_13

collaboration within groups of learners engaging in varied educational activities. Single-user mobile learning scenarios as subclasses of the corresponding, collaborative cases are inherently supported, as well.

To determine which activities are available and to provide a tailored experience both for leisure and academic settings, absolute and relative spatio-temporal context is employed. Furthermore, the framework supports different on- and offline modes and buffering strategies as, in particular in remote areas, the necessary infrastructure or proximity between groups of learners cannot always be assumed.

We will discuss the core conceptual design underlying the framework in the next section. Section 3 then introduces the general architecture of the CollaTrEx prototype system and details both the back end as well as the iOS-based tablet application. To further contextualize our approach, we will discuss related work in Sect. 4 before concluding with a summary and outlook on potential research directions and future developments.

2 Conceptual Design

The CollaTrEx framework integrates the two paradigms of situated learning [2,3] and collaborative learning [4], thus combining context-aware, experiential and social factors. Its prime focus is on intra-group cooperative aspects, i.e., support for active in-situ collaboration within groups of learners exploring their environment. The diverse activities are designed to accommodate various age levels and content ranging from basic, e.g., for city guides or sightseeing, to academic, as for instance in the outdoor collaborative scenarios classified in [5].

In the following, we will outline the key conceptual elements of context, activity and the different buffering levels that form the basis of the suggested architecture and implementation.

2.1 Context

CollaTrEx relies on establishing absolute and relative spatio-temporal context to provide users with different activities. Before detailing these in Sect. 2.2, we first introduce the individual context types which are employed in varying combinations to determine which activities are available at a certain stage.

Location. The *absolute position* of users is the central factor in providing location-based information. Location data can be either a single point of interest (PoI), or a larger area of interest (AoI), optionally together with the orientation.

Proximity. While clearly related to location, the *relative position*, i.e., distance between two or more groups of users, can be a crucial contextual factor and necessary precondition for certain activity types involving inter-group cooperation.

Time. Aside from the spatial dimension, the temporal context plays an important role, i.e., certain activities are only available at certain points in time or during specific periods of time. Allowing for activities that are defined only for an *absolute time* frame during a day, week, month or year is particularly interesting for long-term exploration or finer-grained, choreographed experiences.

History. Similar to how location and proximity relate, time and history differ in that they reflect absolute and *relative time*, respectively. History comprises preceding events and previous achievements which might be necessary preconditions for coherent activity sequences.

As discussed in Sect. 1, modern mobile devices already provide all relevant features for establishing such spatio-temporal context with a high accuracy.

2.2 Activities

The central element in the CollaTrEx framework are the various activities which users can perform depending on their situational context. While the focus is on active group collaboration, single-user mobile learning scenarios are inherently supported, as well; they mostly constitute simpler subclasses of the corresponding collaborative activities.

The individual activity types can be easily combined, as for instance in the image capturing example introduced in Sect. 3.2, and the definition of activity sequences constituting of several subactivities is facilitated by the overall modular approach. It also allows for creating further activity types, in particular with regard to varying use cases and technological progress. The following list therefore is not comprehensive but intended to give an overview of the current activity types.

(a) Collaborative framing.

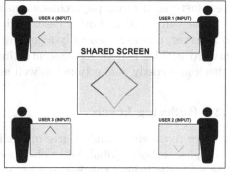
(b) Collaborative sketching.

Fig. 1. Two examples of basic activity types involving a group of four users.

Field Recording. Exploring their environment, users make audio-visual recordings (i.e., sounds or videos, but also still images) of particular objects or places.

Sketching. While it might also be utilised for recording some part of the environment, the sketching activity goes beyond that inasmuch as the users employ their devices to create an aggregate drawing on a single digital canvas together, as illustrated in Fig. 1b.

Object Interaction. In the simplest case, objects (both virtual or real) are collected, dropped or just marked at a specific location (PoI or AoI). The objects or object markers are kept in an inventory that allows further interaction, such as to trade, distribute or even combine them in between the members of a group.

Quiz. A question which, in the collaborative case, might for instance pass an automatic majority voting process before evaluation. A competitive mode, where a winner is determined from the group after a series of questions, is also possible.

Puzzle. The construction (or reconstruction) of a fragmented object by users on a (shared) screen, where the pieces might need to be collected first. The object can be not only an image, but any kind of media or audio-visual content.

Framing. Mostly used in combination with other activities, framing requires the members of a group to position themselves with correct orientation around an object or location. Figure 1a exemplifies this with a regular shape defining the area around a landmark building. However, that can be a complex polygon necessitating more users. The object can also be virtual.

These types can be combined and sequenced into dynamic, context-aware activities, such as to find and mark all occurrences of an object within a certain area, fast-paced races, paperchases and so on.

Albeit in certain, simpler cases individual data can be transmitted directly to a server, one user generally aggregates the result for the group to store and forward it. This is both for concentrating load in the ad-hoc network instead of other more costly connections, as well as for resilience to network failures.

2.3 Buffering Levels

In order to provide a high degree of flexibility, CollaTrEx offers several buffering strategies on both global, i.e., web-based, and local, i.e., ad-hoc, network level. The rationale behind this is two-fold: on the one hand, connection losses should not hamper the seamless experience; on the other hand, supporting advanced collaboration in remote locations without permanent or sufficient connectivity is an explicit design requirement for the framework, which is particularly relevant in connection with academic education (e.g., field trips in geography).

3 The CollaTrEx Prototype System

We have built a prototype system that comprises a front-end implementation for iOS-based tablet devices and a web-based back-end solution for the provision, management and creation of the various activities. The paramount goal was to design a generic, yet simple architecture that allows for easily incorporating extensions to accommodate both new types of activities and future technologies.

3.1 Back End

Recent advances in cloud computing allow for the rapid development and deployment of web applications and services using a platform-as-a-service (PaaS) approach. A clearly discernible, related trend is an API-first strategy that makes use of the HTTP protocol with a RESTful URI design and JSON-encoded messages to provide a single unified entry point for clients and third parties.

Due to its flexibility, effectiveness and reduced complexity, we chose to follow this approach and implemented a web service based on a relational database which provides a RESTful API for fetching the necessary information. The service itself is written in Python using Django and the Django REST Framework which particularly accelerate the development of all CRUD (Create, Read, Update, Delete) operations.

Underlying the back end solution is a PostgreSQL database which, similarly to other database systems, also supports certain location-specific data types via a plug-in mechanism. Many non-relational or NoSQL databases furthermore permit more elaborate location-specific queries. However, in order to maintain full control over the implementation, we store location information such as latitude, longitude, altitude, and heading individually. Furthermore, static and dynamic database entities are distinguished which leads to more purposeful caching while optimizing bandwidth utilization.

Most web-based applications are developed on a single, monolithic code base which, with growing requirements and feature sets, becomes increasingly challenging to maintain over time. Also, to be able to accommodate arbitrary activity types, the system requires an essentially technology-agnostic architecture.

To address the associated long-term complexity and provide the flexibility and scalability needed, we propose a microservice architecture instead which decouples each activity into a separate service with its own database and technology stack scaling independently from others. This allows for efficiently handling any type of activity, as well as large variations in their popularity, i.e., easily scaling also with the changing demand for specific activities.

3.2 Front End/Tablet Application

The tablet application prototype is a native iOS app written entirely in the Swift programming language. It provides a minimal, yet intuitive user interface that focuses on the essential to support an effective learning experience, in particular with regard to exploration and collaboration aspects.

The central element is a map view where, aside from indicating the users' position, the different PoIs linked to the various activities are marked by pins with activity-specific symbols. These pins are colour-coded to reflect the activity status, e.g., blue (available), orange (ongoing), red (failed), green (completed), or grey (yet unavailable). Currently, Apple Maps data is employed in the background, but also alternative providers such as OpenStreetMap or Google Maps can be used for the map overlays.

Figure 2 comprises two screenshots of the application, showing part of the University of Luxembourg's Kirchberg campus with the available or ongoing activities. The navigation bar at the top and the tool bar at the bottom provide quick access to the history, the list of available activities and important settings.

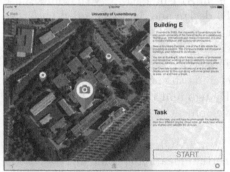 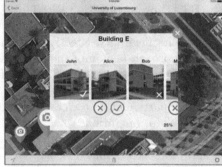

(a) Map screen with a selected PoI and an overview of the concomitant activity. (b) Master screen (aggregation step) of the collaborative image capturing activity.

Fig. 2. Exemplary screenshots of the native, iOS-based tablet application. (Color figure online)

In Fig. 2a, three different activities are available of which one – a collaborative image capturing activity symbolized by the camera icon – is selected. This is done by tapping on the respective pin, which is then enlarged while a semi-transparent view slides in from the right to reveal the details about the selected activity. A swipe gesture to the right clears the view and places the focus back on the map.

The screenshot in Fig. 2b shows the aggregation step of the collaborative image capturing activity, which is a hybrid of the framing and field recording activities introduced in Sect. 2.2. The users John, Alice, Bob etc. have all taken and transmitted their pictures of the E building from various assigned positions and angles around the structure, and now the head of the group validates or rejects the images before the activity can be completed.

In case of connection issues, the buffering techniques described in Sect. 2.3 are employed and the aggregation step is postponed. Generally, the ad-hoc communication is handled via the Multipeer Connectivity Framework, but also the web-based back-end solution can be utilized for synchronizing the data.

4 Related Approaches

Mobile, ubiquitous or pervasive learning have gained serious momentum with the ever-increasing number of smart mobile devices, and many corresponding approaches have been proposed in recent years. However, explicit collaboration aspects are mostly related to the creation of content for later playback and sharing, not to in-situ collaborative activities as part of an experience or narrative.

The Seek'N'Share [6] platform for collaborative mobile learning, for instance, superficially bears a resemblance to our framework, but there are fundamental differences in the underlying objectives and their implementation. Notably, it is less process- but submission-oriented; the individual learners gather material in single-user scenarios, and the actual collaboration concentrates on a final documentation step where the learning outcomes are summarized in a common presentation. As an entirely web-based platform, Seek'N'Share furthermore does not target offline or remote exploration scenarios.

The framework for locative media experience developed within the SHARC project[1] provides an offline mode for its SMEP player, but direct collaboration is also limited to the distributed authoring aspect [7].

Similar location-based educational narratives can be generated using platforms such as the University of Wisconsin-Madison's ARIS[2] or the Massachusetts Institute of Technology's TaleBlazer[3] which focus on augmented reality games.

Another recent platform that supports the collaborative authoring of location-based content is Wandering [8]. It allows for generating interactive learning objects which can, e.g., contain questions that need to be answered in writing or by sending an image related to that specific location, similar to the single-user variants of the quiz or field recording activities discussed in Sect. 2.2.

Elements of the collaborative activity types introduced there can be found in some less research-oriented or commercial products which are mostly non-educational games, i.e., serving entertainment purposes only.

Geocaching[4], while resembling a treasure hunt, already involves direct object interaction and trade going beyond standard capture-the-flag game semantics.

In particular Niantic Labs' alternate reality game Ingress[5] includes some interesting aspects with regard to object interaction. For instance, the players can link three virtual so-called portals together in order to create triangular fields and claim control over the resulting, fenced geographic region. Albeit based on a simple convex polygon, this mechanism is comparable to our framing activity.

[1] http://thesharcproject.wordpress.com/.
[2] http://www.arisgames.org/.
[3] http://www.taleblazer.org/.
[4] http://www.geocaching.com/.
[5] http://www.ingress.com/.

5 Conclusion and Perspectives

We have presented the CollaTrEx framework for collaborative context-aware mobile training and exploration, focusing on collaborative activities performed in situ for a more engaging educational experience.

The framework currently comprises an easily extendable web-based back end for the management and creation of the various activities, as well as a simple-to-use iOS-based client application prototype for tablets. To determine the available activities and provide a tailored experience, absolute and relative spatio-temporal context is employed. Furthermore, the CollaTrEx framework offers several buffering levels for seamlessness and an increased flexibility with regards to connection losses, in particular when in remote areas.

Aside from the obvious refining of features, such as providing enhanced tool support for editing and online supervision, different map extensions or additional activity types, there are various potential directions to develop CollaTrEx further. For example, while not the focus of the framework, integrating the explicit creation of learning materials is an interesting option. Also image recognition techniques, as employed in recent augmented reality systems [9], might be worthwhile for establishing an even finer-grained context.

References

1. Sampson, D.G., Zervas, P.: Context-aware adaptive and personalized mobile learning systems. In: Sampson, D.G., Isaias, P., Ifenthaler, D., Spector, J.M. (eds.) Ubiquitous and Mobile Learning in the Digital Age, pp. 3–17. Springer, New York (2013)
2. Brown, J.S., Collins, A., Duguid, P.: Situated cognition and the culture of learning. Educ. Res. 18(1), 32–42 (1989)
3. Lave, J., Wenger, E.: Situated Learning: Legitimate Peripheral Participation. Cambridge University Press, Cambridge (1991)
4. Vygotsky, L.S.: Mind in Society: The Development of Higher Psychological Processes. Harvard University Press, Cambridge (1978)
5. Vasilou, A., Economides, A.A.: Mobile collaborative learning using multicast MANETs. Int. J. Mobile Commun. 5(4), 423–444 (2007)
6. Heimonen, T., Turunen, M., Kangas, S., Pallos, T., Pekkala, P., Saarinen, S., Tiitinen, K., Keskinen, T., Luhtala, M., Koskinen, O., Okkonen, J., Raisamo, R.: Seek'N'Share: a platform for location-based collaborative mobile learning. In: 12th International Conference on Mobile and Ubiquitous Multimedia. ACM, New York (2013)
7. Cheverst, K., Do, T.V., Fitton, D.: Supporting the mobile in-situ authoring of locative media in rural places: design and expert evaluation of the SMAT app. Int. J. Handheld Comput. Res. 6(1), 1–19 (2015)
8. Barak, M., Ziv, S.: Wandering: a web-based platform for the creation of location-based interactive learning objects. Comput. Educ. 62, 159–170 (2013)
9. Dunleavy, M., Dede, C.: Augmented Reality teaching and learning. In: Spector, J.M., Merrill, M.D., Elen, J., Bishop, M.J. (eds.) Handbook of Research on Educational Communications and Technology, pp. 735–745. Springer, New York (2014)

Increasing the Perceived Camera Velocity in 3D Racing Games by Changing Camera Attributes

Kristoffer Lind Holm[1]([⊠]), Nicolai Skovhus[1], and Martin Kraus[2]

[1] School of Information and Communication Technology, Aalborg University,
Rendsburggade 14, 9000 Aalborg, Denmark
{klh12,nskovh11}@student.aau.dk
[2] Department of Architecture, Design, and Media Technology, Aalborg University,
Rendsburggade 14, 9000 Aalborg, Denmark
martin@create.aau.dk

Abstract. This study investigates how geometric field of view, motion blur and camera altitude can be utilized in 3D third-person racing games in order to increase the perceived velocity. Related studies have concluded that geometric field of view can be used to increase the perceived velocity and, based on subjective measurements, that motion blur has no effect on the perceived speed. This research objectively measures these effects along with the effect of different camera altitudes. The results show that increasing the geometric field of view significantly increases the perceived velocity. They also show that a strong setting of motion blur decreases the perceived velocity. Moreover, the results show that higher altitudes at high velocities increase the perceived speed.

Keywords: Perceived velocity · Geometric field of view · Game camera · Motion blur

1 Introduction

Nowadays, 3D games can have a multitude of camera effects incorporated in their design. Camera shake, field of view, lens flare, occlusion, bloom, as well as variations of blur and other types of distortion are all tools at the disposal and used by game developers today. Furthermore, in games that use a third-person view the developers can also physically move the camera to manipulate the player in various ways, as explained by Schramm [4]. Schramm further argues that these effects can be used both for the cinematographic effect that they carry, but also to strengthen the perceived motion. The latter effect can be used to create seemingly fast-paced games without having to increase the actual velocity, which would usually increase the difficulty.

Elements of motion blur and changes to the geometric field of view are both often seen in games that depend or draw on a notion of high speed gameplay or interaction. We investigated what effect these methods have in a third-person view. Additionally, in games that use a third-person view, the camera is remotely attached to the object that the player is controlling; thus, we also investigated whether altering the position of the camera has an effect on the perceived speed.

© ICST Institute for Computer Sciences, Social Informatics and Telecommunications Engineering 2017
A.L. Brooks and E. Brooks (Eds.): ArtsIT/DLI 2016, LNICST 196, pp. 121–128, 2017.
DOI: 10.1007/978-3-319-55834-9_14

We measure perceived speed by asking test participants to match a target velocity, which is shown with one setting of field of view, no motion blur and one setting of camera altitude by accelerating a sphere to this shown velocity while seeing the sphere with another setting of either field of view, motion blur or camera altitude.

2 Related Work

Mourant et al. [3] performed a study on users' estimation of speed in a real-world driving simulator, at three different geometric field of views (GFoV): 25, 55 and 85. Geometric field of view is the concept of moving the camera back or forth in accordance with the angle of field of view, so that the viewport stays the same at a certain distance [2]. Their study found that people overestimated the produced speeds, and that increased GFoV improved their perception. The study was based on the drivers' ability to estimate a defined speed, without having a shown target speed to refer to. Thus, the results were affected by the long-term memory of the participants.

Sharan et al. [5] studied players' experience of a racing game with simulated motion blur. Their study found that there was no significant difference in the players' experience of speed.

Banton et al.'s [1] experiment placed participants on a motorized treadmill set to a random speed and equipped them with a head-mounted display (n-vision Datavisor). The participants were tasked to signal if the treadmill had to go faster or slower to match the speed shown in the head-mounted display. The treadmill would then be increased or decreased in an increment of 0.5 mph. This study showed that participants set the speed too high when gazing forward. However, when gazing to the left or down, the speed was matched correctly.

In the previous studies, the research focus was not based on objective measurement of game-related speed perception. Mourant et al.'s study is based on a simulation of reality in first-person perspective, and while this study did find significant results, it is unclear whether the results also apply to video games that use a third-person view. Sharan et al.'s study found that motion blur had no significant effect on the perception of speed in a video game; however, this was measured subjectively. In our study perceived speed is measured objectively in a game environment that uses a third-person view in order to draw reliable conclusions for this kind of games.

3 Method

To measure the effect of different settings of GFoV, motion blur, and camera altitudes, a game simulation that uses a third-person camera has been created. The participants were shown a target speed with one camera setting. They were then asked to match this target speed using a different camera setting.

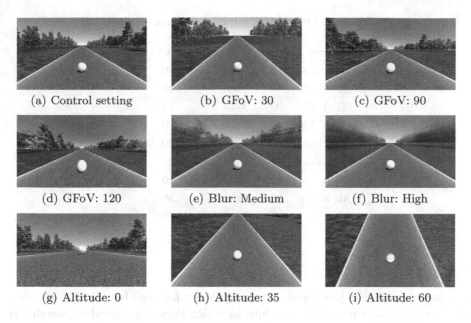

(a) Control setting (b) GFoV: 30 (c) GFoV: 90

(d) GFoV: 120 (e) Blur: Medium (f) Blur: High

(g) Altitude: 0 (h) Altitude: 35 (i) Altitude: 60

Fig. 1. All tested settings

3.1 Participants

Two tests were conducted with 20 participants for each test. The combined number of participants was 40, with 33 males and 7 females, of an average age of 21.2 years (SD: 2.21), the oldest being 31 years and the youngest 18 years.

3.2 Test Platform

The simulation was designed in Unity3D. The experiment was a simulation of a rolling sphere (see Fig. 1(a)). The participants were only able to change the forward velocity of the sphere (and camera). For this purpose, they were given a gamepad with analog buttons, making the changing of velocity easier. The sphere had no texture, but the environment had generated trees and grass for the purpose of optic flow, to aid the participant's perception of velocity. The environment was a straight road with a texture of asphalt, a terrain with grass close to the road, and trees further away. Every time the camera settings were changed by a facilitator (using a keyboard), the whole scene would be reloaded and the sphere was placed at a random position along the road. The simulation logged the participants' set velocity for every camera setting into a text-file. When testing, the simulation ran on a desktop PC, with a 22" full-HD screen and an Intel core i5 processor at 3.3 GHz. It was important to have a powerful desktop PC to perform the simulation without any frame-drop, because a low framerate could bias the participants' perception of velocity.

Table 1. Overview of variables for each setting.

Settings	GFoV	Motion blur	Altitude
Control	60	None	20
GFoV 30	30	None	20
GFoV 90	90	None	20
GFoV 120	120	None	20
MedBlur	60	Medium	20
HighBlur	60	High	20
Alt 0	60	None	0
Alt 35	60	None	35
Alt 60	60	None	60

3.3 Settings

The test showed each participant a target velocity followed by a setting of either GFoV, camera altitude or motion blur in which they were asked to match the shown target velocity. Each setting was used with a medium target velocity (30 m/s) and a higher target velocity (70 m/s). Table 1 shows all settings with their respective variables, as they were used in the test.

Control. The participants were always shown the target velocity, which they were supposed to match, using the control camera setting seen in Table 1 and shown in Fig. 1(a). These settings were chosen because they allowed for both decrements and increments to the settings. There was no motion blur on the control setting since motion blur can only be implemented as an incremental factor and it was not desired to have motion blur apparent in the settings for GFoV and altitude.

GFoV. Initially, only 30 and 90° were tested, which are shown in Fig. 1(b) and (c). For the second test it was decided to include a third setting at 120°, shown in Fig. 1(d). At lower or higher settings of GFoV the visual representation of the game simulation became too distorted. For these settings the distance between the controlled sphere and the camera was changed such that the sphere did not change in size.

Motion Blur. Figure 1(e) shows the implemented motion blur while Fig. 1(f) shows more extreme motion blur. Initially, only the extreme setting of motion blur was tested. While this did appear to have an effect, it seemed like it made the participants perceive the velocity as slower, contrary to what might be expected. This also stood in contrast to the results found by Sharan et al. [5] who observed no significant difference in the perceived speed when motion blur was applied.

Therefore, it was decided to implement a weaker variation of motion blur in the second test. For the test, the motion blur asset of Unity [6] was employed.

Altitude. Altitude measured in degrees describes the camera's altitude from the ground moving upwards around the controlled sphere, maintaining the same distance to the sphere. Figures 1(g), (h) and (i), shows altitudes of 0, 35, and 60°. The camera moves upwards, remaining completely behind the controlled sphere. The settings were tested in a simulation of a race-like game, thus it was decided not to test other camera-positions, e.g. side-ways views. Initially, only 0 and 60° were tested, however these settings left a wide gap between the target setting of 20° and 60°. As 60° appeared to have an effect, it was decided to test an additional setting of 35°.

3.4 Design and Procedure

The first test including the following settings: Control, GFoVs: 30 and 90, altitudes: 0 and 60 and extreme motion blur. The second test included: Control, GFoV: 120, altitude: 35 and both settings of motion blur. Both tests had participants match target velocities of 30 m/s and 70 m/s. The sequence of camera settings in which each participant was asked to match a velocity to the target velocity in the control settings, as well as the sequence of target velocities was always randomized.

The participants were shortly briefed about the test before starting the test. The short explanation described the task, the controls of the gamepad, the general procedure and minor details. The task was to match a target velocity which would either be 30 m/s or 70 m/s, and they could swap between the camera settings in which their chosen velocity was shown and the control setting in which the target velocity was shown. This swapping was performed twice for each tested camera setting. The short swap was controlled by the facilitator when signaled by the test participant. The participants were told that the acceleration which was controlled by the gamepad changed randomly throughout the whole test. Before each new camera setting they were asked to get a good feeling for the target velocity that they had to match first before changing to the camera setting in which they controlled the velocity. The process of swapping back and forth between the target speed and their estimation was implemented to ensure that the participants were able to reach the speed they perceptually felt was accurate, and not the speed they felt was correct based on memory.

After the task was finished, the participants were asked the following questions: age, possession of driver's license, experience in driving the last year, experience in video games and experience in racing games.

4 Results and Discussion

All graphs show the participant's estimated speeds, when matching a target velocity of either 30 m/s or 70 m/s, with the control setting, as described in Sect. 3.3.

Thus, the estimated speeds for 60° GFoV, no motion blur and 20° altitude used the same camera settings (the control settings) when showing the target velocity and when the participants chose a matching velocity. In this case, the estimated velocities are not significantly different from the target velocities, and they have the lowest standard deviation amongst all the collected data, indicating that the task of matching a presented velocity was possible for the participants.

The data has been analysed for variance, using a t-test with a confidence alpha level of 0.05. Due to the previous studies explained in Sect. 2 it will be assumed that GFoV will significantly increase the perceived velocity, leading to a one-tailed analysis while motion blur and altitude will be analysed as two-tailed, since no assumptions can be made. The t-test will analyse for variance from the target velocities of either 30 m/s or 70 m/s.

4.1 Results for GFoV

As suggested by the results of Mourant et al. [3] and Diels et al. [2], it was expected that changing the GFoV would also have an impact for the third-person view. The graph in Fig. 2(a) shows that participants would have a much higher estimated speed than the target with a GFoV of 30°. Thus the speed appeared slower. The results also show a high variance, indicating that the participants had a hard time estimating the speed with this camera setting.

For a GFoV setting of 90°, the estimated speeds drop below the target velocity. The variance also becomes smaller, when compared to the setting of 30°, showing that the participants had a higher degree of agreement regarding the estimated speed. The mean estimation when matching the velocity of 70 m/s was 35.1% lower, and 32% lower when matching the velocity of 30 m/s. A one-tailed t-test shows that the participants perceived a setting of 90 GFoV to be significantly faster than the control setting with 60 GFoV.

The results for the GFoV setting of 120° show that as the GFoV increases further, the effect also increases. The estimated mean values for the target velocity of 30 m/s is 54% lower and 59.9% for the target velocity of 70 m/s. They are also 32.4% and 38.1% lower, compared to the mean values of GFoV 90, indicating that the strength of the effect does not appear to diminish as the setting increases.

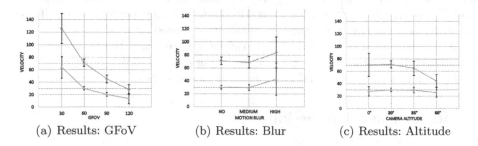

(a) Results: GFoV (b) Results: Blur (c) Results: Altitude

Fig. 2. Graphs of results

4.2 Results for Motion Blur

The results found by Sharan et al. [5] suggest that there was no significant effect of motion blur on the experience of speed. The graph in Fig. 2(b) shows that there is no significant difference between no motion blur and a medium setting of motion blur. However with a strong setting of motion blur, a two-tailed t-test shows that the estimated mean values are significantly higher than the target velocities showing that the participants perceived the speed as slower. When matching a target velocity of 70 m/s, the mean values of the estimated speeds are 19.6% higher and with a target velocity of 30 m/s they are 42.3% higher. This, along with the strongly increased variance in the estimated values shows that the participants had a difficult time perceiving the speeds, which many of the participants also stated during the test. The estimated values for the target velocity of 30 m/s was relatively higher than the estimated values for the target velocity of 70 m/s. This may indicate that in order to recognize movement when a strong setting of motion blur is applied the velocity needs to be higher than a certain limit.

4.3 Results for Altitude

The graph in Fig. 2(c) shows that the mean estimated velocities for 0° altitude are not significantly different from the target, but the variances are high, which indicates that the participants had difficulties estimating the correct velocity. The altitude of 35° did not have a significant difference when matching the target velocity. Relative to the average, participants set it 7.2% lower. For the altitude of 60° both target velocities are significantly different according to the two-tailed t-test. When matching the velocity of 30 m/s, the participants matched it 13.3% lower, and for the velocity of 70 m/s they matched it 36.4% lower. Thus indicating that the velocity at an the altitude setting of 60° was perceived significantly faster than the target velocity with an altitude of 20°. In Banton et al.'s [1] research, the perceived velocity for forward-gazing was slower than for downward-gazing which allowed for a more accurate perceived velocity of the simulation. In our test, the altitude of 60° corresponds to a downward gaze which agrees with the trend in Banton et al.'s research. When the altitude is set to 60°, the only optic flow is due to grass and the road while slow moving objects near the horizon are not visible. At a high velocity, the grass might move so fast that matching the target velocity becomes particularly difficult.

5 Conclusion

For the GFoV of 90 and 120° it can be concluded that the perceived velocity was significantly increased. Further, for a GFoV of 30° it can be concluded that the perceived velocity was significantly decreased. Thus, it can be concluded that increasing the GFoV can significantly increase the perceived velocity in a game with a third-person view. It cannot be concluded whether the effect will be lost

as the GFoV increases beyond 120, and the data did not show any signs of the effect diminishing as the GFoV was increased to this point.

For the medium setting of motion blur, the perceived velocity was not significantly increased. For the high setting the perceived velocity was significantly decreased. Thus, it can be concluded that motion blur does not significantly increase the perceived velocity in a 3D third-person game.

For the camera altitude, the setting of 60° can be concluded to significantly increase the perceived velocity. The data also shows that a setting of 35° altitude at the high target velocity had a tendency towards increased perceived velocity, however it had no significant effect at the lower target velocity. This suggests that the effect of a higher camera position may be more effective at higher velocities.

References

1. Banton, T., Stefanucci, J., Durgin, F.H., Fass, A., Proffit, D.: The perception of walking speed in a virtual environment. Presence Teleoperators Virtual Environ. **14**(4), 394–406 (2005)
2. Diels, C., Parkes, A.M.: Geometric field of view manipulations affect perceived speed in driving simulators. Adv. Transp. Stud. **12**(section B), 53–64 (2010)
3. Mourant, R.R., Ahmad, N., Jaeger, B.K., Lin, Y.: Optic flow and geometric field of view in a driving simulator display. Displays **28**, 145–149 (2007)
4. Schramm, J.: Project paper: analysis of third person cameras in current generation action games. Technical report, Uppsala University, Uppsala, Spring 2013. http://uu.diva-portal.org/smash/get/diva2:628121/FULLTEXT01.pdf. Accessed 15 Dec 2015
5. Sharan, L., Neo, Z.H., Mitchell, K., Hodgins, J.K.: Simulated motion blur does not improve player experience in racing game. In: Motion Games 2013, pp. 149–154 (2013)
6. Unity Technologies: Unity - manual: motion blur (2015). http://docs.unity3d.com/Manual/script-CameraMotionBlur.html. Accessed 15 Dec 2015

Assessment of Stand-Alone Displays for Time Management in a Creativity-Driven Learning Environment

Søren R. Frimodt-Møller[✉]

Department of Architecture, Design and Media Technology, Aalborg University Esbjerg,
Niels Bohrs Vej 8, 6700 Esbjerg, Denmark
sfm@create.aau.dk

Abstract. This paper considers the pros and cons of stand-alone displays, analog (e.g. billboards, blackboards, whiteboards, large pieces of paper etc.) as well as digital (e.g. large shared screens, digital whiteboards or similar), as tools for time management processes in a creativity-driven learning environment. A qualitative study was conducted at the Medialogy education at Aalborg University Esbjerg to probe for attitudes towards time management tools in general and towards having these on a stand-alone display in the workspace of students working in groups on joint projects. Results show that students who use a stand-alone display primarily use an analog one, whereas students who use digital collaborative time management tools prefer to access these on their individual laptops. The students who express preference for analog displays emphasize the advantage of being able to switch to a different modality for in-group discussions, as well as the increased awareness of the time plan caused by such a display. While these advantages would also be advantages for a digital, interactive display, the disadvantages of analog displays listed by the students relate to the fragility of these displays compared to storing information digitally. The findings could indicate a possible market for stand-alone, interactive digital displays combining the 'touch and feel' character of an analog board with the convenience of digital data storage.

Keywords: Time management tools · Digital vs. analog tools · Creativity-driven learning environment · Creative work practices · Workplace design

1 Introduction

This paper describes the findings of a preliminary study of the use of time management tools in the work of student project groups in the Medialogy education at Aalborg University in Esbjerg, Denmark. The focus of the study is the use or feasibility of stand-alone displays, digital (e.g. large shared screens, projections, digital whiteboards etc.) as well as analog (e.g. blackboards, billboards, large pieces of paper etc.), compared to time management tools that are only accessed via laptops, smartphones etc. or personal analog calendars.

Medialogy is an education in media technology with an emphasis on stakeholder-oriented as well as user-centered design processes [1]. The learning environment in the Medialogy education is creativity-driven: Students form groups each semester to work

© ICST Institute for Computer Sciences, Social Informatics and Telecommunications Engineering 2017
A.L. Brooks and E. Brooks (Eds.): ArtsIT/DLI 2016, LNICST 196, pp. 129–136, 2017.
DOI: 10.1007/978-3-319-55834-9_15

on projects of their own choice within a semester theme (semester themes include e.g. audiovisual experiments and interactive experiences among others), and this project work is both a creative process and a process of learning. The learning process associated with the project work is intertwined with the courses offered in a specific semester, all of which aim to support that semester's theme [2]. Consequently, the workflow of the student to some extent mirrors that of an employee in the creative industry, given that the work is focused on the development of a project within a given timeframe.

There seems to be important differences, however, between the Medialogy students and creative professionals in a commercial company, when it comes to time management: Firstly, as evidenced by case studies co-conducted by the author at LEGO® Future Lab in Billund, Denmark [3, 4] and the design company EOOS in Vienna, Austria [5, 6], time management among creative professionals is, to a large extent, handled by designated time planners such as project managers, secretaries and the like. In contrast, Medialogy students, out of necessity, have to handle the time management process on their own, switching between the roles of designer and project manager in often uneven patterns. Secondly, perhaps as a partial consequence of the former observation, there is a tendency among Medialogy students towards having time management tools physically present in the workplace as stand-alone setups (blackboards with writing on them, wall calendars etc.), whereas the public display of time management tools in the professional creative workplace tends to be scarce, instead leaving room for emphasis on ideation, idea development and inspirational items. [3–6] Although the case study described in this paper is relative to a learning environment, it will pave the way for a discussion of the advantages and disadvantages in general, for students as well as professionals, of having stand-alone displays for time management present in the workspace.

2 Qualitative Study of the Use of Time Management Tools Among Students in the Medialogy Education

During more than 4 years of teaching and supervision in the Medialogy education, the author has gathered a general, qualitative understanding of how the student project groups manage their time. Up until 2015, the majority of project groups used a form of time management tool, which was either purely physical, e.g. a plan written on a blackboard, or had a physical counterpart, e.g. printouts of GANTT diagrams or similar, hung up in the working area of the group. However, it has not been clear whether this was simply due to the fact that students during their first semester were encouraged by supervisors to use such publically displayed time plans. Since mid-2015, various logistical obstacles have forced the Medialogy students to share workspaces using analog reservation systems. Many students also choose to work ad hoc in corridors, the library etc. Given that the students have to be more flexible with respect to the physical setup of their daily work, their choice of time management tools becomes even more interesting to probe.

2.1 Method

For this study, a questionnaire was created in Google Forms [7] and posted on two facebook groups directed at Medialogy students from Aalborg University Esbjerg. The questionnaire had a total of 9 questions, but used a branching structure that lead users quickly past questions that were rendered irrelevant by a previous response. As of the submission of this paper, 23 students (out of the 79 students currently enrolled in the education in Esbjerg) spanning 8–14 project groups (6 respondents did not know their official group no.) completed the questionnaire. The students were mostly male, with only 3 female respondents (a spread, which is actually representative of the general male to female ratio among the students). The average age of the students was 24 with a standard deviation of 2.5, the mode age being 25 and median age 23. The youngest respondents were on their 4th semester, whereas at least 8 respondents were 10th semester students (one respondent did not indicate a semester).

The questionnaire used a combination of closed and open questions, the closed ones mainly used either to collect demographics about the users, or to define which branch of the questionnaire the user would be lead through. As this was meant as a qualitative study, emphasis was put on responses to the open questions. In keeping with this, the following subsections are organized according to the topics of the open questions. The quantitative results can, however, be quickly recapped: In addition to the demographic data gathered, 18 out of the 23 respondents answered yes to the question "Do you presently use a type of formalized time management, broadly understood, in your project work (as opposed to just "going with the flow")? (Examples could be a calendar, GANTT charts, software or another type of planning tool.)" 33,3% of the respondents indicated that the time management tools they used included both analog and digital ones, whereas 38,9% used digital tools only and 27,8% analog tools only for time management. All the respondents who used analog time management tools, whether in combination with digital ones or not, had these on public display in their working area (as opposed to working with e.g. private physical calendars and notebooks).

2.2 Sharing of Information from Digital Time Management Tools

With respect to the use of digital time management tools, the picture is a lot different. The respondents who used both digital and analog time management tools did not have a public display of their digital time management, e.g. a large external screen or frequent printouts put up on a billboard. This was somewhat unsurprising, given that one would expect the analog, publically displayed time plan to fill the role of enhancing time plan awareness in the workspace, thus making a similar public display of a digital time management tool unnecessary. What was interesting, however, was that for the respondents who *only* used digital time management tools, these tools were only accessed via the individual students' computers, smartphones etc., not displayed publically. The questionnaire did not contain questions regarding where the respondents typically would sit and work, so it is unclear whether the groups who only use digital time management tools do so because of the lack of wall space, because they often work asynchronously, or for other reasons.

It is, however, interesting to look at the type of digital tools used for time management: Respondents representing 5 different project groups used Google Docs for sharing of time plan information, three groups in combination with commercial project collaboration platforms, namely Teamweek [8] (one group) and Slack [9] (two groups), whereas others used a combination of Google Docs, Google Calendar (for coordinating schedules) and e-mail. One group also mentioned using facebook in combination with Google Docs and Teamweek. Two project groups specifically referred to Google Drive, and not Google Docs for sharing information, which might indicate sharing of time plan information in other file formats via shared folders. One group referred to Google Calendar in isolation as the platform of choice for sharing time plan information. Whereas sharing of information from the aforementioned Google tools could easily be envisioned in a (at least temporarily) static, public format (printouts etc.), other more social network-like platforms, such as the aforementioned Teamweek and Slack, but also Jira [10] and Trello [11] (both mentioned by one group), have formats that seem to afford more active, individualized forms of engagement on behalf of the individual user. I.e., as one would do on facebook, the user is inspired to skim, scroll, go in and out of menus, and move the view around in uneven patterns. It is tempting to hypothesize that students who only work with digital time management tools, regardless of type, prefer to access these via their own machines, exactly because they can control how they view the used platform at any given time. I.e. they may simply have become accustomed to the convenient adaptability of the software to their individual cognitive needs in the situation. If this is the case, it does not bode well for the feasibility of a public digital display for time management, unless this is designed as an actual supplement to the 'individually accessed' time management tools, and not as a mere duplicate of these.

2.3 Pros and Cons of Stand-Alone Time Management Tools as Listed by Medialogy Students

In addition to the questions about their use of analog or digital time management tools, the students were asked the two open questions,

> Think of two scenarios: One where you have your project plan on public display in your working area, and one where you do not. How would you characterize the pros and cons of having a project plan on public display in your working area? Please write a few notes below.

and

> And conversely, if you haven't already answered this above, how would you characterize the pros and cons of not having a project plan on public display in your working area? Please write a few notes below.

Via a content analysis of the student responses [12] to these questions, the following themes were identified.

Awareness via Visibility. The majority of respondents (10 out of the 18 who had answered the first question above) saw it as an advantage of having a publically displayed time plan in the workspace that it improved awareness of the time plan among group members. At the same time, however, 6 respondents saw this as a potential disadvantage,

given that having the time plan visible all the time could lead to stress in situations where it would be preferable to focus on the work to be done. The following statements are representative of both points of view:

> Pro: having the plan in public should be an additional incentive to work harder to stay on schedule. Con: if for some reason you are behind schedule, everyone can see that and make you feel uncomfortable. (23 years old male student, 10th semester)

> Plan on a public display can remind and motivate me to stick with a schedule while I am on my free time, but when I am in a working process I see a need to remove it, because it distracts me and makes me think of all the other stuff I need to do. (22 years old female student, 6th semester)

As mentioned above in the introduction, professional workplaces in the creative industries tend to use designated time management responsible such as project managers, secretaries etc., yet one could easily imagine a scenario where the time management responsible took special care to integrate information on the time plan in the office in a visually salient way, exactly to evoke a stronger consciousness of time constraints among the designers. Whether the reason why this does not happen to a larger extent (other than the occasional small GANTT chart as part of a larger billboard) is due to a preference for digital tools over analog ones among the designated time management responsible (as documented in [3, 5]), is an open question.

Collective vs. Individual Planning. Supporting the hypothesis that some students might prefer to use time management tools on their individual devices due to the adaptive nature of the interface, two respondents commented on the lack of this trait in a publically displayed, and collectively edited, time plan:

> Not everyone in the team has the exact same personal workflow, the time plan could contain too much or too little information to be relevant for everyone when it's displayed publicly. (23 years old male student, 10th semester)

> Having a private one allows me to use my own shortened terms and keywords as opposed to having to make it explicit for others. (25 years old female student, 10th semester)

Similarly, collective vs. individual planning can be considered an issue when it comes to the flexibility of the public display, or lack thereof – i.e. the fact that a public display is location-specific:

> Pro: Sometimes it can be nice to have something physical instead of only digital, so that you can walk around and talk about it. Con: If you only have a physical board/calendar, you can only check out the schedule when you're physically present in the room. (26 years old male student, 10[th] semester)

> We have som[e]times used a timeline on a board, and it's easier to follow what needs to be done, and when it needs to be done. But only when you are currently in the group room. So you need to have data on a mobile platform to follow it when you are not in the group room. (28 years old male student, 4[th] semester)

It should be noted that these two comments clearly identify a public display with an analog one, which is not remotely editable. Having a digital display with remote access might remove exactly this problem. On the other hand, as suggested above in the short review of digital tools used by the students, the success of such a display would be highly dependent on the look and feel of the utilized digital platform.

Lastly, related to this theme, is the issue of privacy, not only between the individual group members, but also between two or more groups sharing the same workspace. At least one student commented that one might not always want other groups to be able to spy on what one's own group is doing.

Analog vs. Digital Tools. As indicated above, some students, in fact the majority, tend to identify the idea of a public display with that of an analog display, e.g. a blackboard, whiteboard, billboard etc., and so some of their answers with respect to the disadvantages of public displays are in fact comments on the disadvantages of analog tools. Disadvantages in this context concern limits in terms of capacity (i.e. an analog info board can only hold so much information), limits in terms of tracking the work process (as an analog display does not have a tracking history), a more tedious update procedure for analog displays than for digital ones, and also the more fragile nature of the analog display compared to cloud- or otherwise web-based time management platforms (i.e. information is less likely to get lost in the latter.) On the other hand, an advantage listed by the students of analog tools over digital ones is the stability in terms of not having to rely on an Internet connection.

Tangibility. Identifying a public display with an analog one also leads the students to praise public displays for their tangibility and related affordances for multimodal editing:

> [...] it's (arguably) easier/more pleasant to move some post-its around than open some cloud storage document and modify rows/columns in an Excel document (which is what I consider a project plan not on public display). (20 years old male student, 4th semester)

> The tangibility of having it [= the analog display] tied to the work place and being able to touch and alter it in the real world is definitely a pro. (25 years old male student, 10th semester)

The students, however, also relate tangibility to the general affordances for getting up in front of the public display and explain something, as witnessed by the comment in connection with the theme of collective vs. individual planning that "sometimes it can be nice to have something physical instead of only digital, so that you can walk around and talk about it" (see above). This type of 'tangibility' is obviously not specific to analog displays, but can also be imagined compatible with e.g. digital whiteboards. (Indeed tests done within the EU-funded research project IdeaGarden [13], which the author has been part of, show that it is.)

Spatial Integration in the Workspace. A theme, which also easily relates to both analog and digital public displays, is how to integrate said display in the physical workspace:

> Con: It might take up valuable space. Though that is dependent on the workspace itself; you might not have the room, or the room is already used for something else. (23 years old male student, 4th semester)

In addition to this more practical issue, making the display part of the surroundings may risk leading to a loss of salience over time:

> [The public display is] more visible, but may be overlooked, if people are used to it being there (30 years old male student, 10th semester)

The latter, however, seems to be dependent on how much the students actively involve the display in their daily work: Frequent use of the display should help maintain its salience.

3 Tentative Conclusions and Further Perspectives

The external validity of the findings in this study is limited by the sample size, but a few tentative conclusions seem to be supported by results from the case study co-conducted by the author at LEGO® Future Lab:

Firstly, tangibility and a modality separate from work at an individual computer seem to be key elements a successful stand-alone display of a time plan can provide to engage the user. The general preference for analog tools over digital ones in the work process of designers at LEGO® Future Lab (as documented in [3, 5, 6]) was exactly grounded on a need for tangibility and free physical movement in the creative work process, a pattern echoed in how some Medialogy students articulate their preferences for analog stand-alone displays.

Secondly, it is still an unfamiliar idea for many students as well as creative professionals that a digital stand-alone display can afford the type of alternate modality for interaction sought after when taking a break from one's own computer. In user tests conducted at LEGO® Future Lab as part of the IdeaGarden project [13] of an interactive, projection-based wall, controlled via (among other possible tools) digital pens or remote access, the main obstacle was impeded accessibility: Because it took too long to start up the prototype and climb the learning curve of the system, many designers chose to use their usual tools for collaborative meetings (post-its etc.) instead. Those who did use the system, however, returned to it on a more regular basis. Given that Medialogy students did not consider the possibility of a digital stand-alone display serving the same purpose as an analog one, it is a subject for further studies, whether students would embrace a digital stand-alone display affording macro-gestural interaction (i.e. similar to the gestural patterns of a generic pen-and-post-it-based or blackboard-based work session).

Thirdly, developers of a platform suited for a digital stand-alone display face several challenges related to interface design: Many existing time management tools with access via a private device inspire the user to modify them to suit his or her own working style. A stand-alone display will either have to be similarly adaptive to the present user – at the risk of losing its role of providing clear, quickly readable visual markers in the joint workspace – or to some extent mimic the alternate modality offered by an analog tool such as a billboard. Finally, as some of the main incitements for having a digital tool rather than an analog one are the possibilities of remote updates and integration of elements produced on private devices, another challenge is making these features work seamlessly with the software interfaces on those devices.

References

1. Aalborg University: Website description of the Medialogy Program (2016). http://www.en.aau.dk/education/bachelor/medialogy. Accessed 25 Mar 2016
2. Aalborg University, School of Information and Communication Technology (SICT) and Study Board for Media Technology: Curriculum for the Bachelor's program in Medialogy (2014). http://www.sict.aau.dk/digitalAssets/101/101063_91650_bsc-medialogi-2014.pdf. Accessed 25 Mar 2016
3. Borum, N., Brooks, E.P., Frimodt-Møller, S.R.: The resilience of analog tools in creative work practices: a case study of LEGO future lab's team in Billund. In: Kurosu, M. (ed.) HCI 2014. LNCS, vol. 8510, pp. 23–34. Springer, Heidelberg (2014). doi:10.1007/978-3-319-07233-3_3
4. Frimodt-Møller, S.R., Borum, N., Brooks, E.P., Gao, Y.: Possible strategies for facilitating the exchange of tacit knowledge in a team of creative professionals. In: Yamamoto, S. (ed.) HCI 2015. LNCS, vol. 9173, pp. 467–475. Springer, Heidelberg (2015). doi: 10.1007/978-3-319-20618-9_47
5. Richter, C., Frimodt-Møller, S.R., Borum, N., Allert, H., Lembke, J., Ruhl, E.: D 2.2 Case-study report on visual knowledge practices (version 1). Public deliverable submitted to the European Commission on 30 September 2013 (2013). http://idea-garden.org/wp-content/uploads/publicarea/IdeaGarden-318552-D2.2-v1.pdf Accessed 25 Mar 2016
6. Richter, C., Allert, H., Albrecht, J., Ruhl, E., Frimodt-Møller, S. R., Petersson, E., Borum, N.: D 2.5 Case-study report on visual knowledge practices (version 2). Public deliverable submitted to the European Commission on 10 September 2015 (2015). http://idea-garden.org/wp-content/uploads/publicarea/IdeaGarden-318552-D2.5-v1.0.pdf. Accessed 25 Mar 2016
7. Google Forms: "About" page for Google Forms (2016). https://www.google.com/forms/about/. Accessed 25 Mar 2016
8. Teamweek: Website for the Teamweek application. URL: https://teamweek.com. Accessed 25 Mar 2016
9. Slack: "Product" page for the Slack application (2016). https://slack.com/is. Accessed 25 Mar 2016
10. Atlassian: Website for the Jira software development tool for teams (2016). https://www.atlassian.com/software/jira. Accessed 25 Mar 2016
11. Trello: Website for the Trello platform (2016). https://trello.com. Accessed 25 Mar 2016
12. Kumar, R.: Research Methodology: A Step-by-Step Guide for Beginners. Sage Publications, pp. 277–288 (2011)
13. Richter, C., Allert, H., Ruhl, E., Albrecht, J., Georgis, C., Bekiari, C., Chrysakis, I., Perteneder, F., Zimmerli, C., Frimodt-Møller, S.R., Brooks, E.P., Silva, E.: D 8.4 Evaluation Report (version 2). Public deliverable submitted to the European Commission on 10 July 2015 (2015). http://idea-garden.org/wp-content/uploads/publicarea/IdeaGarden-318552-D8.4-v1.0.pdf. Accessed 25 Mar 2016. See especially the evaluation of the first demonstrator, pp. 18–22

Sandtime: A Tangible Interaction Featured Gaming Installation to Encourage Social Interaction Among Children

Chulin Yang[✉] and Stephen Jia Wang

Department of Design, Faculty of Art Design and Architecture, Monash University,
Melbourne 3145, Australia
chlyang1992@gmail.com

Abstract. From the study of social-interaction enhanced gaming design, aimed at providing a public environment which supports tangible & social interactions among children, we designed *Sandtime*. *Sandtime* is a public installation designed to encourage such interaction. Using the Tangible Interaction Design approach, this gaming installation features collaborative play and social interactions under public context, where children can collaboratively interact with the virtual in-screen characters by manipulating physical objects. This design is based on the study of how interactive gaming facilities can help to ease anxiety and enhance social interactions among children. In this paper, we want to continue this line of research by exploring further the elements that can enhance such interaction experience. This paper focuses specifically on sensory play and how it can help to facilitate social interaction.

Keywords: Sensory play · Tangible interaction · Social anxiety

1 Introduction

Anxiety disorders in young people are one of the most common forms of psychopathology and it was estimated that 13% of children and teens have anxiety disorders [1]. In terms of emotional functioning, children with high levels of social anxiety occasionally perceive themselves as less socially accepted compared with their less anxious counterparts, becoming socially avoidant and inhibited [2].

In our previous research, we developed a prototype using multi-touch technology to illustrate how interactive group play can help to facilitate social interaction among children [3]. Nevertheless, there are limitations, as researchers claimed that many problems emerge when multi-touch devices are used by very young children in that their fine motor skills are not sufficiently developed [4]. To explore more possibilities in this line of research, in this paper, we present *Sandtime*, a hybrid facility combining digital screen and conventional physical manipulation that allows interactive and collaborative play. In particular, we concentrate on sensory tools for interaction that guide the user to explore and collaborate in a relatively natural way. We also describe the overall design of *Sandtime*.

© ICST Institute for Computer Sciences, Social Informatics and Telecommunications Engineering 2017
A.L. Brooks and E. Brooks (Eds.): ArtsIT/DLI 2016, LNICST 196, pp. 137–144, 2017.
DOI: 10.1007/978-3-319-55834-9_16

Sensory play has the potential to encourage connection among children since tangible sensory feedback aids imitation and cooperation [5]. Yet considering the overall design goal of this project, for those who tend to be anxious and emotionally inhibited [6], it is reasonable to provide more interaction possibilities so as to lower their access thresholds. In our previous design Seesaw, we focused on the elements that may facilitate social interaction, such as big screen and story-telling elements. Then consider-ing constraints on children's ability to manipulate touch devices [4], in the design of *Sand-time*, we wanted to involve more sensory elements to see if physical object and big screen can cooperate to provide a better user experience [7].

We start our study with a survey of existing games related to tangible interaction, in order to see how these games actually transpose tangible interaction concept into social interactions. Comparing different theories about tangible interaction design, Eva Hornecker's research provides insight for social aspects of tangible interaction which includes four mainstream themes as 'Tangible Manipulation', 'Spatial Interaction', 'Embodied Facilitation' and 'Expressive Representation' [8]. Since this analysis provides a fundamental understanding of social interaction as our major goal in the project, we conducted the case study based on her theory [Table 1].

Table 1. Case study based on Tangible Interaction Framework

	Tangible Manipulation (TM)			Spatial Interaction (SI)					Embodied Facilitation (EF)			Expressive Representation (ER)		
	a	b	c	d	e	f	g	h	i	j	k	l	m	n
Climbing Wall (traditional)	√			√		√								
Imsound (2011)	√	√		√					√				√	√
Lite Brite: Super-Sized (2010)	√	√	√				√	√			√			√

(a) Haptic Direct Manipulation; (b) Lightweight Interaction; (c) Isomorph Effects; (d) Inhabited Space; (e) Configurable Materials; (f) Full-Body Interaction; (g) Non-fragmented Visibility; (h) Performative Action; (i) Embodied Constraints; (j) Multiple Access Points; (k) Tailored Representation; (l) Representational significance; (m) Externalization; (n) Perceived Coupling

Traditionally, children's gaming products such as Climbing Wall and Ball Pond encourage tangible interaction by providing space for Spatial Interaction (SI) and physical material for Tangible Manipulation (TM), and children can interact mainly with body movement (SI). However, in the play process, children have the freedom to play as they wish, so their behavior is not directed by the product for Embodied Facilitation (EF), which decreases their motivation to collaborate (EF). Therefore, we assume that more elements are still needed for traditional games to serve as a tool to develop social interaction.

With the flourishing of technology, some new products appear to provide more unique gaming experiences for children (Fig. 1). Imsound enables children to manipulate the light by body movement (TM). The full-body interaction (SI) forms an essential part of this experience. This design is directing the group behavior by guiding them to interact with the light (EF), yet none of the lights in this system are connected with the others, which may lessen the interaction opportunity (EF) among children.

Lite Brite: Super-Sized, inspired by a traditional children toy, creates a big screen for children to create patterns (TM). During the playing process, children can arrange the color pen and display pattern on the screen (ER). Nevertheless, although the sheer size of the screen provides possibilities for group behavior (EF), without a central goal or main focus (EF), users may not feel compelled to collaborate. And for those who feel anxious, it is possible that they will stay in a corner and play by themselves.

Fig. 1. (a) (left) Children playing with Climbing Wall, (b) (middle) Playing environment of Imsound, (c) (right) The usage of Lite Brite: Super-Sized

2 Design Rationale

Sensory-rich play is an inclusive way of encouraging problem solving, exploration and development, as the hands-on approach appeals to children with different thinking and learning styles [9]. Research has also showed that sensory integration techniques can help kids cope with overwhelming feelings by normalizing their feelings and behaviors [10].

When children are undergoing a sensory experience, there is a connection between neuro system and behavior; with tangible manipulation, they develop an understanding towards life [11]. It is also proved that configuration of material objects affect social interaction by subtly directing group behaviour, reinforcing social relations and group learning [8]. Each time a child encounters a sensory stimulus, they will develop nerve connections created from their own sensory experiences, which means that the richer their sensory experiences the stronger will be the patterns for learning, thought and creativity [9].

Since this project aims to develop interaction among children who tend to develop social anxiety, we also need to consider whether sensory play can cater for the requirements of this typical user group. It is argued that expanding tabletop applications with tangible interaction can make computers accessible to children with cerebral palsy and children with social disorders [4]. And tangible interaction has proved to have a positive effect for both normal children and children with cognitive disabilities [6]. Based on the research mentioned above, it is possible for us to assume the potential for sensory play to facilitate social interaction among anxious children. In the next section, we will present the design of *Sandtime* to further illustrate this point.

3 The Overall Design of *Sandtime*

The design of an interactive tool for children is meant to be straightforward and easy to understand. In our previous design, we symbolized a playground game "Seesaw" using touch devices for children to interact (Fig. 2).

We developed *Sandtime* based on the research of Seesaw [3], with a special focus on social aspects in sensory play, to see more design possibilities in this research spectrum. From the design of Seesaw, we have learned the characteristics and requirements of social anxiety for children, and discovered the potential for developing their social connection with public interactive installations. The overall understanding of the relevant technological potentials and limitations provides the prerequisites for the design of *Sandtime*.

Based on sensory play theory, we analyzed different elements in sensory play (Table 2) and incorporated them into this project.

Table 2. Examples of sensory-rich play

Common elements for sensory-rich play	
Sand	Leaves, twigs, moss etc.
Water, bubbles, ice	Shaving foam, gloop, paint
Pepples and shells	Mud
A basket of household objects	String, fabric, buttons etc.
Pastry, playdough, plasticine etc.	Dried rice, pasta, lentils, seeds etc.

Sandtime consists of three main components namely a sand tub, a projection screen and a computer center as shown in Fig. 3. In this system, the major medium for children to interact with is sand. Whenever the children pour the sand into a funnel, they can gain immediate feedback from the screen.

Fig. 2. Phototype of *Seesaw* **Fig. 3.** Using of *Sandtime*

3.1 Interaction Approaches

Given time, children discover through their own independent learning that sand poured into a funnel will naturally flow through the holes. Besides, this system encourages players to not just interact with the screen, but also discover the "gaming themes" in the sand. Each gaming theme is attached to a physical component, which is buried in the

sand tub, waiting for the users to discover. We try to incorporate the feature of sensory play into the discovering process, enabling children to feel the texture of the sand then gradually emerge themselves into the environment. The whole playing process symbolizes children's playing experience by the ocean. In this process, we try to create a sensory-rich environment which has the potential to encourage learning, exploration and creativity [9], so that the whole system is accessible and easy to operate for children.

3.2 Sensory Input Enrichment

When children pour the sand into funnel, they can see the particle pattern generating on the screen. This process presents the transformation between tactile and visual sense, which is two of the major senses for children (Table 2). From this process, we want to create the linkage between different senses so as to strengthen sensory simulation for children, thus their action and motor responses can be developed [9], providing the prerequisite for learning, thought and creativity activities.

Table 3. Different senses

External senses	Internal senses
Visual(sight)	Vestibular(balance)
Olfactory(smell)	Proprioceptive(position in space)
Auditory(sound)	Kinaesthetic(movement)
Tactile(touch)	Baric(weight)
Gustatory(taste)	Thermic(temperature)

To further enrich and vary sensory simulation in *Sandtime*, we present different storylines and different gaming scenarios (Table 4). Take Snowman storylines as an example, children can pour the sand to generate a snowman on the screen. Each of the scenarios provides various sensory elements for users, which is correspond with the core elements in sensory-rich play (Table 3).

Table 4. Different storylines in *Sandtime*

Storyline	Sensory input	Elements for sensory output
Life of a tree	sand(Tactile)	leaves, birds
Saving the whale		bubbles, water
Snowman		snow, accessories for snowman

Children in anxious state tend to be socially avoidant and emotionally distracted [12]. Neuroscientists have identified a strong link between memory recollections and sensory elements such as sight, smell and touch senses [9], which have the potential to draw children's attention and help maintain focus [5]. By playing in the sand and experiencing various storylines, children develop the possibility to recollect the time when they were playing in the beach, which may help them to focus and ease anxious feelings.

3.3 Collaborative and Competitive Behavior

Through the playing with sand, children share the same physical object and feel their fellow players' presence, which makes it easier to establish joint attention [5]. Yet to develop for children in anxious state, it is reasonable to provide more interaction chances in this system.

Sandtime also encourages children to collaborate and compete. The two users who are next to each other can pour the sand together to create a new object (Fig. 3). For instance, in The life of a tree, they can create a bird, which will fly actively onto the tree. And at the same time, the two players can cooperate to compete with the other groups.

During the collaborative and competitive process, children are connected with each other physically and emotionally, focusing on the same task. Since it is said that attention control condition would facilitate untrained positive or neutral social behaviors as well as peer acceptance, we assume this design will further develop the social interaction between children and their counterparts.

3.4 Implementation

Technically, we use arduino to build the connection between projection screen and physical object (Fig. 4). An Actionscript 3.0 (AS3) program is run on the computer, and connected to a digital screen, or projected on the wall. The sand funnel is set in front of the screen. Inside the funnel, we have inserted an arduino board and sensors. When users pour the sand into the funnel, the data in the arduino board will change and synchronize with AS3 program. Then the users can see that the physical object is transformed into a visual pattern on the screen.

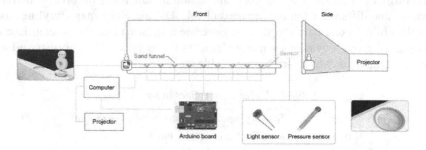

Fig. 4. System structure of *Sandtime*

The flowing speed of particles is consistent with natural objects, which is controlled by the following algorithm:

```
tempParticle.x = (target1.x - target1.width/8) +
(Math.random()*target1.width/2);
tempParticle.y = (target1.y - target1.height/8) +
(Math.random() * target1.height/2);
```

When the particles are generated, the start point and the end point have already been set, so the particles will flow towards a certain area on the screen.

To further mimic the actual particle effect, we use the laws of physics to vary the direction and rate of particle speed. Naturally, there will be friction and gravity restricting the speed of an object, so we also try to imitate this notion by gradually decrease the speed.

```
tempParticle.rotation = Math.random()*360;
tempParticle.rot = Math.atan2(target1.y - target2.y, tar-
get1.x - target2.x);

tempParticle.xSpeed = Math.cos(tempParticle.rot) * radi-
ans / particleSpeed;
tempParticle.ySpeed = Math.sin(tempParticle.rot) * radi-
ans / particleSpeed;
```

Another element that we try to mimic is viscosity. When the particles come close to the end point, the speed will become zero, making it stick temporarily to that position. As the speed keeps increasing, the particle will move again after a while.

```
if(tempParticle.hitTestObject(target))
{
  tempParticle.xSpeed=0;
  tempParticle.ySpeed=0;
}
```

4 Discussion and Future Work

In this paper, we have described the architecture and development of an interactive system. We have explored and investigated the possibilities of incorporating tangible elements into the system to facilitate collaborative behaviors. The system is expected to become an effective tool for children to build connection since it provides rich sensory information.

For our future work, we are looking forward to improve *Sandtime*, such as by creating more storylines and conducting concrete evaluations.

Following are some possible directions for further development, given that research has proved the positive influence of gaming complexity for children. It is said that games including levels or parts that have different degrees of difficulty can facilitate engagement among the children [13]. Yet what we also concerned with is how to enrich the gaming experience without affecting the group playing experience. Children prefer switching games frequently when they played alone, but they do not switch among games as much when they are in a group [13]. So we may need to further consider the balance between system complexity and children group engagement.

In this paper we presented a sensory facility for children to interact, yet what we are still not sure of is whether this design is a superior option for children to choose,

compared with touch devices. To further examine the usability of *Sandtime*, we may need to develop another prototype, getting rid of tangible elements for further evaluation. What we are interested in is the added value provided by tangible elements, and how those elements can affect children's behavior.

References

1. Sensory Integration activities to help kids with fear and anxiety. http://www.examiner.com/article/sensory-integration-activities-to-help-kids-with-fear-and-anxiety
2. Ginsburg, G.S., La Greca, A.M., Silverman, W.K.: Social anxiety in children with anxiety disorders: relation with social and emotional functioning. J. Abnorm. Child Psychol. **26**(3), 175–185 (1998)
3. Yang, C., Wang, S.J.: Seesaw: an interactive display to facilitate social interaction. Procedia Technology **20**, 104–110 (2015)
4. Marco, J., Cerezo, E., Baldassarri, S.: Bringing tabletop technology to all: evaluating a tangible farm game with kindergarten and special needs children. Pers. Ubiquit. Comput. **17**(8), 1577–1591 (2013)
5. Dsouza, A., Barretto, M., Raman, V.: Uncommon sense: interactive sensory toys that encourage social interaction among children with autism. In: Workshop paper presented at IDC, p. 12 (2010)
6. Hengeveld, B., Voort, R., van Balkom, H., Hummels, C., de Moor, J.: Designing for diversity: developing complex adaptive tangible products. In: Proceedings of the 1st international conference on Tangible and embedded interaction, pp. 155–158. ACM (2007)
7. Wang, S.J.: Fields Interaction Design (FID): The Answer to Ubiquitous Computing Supported Environments in the Post-Information Age. Homa & Sekey Books, Paramus (2013)
8. Hornecker, E.: A design theme for tangible interaction: embodied facilitation. In: Gellersen, H., Schmidt, K., Beaudouin-Lafon, M., Mackay, W. (eds.) ECSCW 2005. Springer, Dordrecht (2005)
9. Gasgoyne, S.: Sensory Play: Play in the Eyfs, vol. 1. Andrews UK Limited (2012)
10. What is sensory integration and how can it help. http://www.examiner.com/article/what-is-sensory-integration-and-how-can-it-help-my-child
11. Dunn, W.: The impact of sensory processing abilities on the daily lives of young children and their families: a conceptual model. Infants Young Child. **9**(4), 23–35 (1997)
12. Jean Ayres, A., Robbins, J.: Sensory Integration and the Child: Understanding Hidden Sensory Challenges: Western Psychological Services (2005)
13. Inal, Y., Cagiltay, K.: Flow experiences of children in an interactive social game environment. Br. J. Educ. Technol. **38**(3), 455–464 (2007)

The Imitation Game to Cultural Heritage: A Human-like Interaction Driven Approach for Supporting Art Recreation

Fiammetta Marulli[1(✉)] and Luca Vallifuoco[2]

[1] DIETI, University of Naples Federico II, Naples, Italy
fiammetta.marulli@unina.it
[2] MoonRiver Graphic Art Studio, Naples, Italy
luca.vallifuoco@live.it

Abstract. Smart IoT technologies set a milestone in supporting new enjoyment models for Art and Cultural Heritage, providing amazing technological experiences. However, users, while interacting almost purely by mediation of smart devices or augmented VR displays, practically keep themselves out from living the fullness of the surrounding cultural sites experience, establishing no direct dialogues or interactions with artworks. It sounds quite like to be in the living-room, looking at very appealing documentaries, equipped with exciting smart technologies. This paper focuses on the importance of "re-humanize" art recreation models, proposing a human-like interaction driven approach. Holographic projections, reproducing human or fantasy characters, play the human presence imitation game, when users are detected close to any artwork, interacting and dialoguing with them in natural language. An IoT infrastructure, an NLP platform and a Holographic Projection Engine implement a system for supporting holographic projections. Preliminary experiments were promising, thus motivating authors to further investigations.

Keywords: Cultural Heritage · Art recreation paradigms and models · Human-centered computing · Natural language interfaces · Natural Language Processing · Speech recognition · Holographic simulations · Internet of Things · Smart environments

1 Introduction and Related Works

Current Internet of Things (IoT) smart technologies set an effective milestone in supporting novel models for enjoying Art and Cultural Heritage (CH). The widespread "talking" museum and "smart sites" [1] or the augmented virtual reality (AVR) systems [2] evidence successful applications. This type of applications implements very exciting and advanced solutions (e.g., multimedia smart guides [3], provided with intelligent profiling systems for multimedia contents tailoring [4–6]), but it turns into a too strongly device-driven approach. Indeed, the experience of users visiting cultural sites or artworks exhibitions, is strongly mediated by the usage of personal smart devices or provided AVR displays (e.g., the Oculus Rift display).

© ICST Institute for Computer Sciences, Social Informatics and Telecommunications Engineering 2017
A.L. Brooks and E. Brooks (Eds.): ArtsIT/DLI 2016, LNICST 196, pp. 145–153, 2017.
DOI: 10.1007/978-3-319-55834-9_17

An increasing number of present researches focuses on studying the "appeal" and the appreciation level of such technologies against users' emotions and involvement, when they are applied to CH domain. Some preliminary results from these studies [7, 8] highlighted a still not significant increase or improvement in the cultural attitudes and sensitivity of the users, after a "smart" visit experience.

Most of "common" users (those ones having no particular skills in the art field) are strongly charmed by smart and amazing new technologies but very little engaged with the cultural experience offered by living museum atmospheres. On the other side, art lovers and experts are more interested to establish a kind of deep "sentimental" correspondence and dialogue with artworks and museum atmosphere (by admiring and touching objects, whenever it's allowed), so discarding quite fully the usage of technologies.

This kind of antithetical behaviors evidences a still weakly pervasive and still intrusive approach in creating synergies between smart technologies and cultural sites. Smart cultural approaches should be able to engage users really, without jeopardizing their interest towards the cultural context or the support offered by smart Information Technologies (ITs). Very often, users, while interacting by their smartphones or AVR displays, keep themselves out quite fully from living and experience the surrounding cultural site. No "dialogue" or direct deeply pulsing interactions are established with the artworks. A museum visit would risk to "sound" quite like the same to be in the own living-room, looking at very interesting documentary packed in contents, equipped with amazing technologies, thus putting users fully out of the cultural site atmosphere.

Another not trivial issue concerns the selection and organization of an appropriate knowledge to transfer to users. They, differencing by cultural and social background, by age and sensitivity, have to be approached in different ways, if the goal is an effective engagement with the context they are experimenting. The author of [9] proposes an authoring platform for automatic generation of tailored textual artworks descriptions, basing on users' profiling information (e.g., art biographies in the shape of little fables for schoolchildren).

Therefore, main limitations of available smart cultural service infrastructures consist exactly in the way they set the communication paradigm between visitors and cultural objects. Better profiled interactions, exploiting the means of human-like natural interactions and natural language could help in overtaking these problems.

After all, the easiest way for a user to acquire information and to express his/her needs and preferences regarding a desired service or condition, is to use natural language. Incompleteness and ambiguity, typical of natural languages, offer rooms for discussions, but present textual entailment and paraphrases methods [10, 11] provide relevant contributions to limit these problems.

Starting from the discussed standpoint, this paper focuses on the importance of "re-humanize" art recreation models, proposing a human-like interaction driven approach, that could contribute to reinforce the role played by the most advanced smart ITs in reaching the goal of a deep and effective involvement in CH of human visitors.

As detailed in the following, a natural language driven process, exploiting naturally speaking holographic projections, is proposed to make art objects "speaking", thus reestablishing a natural communication with visitors, who are so provided with the opportunity, when in front of an artworks, to be part of new experiences of knowledge.

Holograms, reproducing human figures or fantasy characters (for children audience), play the human presence imitation game, when users are detected nearby an artwork. By exploiting the potentiality of IoT well-assessed infrastructures and applications, an NLP platform and a Holographic Simulation engine, a smart human-like driven model of interaction is implemented in a unique platform. It allows to manage holograms projections and interactions in a humans-like way, dialoguing with human users in natural language. Different appearances for holographic characters can be proposed to support a further customization and variation for the performed interactions. In this perspective, the proposed approach and its implementing system provide support for selecting very popular fables and fantasy cartoons (e.g., Walt Disney Production) as holograms to implement an effective human-like speaking artworks environments. Finally, we illustrate this possibility by showing how an IoT environment can implement this approach into CH.

2 The Imitation Game Approach for Holographic Characters

IoT, coupled with existing capabilities of speech processing and dialogue management in natural language, put the basic prerequisites for an ecosystem of human-like speaking things. This will enable a direct and natural connection between human users and the information cloud, thereby making effectively "smart" not only terminals like computers and mobile phones but also physical environments such as cities, homes, offices, shops and museums. Talking to a disembodied human voice is not like talking to a human figure. Aside the fuller user experience that it provides, human-like figures can be used to interact with users whenever there is need of visual demonstration, as in explaining an artwork.

Holographic human beings bring one step further the capabilities of interaction of "speaking" things, in that they can provide support for full-fledged dialogues in natural language. This basic technology allows capturing, in the form of holographic simulations, sequences of actions performed by human actors that can be matched with requests coming from human users through the integration with technologies for speech processing, natural language understanding, gesture recognition, linked data and knowledge representation. Deployment is through standardized carriers such as ordinary projector optimized for 3D displays with very high resolutions (at least 4 K UHD), always maintaining full size reproduction of the holographic human being so as to make the user experience totally natural and familiar. Since different types of audiences should be enjoyed, diversified holographic resemblances are supported for children and very young people: fantasy characters from fables, cartoons and animation movies (Disney Pictures, e.g.) were selected because of their popularity and the large availability of video materials for graphic elaborations.

Furthermore, holograms of human appearance are obtained by projecting prerecorded video segments, depicting human actors performing a set of facial expressions, mimics and pronouncing a set of answers and questions for users. By the way, the number of different video segments to record, in order to offer a reasonable level of variety for different audiences and coverage for a small museum or exhibition (about 100 artworks),

turns into a bottleneck, demanding significant times and economic resources waste. By adopting animation movies and cartoons characters, the effort due to implement the imitation game for speaking holograms is reduced to dubbing characters only. Such a solution enhances our choice to select cartoons and fables characters to generate holographic figures, beyond the appealing and the popularity of such figures at children and young people eyes.

Figure 1 shows a prototyping experimental installation deployed at the Civic Museum of CastelNuovo, in Naples (Southern Italy), where the fable character "Alice in Wonderland", appears in one of the exhibition rooms, telling the visitors about a set of beautiful marbles and gypsum Italian sculptures.

Fig. 1. Alice Hologram waiting for interactions with human visitors.

3 The Natural Language Driven Process for Speaking Holograms

A fundamental step in supporting interactivity is to make the holograms cloud-connected and capable of transferring information back and forth over the Internet. In fact, this is a necessary condition for the holographic figures to be able to answer the requests of the users providing them with the needed information. The IoT brokerage services are essential in this respect, being this a typical case of communication between the machines maintaining the information and the "animated thing", namely the holographic figure, that would provide them to the user. Pro-active and reactive event processing, audio mining, content optimization and context-aware recommendation can be also exploited effectively to turn holograms into revolutionary user experiences and interfaces. A Natural Speech Recognition system and a Questions & Answers (Q&A) engine

are the core components. The Q&A engine is employed to find matching answers for well-formed requests.

At a glance, the processing flow is composed of the following four steps:

1. *Speech to Text conversion.* An instance service is listening on a communication bus, waiting for a user' s request. Speech recognition and translation into textual format was implemented employing Microsoft DotNet 4.0 Framework Solution (ASR and TTS SDKs).
2. *Text Analysis and Request Categorization.* Typical text analysis and text entailment methods are applied to incoming textual requests to identify a correct category. The output is represented by lists of relevant terms and categories useful to match suitable answers and to select video segments for playing holograms.
3. *Question and Answer Matching.* Categories and terms summarizing the request are matched against a Knowledge Base (KB). CH experts provided specific domain ontologies, vocabularies and answers to populate effectively the underlying KB.
4. *Text to Natural Language Speech Generation.* When an answer matches against a submitted request, an event consisting in playing a speaking hologram is created and projected close to the inquired artwork.

4 System Architecture and Components

The capability of involving users into truly engaging interactions derives also from the easiness with which the implemented system for NLP can be integrated within a modular architecture that takes advantage of a variety of technologies from IoT. It is composed, at a glance by:

1. An IoT Application Infrastructure, including:
 - A *Wireless Sensor Network* (WSN), typically made of smart beacons devices, to detect human users' locations and movements, by the exploitation of the most advanced Bluetooth low power consumption technologies;
 - An *Application* (an App) for smart devices, detecting users' presence and exploiting smart devices microphone to collect users' questions.
 - A *Message Delivery Service* (MDS), responsible for receiving vocal inputs incoming from the App for delivering it to the ADM subsystem.
2. An Action and Dialogue Manager (ADM), including:
 - a *Natural Language Processing Engine* (NLPE), engaged with processing vocal signals forwarded by the MDS, and translating them into textual messages. It bases on Voice Recognition and Speech to Text services.
 - A *Questions & Answers* (Q&A) engine, deputed to process the textual request against a KB containing a set of possible answers. This engine is currently implemented as a set of logic and semantic rules to extract the most meaningful terms composing the request and to entail similar ones;
 - A *Video Dispatcher*, receiving the selected answer and using it as a key to query a Multimedia NoSQL Database (MongoDB), to select the corresponding video segment for the holographic figure to be played.

5 A Case of Study: An IoT Environment for Speaking Holograms

For a deeper comprehension of the Human-driven interactions environment, performed by the speaking holograms, we considered the following experiment, a tourist visiting the National Archeological Museum of Sannio Caudino (Benevento, Southern Italy) exhibiting ancient Greek vessels, among which the precious Crater of Assteas. This environment offers a WSN, enabling visitors to interact with the cultural objects exhibited, by exploiting their personal smart devices and an appropriate App. The typical scenario of our case of study consists in a user visiting an exhibition room and walking through several ancient Greek bowls and objects; when he is particularly next to one of them, his presence is detected, because his mobile device (running a provided App) interacts with and a sensor coupled to that object (placed on the basement, for example). This condition triggers the cultural object animation, by projecting a holographic figure; it immediately engages a dialogue, in human natural language with the visitor. The hologram invites its interlocutor to learn more about the place and the object he is close to. At the first interaction, the holographic figure welcomes the user, proposing messages in four different languages, at the current version (Italian, English, French and Spanish).

Figure 2 shows the use case for a visitor next to an ancient vessel, thus triggering the projection of the holographic illusion.

Fig. 2. An example of Speaking Hologram interaction with a user by IoT

Our approach builds on an existing paradigm of pro-active interaction but at the same time forces a significant paradigm shift, where interactions are effectively driven by natural language. Answers are provided as short user categories profiled narrations. When a visitor is detected close to any art object, the hologram figure invites the user to submit a question (suggests some questions and topics) or a request for information (about history, author,

style and techniques, etc.) by using his/her personal smart device. User speaks to the hologram as a human guide, submitting a question among the suggested ones. The visitor can also discard the dialogue request, thus interrupting the conversation (pronouncing some "magic stop words") with the hologram just like in a real human dialogue. The underlying system supporting the holographic projection, automatically recognizes the user's language response at the first time interaction. If a request is correctly recognized by the backend underlying system, a video segment, playing the hologram acting the correct matching answer, is projected. The matching process, as described in the previous section, is based on a NLP and a Q&A engine; it selects the corresponding answer, given a well identified and recognized question or a significant part of it. If any question can't be recognized by the system (too noisy environment, bad spelling, unsupported languages or questions), an idle video segmenti s projected; thus, the hologram, asks the user to submit his/her request once again. A number of trials have been performed to assess users' enjoyment and consequently, the naturalness and the utility of the proposed application. A sample of about 500 visitors were asked to fill in a post-visit questionnaire, during a set of events celebrating the exhibition of the precious Crater of Assteas. Users were stimulated to express their level of agreement with a set of statements, using a 10-point Likert scale, or to make choices between proposed options. We adopted four usability dimensions to have an overall estimation for the proposed approach: simplicity (SIM), usefulness (USN), enjoyment (ENJ) and the naturalness of the interaction (NAT). Table 1 summarizes results extracted from the users' answers, the most relevant questions related to the four dimensions considered and their average ratings. The overall degree of satisfaction manifested by users towards the proposed approach was positive with an average rating of 8.86 (ENJ04).

Table 1. Post-visit questionnaires results.

Question ID	Description	Score
SIM01	It was easy to interact with the exhibit artworks	8.56
NAT01	I appreciate the clearness of the spoken dialogue	8.32
NAT02	The waiting time in the performing interaction was in my expectations	7.89
NAT03	I appreciate the naturalness of the interaction with the environment	8.45
ENJ01	I appreciate the artworks detection metaphor	8.45
ENJ02	Using the infrastructure contributed to increase my will to visit other art exhibitions and my knowledge	8.09
ENJ03	System positively contributed to the enjoyment of my visit	8.87
ENJ04	I overall appreciated the proposed approach and the infrastructure	8.86

6 Conclusions and Future Work

This paper presents a human-like interaction driven approach, in the advanced IoT application context, supporting the Cultural Heritage environment, also suitable for Tourism and Smart Urban Environments, by advancing the available user-experience based on smart devices via the interaction with really and human-like speaking things and holograms. We illustrate this possibility through the description of the dialogue management system and the system architecture supporting speaking things and holograms. Holographic figures represent a variation on the semblance of the intelligent pre-technological interface par excellence, that is, the human figure. In this way, a "static" art exhibition, supported by a fully device-driven interaction, turns into a "living" one and the speaking hologram interact with the visitor, by exchanging questions and answers, in a human natural way. The adopted communication strategy bases on selecting different holographic figures (real human actors performing videos or fantasy characters) to display, according to the audience. Particular attention has been paid to the children audience, in order to make culture and art environment more charming for their learning. The adopted approach in the platform design promises to be scalable and flexible enough to support extensions. As future work, more sophisticated text analysis and semantic based strategies will be exploited, to support more dynamic and complex dialogues. Preliminary experiments evidenced curiosity and appreciation by visitors, so motivating the authors to further improvement.

References

1. Chianese, A., Marulli, F., Moscato, V., Piccialli, F.: A "smart" multimedia guide for indoor contextual navigation in Cultural Heritage applications. In: IEEE IPIN 2013, pp. 1–6 (2013)
2. Brancati, N., Caggianese, G., Frucci, M., Gallo, L., Neroni, P.: Touchless target selection techniques for wearable augmented reality systems. In: Damiani E., Howlett R., Jain L., Gallo L., De Pietro G. (eds.) Intelligent Interactive Multimedia Systems and Services, pp. 1–9. Springer. Cham (2015)
3. Chianese, A., Marulli, F., Moscato, V., Piccialli, F.: SmARTweet: a location-based smart application for exhibits and museums. In: IEEE SITIS 2013, pp. 408–415, December 2013
4. Chianese, A., Marulli, F., Piccialli, F., Valente, I.: A novel challenge into Multimedia Cultural Heritage: an integrated approach to support cultural information enrichment. In: IEEE SITIS 2013, pp. 217–224, December 2013
5. Bordoni, L., Ardissono, L., Barceló, J.A., Chella, A., de Gemmis, M., Gena, C., Iaquinta, L., Lops, P., Mele, F., Musto, C., Narducci, F., Semeraro, G., Sorgente, A.: The contribution of AI to enhance understanding of Cultural Heritage. Intelligenza Artificiale 7(2), 101–112 (2013)
6. Ardissono, L., Kuflik, T., Petrelli, D.: Personalization in cultural heritage: the road travelled and the one ahead. User Model. User-Adap. Inter. J. Personalization Res. 22(1), 73–99 (2011)
7. Benedusi, P., Chianese, A., Marulli F., Piccialli, F.: An associative engines based approach supporting collaborative analytics in the internet of cultural things. In: Proceedings of the 10th International 3PGCIC 2015 Conference, November 2015

8. Benedusi, P., Marulli, F., Racioppi, A., Ungaro, L.: What's the matter with cultural heritage tweets? an ontology–based approach for CH sensitivity estimation in social network activities. In: IEEE SITIS 2015, November 2015
9. Marulli, F.: IoT to enhance understanding of cultural heritage: fedro authoring platform, artworks telling their fables. In: Atanasovski, V., Leon-Garcia, A. (eds.) FABULOUS 2015. LNICST, vol. 159, pp. 270–276. Springer, Heidelberg (2015). doi: 10.1007/978-3-319-27072-2_35
10. Androutsopoulos, I., Prodromos, M.: A survey of paraphrasing and textual entailment methods. J. Artif. Intell. Res. **30**, 135–187 (2010)
11. Piccialli, F., Marulli, F., Chianese, A.: A novel approach for automatic text analysis and generation for the Cultural Heritage domain. In: Multimedia Tools and Applications (2016)

Enhancing the Multisensory Environment with Adaptive Game Audio Techniques

Ben Challis[1(✉)], Angela Kang[1,2], Rachel Rimmer[1,2], and Mark Hildred[2]

[1] Manchester Metropolitan University, Cheshire, UK
b.challis@mmu.ac.uk
[2] Apollo Ensemble, York, UK
https://www.cheshire.mmu.ac.uk/dca/department-research
https://www.apolloensemble.co.uk

Abstract. Two workshop case studies are described that document the potential for applying novel approaches to the use of technology in multisensory environments. In contrast to current trends, the environments were regarded as a space within which to work rather than as a given set of technologies. Stimulating interactive story-worlds were enabled for groups of children with mixed Special Educational Needs where technology could empower the different groups to affect the environment as a whole. Arts-based leadership experience was regarded as key within the studies as were methods for moving beyond passive modes of interaction with sound and music. A novel approach to creating interactive 'soundtracks' is described that takes adaptive techniques from computer game audio and applies these within a physical space.

Keywords: Accessibility · Music · Dance · Technology · Multisensory environments · Play · Adaptive game audio

1 Introduction

It is widely accepted that there are observable benefits to be gained for individuals with significant learning difficulties who regularly interact with sensory stimuli. The suggestion that fundamental sensory stimulation could be a more direct way of reaching out to individuals with profound and multiple learning difficulties (PMLD) was originally proposed by Hulsegge and Verheul [1] in the late 1970s. In their book 'Snoezelen: Another World' they described specialist rooms within the De Hartenberg Centre in the Netherlands being equipped as controlled sensory environments where a care assistant could work with an individual with PMLD as she or he interacted with a range of sensory stimuli. There was great emphasis placed on reaction and play within these sessions and though, at some level, learning might be achieved, it was not a primary aim of the sensory activities.

The Snoezelen model of having dedicated sensory rooms (sometimes referred to as 'dark' and 'light' rooms) is still relatively commonplace within current Special Educational Needs (SEN) provision and there are now specialist suppliers that will equip such spaces. However, as Pagliano [2] observes, many of

© ICST Institute for Computer Sciences, Social Informatics and Telecommunications Engineering 2017
A.L. Brooks and E. Brooks (Eds.): ArtsIT/DLI 2016, LNICST 196, pp. 154–161, 2017.
DOI: 10.1007/978-3-319-55834-9_18

the technologies being used in the 1970s were becoming available as a result of the arrival of the discotheque where audio-visual equipment was emerging that would enhance the sensory environments being created for mainstream entertainment; mirror-balls, sound-to-light units and projector wheels were all commonly used against a backdrop of amplified and beat-based music. Alongside these audio-visual technologies, a variety of new plastic materials were also becoming available such that soft-play furnishings could be manufactured using wipe-clean PVC, velcro could be used for rapid but secure fastenings and vacuum forming techniques were enabling the production of lightweight playground equipment. There were also key sociological advances happening that would lead to a progressive movement away from the institutionalisation of individuals with physical and cognitive challenges and more towards mainstream integration. The Snoezelen concept emerged out of these landmark events, offering safe environments where individuals with PMLD could be immersed in stimulating yet playful activities and all within a therapeutic context.

The longterm benefits of working with sensory spaces are still to be fully assessed and where research has been carried out the results have tended to be inconclusive (e.g. [3,5]) or perhaps not open to generalisation (e.g. [4]). There is still substantial value to be attached to personal observations and experiences though as the special needs educator is typically working at an individual needs level where the opportunity to generalise rarely arises. This is an aspect that Mount and Cavet [6] identify in their review of similar studies into the relative merits of multisensory environments (MSEs), ultimately arguing that there is likely to be as much significance to be placed on the quality and abilities of the individual member of staff as the equipment and spaces they are operating within. MSEs can now be regarded as widely available within SEN provision in the UK and have evolved from the Snoezelen model to exist in a number of contrasting forms including rooms, gardens, corridors, trolleys, pools and even corners. However, there is little literature available on what 'good' design practice might be or, indeed, the kinds of activities that might be carried out within any given environment. Recent research into the design and use of MSEs in England and Wales [7] has identified a number of areas that are worthy of further investigation.

Generic Resources. There is a noticeable trend for spaces to be equipped with a standardised set of resources (mirror-ball, bubble-tubes, infinity tunnel, audio playback etc.) yet with little evidence to suggest why this should be. In contrast, there is also evidence of SEN educators making creative use of repurposed technologies within ad hoc spaces with very positive results.

Passive Use of Sound and Music. Though there is evidence of individuals with PMLD responding positively to musical stimuli, much of the typical interaction with music in MSEs will tend to be passive; a backdrop against which other activities might be carried out.

Themed Play and Story-Telling. The technologies that typically populate MSEs are not always flexible in terms of enabling the creation of thematic

environments. Indeed such spaces can often be fixed environments with a standard set of resources.

Working with Groups. Although the Snoezelen model for the MSE was originally aimed at working exclusively with individuals with PMLD, there is now a wider recognition that exposure to sensory stimulation can offer potential benefits across a broader spectrum of people with learning difficulties and communication challenges; this can offer clearer opportunities for working with groups.

2 Case Studies

Two case studies are described as initial attempts at addressing some of the issues that have just been outlined. They are also the start of a collaboration between the Department of Contemporary Arts (Manchester Metropolitan University) and Apollo Ensemble and it is anticipated that the project's findings will inform the design of new methods for interaction within specialist software environments. Both case studies have focused on the design of music workshops for children with cognitive and/or physical challenges attending SEN schools in the North of England and a number of common themes have been explored.

Environments. Both sets of workshops were hosted in theatre 'black box' rehearsal spaces. This offered a relatively large space to work with such that a group of around fifteen individuals could work safely across the whole space if required. With black-out being available, any coloured lighting and projected images used could have greater impact, offering a more immersive sense of 'place' within the themed environments being suggested.

Technology. A key aim was to create an immediately stimulating and almost 'magical' environment where simply being in the space would be fun or exciting. Added to this was the notion of being able to progress from one environment to another to create a journey or story to use as a backdrop for encouraging game play. To enable this, a core suite of wireless controllers was identified that could form the basis for rapidly establishing a themed environment or 'story world'. At the heart of this was an RFID card reading sensor that could be used to immediately switch from one environment to another with the participants being able to choose where to travel to next. The image printed on each card corresponded to a larger image being projected onto a backdrop screen along with an ambient soundscape that would complement that particular environment. In addition to this, coloured DMX lighting was being controlled to further enhance the immersive experience being created; blue for water, green for jungle, red for volcano etc. Colour changing LED spot lights were distributed on either side of the screen and partly around the workshop group in such a way that all lights could be switched to a specific colour simultaneously. Control over the colour of the lighting was achieved using a large but lightweight PVC dice housing an orientation sensor. Each side of the dice was a different colour and the lights were programmed to match the colour of that side which was face up; rotating the dice would rotate through the colours.

Game Play. As will already be apparent, great emphasis was placed on using game play throughout the workshops. Other than being a stimulating environment to experience in a passive sense it was important that the workshop should remain engaging throughout, offering opportunities for the group to make choices and to lead the way where possible. With this in mind, there was a careful balance to be maintained between prescribed and improvised activities such that there would always be a new activity to explore but wherever the opportunity might arise to react to an idea that emerged from the group it could be taken.

Feedback. General observations were gathered that included reflections by workshop coordinators along with comments offered by educators and care-workers in attendance with each group. The input of these individuals was particularly valuable in terms of better understanding how stimulating and enjoyable the activities appeared to be for the groups with whom they were so familiar. They were also able to suggest how appropriate these same activities and environments might be for other groups that they were working with.

2.1 Artscool 2015

For this series of workshops, a story world was constructed around a tropical island adventure featuring ten locations including a beach, a jungle, rope bridges, paths, waterfalls, pools and a volcano. There were animal images that could be selected to appear on demand including an elephant, tiger, monkeys and parrots. Hand percussion was used to allow the group to create jungle rhythms throughout and carefully selected tuned percussion was used to allow pentatonic textures to be created at the beach and pool.

Simple rhythm-games were employed as ice-breaker activities at the opening of the workshop but the main focus from then on was the creation of a musical journey across the island moving between the different locations. There would be a starting location set by the workshop leaders but this choice could be passed to someone from the group by selecting a new card for the RFID reader; the new environment would appear automatically. Some time would be allowed to absorb the ambient soundscape and identify the sounds and images within it. Someone might use the dice sensor to pick a lighting colour to go with the scene and the activity could switch to playing musical games within the current location.

For the jungle images, the group might copy a simple rhythm to represent the sound of walking but then be ready to drop into a slower 'stomping' rhythm if the image of the elephant appeared on screen for example. The leaders would employ obvious physical gestures to suggest when to play loud or quiet, fast or slow, long or short and, finally, when to stop. At images of bridges, someone from the group might be asked to take a walk across the floor as if crossing a real bridge whilst the rest of the group would time their rhythm to match the footsteps. Walking steadily, pretending to teeter, becoming steady again and then a last dash to the end would all be supported by spontaneous but matching rhythms: steady, chaotic, steady, fast.

At the various waterside locations the musical activities would focus on creating serene textures with each member of the group having two or three selected chime bars to strike. The coordinator could conduct the group to gradually enter into the texture one-by-one, perhaps with a set rhythm or perhaps quite randomly. As with the rhythm games, the leaders would use physical gestures or body position to suggest whether the chimes should be struck loudly or quietly, quickly or slowly and shakers might be added to strengthen the water-like effect.

Reflections and Observations. Two groups of about ten children were involved with these workshops and, although the sessions were approximately one hour long, both groups remained completely engaged throughout and were clearly enthusiastic to take part. This was reinforced as an observation by both educators and care workers alike who made specific reference to these particular groups as being quite difficult to keep engaged; this level of sustained attention was far beyond their initial expectations. A key factor in this was probably the level of contrast being offered between the different locations where there was already much to absorb in terms of image, soundscape and lighting; simply changing locations would offer great variety and therefore new interest even in a quite passive sense. Participants were eager to contribute to the various musical games being led at each new location and opportunities to affect the environment directly were met with similar enthusiasm. Within the space, technology was being used to translate small movements into large gestures such that choices being made in a game-like way would dramatically affect the mood and feel of the immediate environment; rotating the dice would alter the colour of the whole environment and changing the image placed on the card-reader would transform the look and sound of landscape being visited. In this sense, the outcomes being offered were really quite empowering even though the interaction required for each was easy to achieve. Though the technology was enabling swift transitions between potentially exciting environments, the musical games and activities that were then explored were reliant on leadership from the workshop coordinators working with acoustic instruments. In this sense, the workshop design being explored here suggested a promising balance between technology enhanced environment and traditional music techniques but with considerable reliance on one or music specialists to lead and improvise around the activities.

2.2 Cheshire Buddies 2015

In contrast to Artscool, this workshop placed greater emphasis on the use of assistive technologies in triggering and controlling sound within the sensory environment. Again, efforts were made to create an exciting and magical atmosphere with images and soundscapes that could be used to create story-lines for game play. The design behind the workshop was tailored to allow for input from an experienced community dance practitioner. She would lead much of the game-play within the environment, encouraging actions that would make use of body movement across the available space. The themed environments included outer

space, walking on the moon, scuba diving, mountain climbing and skiing and as with the earlier workshops, each set of images would have unique soundscapes and controllable lighting to enhance the overall effect.

Additional technologies such as motion sensors and pressure sensitive floor-pads were incorporated such that all the music supporting the dance could be shaped and controlled by the physical movement of the participants. To enable this, the music for the workshop was created using a compositional approach drawn from computer gaming that is generally described as adaptive audio. Such approaches can allow a constant soundtrack to adapt as the game-play follows a non-linear narrative. For example, a single parameter of 'intensity' might be used to match a game's levels of action, influencing the pace, texture and style of accompanying music in addition to any environmental ambiences, sound effects and musical stingers. Though there are several different approaches for creating adaptive audio environments (see [8]), one key approach is to create looped music as a series of layers that are always in play but where the overall audio-mix will be dependant on the changing value of just one or two parameters.

For the purposes of this workshop, a number of pieces of adaptive music were produced that could all be mapped and controlled using only a small number of parameters. To achieve this, each looped piece was based on six separate layers each of which had independent volume control. Two layers (typically bass and percussion) were controlled using a Leap Motion sensor (a non-contact desktop gaming device that monitors hand and finger gestures). This particular sensor was chosen knowing that there could be one or two individuals within the group with mobility challenges yet just simple left or right hand movement could enable these individuals to still take part and to contribute in a particularly effective way. The remaining four layers would be musically textural, made of harmonic patterns and incidental melodic phrases, all mapped along the single dimension offered by an ultrasound sensor with a range of about three metres. Though only offering a single dimension to work with, adaptive audio techniques mapped the same single value across four envelope parameters such that a variety of mixes could be moved through along the length of the beam. The aim was for one or two people to work with the beam, exploring the different layered mixes in an expressive way. Lastly, each of four floor-pad sensors could trigger a variety of 'stingers', again, a technique associated with game audio where a musical flourish can be triggered at any point in the game play whilst always appearing to 'fit' against the changing musical backdrop.

As with the earlier workshops, the structure behind the activities was part-prescribed and part-improvised to once again enable the leader to respond and react to opportunities that might emerge from within the group. An initial ice-breaker game involved the dice sensor being passed around the group in a circle. Each person created a dance gesture with the dice which would also effectively set the colour of the environment until the next person's turn. Though the same theatre black-box space was used for this workshop as with the previous ones, more lights were set up this time such that changing the colour offered even greater impact. Again, the card reader sensor was used to help choose

the different locations and the leader would then look for body movement being suggested within the image to take the group on a journey across the floor space, imitating the movements of the leader. Once established as a game, the lead would be offered over to someone else in the group. Gradually, the three music controlling technologies were introduced to the group, once again playing and improvising through copying whilst creating the music which would support the activity for the rest of the group. Once all the different music making actions had been explored by the majority of the group a semi-improvised piece was devised that gradually involved more and more movement and music. Finally, some of the group members choreographed the actions of the others by indicating when and how to move.

Reflections and Observations. One group of approximately fourteen children took part in this particular workshop and similar levels of engagement and enthusiasm were observed throughout as with the earlier workshops. Again, this was noted by both the workshop coordinators and care workers alike. Though it is clearly positive that the environment was stimulating for the participants, the observations from the dance-coordinator leading the workshop are fundamental in terms of appreciating how the environment was suggesting and enabling particular modes of activity to take place. One of the most significant observations was that the environment and the technology within it were creating active opportunities for movement to occur. The environment provided an open structure to play within and because of this the role of the leader became one of facilitating participants towards being creative and playful on their terms, making choices about their engagement with the stimuli. Participants appeared to own their own movement and decisions with a sense of empowerment being created through the use of appropriate technologies; desires into active-opportunities into larger sonic and visual outcomes. The environment enabled play with no suggestion of 'right' or 'wrong'. Individuals could be encouraged to improvise and explore the technology which invited a range of responses and possibilities with every individual bringing something different into the space expressed though their own physicality.

3 Conclusion

Conceiving of the MSE as being a space within which to work as opposed to a discrete set of technologies can offer greater flexibility for creating stimulating interactive experiences. This additional flexibility can also enable group based activities to occur more readily and having specialist performance experience available enables improvisation to be used as a vehicle for creating and adapting activities to be both responsive and immediate. Using technology to enable actions and choices can clearly help make the environment accessible but the benefits of designing the environment to respond more coherently as a whole is perhaps less apparent; offering considerable empowerment by mapping small interactions into greater outcomes that transform the look, sound and 'feel' of

the space. It is also apparent that devising an experience that is thematic can assist with the creation of a story-world to work within but that this can be further enhanced by conceiving of the story as being as a journey across a series of connected spaces. Lastly, applying adaptive techniques for controlling sound and music similar to those used in computer game design appears to offer intuitive interaction and exploration within a given sonic landscape. This allows artists to compose interactive soundtracks without knowing the exact gestures to be harnessed whilst also enabling workshop leaders who are perhaps musically inexperienced to lead group-based activities that offer expressive opportunities for interacting with music and sound. A simple model for employing adaptive audio techniques in MSEs has been demonstrated as a prototype and work is now under way to explore how best to enable this same concept within software tools such as Apollo Ensemble. Though the activities described here are regarded as novel, the participants for the case studies were all from SEN schools and in that sense can be regarded as relatively typical within a context of MSEs. However, there are likely to be other user groups who would benefit from engaging in sensory play where specific rehabilitative outcomes might be desired. With this in mind, the current project is being extended to working with stroke survivors where head-related trauma has led to often quite complex physical and cognitive challenges. The aim in this new context will be to consider how similar adaptive game-audio techniques might be mapped to quite specific individual movements and gestures that can complement a given programme of rehabilitation.

References

1. Hulsegge, J., Verheul, A.: Snoezelen: Another World. Rompa, Chesterfield (1988)
2. Pagliano, P.: Using a Multisensory Environment: A Practical Guide for Teachers. David Fulton Publishers, London (2001)
3. Stadele, N.D., Malaney, L.A.: Effects of a multisensory environment on negative behavior and functional performance on individuals with autism. J. Undergrad. Res. 4, 211–218 (2001)
4. Slevin, E., McClelland, A.: Multisensory environments: are they therapeutic? A single-subject evaluation of the clinical effectiveness of a multisensory environment. J. Clin. Nurs. 8, 48–56 (1999)
5. Vlaskamp, K., de Geeter, K.I., Huijsmans, L.M., Smit, I.H.: Passive activities: the effectiveness of multisensory environments on the level of activity of individuals with profound multiple disabilities. J. Appl. Res. Intell. Disabil. 16, 135–143 (2003)
6. Mount, H., Cavet, J.: Multisensory environments: an exploration of their potential for young people with profound and multiple learning difficulties. Br. J. Spec. Educ. 22(2), 52–55 (1995)
7. Challis, B.P.: Designing for musical play. In: Brooks, A.L., Brahnam, S., Jain, L.C. (eds.) Technologies of Inclusive Well-Being. Studies in Computational Intelligenc, vol. 536, pp. 197–218. Springer, Heidelberg (2014)
8. Van Geelen, T.: Realizing groundbreaking adaptive music. In: Collins, K. (ed.) From Pac Man to Pop Music. Ashgate (2008)

Investigating the Effect of Scaffolding in Modern Game Design

Kasper Halkjær Jensen and Martin Kraus(✉)

Aalborg University, Rendsburggade 14, 9000 Aalborg, Denmark
Khjell@student.aau.dk, martin@create.aau.dk

Abstract. Nowadays, game developers are much more focused on providing players with short-term rewards for overcoming challenges than they have been previously. This has resulted in a lot of games having more scaffolding to teach the players what to do, so they don't quit the games in frustration of not knowing what to do.

This paper investigates the effects that scaffolding in games has on players' experience of a game. To this end, a custom game was designed and implemented that contained a number of different scenarios with different types of scaffolding. This was used to conduct an experiment on 18 participants, measuring their experience with the scenarios they were tasked with completing. It turned out that participants overall found the scenarios with subtler scaffolding more interesting than the ones with text based scaffolding or no scaffolding at all. Additionally, they felt better about completing the scenarios that did not make use of scaffolding.

Keywords: Video games · Game design · Player experience · Player motivation · Scaffolding

1 Introduction

Early on in video game history, games were very hard on purpose because they were meant to be played in arcades, and players would have to pay to continue playing. It was common for games to just show a few hints and leave it up to the player to figure out what to do. Nowadays, a lot more games have repeated text prompts and tutorials teaching the players what to do. It is much more important for game developers now that they can retain their players because of how the business models of these games have changed. Today, downloadable content provides a lot of additional revenue for developers, and they want to make sure the players stick around longer such that they spend their money on it [9].

The prevalence of grinding [7] based challenges in games makes it possible to reach a wider audience, which could be why a lot of casual games prefer this approach versus grip based challenges. Grinding-based challenges make sure that if a player puts in a certain amount of time, they will be provided with some reward. This keeps more people playing than allowing for the possibility of getting stuck on hard challenges.

In recent years, more attention is being paid to the design of various challenges in games, because allowing players to repeatedly overcome challenges makes them more

© ICST Institute for Computer Sciences, Social Informatics and Telecommunications Engineering 2017
A.L. Brooks and E. Brooks (Eds.): ArtsIT/DLI 2016, LNICST 196, pp. 162–169, 2017.
DOI: 10.1007/978-3-319-55834-9_19

likely to keep playing [8], but it seems like the more attention developers are paying, the more they feel the need to very explicitly tell the players what they need to do throughout. This approach is referred to as scaffolding [5] (and references therein).

Scaffolding is defined as help given to a learner that is tailored to the learner's specific goals at any given time, while also helping them actually learn what they have to learn. Directly telling the learner what to do might make them complete the task, but then they might just be stuck on the next one since they never actually learned how to complete the task. Instead, good scaffolding provides the learners with hints and prompts that help them figure out what they have to do [6].

This paper investigates to which degree the quality of the scaffolding [5] impacts the player experience in modern games. Are players less interested when the scaffolding is bad and directly tells them what to do, as opposed to when they figure out the solution for themselves because of good scaffolding?

This is investigated through a custom game, made for this specific purpose, which ensures that the game is able to single out the factors that this paper will try to investigate, and making the test perfectly uniform. This was possible by designing the test so that different participants played the same selection of control, indirect and text based challenges.

2 Background

2.1 Game Mechanics

In an interview, Super Mario 3D Land Director Koichi Hayashida [1] described the way they implemented new challenges in the levels. It followed a simple four-step structure: The new element is first introduced in a safe environment (Fig. 1.1). Then there is a similar challenge, but without the safety net of the first (Fig. 1.2). It is then applied in a different way than the first two times, to show that the mechanic is not just one-dimensional (Fig. 1.3). Finally, the big payoff moment combines the various ways the mechanic can work, and is harder, and thus also more interesting than the previous challenges.

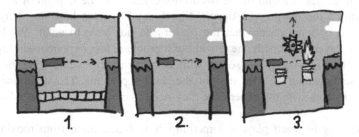

Fig. 1. Example from a hypothetical Super Mario level. If the player falls down in Scenario 1, they land on a platform and can go back up and try again (safe environment). Scenario 2 provides the same challenge, but without the safety net. Scenario 3 uses the same concept but adds variety and new threats that the player has to deal with at the same time.

The last step here is not needed to teach the mechanic, but is included in the description since the Mario games often have levels based on specific mechanics. The newly taught mechanic is thus often abandoned in favor of a new mechanic in the very next level, which is why the players need some sort of payoff after being taught a mechanic.

2.2 Player Motivation

Nicole Lazzaro elaborated on players' motivation while playing games and tied it to four key factors: Hard Fun, Easy Fun, Altered States, and The People Factor [2]. Different people find different factors in a game fun, and one could argue that by changing how the challenge is presented, one changes which players the challenge appeals to. The main two factors that we focus on in this paper are Hard Fun and Easy Fun.

Hard Fun focuses on personal triumph, and is about players playing to see how good they are at the game. This means that the main objectives are, for example, completing the game, earning the highest score, or beating the enemy team. Because of this, skill-based games (as opposed to chance-based games) are often more enjoyable for players who prefer Hard Fun. Some games that are Hard Fun could be fast-paced platformers; e.g., Super Meat Boy, or competitive games; e.g., Dota or Counter Strike.

Easy Fun relates to the whole game experience, rather than just the objective. The main objectives of players who seek out Easy Fun are to explore the world and trying to come up with their own solutions to problems they are presented with, immersing themselves in the story of the game, or even just doing things that feel satisfying because they are presented with juicy visual effects. Games in this category could be story-based games, e.g., Mass Effect, or sandbox games e.g., Minecraft.

If a game has a section with a lot of scaffolding, a player who prefers Easy Fun might be just as satisfied when completing the tasks as players who enjoy Hard Fun would be when they complete a much harder challenge. This should not discredit one type of fun or the other, but ideally a compromise between the two could be found that allows both types of players to have a good experience with a challenge.

A possible solution to the problem of players not enjoying the same kind of challenges in games is found in the twenty-nine-year-old The Legend of Zelda. In an investigation of the dungeon designs, Mike Stout [3] notes how the dungeons are designed with optional rooms that the players do not have to enter. While a more experienced player might rush ahead without a problem, less experienced players have the option of familiarizing themselves with new enemy types and equipment in less dangerous settings than the road straight ahead often presents. This additional training might provide them with the experience they need to push on, without needing to hold their hand.

Another way to teach players something is to block them from moving further unless they solve a problem they are presented with. This will force players to figure out the solution to the problem, or they will simply be unable to proceed. This method is used throughout many games, including Valve's Half Life 2 [4] (Fig. 2).

Fig. 2. Example from Half Life 2. Players are blocked, and cannot move ahead until they use the gravity gun. The players then learn how to use the gravity gun offensively.

3 Method

To investigate how helpful scaffolding is in different scenarios, we created a custom game based on information from the previous research in the field, as well as the use of scaffolding in a number of games, in particular titles from the 'Mario', 'Zelda' and 'Half Life' series.

3.1 Experiment Design

We created a small game specifically with the purpose of being able to conduct a uniform experiment, as opposed to having participants play parts of different games. The design of this game, and how it fits into the overall experiment is detailed next.

3.1.1 Game Design

Based on various scenarios in existing games, three different scenarios were created within the same custom game. Each game scenario has three different versions. In no particular order: a version using indirect teaching, one using text to teach the objective, and a control version, which has neither scaffolding method. The objective of each scenario is to find a key, and the players are instructed that this is their goal before they start the experiment. The scenarios are depicted in Figs. 3, 4 and 5. Each scenario is based on scenes from existing games as explained next:

Fig. 3. The 'Pots' scenario with indirect scaffolding. **Fig. 4.** The 'Trees' scenario with indirect scaffolding. **Fig. 5.** The 'Ball' scenario with indirect scaffolding.

In the 'Pots' scenario (Fig. 3), the players have to smash the pots in the back to retrieve the key. In the version with indirect teaching, the pots blocking the entrance make sure that the players know how to smash pots before they proceed. This scenario is inspired by the sawblade scenario from Half Life 2 [4].

In the 'Trees' scenario (Fig. 4), the players have to cut down a row of trees to get to the key. They are taught that they can cut down trees by being forced to fight enemies right next to the trees – accidentally hitting a tree will cut it down. This scenario is inspired by the tree scenario in Zelda: Phantom Hourglass [10]. The control version lacks the trees that the player can accidentally hit while fighting the enemies.

In the 'Ball' scenario (Fig. 5), the players have to push the ball to the lowered floor tile. Their attention is led to this objective by the line on the ground. This scenario is inspired by the mushroom puzzle in Zelda: The Minish Cap [11]. The control version does not have the darker colored line on the floor to direct the attention of the player.

Finally, the text versions of the scenarios are similar to the control versions but contain the following lines as the players enter the puzzle areas, all based on the same template:

Pots: "Hm, maybe there is a way to smash these pots".
Trees: "Hm, maybe I can use my sword to cut down obstacles".
Ball: "Hm, maybe this ball can be used for something".

3.1.2 Experimental Design

For the final test, we employed a chi-squared design with a fixed randomization. With three scenarios with three versions each that meant that nine tests were the least possible amount of tests needed to have one starting with each different version.

The whole experiment was estimated to take less than 10 min for each participant, depending on how long they take on each scenario. The breakdown is 1 min for an introduction, 2 min for each scenario (6 min total) and then 2 min for a post-test questionnaire, with 1 min extra for getting them set up.

During the test, the screen, as well as a video feed from the web camera was recorded. This recording was used to see if there were any errors in the logging of the times from the test.

3.1.3 Post Test Questionnaire

After the test participants finished the test, they were asked to answer a very short questionnaire. First, they were asked how long they think they spent on each task. This was used to hold up against their actual completion times to measure if they were in a state of flow. However, the data collected on this proved inconclusive.

Secondly, they were asked to rate the three test scenarios based on three different factors; how interesting they were, how good they felt about completing them, and how hard they thought they were. The ratings were based on participants sorting the challenges from least interesting to most interesting, and the same for the other categories.

The questionnaire looked as follows:

For each puzzle, estimate how long they took to complete (in seconds)
Pots: _____ Trees: _____ Ball: _____
Sort the puzzles based on how interesting they were (least interesting first)

Sort the puzzles based on which you felt the best about completing (worst first)
Sort the puzzles based on difficulty (easiest first)

3.1.4 Apparatus

1 × PC with keyboard, mouse and web camera.

4 Results

Eighteen test participants went through the experiment – all were from an IT related education. Fifteen participants were male, three were female. p-values are based on a standard unpaired student's t-test. All results are based on the questionnaires filled out by the test participants after they completed the puzzles.

For the ratings based on how interesting participants thought the puzzles were, the overall average for indirect puzzles was 2.22 (standard deviation $\sigma = 0.94$). This puts it significantly higher than the control puzzles, which had an average of 1.83 ($\sigma = 0.70$), with a p-value of 0.015. In addition, the indirect puzzles were also rated significantly higher than the text based puzzles, which had an average rating of 1.94 ($\sigma = 0.80$), with a p-value of 0.028 (Fig. 6).

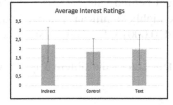

Fig. 6. Test participant ratings on how interesting they found the puzzles.

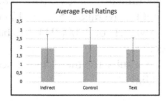

Fig. 7. Test participant ratings of how accomplished they felt when completing the puzzles.

Moving on to the ratings on how good they felt when completing the different puzzles, participants actually felt significantly better about completing the control puzzles, which had an average rating of 2.17 ($\sigma = 0.98$), compared to the 1.94 ($\sigma = 0.80$) of the indirect puzzles, and the 1.88 ($\sigma = 0.68$) of the text based puzzles. Control versus indirect had a p-value of 0.052, and control versus text had one of 0.048. It makes sense that people felt more accomplished when completing the control test, as participants did not receive any assistance in completing the puzzles (Fig. 7).

Finally, the participants rated the three puzzles based on how difficult they thought they were. The assumption here was – based on the results from the previous set of ratings – that the test participants overall would rate the control test the most difficult. This however, did not turn out to be the case, with every result based on these ratings being insignificant. The control puzzles had an average difficulty rating of 2.0 ($\sigma = 0.84$), versus 2.16 ($\sigma = 0.70$) of the indirect puzzles, and 1.83 ($\sigma = 0.92$) of the text puzzles.

The fact that none of the types of scaffolding (indirect, control, text), were rated significantly different in terms of difficulty was likely due to the difference in the three scenarios. The 'Ball' scenario received the highest rated difficulty across all three types, indirect, text and control, with an average rating of 2.88 ($\sigma = 0.32$), compared to the control and text, which both had an average of 1.55 ($\sigma = 0.61$). It was thus hard to tell if indirect was any different from control and text (Fig. 8).

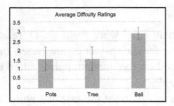

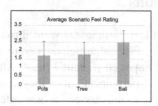

Fig. 8. Test participant ratings of how difficult they found the different scenarios.

Fig. 9. Test participant ratings of how accomplished they felt when completing the different scenarios.

The assumption that test participants felt better when completing a task that they also rated harder is supported by the 'feel' ratings as seen in Fig. 9. 'Pots' had an average difficulty of 1.72 ($\sigma = 0.82$), 'Trees' were right behind with 1.77 ($\sigma = 0.73$). This put the average 2.5 ($\sigma = 0.7$) of the 'Ball' puzzle highly significantly above both, with p-values of 0.000044 for ball versus pots and 0.00013 for ball versus trees respectively.

The results for the different scenarios are consistent across the different types of scaffolding.

5 Discussion and Conclusion

As it turned out, most players found the puzzles with indirect scaffolding significantly more interesting than the control puzzles – however, they felt slightly worse about completing them than the control puzzles. There is clearly a balance to be struck here, but finding the best level of scaffolding is complicated and presumably depends on many factors.

If the developer of a given title just wants the players to complete the game as fast as possible, text prompts appear to be the most efficient way of allowing the players to quickly figure out how to complete a given task, but at the cost of making the players less interested in the puzzle overall.

The fact that the players felt more satisfied when completing the tasks that they rated as more difficult can potentially be attributed to the fact that the players were all students in an IT related education. This means that they are more likely to have a technological background than the average person, which may influence the type of game they prefer playing.

In conclusion, indirect scaffolding led to players being more interested in the challenges they faced, but there appears to be a tradeoff between making challenges more interesting, and providing a stronger feeling of accomplishment. It will vary from game to game if the developers think the tradeoff of feeling accomplished versus having interesting scenarios is worth it.

In case this is investigated further, more attention must be paid to making sure the different puzzles are more even in terms of difficulty, as some significant results in this test might have been overshadowed by the vast difference in difficulty in the different scenarios.

References

1. Nutt, C.: The Structure of Fun: Learning from Super Mario 3D Land's Director, Gamasutra, 13 April 2012. http://www.gamasutra.com/view/feature/168460/the_structure_of_fun_learning_.php. Accessed 30 July 2015
2. Lazzaro, N.: Why We Play Games: Four Keys to More Emotion Without Story. Game Developers Conference (2004). http://www.xeodesign.com/xeodesign_whyweplaygames.pdf. Accessed 09 Dec 2015
3. Stout, M.: Learning From The Masters: Level Design In The Legend Of Zelda, Gamasutra, 3 January 2012. http://www.gamasutra.com/view/feature/134949/learning_from_the_masters_level_.php. Accessed 30 July 2015
4. Valve, "Half Life 2", 16 November 2004. http://store.steampowered.com/app/220/
5. Barzilai, S., Blau, I.: Scaffolding game-based learning: Impact on learning achievements, perceived learning, and game experiences. Comput. Educ. **70**, 65–79 (2014)
6. Sawyer, R.K. (ed.): The Cambridge Handbook of the Learning Sciences. Cambridge University Press, Cambridge (2005)
7. Bateman, C.: Imaginary Games. John Hunt Publishing, UK (2011)
8. Kim, S.: Games for the rest of Us: puzzles, board games, game shows. In: Computer Game Developers Conference (1998). http://www.scottkim.previewc40.carrierzone.com/thinkinggames/cgdc98.html. Accessed 06 Nov 2015
9. Juul, J.: A Casual Revolution: Reinventing Video Games and their Players. MIT Press, Cambridge (2010)
10. Nintendo, The Legend of Zelda: Phantom Hourglass (2007). https://en.wikipedia.org/wiki/The_Legend_of_Zelda:_Phantom_Hourglass
11. Nintendo, The Legend of Zelda: Minish Cap (2004). https://en.wikipedia.org/wiki/The_Legend_of_Zelda:_The_Minish_Cap

AstsIT and DLI 2016, Day 2

Multi-kinect Skeleton Fusion for Enactive Games

Nikolaj Marimo Støvring, Esbern Torgard Kaspersen, Jeppe Milling Korsholm,
Yousif Ali Hassan Najim, Soraya Makhlouf, Alireza Khani, and Cumhur Erkut[✉]

Department of Architecture, Design and Media Technology, Aalborg University Copenhagen,
Copenhagen, Denmark
{nstavr14,ekaspe14,jkorsh14,ynajim14,smakhl14,
akhani14}@student.aau.dk, cer@create.aau.dk

Abstract. We present a procedural method and an implementation of multi-Kinect skeleton fusion on Unity environment. Our method calibrates two Kinects by combining the relative coordinates of a user's torso onto a single coordinate system. The method is tested with a small number of participants in scenarios involving multiple users, results indicate that the method provides an improvement over a single camera, and it is accurate enough for games and entertainment applications. The video demonstration of the system is provided, and future directions to improve accuracy are outlined.

Keywords: Motion tracking · Depth cameras · Sensor fusion · Occlusion

1 Introduction

Tracking of one or multiple human bodies is currently feasible with computer vision [1]. Human posture and gestures are studied and tested within various applications; they can properly represent human kinematics and be used for tracking as well as activity recognition [1].

One way of tracking human is to use active depth cameras, which send out light, and upon processing the feedback, produce depth maps instead of an RGB picture. A good example of such an active camera is the Microsoft Kinect. Created as a controller for the Xbox 360 console, Kinect enables the user to play games by following her body movements. The Kinect-v1 combines a passive RGB camera with an active depth sensor, using a structured light pattern, and is capable of body recognition and skeletal tracking in real time [2].

Because of Kinect's capabilities, availability of development tools, and its consumer price range, many researchers have proposed new application areas using the sensor. For instance, its potential in education has been explored by [3]. However, when used in such multiple-user setups, Kinect suffers from the occlusion problem. A way to overcome the occlusion problem could be to set up multiple cameras, so that they can track objects in a scene from different angles, thereby reducing the possibility of occlusion. Various methods of combining multiple depth cameras have been reviewed in [4]. Most of the methods rely on point-clouds, and require the use of a checkerboard grid or other calibration objects. More recent methods rely on skeleton-based calibration of multiple

© ICST Institute for Computer Sciences, Social Informatics and Telecommunications Engineering 2017
A.L. Brooks and E. Brooks (Eds.): ArtsIT/DLI 2016, LNICST 196, pp. 173–180, 2017.
DOI: 10.1007/978-3-319-55834-9_20

cameras; for instance in [5], an absolute orientation algorithm proposed by Umeyama and his colleagues [6] has been combined with multi-frame Kalman filtering to dynamically calibrate multiple depth cameras based on the skeletal data.

In this paper, we show a fast and computationally efficient implementation by imposing a symmetric initial calibration step and neglecting the possible drift. The results may not be as accurate as the needs of therapeutic applications, however they are good enough for entertainment and gaming purposes.

The structure of this paper is as follows. In the next section, we provide some background, specifically on skeleton tracking with the Kinect SDK, tracking multiple people, and occlusion problems. Then we describe the pragmatics of our implementation, followed by the tests we have conducted for evaluating our approach. We present the results of these tests, discuss the outcomes and possible improvements, and conclude the paper, indicating future work in the field.

2 Background

In this section we first review the skeleton tracking with the Kinect SDK. After this, we describe the calibration of multiple depth cameras.

2.1 Skeleton Tracking with the Kinect SDK

The Kinect depth camera, combined with the IR sensor is capable of tracking up to six people at once [7]. Of those, two people can be assigned a skeleton. Kinect SDK assigns 20 points to a tracked person. Every point is mapped to a key joint or position on the human body, effectively creating a skeleton. The Kinect is also capable of assigning a seated skeleton; that is assigning a 10 point skeleton to a seated person. It is important to point out that the Kinect SDK cannot distinguish between the front and back of a person.

The recognition and tracking of skeletons are carried out in Kinect SDK using a dedicated GPU and machine learning techniques. They increase motion tracking accuracy and can be used for advanced applications. An example of an advanced application is the posture recognition system described in [8]. This method assigns vectors to the body joints and checks the current posture against predefined ones.

The position tracking error of Kinect, averaged on the horizontal and vertical angles, is found as 29 mm (see http://chhs.gmu.edu/ccid/upload/s12-Gelman.pdf). The largest observed error was about 40.5 mm at a distance of 0.876 m from the object in question, while the smallest error was around 16.5 mm at a distance of 3.07 m. In its most accurate range (around 2–3 m) Kinect has an average tracking error of 22.4 mm.

2.2 Occlusion and Multi-camera Setups

Depth cameras work with the principle that both the emitted light is reflected from a target. If other objects are in the propagation path of the light, this assertion does not hold, and occlusion occurs. Moreover, the inhomogeneity of the medium or reflecting

surfaces may result in blind spots. In recent years, occlusion and blind spots problems of the depth cameras have been increasingly tackled [9]. To increase the recognition rate of an object from the sensors, four cameras placed 5 m apart are arranged in [9] to surround a specific tracking area. With multiple angles to study the same object, the boundary between the object and the background is cleared, making that object the cameras' focal point. With this setup, it is possible to correct the skeletal data of a self-occluding participant but not when multiple participants are within the tracking area. To fix blind spots with multiple users, additional motion sensors are placed on users to collect rotation data, which is later combined with the data the Kinects receive, to be fused into a skeleton.

Various methods that entirely rely on multiple depth cameras without additional motion sensors have been reviewed in [4], and more recent methods rely on skeleton-based calibration of multiple cameras [5], as mentioned in the Introduction. We proceed with a procedural description of our implementation.

3 Implementation

We use the position of a tracked user, in the form of one or more vectors, to calculate the position of the camera relative to it. As a user is represented by a position in each camera, and assuming that the positions calculated by each camera are fairly close to each other in the real world, we assume that the difference between these positions must be equal to the distance between the cameras. To get these positions, we use the joints and the center of gravity obtained from the Microsoft Kinect SDK, and visualize the coordinate systems of each depth cameras, as well as the reference coordinate system (main camera) of Unity.

In the current implementation, we use Unity 5.2 and its new Network code. This feature allows us to easily set up a scene and server that multiple clients, or Kinects, can connect to and thereby transfer data about the positions of the users over the network. The Network Manager component is only placed on one object in the scene; every other object has a Network Identity component. The manager keeps track of all these identities, manages all networking. The Network Manager HUD component handles the interface, and adds buttons to the scene, to start a server, connect to a server as a client, or start the server as a host, which also counts as a client.

The position and orientation of the tracked user are acquired and subsequently used in calibration. The information is received from the Skeleton Stream, which contains the position and orientation of every user that the Kinect tracks. We then check whether or not the movement is mirrored; the z-axis movement registered by Kinect is inherently mirrored, and therefore, we want to mirror it again to make the movement unfold in the natural direction.

Then we start with calibration, if enabled. The first check is for rotation: the script gets the horizontal and vertical rotation seen by each camera in comparison to the default coordinate system of Unity. Then we calculate the quaternion angle between the offset and a unit vector for each camera, converting the resulting angles into a quaternion matrix. The horizontal and vertical matrices are multiplied to yield the rotation matrix.

The reference position vector is then multiplied with the rotational matrix. The new position vector indicates where the cube would have been if the cameras had only been offset in position and had a zero-degree angle between them. In other words, the position vector correlates directly to how the camera is positioned in relation to the main camera of Unity. Finally, we add the positional offset, which aligns the cubes on top of each other.

However, this alignment does not yet guarantee the alignment of the orientation of the user. For this, we consider shoulder and hip center joints from the skeleton data. We first invert their z-coordinate, as discussed above. To find the horizontal orientation, the position of the left shoulder is subtracted from that of the right shoulder, the difference is projected onto a unit vector. The vertical orientation component is calculated similarly, but uses center-shoulder and center-hip joints. Both angles are applied to the aligned cube, forcing it to face the same direction as the real-life user.

The video demonstration of the system is provided at https://vimeo.com/156941392 (password: ArtsIT16-AAU-CPH). Figure 1 below presents an instant where a single camera would provide an occluded image, but two cameras within our implementation alleviates this problem.

Fig. 1. An example snapshot from the video where the cameras were placed at the edges of the scene view. A single camera would provide an occluded image, but two cameras keep track of two people, represented by the blue and yellow cuboids. (Color figure online)

4　Evaluation

In order to evaluate the effectiveness of the Positional Vector Calibration Setup (PVC), we made an evaluation to compare two conditions; the PVC setup and a single camera setup. The variables of our tests were the error rate in tracking, and accuracy, measured in the offset between a participants' actual and detected position. The users were on a known position (marker) but we did not measure precisely their position. So the error of the fusion is sensitive to this position error.

We have controlled the independent variables: the number of people and their positions in the test scene. We have started with a pilot and tested different scenarios. The setups are illustrated on Fig. 2. All authors, but the last one have participated to tests. Since this is a physical and not perceptual or assessment test, the familiarity of the participants with the system is not considered important.

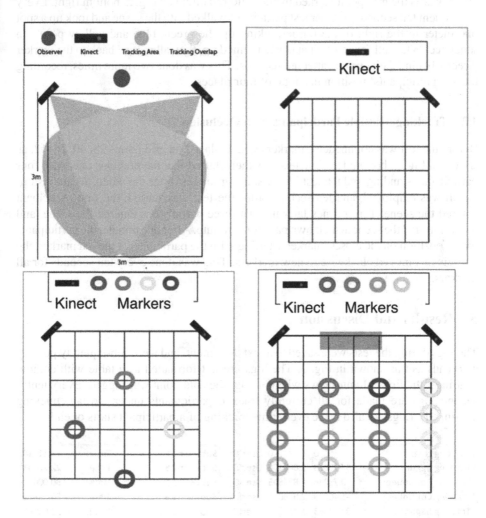

Fig. 2. From top left, clockwise: Pilot, Final, Test 1, and Test 2 setups. (Color figure online)

In the pilot, the dead spots of single and two Kinect configurations were identified (Fig. 2, top left), and the floor markers have been set accordingly (Fig. 2, top right).

4.1 Tracking Multiple Participants Without Occlusion

For this test we had four participants standing next to the marked area and the video for the test was started. Next, the test leader enabled the tracking; a stop watch was started simultaneously. After ten seconds, the first participant entered and walked across the area towards the grid point marked by the solid red circle on Fig. 2, bottom right. Every subsequent ten seconds, another test participant walked into the scene and took up a spot one meter to the right of the former, taking up the green, blue and yellow points in sequence. When all four participants where lined up, they all moved back to the marker directly behind their current, after ten seconds. This was done two more times, recording the test participants' position in a total of four places.

4.2 Tracking Multiple Participants with Occlusion

Before the test was commenced, markers where placed on grid points 28, 40, 24, 12, as shown in Fig. 2, bottom left. The test was then started like the previous one, with four participants standing and the test leader starting the test after the video. Again a stop-watch was employed, and ten seconds after the test was started, the first participant entered the scene. Ten seconds later the last three participants entered the scene, and moved around the scene at their own pace for a minute. After one minute, the participants took a position on the closest marker. Starting with the participant at the red marker, the participants moved clockwise to new markers. This was done every ten seconds for all markers.

5 Results and Discussion

The logs during the tests were saved to a text document, and were subsequently put into a spreadsheet as shown in Fig. 3. The logs are not formatted as a table with column headings; the first column shows when or why the data point was logged. Every tenth-second logs are made for all currently tracked participants under the tag 'tracking continued'. Logs are also made every time tracking of a participant starts or ends.

Tracking Lost:	0	0	UserID:	SubUser 2 5	Time:	17.11814
Tracking Begun:	0.875678	2.040108	UserID:	SubUser 2 5	Time:	22.22043
Tracking Continued:	-0.73238	1.838845	UserID:	SubUser 2 5	Time:	30.00054
Tracking Continued:	-1.40089	2.578075	UserID:	SubUser 1 3	Time:	50.03892
Tracking Begun:	0.083083	1.417884	UserID:	SubUser 1 4	Time:	51.90162
Tracking Lost:	-1.10725	3.013424	UserID:	SubUser 1 3	Time:	53.89946

Fig. 3. Sample log from the test. The columns are the tag, the position, which Kinect tracked the participant and the time.

To find the rate of errors in tracking based on this data, the 'tracking continued' logs were combined from the two Kinects and ordered according to time stamps. To account for participants being tracked by more than one Kinect amounts of overlap in the scene

where calculated. To calculate this, it was decided that if the difference in either the x or z values of two points with the same timestamp were below a threshold of 25 cm, it would be counted as an overlap.

After calculating overlaps, the total amount of detected participants were calculated by adding the number of participants detected without overlaps. The final precision of the tracking algorithm, while tracking multiple participants with possible occlusion, is found to be 81.82%.

In calculating the magnitude of the offset, the logs were sorted in time. The difference between the actually and detected positions were determined, and the magnitude of the offset vector was calculated. The mean magnitude offsets for the first test was found to be 25,55 cm for one Kinect and 15,54 cm for two Kinects.

As our system relies on local network connectivity to synchronize tracking data, delays in data transferring might have resulted in it being out of sync. The delays could have been minimized with a direct connection to a single computer. This would also have avoided the risk of potential packet loss. However, using a single computer was not an option, as the motherboards and USB busses of the computers available for our experiments were not designed to handle data streams from multiple Kinects simultaneously.

The stands which held the Kinects, as well as the markers placed on the grid, might have been slightly moved during the course of the test. This could have caused interference in terms of accuracy and could have been completely avoided by re-measuring and re-calibrating the setup before each test. Our reference grid measurements might also have causing offset; a better solution would be to benchmark our method against well-established and accurate methods.

During our tests, it appeared that the Kinects had trouble with detecting dark colors. This might be due to the IR projection from the Kinect being absorbed rather than reflected by dark materials. This could have been avoided by not wearing dark clothing during tests.

6 Conclusions and Future Work

We presented a procedural method and an implementation of multi-Kinect skeleton fusion on Unity environment. Our method calibrates two Kinects by combining the relative coordinates of a user's torso onto a single coordinate system current, by calculating the rotation, translation, and scaling in a short calibration time. The method resembles the work in [5], however the continuous tracking in successive frames by Kalman filtering in [5] is simplified here to an on-demand calibration scheme, which is accurate enough for entertainment and gaming purposes. The method is tested with a small number of participants, leaving benchmarks against accurate Motion Capture systems such as Vicon, or other methods such as [5, 10] as future work.

In our tests involving multiple users, we have obtained considerably lower accuracy, compared to the theoretical offset of a single Kinect (2.9 cm) in the optimum distance with a single user. Specifically, the average offsets we have obtained were 22.65 cm and 12.64 cm, for one and two Kinects (fused by our method), respectively. However, we

can conclude that our method significantly improves the accuracy of tracking multiple users in an optimally visible area, compared to a single Kinect. It is also worth mentioning that we have used Kinect-v1 s in our experiments, which are known to cause interference by the usage of structured IR-light. Kinect-v2 s, which rely on time-of-flight instead of structured light, may give better results in the future.

Currently we are extending our displacement-only method with velocity-based calibration. The advantage of this method is that it will not require an absolute coordinate system, and the calculations will be simpler. Moreover, we are also experimenting with calibrating the microphone arrays of multiple Kinects by sonic gestures [11].

References

1. Moeslund, T.B., Hilton, A., Krüger, V., Sigal, L.: Visual Analysis of Humans. Springer, London (2011)
2. Zhang, W.: Microsoft kinect sensor and its effect. IEEE Multimedia **19**, 4–10 (2012)
3. Hsu, H.J.: The potential of Kinect in education. Int. J. Inf. Educ. Technol. **1**(5), 365–370 (2011)
4. Berger, K.: A state of the art report on multiple RGB-D sensor research and on publicly available RGB-D datasets. In: Shao, L., Han, J., Kohli, P., Zhang, Z. (eds.) Computer Vision and Machine Learning with RGB-D Sensors, pp. 27–44. Springer, Cham (2014)
5. Li, S., Pathirana, P.N., Caelli, T.: Multi-kinect skeleton fusion for physical rehabilitation monitoring. In: Proceeding 36th Annual International Conference of the IEEE Engineering in Medicine and Biology Society (EMBC) (2014)
6. Umeyama, S.: Least-squares estimation of transformation parameters between two point patterns. IEEE Trans. Pattern Anal. Mach. Intell. **13**, 376–380 (1991)
7. Giorio, C., Fascinari, M.: Kinect in Motion - Audio and Visual Tracking by Example. Packt Publishing, New York (2013)
8. Monir, S., Rubya, S., Ferdous, H.S.: Rotation and scale invariant posture recognition using Microsoft Kinect skeletal tracking feature. In: Proceeding 12th International Conference on Intelligent Systems Design and Applications (ISDA), pp. 404–409 (2012)
9. Jo, H., Yu, H., Kim, H., Sung, J.: A Study of Multiple Body Tracking System for Digital Signage of NUI Method. Advanced Science and Technology Letters, pp. 91–95 (2015)
10. Staranowicz, A.N., Ray, C., Mariottini, G.-L.: Easy-to-use, general, and accurate multi-Kinect calibration and its application to gait monitoring for fall prediction. In: Proceeding 37th Annual International Conference of the IEEE Engineering in Medicine and Biology Society (EMBC) (2015)
11. Jylhä, A., Erkut, C.: A hand clap interface for sonic interaction with the computer. In: Proceeding Conference Human Factors in Computing Systems, Boston, April 2009

Analysing Emotional Sentiment in People's YouTube Channel Comments

Eleanor Mulholland[1(✉)], Paul Mc Kevitt[1], Tom Lunney[1],
and Karl-Michael Schneider[2]

[1] School of Creative Arts and Technologies, Ulster University,
Derry/Londonderry, Northern Ireland, UK
mulholland-e9@email.ulster.ac.uk,
{p.mckevitt,tf.lunney}@ulster.ac.uk
[2] Google Ireland Ltd., Barrow Street, Dublin, Ireland
karlmicha@gmail.com

Abstract. Online recommender systems are useful for media asset management where they select the best content from a set of media assets. We are developing a recommender system called 360-MAM-Select for educational video content. 360-MAM-Select utilises sentiment analysis, emotion modeling and gamification techniques applied to people's comments on videos, for the recommendation of media assets. Here, we discuss the architecture of 360-MAM-Select, including its sentiment analysis module, 360-MAM-Affect and gamification module, 360-Gamify. 360-MAM-Affect is implemented with the YouTube API [9], GATE [5] for natural language processing, EmoSenticNet [8] for identifying emotion words and Rapid-Miner [20] to count the average frequency of emotion words identified. 360-MAM-Affect is tested by tagging comments on the YouTube channels, Brit Lab/Head Squeeze [3], YouTube EDU [28], Sam Pepper [22] and MyTop100Videos [18] with EmoSenticNet [8] in order to identify emotional sentiment. Our results show that *Sad, Surprise* and *Joy* are the most frequent emotions across all the YouTube channel comments. Future work includes further implementation and testing of 360-MAM-Select deploying the Unifying Framework [25] and Emotion-Imbued Choice (EIC) model [13] within 360-MAM-Affect for emotion modelling, by collecting emotion feedback and sentiment from users when they interact with media content. Future work also includes implementation of the gamification module, 360-Gamify, in order to check its suitability for improving user participation with the Octalysis gamification framework [4].

Keywords: 360-MAM-Affect · 360-MAM-Select · Affective computing · Brit Lab · EmoSenticNet · Gamification · Google YouTube API · Head Squeeze · Machine learning · Natural language processing · Recommender system · Sentiment analysis · YouTube · YouTube EDU

1 Introduction

The consumption of online video content has become one of the most popular activities on the Internet. In the UK, online video audiences continue to grow on all devices and

© ICST Institute for Computer Sciences, Social Informatics and Telecommunications Engineering 2017
A.L. Brooks and E. Brooks (Eds.): ArtsIT/DLI 2016, LNICST 196, pp. 181–188, 2017.
DOI: 10.1007/978-3-319-55834-9_21

the number of daily video viewers on mobile devices has increased by 46% between May, 2014 and May, 2015 [15]. YouTube alone has 300 h of video uploaded every minute and over half the video views come from mobile devices [29]. Recommender systems have proven their ability to improve the decision-making processes for users in situations that often involve large amounts of information, such as the selection of movies to watch online [11].

We are currently developing an online recommender system (360-MAM-Select) [6, 17] that employs sentiment analysis and gamification techniques applied to people's comments on videos to achieve higher quality video recommendations for users. 360-MAM-Select will adapt to sentiment expressed by users on videos, whilst gamification will motivate engagement with video content. Section 2 discusses related work on recommender systems and sentiment analysis and Sect. 3 the design and implementation of 360-MAM-Select with its sentiment analysis module, 360-MAM-Affect and its gamification module, 360-Gamify. Section 4 discusses results from testing 360-MAM-Affect by tagging comments on the YouTube channels, Brit Lab/Head Squeeze, YouTube EDU, Sam Pepper and MyTop100Videos with EmoSenticNet in order to identify emotional sentiment. Section 5 examines 360-MAM-Select in relation to other work and Sect. 6 concludes with plans for future work.

2 Background and Literature Review

2.1 Recommender Systems

Recommender systems recommend products and services whilst searching online content and rank products against others for comparison. Improving online decision-making processes, particularly in electronic commerce, then allows online users to cope with large amounts of available information [21]. Recommender system algorithms need to personalise the user experience effectively [14]. This poses a challenge, requiring efficient algorithms to supply high quality recommendations to end users [23]. Faridani [7] trained a recommender model for an online clothes store, using textual and numerical ratings from the Opinion Space dataset. Hanser et al. [10] developed NewsViz giving numerical emotion ratings to words calculating the emotional impact of words and paragraphs, facilitating the display mood of the author over the course of online football reports. NewsViz tracks the emotions and moods of the author, aiding reader understanding. Tkalčič et al. [25] propose a Unifying Framework for emotion detection and inclusion in recommender systems. This framework has three main phases: (1) entry, (2) consumption and (3) exit [25]. Most research has shown that emotions can be influential in making recommendations [30]. Little research has explored, 'how emotions interact with recommendation algorithms - the usage of emotional variables in the recommendation process' [30, p. 22].

2.2 Sentiment Analysis

Sentiment analysis is the process of recognising negative, positive and neutral opinions [27]. The advantage of sentiment analysis, when compared with traditional methods of opinion collecting, such as surveys, is that sentiment analysis can provide

a larger sample for a lower cost than traditional survey methods. Customer surveys can be very limited and costly for organisations to conduct [19]. The challenge faced by sentiment analysis is the sheer variety of data on the Internet, and that it is available in so many different forms. This information is not static, as new information is uploaded almost constantly, and most of it can be edited and changed over time [12]. Natural Language Processing [1, 19] and Machine Learning [26] techniques are frequently utilised in sentiment analysis. Lerner et al. [13] found emotions to be powerfully influential on decision-making and proposed a model of decision-making called the Emotion-Imbued Choice (EIC) model, which synthesises their findings. The EIC model takes into account emotions in two ways, firstly through the decision maker's prediction of their expected emotions as a result of the outcome of their decision and secondly, through the current emotions of the decision maker, which traditionally have been excluded from rational choice models [13].

3 Design and Implementation of 360-MAM-Select

Figure 1 shows the architecture of our recommender system for media asset management (360-MAM-Select) for monitoring and engaging users during the selection and viewing of media content, incorporating a module for sentiment analysis and emotion modelling (360-MAM-Affect) based on the Unifying Framework [25] and EIC model [13]. The gamification module, 360-Gamify, is based on the Octalysis gamification framework [4, p. 815] which displays the various gamification techniques used in applications to motivate users in different ways [4]. 360-MAM-Affect's emotion modelling module collects emotion data from the user during the entry, consumption and exit stages of the Unifying Framework, facilitating access to how the user responds emotionally to a video. Emotion data is collected on two levels, the primary emotion (mood direct experience) and the meta emotion (thoughts and feelings about the mood) [16, p. 102]. Users will choose one of the seven emotions they feel represents their present state with the Emotion Feedback Emoticon Popup shown in Fig. 1, and they will identify if they liked or disliked feeling that emotion. Recommender systems are employed to aid decision making and emotions have been found to be key in decision making [13], and hence we plan to further aid decision making by understanding users' emotions with 360-MAM-Select. The EIC model will be implemented in 360-MAM-Affect to collect data on current user emotions and expected emotion outcomes, in order to gather information about users' decision making on choosing media content. 360-MAM-Affect's sentiment analysis module harvests user YouTube comments on video content and identifies its overall reception. A collection of comments on a video aids its rating within 360-MAM-Select, in order to provide tailored recommendations for particular users. 360-Gamify provides incentives to users to interact with 360-MAM-Select by rewarding them for providing primary and meta data feedback on their emotional state or their text comments and likes/dislikes.

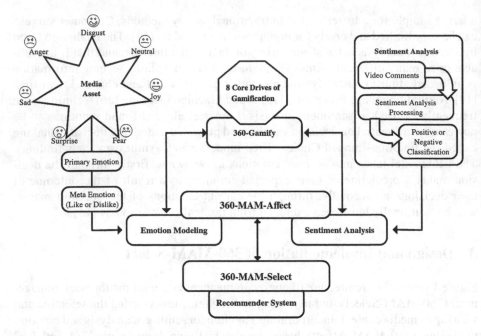

Fig. 1. Architecture of 360-MAM-Select

We implemented 360-MAM-Select's sentiment analysis module, 360-MAM-Affect using Google's YouTube API [9] for YouTube data, GATE [5] for natural language processing, EmoSenticNet [8] for identifying emotion words and RapidMiner [20] for counting the average frequency of emotion words identified. Specific YouTube channel video URLs were harvested using Google's YouTube API [9]. We then used the Google YouTube API to reap the 100 most recent user comments from each video URL. This returned a separate plain text file for each URL, with each comment collected separated by a new line.

4 Results on Analysis of YouTube Channel Comments

We gathered comments from four different YouTube Channels as shown in Table 1. Two of these channels contained mostly science and educational videos (Brit Lab [3], YouTube EDU [28]), the third was a Vlogger's Channel called Sam Pepper [22] which contained a variety of video genres and the fourth, "MyTop100Videos" [18], was collected from a playlist containing a selection of the most disliked videos on YouTube which varied in genre from education to music and Vlogs.

Table 1. YouTube channel video URLs harvested

| YouTube Channel | Format | | Number of URLs |
	Playlist	Channel	Reaped
Brit Lab/Head Squeeze		✓	490
YouTube EDU	✓		389
Sam Pepper	✓		128
MyTop100Videos	✓		426
Total			1,433

We tagged the reaped YouTube comments with emotions associated with specific concepts [17]. The plain text files reaped by the YouTube API containing YouTube comments were tagged with one or more of the relevant emotions (*Anger, Disgust, Joy, Sad, Surprise, Fear* or *Neutral*) for each concept found. This was achieved with EmoSenticNet which assigns six WordNet-Affect [24] emotion labels to SenticNet concepts and can be applied to sentiment analysis and other forms of opinion mining [8]. The natural language processing and text engineering tool, GATE, was utilised for tagging words with associated concepts from EmoSenticNetusingits ANNIE Gazetteer for text information extraction [5]. The ANNIE Gazetteer was manually modified to include lists of concepts linked to emotions from EmoSenticNet [8]. These tagged text files containing YouTube comments were then processed by RapidMiner [20] in order to identify the frequency of tagged emotions within each separate URL from each YouTube channel. We reaped up to 100 of the most recent comments from each of the 1,433 videos and calculated the average frequency of tags for *Anger, Disgust, Joy, Sad, Surprise, Fear* and *Neutral* across all of the YouTube channels, as shown in Fig. 2.

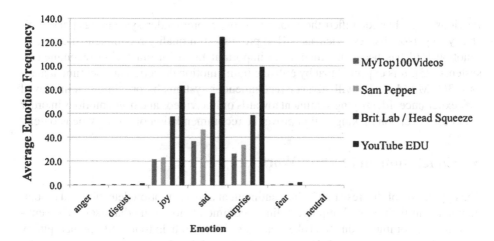

Fig. 2. Average emotion frequencies across YouTube channels

These averages were calculated by arithmetic mean:

$$(A = \frac{S}{N})$$

A = average emotion frequency, S = total sum of given tagged emotion and N = total number of video URLs for given channel. Three (*Sad, Surprise* and *Joy*) of the seven emotion tags were above 20 for average emotion frequency, which have previously been found to be more frequently related to concepts from EmoSenticNet [17]. *Anger, Disgust, Fear* and *Neutral* were considerably lower with none of these four emotions being higher than 3 for their average emotion frequency. However, this could be attributed to fewer concepts in EmoSenticNet being linked to these emotion tags [17]. The least common emotion was, *Neutral,* with an average emotion frequency of only 1, though this was not unexpected due to the low number of concepts in EmoSenticNet that were found to be neutral [17]. It is surprising that the channels, *MyTop100Videos* and *Sam Pepper* do not appear to have a higher average number of emotion tags for *Anger, Disgust, Sad* or *Fear*, considering the playlist chosen from *MyTop100Videos* includes some of the most disliked videos on YouTube. *Sam Pepper* has incurred a huge degree of criticism online for abusive and harassing actions in his videos [2]. Hence, it was expected that more negative emotions would have been found in comments on his videos. It is noted that both *MyTop100Videos* and *Sam Pepper* scored much lower in *Joy* and *Surprise* on average than the two educational YouTube channels, *Brit Lab/Head Squeeze* and *YouTube EDU*.

5 Relation to Other Work

Previous work has identified the importance of recommender systems [21] and their ability to personalise experiences [14] to provide high quality recommendations [23]. Emotion [16] has been identified as an important factor in improving recommender systems [25]. It is expected that by utilising both emotion detection and sentiment analysis, 360-MAM-Select will advance recommender systems by providing an improved user experience. Identifying sentiment towards online videos and user emotions in order to aid user decision making will improve the recommendation of online video content.

6 Conclusion and Future Work

The hypothesis of this research is that sentiment analysis, emotion detection and modelling and gamification will improve online recommendation of media assets. The sentiment in user comments on YouTube channel videos will help to identify higher quality content. Here, we discussed the architecture of 360-MAM-Select, our recommender system for media assets, including its sentiment analysis module, 360-MAM-Affect and its gamification module, 360-Gamify. We discussed the implementation of 360-MAM-Affect, employing the YouTube API, GATE for natural language processing, EmoSenticNet for identifying emotion words and RapidMiner for counting the average

frequency of those identified emotion words. We discussed results from testing 360-MAM-Affect by tagging YouTube channel comments with EmoSenticNet in order to identify emotional sentiment. Future work includes further implementation and testing of 360-MAM-Select using the Unifying Framework [25] and Emotion-Imbued Choice (EIC) model [13] within 360-MAM-Affect for emotion modelling, by collecting emotion feedback and sentiment from users when they interact with media content. The gamification module, 360-Gamify, will also be implemented and tested with the Octalysis gamification framework [4].

Acknowledgments. We wish to thank Dr. Brian Bridges, Dr. Kevin Curran and Dr. Lisa Fitzpatrick at Ulster University, John Farren and Judy Wilson at 360 Production Ltd. and Alleycats TV for their useful suggestions on this work. This research is funded by a Northern Ireland Department of Employment & Learning (DEL) Co-operative Awards in Science & Technology (CAST) Ph.D. Studentship Awardat Ulster University.

References

1. Bing, L.: AI and opinion mining. IEEE Intell. Syst. **25**(3), 76–80 (2010)
2. Blair, O.: Sam pepper heavily criticised for vile fake murder prank video. http://www.independent.co.uk/news/people/sam-pepper-criticised-over-vile-prank-fake-murder-video-a6754861.html. Accessed 15 Dec 2015
3. Brit Lab/Head Squeeze.: 360 Production. https://www.youtube.com/user/HeadsqueezeTV. Accessed 15 Dec 2015
4. Chou, Y.K.: Actionable Gamification: Beyond Points, Badges, and Leaderboards. Leanpub, Fremont (2015)
5. Cunningham, H.: General Architecture for Text Engineering (GATE). https://gate.ac.uk/. Accessed 10 Dec 2015
6. Downes, G., McKevitt, P., Lunney, T., Farren, J., Ross, C.: 360-PlayLearn: gamification and game-based learning for virtual learning environments on interactive television. In: Walshe, R., Perrin, D., Cunningham, P. (eds.) Proceedings of the 23rd Irish Conference on Artificial Intelligence and Cognitive Science (AICS-2012), Carlton Hotel, Dublin Airport, Dublin, Ireland, 17–19 September 2012, pp. 116–121. Logos Verlag, Berlin (2012)
7. Faridani, S.: Using canonical correlation analysis for generalized sentiment analysis, product recommendation and search. In: Proceedings of the Fifth ACM Conference on Recommender Systems, Chicago, Illinois, USA, 23–27 October, pp. 355–358 (2011)
8. Gelbukh, A.: EmoSenticNet. http://www.gelbukh.com/emosenticnet/. Accessed 20 Feb 2014
9. Google: YouTube API: Google Developer's Guide. https://developers.google.com/youtube/. Accessed 17 Nov 2015
10. Hanser, E., McKevitt, P., Lunney, T., Condell, J.: NewsViz: emotional visualization of news stories. In: Inkpen, D., Strapparava, C. (eds.) Proceedings of the NAACL-HLT Workshop on Computational Approaches to Analysis and Generation of Emotion in Text, Millennium Biltmore Hotel, Los Angeles, CA, USA, 5 June, pp. 125–130 (2010)
11. Kant, V., Bharadwaj, K.K.: Integrating collaborative and reclusive methods for effective recommendations: a fuzzy Bayesian approach. Int. J. Intell. Syst. **28**(11), 1099–1123 (2013)
12. Khan, K., Baharudin, B.B., Khan, A., e-Malik, F.: Mining opinion from text documents: a survey. In: Proceedings of the 3rd IEEE International Conference on Digital Ecosystems and Technologies, Istanbul, Turkey, 1–3 June, pp. 217–222 (2009)

13. Lerner, J.S., Li, Y., Valdesolo, P., Kassam, K.: Emotion and decision making. Annu. Rev. Psychol. **66**, 799–823 (2015). (Supplemental Materials)
14. Linden, G., Smith, B., York, J.: Amazon.com recommendations: item-to-item collaborative filtering. IEEE Internet Comput. **7**(1), 76–80 (2003)
15. Martin, B.: 2015 UK Digital Future in Focus (whitepaper). 2015 Digital Future in Focus. https://www.comscore.com/Insights/Blog/2015-Europe-Digital-Future-in-Focus. Accessed 17 Dec 2015
16. Mayer, J.D., Gaschke, Y.N.: The experience and meta-experience of mood. J. Pers. Soc. Psychol. **55**(1), 102–111 (1988)
17. Mulholland, E., McKevitt, P., Lunney, T., Farren, J., Wilson, J.: 360-MAM-Affect: sentiment analysis with the Google prediction API and EmoSenticNet. In: Proceedings of the 7th International Conference on Intelligent Technologies for Interactive Entertainment (INTETAIN-2015), Politecnico di Torino, Turin (Torino), Italy, 10–12 June, pp. 1–5 (2015)
18. MyTop10Videos: MyTop100Videos. https://www.youtube.com/user/MyTop10Videos. Accessed 15 Dec 2015
19. Nasukawa, T., Yi, J.: Sentiment analysis: capturing favourability using natural language processing. In: Proceedings of the 2nd International Conference on Knowledge Capture, Sanibel Island, FL, USA, 23–25 October, pp. 70–77 (2003)
20. RapidMiner: RapidMiner. https://rapidminer.com/. Accessed 4 May 2015
21. Ricci, F., Rokach, L., Shapira, B.: Recommender Systems Handbook. Springer Press, New York (2011)
22. Sam Pepper: Sam. https://www.youtube.com/user/OFFICIALsampepper. Accessed 15 Dec 2015
23. Śnieżyński, B.: Recommendation system using multistrategy inference and learning. In: Niewiadomski, A., Kacprzyk, J., Szczepaniak, P.S. (eds.) Advances in Web Intelligence, pp. 421–426. Springer, Berlin (2005)
24. Strapparava, C., Valitutti, A.: WordNet-Affect: an affective extension of WordNet. In: Proceedings of the 4th International Conference on Language Resources and Evaluation (LREC 2004), Lisbon, Portugal, 26–28 May, pp. 1083–1086 (2004)
25. Tkalčič, M., Košir, A., Tasič, J.: Affective recommender systems: the role of emotions in recommender systems. In: Proceedings of the RecSys 2011 Workshop Human Decision Making in Recommender Systems (Decisions@RecSys 2011), Chicago, Illinois, 23–27 October, pp. 9–13 (2011)
26. Tzanis, G., Katakis, I., Partalas, I., Vlahavas, I.: Modern applications of machine learning. In: Proceedings of the 1st Annual SEERC Doctoral Student Conference – DSC 2006, 1(1), Thessaloniki, Greece, 10 July, pp. 1–10 (2006)
27. Wilson, T., Wiebe, J., Hoffmann, P.: Recognising contextual polarity in phrase-level sentiment analysis. In: Proceedings of the Conference on Human Language Technology and Empirical Methods in Natural Language Processing (HLT 2005), Vancouver, British Columbia, Canada, 6–8 October, pp. 347–354 (2005)
28. YouTube EDU: YouTube EDU. https://www.youtube.com/channel/UC3yA8nDwraeOfnYfBWun83g. Accessed 15 Dec 2015
29. YouTube: YouTube Statistics. http://www.youtube.com/yt/press/statistics.html. Accessed 17 Mar 2015
30. Zheng, Y., Burke, R., Mobasher, B.: The role of emotions in context-aware recommendation. In: Proceedings of the 3rd International Workshop on Human Decision Making in Recommender Systems, ACM, Hong Kong, China, 12 October, pp. 21–28 (2013)

Mobile Device Applications for Head Start Experience in Music

Szu-Ming Chung[✉] and Chun-Tsai Wu

Department of Digital Content Design, Ling Tung University,
1 Ling Tung Road, Taichung 408, Taiwan, ROC
{szuming,ltctht53}@teamail.ltu.edu.tw

Abstract. This research intends to develop music games as mobile device applications on android system for head start experience in music. The study of design content includes the perception, knowledge formation, musical knowledge and ability, and children's play and learning motivation. 8 mobile device applications across two levels have been created and 4 of the first game level are tested by 21 preoperational children. In the latter part of this qualitative research, researchers collect data from participants' observation, video recording, and tablet input data records. The credibility and validation study consisted of two steps: analyzing and comparing 3 dimensions of attitude, interaction, and problem solving of collected data.

Keywords: Musical game · Multi-touch applications · Qualitative research

1 Introduction

To study musical game design principles, this research developed a test using multi-touch applications. In previous explorations of educational theories and music teaching methods, Chung [1] summarized important considerations for designing musical serious games: (1) pre-operational children can only perform certain cognitive functions, such as, differentiating, classifying, sequencing, egocentric representation thinking, and lack cause-effect reasoning abilities; (2) musical development in pre-operational children consists of sensing steady beats, pitch degrees and intervals, and to assess musical knowledge and representation through music activities (singing with movements, performing, improvising, conducting, and so on); (3) the preference of teaching contents and materials is sequential learning of rhythmic and melodic patterns, pentatonic scales, and folk songs/tunes.

To study the assessment of young children in musical game playing, the researchers developed 8 nonconsecutive applications over 2 levels to provide the experience and challenges of musical elements appropriate for the age range. The tested subjects were 21 children of ages 4 to 5 years old. Over the course of 10 weeks, 15 min sessions, once a week, were conducted for each child. During testing, the researchers made observations of the participants, collected video recordings and tablet input data records for analysis and discussion. To confirm the credibility and validity of this testing, we hired two graduate students as coders to perform the analysis on three dimensions: attitude, interaction, and

© ICST Institute for Computer Sciences, Social Informatics and Telecommunications Engineering 2017
A.L. Brooks and E. Brooks (Eds.): ArtsIT/DLI 2016, LNICST 196, pp. 189–196, 2017.
DOI: 10.1007/978-3-319-55834-9_22

problem solving. Their analysis extended to sub-items including: active/passive, interested/non-interested, emotional expressions, physical/verbal responses to visual/auditory cues, and exploring possible gameplay/inquiring for answers to problems. Furthermore, we examined and compared their analysis results. The following sections review the literature related to this research, development of musical applications on mobile devices, analysis and comparison results of two coders, and a conclusion.

1.1 Perception and Musical Ability

In the research of synchronization of beats, preparation, and attention, "tapping" is the most accurate practice of playing or keeping steady beats [2–5]. Humans tend to hit 20 to 60 ms earlier than the constant beats of the duple meter due to the sense of balance [6]. Accents appear to help in accurately executing steady beat tapping [7].

Humans possess auditory as well as visual perception abilities to easily differentiate melodic patterns (Gestalt theory). Melody is constructed by successive pitches with shapes and directions. Humans can also perceive melodic figures (musical themes) and background (instrumentation/orchestration), which are not necessarily true to different octaves. On the contrary, within an octave, the Gestalt principles function well on proximity, similarity, good continuation and coherence [8]. Without any musical training, 6-year-old children are no different from 11-year-olds in perceiving musical sound including the main melodies accompanied by the harmonic progressions [9].

1.2 Knowledge Formation and Musical Knowledge

The formation of knowledge requires perceptual experience to make sense of daily activities [10]. Based on Croce [11], the hierarchy of knowledge is formed through the sensory impressions and intuitive knowledge to reach logical knowledge. Croce assumes that logical knowledge continues to accumulate through intuitive knowledge linked by dynamic forms, images, and multiple representations. Thus, the intuitive knowledge is the core transformation between perceptions/sensory impressions and significant meanings/logical knowledge in the human brain.

The above analysis of how humans acquire knowledge is similar to Bruner's knowledge mapping [12]. Bruner believes that sensation, intuition, and analytic knowledge represent the knowledge system of human reality: the *enactive* (sensation), the *iconic* (image thinking), and the symbolic (abstract thinking, reflecting, and communicating).

1.3 Children's Play and Learning Motivation

A sense of competence and self-efficacy is related to a child's value of an activity [13]. According to Flow theory, the equal activity levels of challenge and self-perceived competence will most likely engage children in efficient learning [14]. While children's play may not ensure successful learning in school, it certainly offers possibilities of learning [15]. Children in play are observed to be relaxed and in pleasure. Matching challenge in gameplay to pre-operational motor skills motivates children's exploration in musical play activities.

2 Developing Musical Applications on Android System

Through applying the above theories in pre-operational children, the musical activities provide a head start and prepare children to assess their knowledge and abilities in music. Such musical applications should consist of an optimal selection of age range appropriate content, and interactivity integrated with musical activities. The next two sections discuss the design of selected musical contents, and their multi-touch interactions on the android system.

2.1 Musical Contents

To expose musical concepts to pre-operational children, we selected steady beat tapping, two-pitch interval matching (on a rainbow ladder as 7 bottom-up steps to represent the 7 tones in an octave scale), up/down scales, and pentatonic bubble improvisation for the first level. The advanced level is constructed with more advanced contents of the consonant/dissonant interval of seconds and thirds, musical form creation, and melodic pattern improvisation. The second level could be challenging for pre-operational children. These games should comply with perceptual abilities, cognitive development, knowledge forming process, and music teaching method. Beyond theoretical considerations, the intention was to engage children continuously with gameplay and creative activities, such as, pentatonic tones and melodic pattern improvisation.

2.2 Multi-touch Application and Interactivity

A multi-touch application developed with ADOBE FLASH on the Android system motivates human-computer interaction by single/dual/multi-touch of tapping, pinching, swiping, wobbling, and shaking. It not only substitutes for keyboard and mouse but also offers direct manipulation in interaction with a computer interface. Through detecting the deficiency of multi-touch technology on the Android system (swiping and pinching) and pre-operational children's incompatible sensorimotor skills (eye-hand coordination and

Table 1. The list of multi-touch interactions designed for each game

Game level	Game interface	Musical contents	Multi-touch interaction/s
1	Bouncing Penguin	Steady beat tapping	Tapping
1	Rainbow Ladder	Pitch/interval matching	Tapping
1	Rolling Ball	Up/down scales matching	Wobbling
1	Ocean Bubbles	Pentatonic Improvisation	Tapping
2	Hopscotch	Intervals of seconds and thirds	Single/dual touch
2	Tetris	2nds/3rds matching	Tapping
2	Diamond Beading	Musical form construction	Swiping
2	Ocean Bubble Links	Melodic pattern improvisation	Tapping

hand-finger gestures), we integrated the age range appropriate musical contents with compatible sensorimotor skills for multi-touch interactions. Table 1 displays the multi-touch interactions designed for each game interface.

3 Qualitative Research on Music Games

Qualitative research usually requires long term development, elongated schedule arrangement, and mandatory codes of ethics governed by the Ministry of Science and Technology in Taiwan. We have tested 21 subjects in a private kindergarten. We have only finished the first testing of 4 musical applications of the first game level. Two of the subjects have been through a second testing with satisfactory results. Through careful examining the collected data and discussions, we conducted the analysis on three dimensions: attitude, interaction, and problem solving in accordance with sub-items: passive/active, interested/non-interested, emotional expressions, physical/verbal responses to visual/auditory cues, and exploring possible gameplay/inquiring for answers to problems. The following figures display 4 musical applications from level 1 and the results of analysis and comparison between coder 1 and coder 2 (graduate student researchers).

Remark 1. The representative codes used in the following figures are: SN-Number of Subjects; a1-Active; a2-Interested; a3-Emotional expression; i1-Physical response; i2-Verbal response; i3-Response to visual/auditory cues; p1-Exploring possible gameplay; p2-Enquiring for answers to problems; C1-Coder 1; C2-Coder 2.

We first noticed that (a) and (b) in Figs. 1, 2, and 4 have the most similar analysis; and (c) in all figures have significantly opposing results. The verbal interactions were most preferred in 4 games.

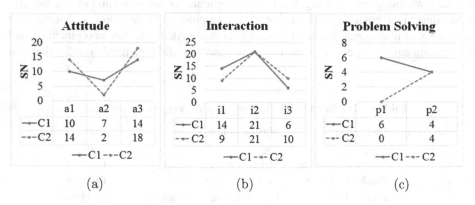

(a) (b) (c)

Fig. 1. Bouncing Penguin: analysis and comparison of 3 dimensions as (a) Attitude; (b) Interaction; and (c) Problem Solving.

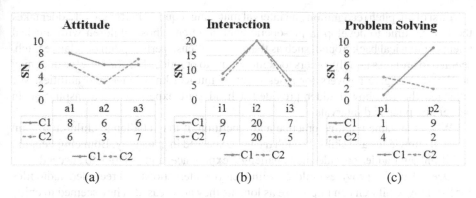

Fig. 2. Rainbow Ladder: analysis and comparison of 3 dimensions as (a) Attitude; (b) Interaction; and (c) Problem Solving.

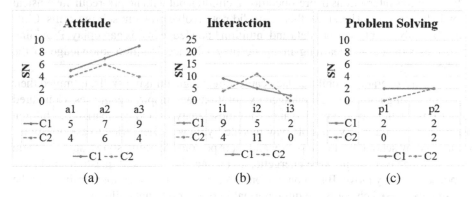

Fig. 3. Rolling Ball: analysis and comparison of 3 dimensions as (a) Attitude; (b) Interaction; and (c) Problem Solving.

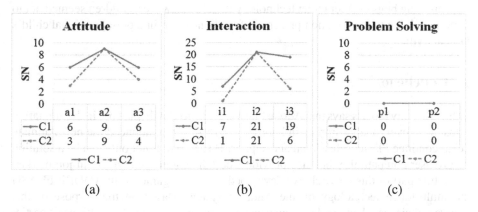

Fig. 4. Ocean Bubbles: its analysis and comparison of 3 dimensions as (a) Attitude; (b) Interaction; and (c) Problem Solving.

First of all, pitch recognition and interval matching required in Rainbow Ladder takes the longest time to develop in pre-operational children. Those children with musical talents or musical background, such as the ability to sense perfect pitch or relative pitch, seemed to progress rapidly, others took more time to practice. The Rainbow Ladder may not be able to give answers for assessment of musical knowledge and abilities. We expected the Rainbow Ladder provided a head start experience and inspiration in perceiving pitch and intervals.

When the game requires practice and repetition, it may challenge children to gain musical knowledge and skills through trying to succeed in gameplay. Bouncing Penguin and Rainbow Ladder provide such challenge, experience, and practice to succeed.

Ocean Bubbles provides children with creative interactions and recorded audio files for listening. Children can improvise as long as they are pleased. They seemed to enjoy tapping the emerging bubbles and listening to recorded improvisation. The analysis and comparison in (c) of Fig. 4—no problem solving—display that a creative music application requires interactions in pre-operational children but with no pre-requisite musical knowledge or skills. Therefore, this game did not involve problem solving skills. Children may only refer to sensory data and intuition knowledge in this gameplay. Providing further experience and learning in music may advance intuition knowledge to the symbolic stage.

Since pre-operational children lack cause-effect logic thinking skills, it limited their problem solving ability but encouraged explorations and inspired enquiries. Compared to our observations of the participants with these analyses and comparisons, children preferred to try out every possible way repeatedly. Few of them tried to ask questions. Influenced by school discipline policy and their personal learning styles, some of them were well behaved, some were energetic, and some always asked questions and gave responses to every move. Based on personal experience and educational training of the researchers, these behaviors are quite normal in pre-operational children.

Figure 3 shows some controversies in the results between the two coders. This application did not always run smoothly. We suspect that problems were caused by the programming bugs or Acer tablet technology deficits. However, children seemed not to be bothered due to the common presence of trial-and-error in a pre-operational child's daily activities.

4 Conclusion

Although many reports says that Adobe Flash is going to slowly fade out in the animation industry, to everyone's surprise, in February 2016 Adobe announced the new Animate CC to continue Flash professional and support HTML 5.0. It not only can be a solution for browser compatibility but also provide a certain amount of demand in job market. In the first part of this research, we developed 8 musical games with ADOBE FLASH and multi-touch technology on the Android system. Based on the purpose of this research, their visual and auditory interface design, testing, and observations of participants, video recordings, and tablet input data records were summarized in the previous publication: "Serious Music Game Design and Testing" [1]. This paper reports the latter

portion with the intention to further the study of the theoretical foundation and its applications, and confirm the credibility and validity through the analyses and comparison of two other coders.

The findings of this qualitative research include: (1) the purposeful aims of game design and multi-touch applications influence children's attitude, interaction, and problem solving; (2) the musical game designed as multi-touch application tends to motivate a pre-operational child's active attitudes and interactions with tablet computers; (3) the musical game that requires practice provides a challenge to pre-operational children; (4) the musical game design with creative functions and recorded audio files encourage interactions and repetition; and require no pre-requisite musical knowledge and skills; Children refer to sensory data and intuitive knowledge in such gameplay, which possesses the potential to expand to a higher level of symbolic knowledge. These findings conclude that these musical applications/games design with multi-touch interactions on Android system not only provide a head start experience in music but also challenge pre-operational children to advance their musical knowledge and skills to a higher level.

Acknowledgments. This research is funded by the Ministry of Science and Technology, ROC in Taiwan.

References

1. Chung, S.-M.: Serious music game design and testing. In: Ma, M., Oliveira, M.F., Baalsrud Hauge, J. (eds.) SGDA 2014. LNCS, vol. 8778, pp. 119–133. Springer, Heidelberg (2014). doi:10.1007/978-3-319-11623-5_11
2. Bregman, A.S.: Auditory Scene Analysis: The Perceptual Organization of Sound. MIT Press, Cambridge (1990)
3. Woodrow, H.: The effect of rate of sequence upon the accuracy of synchronization. J. Exp. Psychol. **15**(4), 357–379 (1932)
4. Dunlap, K.: Reaction to rhythmic stimuli with attempt to synchronize. Psychol. Rev. **17**(6), 399–416 (1910)
5. Stevens, L.T.: On the time sense. Mind **11**(43), 393–404 (1886)
6. Wohlschläger, A., Koch, R.: Synchronization error: an error in time perception. In: Desain, P., Windsor, L. (eds.) Rhythm Perception and Production, pp. 115–127. Swets and Zeitlinger Press, Lisse (2000)
7. Semjen, A., Schulze, H.-H., Vorberg, D.: Temporal control in the coordination between repetitive tapping and periodic external stimuli. In: Auxiette, C., Drake, C., Gerard, C. (eds.) Proceedings of the Fourth Rhythm Workshop: Rhythm Perception and Production, pp. 73–78 (1992)
8. Dowling, W.J.: Melodic contour in hearing and remembering melodies. musical perception. In: Aiello, R., Sloboda, J.A. (eds.) Musical Perception, pp. 173–190. Oxford University Press, New York (1994)
9. Colwell, R. (ed.): MENC Handbook of Musical Cognition and Development. Oxford University Press, New York (2006)
10. Polanyi, M., Prosch, H.: Meaning. University of Chicago Press, Chicago (1975)
11. Swanwick, K.: Musical Knowledge: Intuition, Analysis, and Music Education. Routledge, New York (1994)

12. Bruner, J.S.: The Relevance of Education. The Norton Library, New York (1971)
13. Parncutt, R., McPherson, G.E. (eds.): The Science & Psychology of Music Performance: Creative Strategies for Teaching and Learning. Oxford University Press, New York (2002)
14. Csikszentmihalyi, M.: Flow. Harper & Row, New York (1990)
15. Singer, D.G., Golinkoff, R.M., Hirsh-Pasek, K. (eds.): Play = Learning: How Play Motivates and Enhances Cognitive and Social-Emotional Growth. Oxford University Press, New York (2006)

The Effect of Interacting with Two Devices When Creating the Illusion of Internal State in Passive Tangible Widgets

Christoffer Bech, Andreas Heldbjerg Bork, Jakob Birch Memborg[(⊠)],
Lasse Schøne Rosenlund, and Martin Kraus

Aalborg University, Rendsburggade 14, 9000 Aalborg, Denmark
{cbec12,abork12,jmkn11,lrosen12}@student.aau.dk, martin@create.aau.dk

Abstract. This paper investigates whether the illusion of internal state in passive tangible widgets is stronger when using one touchscreen device or two devices. Passive tangible widgets are an increasingly popular way to interact with tablet games. Since the production of passive widgets is usually cheaper than the production of widgets with internal state, it is much more cost-efficient to induce the illusion of internal state in passive widgets than to use tangible widgets with an actual internal state. An experiment was conducted where the participants' belief in the illusion was determined by means of an interview with questions regarding the functionality of the tangible widgets. The results show that using two devices is significantly better at inducing the illusion of internal state.

Keywords: Illusion of internal state · Internal state illusion · Tangible widgets · Internal state on touch screen devices

1 Introduction

Touchscreen devices, such as tablets and smartphones, have become common household objects and therefore new interaction methods for these devices are more interesting than ever. Tangible Widgets (TW) offer new forms of interaction and are gaining popularity, especially for tablet games. TWs are physical tokens that lead conductivity from the user or through electronic signals to the touchscreen. Companies such a LEGO [9,10] and Disney [5,6] have produced and sold games utilising different types of TWs: TWs without electronic equipment — and therefore not requiring a battery — are henceforth referred to as *Passive Tangible Widgets* (PTW). TWs that can store information, e.g., in a memory chip, are henceforth referred to as *Internal State Tangible Widgets* (ITW). Since the production of PTWs is usually considerably cheaper than the production of ITWs, it is much more cost-efficient to induce the illusion of internal state in PTWs than to use ITWs with an actual internal state. Therefore, this project researches whether it is possible to create an illusion of internal state in PTWs, with the focus on whether using two touchscreen devices enhances the illusion when compared to the use on only one touchscreen. To this end, an experiment was conducted with

© ICST Institute for Computer Sciences, Social Informatics and Telecommunications Engineering 2017
A.L. Brooks and E. Brooks (Eds.): ArtsIT/DLI 2016, LNICST 196, pp. 197–204, 2017.
DOI: 10.1007/978-3-319-55834-9_23

two different versions of a tablet game involving imitation of storing and transferring data with a PTW. One version imitates data transfer within one device, and the other imitates data transfer between two separate devices. This paper describes the process and results of the conducted experiment.

2 Related Work

Yu et al. [12] described methods for creating passive tangible widgets that can be uniquely identified. The widgets use conductive touch points in a pattern to register on a touchscreen. The pattern consists of a coordinate system made by three points forming a 90-degree angle. Additional touch points are placed in a unique pattern inside the coordinate system to represent the ID of the widget.

Bock et al. [2,3] researched the use of PTWs in games and concluded that using these was an interesting and entertaining way of interaction with games on touchscreen devices. In addition, movement in their game was easier and more intuitive with PTWs compared to finger touch. For their research, they developed a detection algorithm for PTWs and implemented it to be used with the Unity game engine. The algorithm required PTWs with four touch points; three touch points forming a 90° angle, similar to Yu et al. [12], and with a fourth point for a unique ID. This pattern can be seen in Fig. 1(a). The implementation by Bock et al. was used in order to identify the created PTWs in this research.

(a) (b)

Fig. 1. Passive tangible widgets: *(a)* The bottom of the PTWs shows their touch pattern. *(b)* The top of the PTWs is covered with conductive material.

3 Materials and Methods

This section describes the design and implementation of the widgets and the game; in particular, how the game was designed to induce the illusion of internal state.

3.1 Widget Design

Two unique PTWs were designed with three detection points and a unique ID. The PTWs were designed and modelled in Maya and 3D-printed. Holes were made for conductive material and filled with tinfoil. The top of the PTWs were wrapped with conductive tape, as seen in Fig. 1(b), which allowed for better conductive flow between touch points. Using tinfoil ensured that the widget's bottom and touch points were flattened and thus more stable.

3.2 Game Design

A Lemmings-style game was designed, where the player had to guide a number of non-player characters through levels containing obstacles. The player had access to several virtual tools in a virtual toolbox to overcome the traps and complete four levels. Two PTWs were used to pick up and control the tools. When a widget was placed on the screen, the selected tool followed its movement and rotation. The tools could be picked up and changed freely using the widgets and the toolbox. Two versions of the game were made, one where the toolbox was integrated as a window on a tablet, see Fig. 2(a), and one version where it was displayed on a separate device next to the tablet, see Fig. 2(b). Wireless networking was used to create communication between the tablet game and the separate device. The toolbox was able to identify which widget was used to pick up a tool and the game controlled which widget contained which tool.

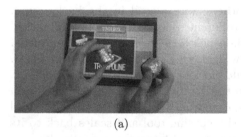 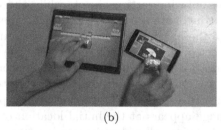

(a) (b)

Fig. 2. Game versions: *(a)* The one-device version with the integrated toolbox. *(b)* The two-device version with the toolbox on a separate smartphone.

3.3 Illusion of Internal State

For the participants to believe in an internal state in PTWs, they must see the widgets as being independent from the game. In order to create a perception of them being separate systems, such as seen with the ITWs used in e.g. Skylanders [1], data transfer was imitated between the toolbox and the game. The toolbox was designed to give visual and auditory feedback to the player when saving and placing tools with the PTW, to imitate the tools being stored in the widget. The toolbox contained three tools set up in a horizontal menu, where all of the images

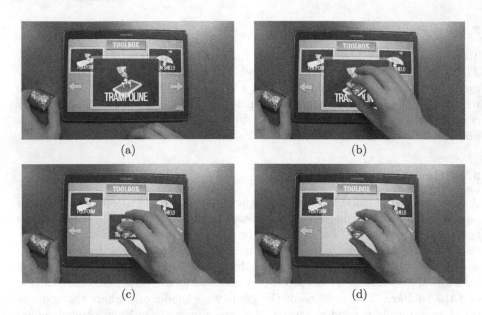

Fig. 3. The progress of scaling the image of a tool when picking it up. *(a)* The "trampoline" tool is ready to be picked up. *(b)* The user places a widget on the image of the tool. *(c)* The image of the tool is scaled down and *(d)* it disappears from the screen.

were visible at the same time. The tool in focus had its image scaled up and was the only interactive object, while the others were placed in the background. Buttons were used to scroll through the different tools. When tools were picked up, the image of the tool scaled down underneath the widget, creating a visual effect of the tool being sucked into the widget, this effect is depicted in Fig. 3. Once a tool had been picked up, it would no longer be visible in the toolbox. It was possible to place a tool back into the toolbox by placing the widget on an empty space, or by placing it on top of another tool. In both cases the tool image appears at the initial location of the specific tool and scales back to its initial size. All widget interaction was accompanied by auditory feedback.

4 Experiment Design

The experiment used a between-group [7] design with 15 participants playing the one-device game version and 15 participants playing the two-device game version. When the experiment began, the participants were introduced to the game, the widget and the toolbox in order to ensure that they understood the concept. In order to prevent bias in the introduction of the widgets, no hints to the functionality of the widget were given. If the participants asked about the functionality of the widget during the interview, they were told that they would be informed after the interview was done. This was because if the participants were told of the functionality before the end, such as that the pattern underneath

was read by an algorithm in the game, it would bias their belief in the illusion of internal state.

After the playthrough of the game, a questionnaire [8] was given to gather demographic information about the participants such as their background and technical knowledge. It was also used to gather quantitative data, in the form of Likert scale questions, regarding the widgets' stability, interaction, etc. After the questionnaire, a semi-structured interview [4] was conducted asking the participants questions about the functionality of the widget. Four interview questions were designed to determine whether the participants believed in the illusion:

- "If you should describe the widget in your own words, how does it work on a technical level?"
- "In your own words, how did the tools come from the toolbox to the game?"
- "In the toolbox, you have registered the trampoline to one widget. What do you think would happen if you placed a completely identical widget in the game?"
- "What do you believe is inside the widget?"

An interobserver evaluation was used, and four of the authors used these four questions and video recordings of the interviews as the base of determining whether a participant believed in the illusion [11]. After individual evaluation, each participant was discussed as to whether they believed in the illusion. A third option, *inconclusive*, was chosen if less than three observers agreed on a participant's belief. In these cases, not enough information was available from the interview questions to clearly determine a belief. Strong indications to a belief in the illusion were, for example, when the participants stated that there was a memory chip inside the widget, or strongly indicated that the widget was storing tools inside of it. Indications towards not believing in the illusion were if participants thought the tablet stored the data, that the screen registered the pattern of touchpoints or that nothing was inside the widget.

5 Results

The experiment was conducted on participants with different areas and levels of university experience. It was assumed that the participants had varying levels of technical knowledge, which would be beneficial when trying to determine whether this had an effect on the illusion of internal state. The participants consisted of 18 males and 12 females, in the ages of 20–26 years. On a Likert scale ranging from 1 (very bad) to 5 (very good), the participants rated their general abilities with using tablets on average as 3.53. For the statement "I have advanced knowledge of tablets and smartphones", the participants rated 2.78 on a scale from 1 (totally disagree) to 5 (totally agree).

When asked the question "If you should describe the widget in your own words, how does it work on a technical level?", some participants misunderstood the question and answered about the interaction and advantages with the widget. In these cases, the question was rephrased or elaborated to try to get a valuable

answer. In most cases it was possible to get the participant to understand the question and give their explanation.

When asked the question "In your own words, how did the tools come from the toolbox to the game?", participants in the one-device sample group had difficulties understanding it. This could be because the toolbox was integrated into the game environment and therefore the toolbox and the game was seen as a whole, whereas it was considered separate in the two-device sample group. This confusion about the question led to the question being omitted from the rest of the participants in the one-device sample group, which meant that there was less information available to determine their belief in the illusion for the interobserver evaluation. The expected feedback from the question was that they either thought the widget or the tablet controlled the storing of data. Since there were several questions asking about the functionality of the widget, it was not an issue to omit the question, as the same information could be deduced from these.

When asked the question "In the toolbox, you have registered the trampoline to one widget. What do you think would happen if you placed a completely identical widget in the game?", the participants' answers ranged from "nothing" to "it would show the trampoline". These questions indicated their belief in whether the widget actually stored the data, as if containing a memory chip. Participants were presented with an identical widget, but not all participants got a hands-on look at it, but had it lying in front of them on the table. This meant that they did not see the identical pattern underneath the widgets. It was, however, stated by the presenter that they were completely identical. Some participants who noticed the pattern underneath would in some cases change previous statements in favour of less strong indications of the widgets having internal state.

When asked the question "What do you believe is inside the widget?", the most common answers were "a memory chip", "magnets" and "I don't know". When the participants answered "magnets", it often seemed like a random guess, as they had no other ideas. These cases were not used as determining factors in the interobserver evaluation, as they are vague and can have several meanings.

The interobserver evaluation made it possible to determine the belief in the illusion for everyone except four participants, two from each of the groups. These four participants were categorised as inconclusive, as they gave contradictory answers or no answers with any indication towards a belief or not. Table 1 shows that a total of 6 participants believed in the illusion for the one-device sample group and 13 in the two-device sample group. A Wilcoxon ranked sum test determined that the belief of internal state in the two sample groups were significantly different from each other with a p-value of 0.0042.

No significant correlation was found between the participants' belief in the illusion and their answers to different Likert scale questions, such as their knowledge of tablets and smartphones, reliability of widgets, etc.

Table 1. Results of the interobserver evaluation.

Version	Believers	Non-believers	Inconclusive
One-device	6 (40%)	7 (46.7%)	2 (13.3%)
Two-device	13 (86.7%)	0 (0.0%)	2 (13.3%)

6 Discussion and Conclusion

It was not possible to determine the belief in the illusion of internal state of all participants. During the interview, the participants whose believes were not determined gave contradictory answers indicating that these participants both believed and did not believe in the illusion of internal state. Some participants would give a lot of different options, but stating that they were complete guesses and they did not know the answer. Others would not guess at all and simply stated that they did not know, despite attempts at rephrasing the questions and trying to make the participants elaborate on their answers.

Nonetheless, the results showed that using two devices was significantly better at inducing the illusion compared to one device. To achieve this result, the two devices had to resemble separate systems that were capable of functioning with the widget as the communication tool between them. In the experiment it was found that there was no correlation between the technical knowledge of the participants and their belief in the illusion of internal state, however, the participants assessed their own technical knowledge. Thus, future work should include less subjective assessments.

It would also be interesting to investigate if changing the appearance of the PTWs, such that the touch points at the bottom are indistinguishable, would impact the illusion of internal state. Furthermore, it remains to be discovered whether a system using PTWs with predefined game objects affects the illusion of internal state. Predefined PTWs would resemble the existing ITWs where their ID is bound to a game tool or character.

References

1. Activision Publishing Inc.: Skylanders video game - official website (2015). https://www.skylanders.com/da. Accessed 9 Dec 2015
2. Bock, M., Fisker, M., Fischer Topp, K., Kraus, M.: Initial exploration of the use of specific tangible widgets for tablet games. In: Aiello, L.M., McFarland, D. (eds.) SocInfo 2014. LNCS, vol. 8852, pp. 183–190. Springer, Cham (2015). doi:10.1007/978-3-319-15168-7_23
3. Bock, M., Fisker, M., Topp, K.F., Kraus, M.: Tangible widgets for a multiplayer tablet game in comparison to finger touch. In: Proceedings of the Annual Symposium on Computer-Human Interaction in Play, CHI PLAY 2015, pp. 755–758. ACM, New York (2015)
4. Cohen, D., Crabtree, B.: Qualitative research guidelines project (2006). http://www.sswm.info/sites/default/files/reference_attachments/COHEN%202006%20Semistructured%20Interview.pdf. Accessed 9 Dec 2015

5. Disney: Appmates - mobile application toys (2015). http://www.appmatestoys. com/. Accessed 9 Dec 2015
6. Disney: Disney infinity (2015). https://infinity.disney.com/dk. Accessed 9 Dec 2015
7. Ha, R.R., Ha, J.C.: Integrative Statistics for the Social and Behavioral Sciences. Sage Publications Inc., Thousand Oaks (2011)
8. Taylor-Powell, E., Hermann, C.: Collecting evaluation data: surveys. Cooperative Extension Publications (2000). http://learningstore.uwex.edu/Assets/pdfs/ G3658-10.pdf. Accessed 9 Dec 2015
9. The LEGO Group: App brick - ultra agents (2015). http://www.lego.com/en-us/ ultraagents/app-brick. Accessed 9 Dec 2015
10. The LEGO Group: Lego dimensions (2015). http://www.lego.com/en-us/ dimensions. Accessed 9 Dec 2015
11. Viera, A.J., Garrett, J.M.: Understanding interobserver agreement: the kappa statistic. Fam. Med. **37**(5), 360–363 (2005)
12. Yu, N.-H., Chan, L.-W., Lau, S.Y., Tsai, S.-S., Hsiao, I.-C., Tsai, D.-J., Hsiao, F.-I., Cheng, L.- P., Chen, M., Huang, P., Hung, Y.-P.: Tuic: enabling tangible interaction on capacitive multi-touch display. In: Proceedings of the SIGCHI Conference on Human Factors in Computing Systems, CHI 2011, pp. 2995–3004. ACM, New York (2011)

A Multimodal Interaction Framework for Blended Learning

Nikolaos Vidakis[1], Kalafatis Konstantinos[1], and Georgios Triantafyllidis[2(✉)]

[1] Department of Informatics Engineering, Technological Educational Institute of Crete,
71500 Heraklion, Greece
nv@ie.teicrete.gr, kalafatiskwstas@gmail.com
[2] Medialogy Section, Aalborg University Copenhagen, 2450 Copenhagen, Denmark
gt@create.aau.dk

Abstract. Humans interact with each other by utilizing the five basic senses as input modalities, whereas sounds, gestures, facial expressions etc. are utilized as output modalities. Multimodal interaction is also used between humans and their surrounding environment, although enhanced with further senses such as equilibrioception and the sense of balance. Computer interfaces that are considered as a different environment that human can interact with, lack of input and output amalgamation in order to provide a close to natural interaction. Multimodal human-computer interaction has sought to provide alternative means of communication with an application, which will be more natural than the traditional "windows, icons, menus, pointer" (WIMP) style. Despite the great amount of devices in existence, most applications make use of a very limited set of modalities, most notably speech and touch. This paper describes a multimodal framework enabling deployment of a vast variety of modalities, tailored appropriately for use in blended learning environment.

Keywords: Multimodal human-computer interaction · Blended learning

1 Introduction

Multimodal interaction seeks to promote a more natural way of human-computer interaction. Despite studies proving that multimodal interfaces are not more efficient or quicker than standard WIMP interfaces [1], these interfaces were also proven to be more robust and stable [2]. Moreover, multimodal interfaces enjoyed greater acceptance from the vast majority of users. Multimodal interaction displays full support of naïve physics (multi-touch interaction), body awareness and skill (gesture and speech interaction), environment awareness and skills (plasticity), as well as social awareness and skills (collaboration and emotion based interaction).

Despite these benefits, multimodal interaction is quite demanding in terms of design and implementation. Multimodal interaction can make use of any type or number of modalities, requiring a wide range of skills in unrelated domains such as software engineering, human-computer interaction, artificial intelligence and machine learning. Moreover, a review of the literature reveals that few multimodal corpora currently exist,

© ICST Institute for Computer Sciences, Social Informatics and Telecommunications Engineering 2017
A.L. Brooks and E. Brooks (Eds.): ArtsIT/DLI 2016, LNICST 196, pp. 205–211, 2017.
DOI: 10.1007/978-3-319-55834-9_24

and are targeted in specific modules and components of a multimodal interaction system. Moreover, most multimodal interaction systems, make use of a limited set of modalities, typically speech and gesture recognition.

Oviatt et al. [3] consider the following research directions: *new multimodal interface concepts,* such as blended interfaces that use both passive and active modes, *error handling techniques,* such as mutual disambiguation techniques, and dialogue processing techniques, *adaptive multimodal architectures,* that involve systems that automatically adjust to users and surroundings, and finally, *multimodal research infrastructures,* such as software tools that support the rapid creation of multimodal interfaces.

Garofolo [4] identifies another set of technological challenges, that is: *data resources and evaluation,* as the limited number of multimodal corpora in existence makes thorough evaluations unachievable, *core fusion research,* such as novel statistical methods and data representation heuristics and algorithms and, ultimately, *driver applications,* needed to guide research directions. Summarizing these findings, the following subset is derived, which is believed to be a representation of the most important issues in the field.

- *Architectures for multimodal interaction*: Because of the concurrent nature of these interaction types, tools that help in the rapid design and prototyping of multimodal interfaces are required, in order for multimodal interaction to become more mainstream.
- *Modelling of the human-machine dialog*: Because of the complex nature introduced by the large number of input and output modalities.
- *Fusion of input modalities*: A research domain, tightly coupled to human-computer dialog modeling, concerning effective fusion algorithms able to take into account multiple aspects of human-machine dialog.
- *Time synchronicity*: The ability to take into account, and adapt to multiple modal commands which can trigger different meanings, following their order, and delay between them.
- *Plasticity/adaptivity to user & context*: The capability of a human-machine interface to adapt both to the system's physical characteristics and environmental variables while preserving usability [5].
- *Error Management*: Being the weak link of multimodal interaction, since it is always assumed that users will behave in perfect accordance with the system's expectations of behavior, and that no unwanted circumstance will appear. Apparently, this is not the real life case, and error management will have to be carefully handled if multimodal interfaces are to be used broadly.
- *User feedback* is somewhat related to error management, in that the user is allowed to correct or adjust the behavior of the multimodal system in real time.

This paper presents a specific and efficient architecture and framework of multimodal interaction to be used in a blended learning environment. In the following Section, different interaction modalities will be investigated, while in Sect. 3 the main goals and principles of the blended learning approach will be presented. Section 4 presents the proposed multimodal interaction framework. Finally, Sect. 5 draws the conclusions.

2 Interaction Modalities

According to Bellik and Teil [6] modality is "a concrete form of a particular communication mode" where mode is defined as the five human senses (sight, touch, hearing, smell and taste) which constitute the receiving information, and the multifarious ways of human expression (gesture, speech, etc.) which constitute the product information. Furthermore, Bellik and Teil's definition characterizes the nature of information of human communication as visual mode, sound mode, gestural mode, etc. For example, noise, music and speech are modalities of the sound mode.

Nigay and Coutaz [8] formally present the modality as: $m = (d,r)|(m,r)$, where "d" denotes the physical I/O device, "r" an interaction language (representational system) and "m" an interaction modality. For example, the speech modality can be defined using the "Microphone" as a physical device and "Pseudo-natural language" as an interaction language (Table 1).

Table 1. Examples of interaction modalities

Modality	Mode	Interaction language	Device
Acceleration	Gesture	Direct manipulation	Accelerometer
Speech	Voice	Natural language	Microphone
Hand motion	Gesture	Specialized sign language	RGB camera
Facial expression	Gesture	Specialized sign language	RGB camera
Pointing gestures	Tactile	Direct manipulation	Touch screen
Orientation	Gesture	Direct manipulation	Gyroscope
Speech synthesis	Audio	Natural language	Speakers

Modalities can also be classified according to the required user attention. A modality may be considered active if used consciously by the user, while it can be considered passive if used unconsciously. For example, using hand motions to control a specific element of the user interface is considered an active modality, while capturing the user location with a GPS is considered passive, since it does not need user attention. However, if the user moves on her own to go to a particular location by using the GPS location to create a path, the position using GPS modality may be then considered active.

A system is considered multimodal when it processes "two or more combined user input modes (such as speech, pen, touch, manual gesture, gaze and head and body movements) in a coordinated manner with multimedia systems output" [9].

3 Blended Learning

Over the years, pedagogical methods evolved and consistently improved compared to the educational systems of the past. A significant factor of this progress is unquestionably the increasing use of technology in teaching. Nowadays, most educators prefer to blend

traditional teaching with interactive software, in order to achieve the maximum involvement of their students and to consolidate their learning.

A sufficient description of blended learning could be the following: "Blended learning is the process of using established teaching methods merged with Internet and multimedia material, with the participation of both the teacher and the students" [10]. Still, there are a few matters in question regarding the process of creating blended learning environments [11]:

- Firstly, there is the issue of the importance of face to face interaction. Several learners have stated that they are more comfortable with the part of live communication in merged teaching methods, considering it more effective than the multimedia based part. Others are of the exact opposite opinion, which is that face to face instruction is actually not as required for learning, as it is for socialization. There are also those who believe that both live interaction and online or software material are of the same significance and it is the learner's decision which of the two is more suitable for their educational needs.
- Secondly, there is the question of whether the learners opt for combined learning exclusively because of the flexibility and accessibility of the method, without taking into account if they are choosing the appropriate type of blended teaching. Also, there are doubts regarding the ability of the learners to organize their own learning without the support of an educator.
- Another matter, is the need for the instructors to dedicate a large amount of time to guide the learners and to equip them with the necessary skills in order to achieve their goals. In addition, the instructors need to continue being educated themselves to be able to meet the requirements of blended teaching.
- There is also the argument that schools which have integrated technology into the curriculum are mostly addressed and beneficial to people in a comparatively favorable position in terms of economic or social circumstances. This, however, is refuted by the fact that blended teaching methods are quite affordable and easily accessible. The quick distribution of the multimedia material used in this type of instructing, is considered an advantage, but the universality of the system raises the need to modify the provided material, in order to make it more culturally appropriate for each audience.
- Lastly, a continuous effort is being made to proceed to the new directions given by the novelties of technology while maintaining a low-priced production of educational material. The uninterrupted evolution of communication and information technology is making this effort rather strenuous for the developers of such teaching models.

Despite the difficulties faced when designing blended learning techniques, the advantages of combining face to face instructing with technology are many. Some of enormous importance are [11]:

1. The learner is intrigued by the procedure itself and as a result, the material being taught seems more interesting to them. This leads to the easier accomplishment of the educational goals that the teacher has set.

2. There is no limitation regarding the time or the place of the lesson. A student can attend remote classes being offered online, frequently having the opportunity to record and watch again the lesson.
3. The cost of the teaching process is greatly reduced. Every school unit that uses blended learning, has access to a variety of Internet and software material which would require a lot of time and effort to be independently produced, resulting in additional expenses.
4. In industrial applications of blended learning, it has been observed that the desired results have been achieved twice as fast as with the established instruction methods.

Blended learning should not be conceived solely as a method of enriching the class with technology or making the learning process more accessible and engaging. Its main purpose is to modify and adjust the teaching and learning interaction in order to upgrade it. It assists and enables the growth of critical thinking, creativity and cognitive flexibility [12]. In this context, the following section presents a framework of multimodal interaction to be used in a blended learning environment.

4 Multimodal Interaction Framework for Blended Learning

Based on the goal for an efficient "educational platform for blended learning that enables multimodal player interaction" a framework has been developed that lays between the interaction devices deployed by the users and the engine used by the system platform, endowing the application with multimodal interaction capabilities. Figure 1 demonstrates the framework's architectural overview.

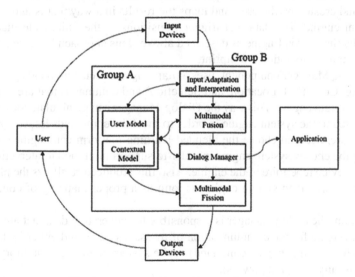

Fig. 1. Framework's architectural overview.

The framework consists of two main modules namely the Context Management module (group A) and the I/O Management module (group B). In more detail the Context

management module includes the "User Model" and the "Contextual Model" components and the I/O Management module includes "Input Adaptation and Interpretation", "Multimodal Fusion", "Dialog Management" and "Multimodal Fission" (see Fig. 1). In the next few paragraphs the framework modules and components are described in detail.

The Input Adaptation and Interpretation component, is responsible for the recognition of data provided by the user. This recognition can be both direct, e.g. speech recognition directly from the microphone, and indirect, e.g. gesture recognition from the Microsoft Kinect sensor.

The Multimodal Fusion component is responsible for interpreting data from the recognizers into meaningful commands. In a blended learning platform, which is deployed in a set-box environment, with often limited processing power, it is crucial to minimize the workload of each component framework. For that reason, the fusion component is centered towards decision level fusion, which assigns a major amount of responsibility to the various recognizers, which provide data that must be interpreted and merged to achieve a final interpretation. A frame-based strategy was chosen due to its simplicity and the ease of augmentation. These augmentations, among others, include attribute constraints and modality prioritization.

The Dialog Manager component, manages changes in the application state, and is responsible for the communication of the framework with the application. It is also responsible for providing output information to the Fission Engine for communication between the framework and the user.

In our approach the dialog manager module uses a finite state machine to identify the command created by the user, and maps the results in a way that is understandable by a system engine. The data that trigger transitions in the finite state machine are generated by the Fusion Engine as described above. This approach is chosen due to the relatively small computational footprint.

The Dialog Manager component, uses a mapping between commands generated by the user (e.g. Command, Location, and Selection) and commands that are understandable by the system engine. This way the Dialog Manager can manipulate the commands communicated to the system engine in order to meet the commands issued by the user. Due to this architectural choice the blended learning platform can augment the functionality of the chosen system engine in order to support multimodal interaction and/or expand the device repertoire of the engine. Also this architecture allows the platform to function with any given system engine as long as a proper mapping of commands is created.

In addition, the dialog manager is responsible for generating data that are passed to the Fission Engine for the communication of messages generated either by the framework itself (e.g. an incomplete command) or the system engine (e.g. auditory notifications, for visually impaired players).

The Fission Engine component. The Fission Engine component is responsible for generating appropriate output messages directly to the user, in a format that is compliant with the user and application context, as well as the environmental variables.

5 Conclusion

In this paper we have presented the ongoing work on a framework that supports multimodal interaction to assist blended learning. Our primary design target is to set up a framework that supports multimodal interaction on educational games according to available I/O modalities, user needs, abilities and educational goals.

Ongoing work covers a variety of issues of both technological and educational engineering character. Some of the issues to be addressed in the future include: (a) Run various use cases in vivo with the guidance and involvement of users and (b) Elaborate further on the Multimodality Amalgamator module to involve more input and output modalities so that the roles between game player and machine are reversed and the player performs gestures, sounds, expressions etc. and the machine responds.

References

1. Oviatt, S.: Ten myths of multimodal interaction. Commun. ACM **42**(11), 74–81 (1999)
2. Oviatt, S.: Advances in robust multimodal interface design. IEEE Comput. Graph. Appl. **23**(5), 62–68 (2003)
3. Oviatt, S., Cohen, P., Wu, L., Vergo, J., Duncan, L., Suhm, B., Bers, J., Holzman, T., Winograd, T., Landay, J., Larson, J., Ferro, D.: Designing the user interface for multimodal speech and pen-based gesture applications: state-of-the-art systems and future research directions. Hum. Comput. Interact. **15**(4), 263–322 (2000)
4. Garofolo, J.: Overcoming barriers to progress in multimodal fusion research. In: Multimedia Information Extraction: Papers from the 2008 AAAI Fall Symposium Arlington, Virginia, pp. 3–4. The AAAI Press (2008)
5. Thevenin, D., Coutaz, J.: Plasticity of user interfaces: framework and research agenda. In: Proceedings of INTERACT, vol. 99 (1999)
6. Elouali, N., Rouillard, J., Pallec, X.L., Tarby, J.-C.: Multimodal interaction: a survey from model driven engineering and mobile perspectives. J. Multimodal User Interfaces **7**(4), 351–370 (2013)
7. Bellik, Y., Teil, D.: Définitions Terminologiques pour la communication multimodale. In: presented at the Proceedings of Interface Hommemachine (IHM) (1992)
8. Nigay, L., Coutaz, J.: Multifeature systems: the CARE properties and their impact on software design. In: Multimedia Interfaces: Research and Applications, Chap. 9 (1997)
9. Oviatt, S.: Advances in robust multimodal interface design. IEEE Comput. Graph. Appl. **23**(5), 62–68 (2003)
10. Friesen, N.: Report: Blended Learning (2012)
11. Bonk, C.J., Graham, C.R. (eds.): Handbook of Blended Learning: Global Perspectives, Local Designs. Pfeiffer Publishing, San Francisco, Chap. 1.1, Blended learning systems: Definition, current trends, and future directions (2005)
12. Singh, H., Reed, C.: A white paper: achieving success with blended learning. Centra softw. **1**, 1–11 (2001)
13. Garrison, D.R., Kanuka, H.: Blended learning: uncovering its transformative potential in higher education. Internet High. Educ. **7**(2), 95–105 (2004)

Multimodal Detection of Music Performances for Intelligent Emotion Based Lighting

Esben Oxholm, Ellen K. Hansen, and Georgios Triantafyllidis[✉]

Lighting Design - Architecture, Design and Media Technology, Aalborg University Copenhagen,
AC Meyers 15, 2450 Copenhagen, Denmark
ebonde14@student.aau.dk, {ekh,gt}@create.aau.dk

Abstract. Playing music is about conveying emotions and the lighting at a concert can help do that. However, new and unknown bands that play at smaller venues and bands that don't have the budget to hire a dedicated light technician have to miss out on lighting that will help them to convey the emotions of what they play. In this paper it is investigated whether it is possible or not to develop an intelligent system that through a multimodal input detects the intended emotions of the played music and in real-time adjusts the lighting accordingly. A concept for such an intelligent lighting system is developed and described. Through existing research on music and emotion, as well as on musicians' body movements related to the emotion they want to convey, a row of cues is defined. This includes amount, speed, fluency and regularity for the visual and level, tempo, articulation and timbre for the auditory. Using a microphone and a Kinect camera to detect such cues, the system is able to detect the intended emotion of what is being played. Specific lighting designs are then developed to support the specific emotions and the system is able to change between and alter the lighting design based on the incoming cues. The results suggest that the intelligent emotion-based lighting system has an advantage over a just beat synced lighting and it is concluded that there is reason to explore this idea further.

Keywords: Multimodal detection · Emotion-based lighting

1 Introduction: Music, Emotion and Light

The origin, meaning and purpose of music is not clear cut. Though, one common theme seems to be agreed upon: Music convey emotions. As Juslin and Laukka [1] puts it: *"[...] A convincing emotional expression is often desired, or even expected, from actors and musicians".*

Music is capable of generating and amplifying the feelings of being happy, sad, angry, motivated, etc. [2]. Examples of how music is used in our daily lives underscores this statement. Think of the nature of the music used at e.g. a funeral versus a summer party, or how the music in a cozy café seeks to generate a relaxed and laid back atmosphere. Another example is the way music effectively is used in movies to enhance the intended emotion of a particular incident.

© ICST Institute for Computer Sciences, Social Informatics and Telecommunications Engineering 2017
A.L. Brooks and E. Brooks (Eds.): ArtsIT/DLI 2016, LNICST 196, pp. 212–219, 2017.
DOI: 10.1007/978-3-319-55834-9_25

If one of the main purposes of music is to convey emotions, then it must be assumed that the purpose of live concerts is to convey emotions as well. When listening to a record, only the auditory sense is being used as a channel for receiving the emotional output. At live concert the visual sense is brought into play as well.

Several visual tools can be used to express certain emotions. One is, that apart from playing the music, the performers are able to use their body language and facial expressions to convey emotions. Another is the outfit of the performers and the stage decoration. It can be done in a way that brings out certain emotions and moods. A third factor is lighting. Whether intended or not the lighting has an effect on the conveyed emotions.

At the time being, research that either approves or disproves this third statement has not been found. Therefore, it is treated as a hypothesis. However, there seems to be a common agreement upon that lighting is important for the emotions communicated at concerts:

"Lighting at a rock show is one of those things that most people don't consciously think about but can strongly impact their experience. Through lighting techniques, a stadium show can feel as intimate as a small club show. The audience can be made to feel inspired, disturbed, moved, or impressed, depending on the emotions that the artist is trying to communicate. It is one of the many sophisticated ways that the rock concert industry has developed to enhance the live concert experience and make it truly spectacular" [3].

"Lighting adds as much to the experience as the artist we have paid money to see. Nowadays, when we perhaps spend much more of our money on seeing our favorite musicians live than we do on expanding our CD collection, the role of lighting in these events has never been more under the spotlight" [4].

A concert is always accompanied by lighting in someway. From advanced pre-programmed light shows at big stadium concerts with an audience of tens of thousands to a few static light sources at small stage in a café with maybe five people (not) looking. Even when there is no dedicated lighting for the concert, there will always be the daylight or the artificial light that is in the room where the music is performed. Whether the lighting helps to convey the intended emotions or not, depends on if the lighting fits with the intended emotions of the music. E.g. if the purpose of the music being performed on a small stage in a café is to provide relaxing background music, then a few static bulbs helps to enhance the feeling of relaxation. No movements, no blinking lights and no shifting colors. In the same way, if the purpose of the stadium rock concert is to convey emotions of excitement, control and anger, then the advanced pre-programmed light show seems like an optimal way to enhance that. A lot of variation, shifting colors, blinking lights. Try to imagine the opposite. A wild light show for the relaxing café concert and a few static bulbs for the rock concert. It would not fit well with the music.

This statement is supported by Ethan Weber, who has designed lighting for Marilyn Manson, My Chemical Romance and Green Day and operated lights for The Rolling Stones and U2. When talking about one of his successful lighting design he ends concluding: *"The lighting worked because it matched the emotional meaning of the song"* [5].

In this context, this paper tries to answer the question of how to create an intelligent lighting system that helps conveying the intended emotion of what is being played at a concert and thus enhancing how well the emotions are being perceived by the audience. Answering this question will provide the added value of enabling bands on a budget

playing at small venues to give a stronger emotional live performance through lighting. At the time being, this work does not seek to compete with a dedicated light technician or a fully programmed light show. Rather it should be seen as an improvement to the beat-synced lighting and ultimately as an option to the in-house light technician.

The rest of the paper is organized as follows: The next section analyses the emotion cues (both auditory and visual) that are perceived by the audience. Then, the proposed design solution for the lighting control is presented in Sect. 4 to support conveying the intended emotion at a concert. Next section presents a proof of concept test and finally conclusions are discussed in the last section.

2 Analysis: Emotion Cues

When an audience are looking at a performer or a band playing a song, the two most activated senses are the auditory and the visual.

Auditory emotion cues: Research on music and emotion shows that there exists several cues in music that can be used to determine the emotion of what is being played. As Juslin and Sloboda write [6]: *"[...] researchers have tried to describe the means by which performers express specific emotions [...] One main finding from this line of research is that the performer's expressive intention affects almost every aspect of the performance; that is, emotional expression in performances seems to involve a whole set of cues - or bits of information - that are used by performers and listeners."*

Also, Juslin and Sloboda have summed up the results in a diagram showing the auditory cues used to express happiness, sadness, anger, fear and love/tenderness. These are the emotions that have been studied most and furthermore are regarded as 'basic-emotions' by scientists [6]. As shown in Fig. 1, a vast amount of different cues affects the intended emotion. However, they are not equally important and they are not always present. They end up concluding that the cues that have the greatest impact on the

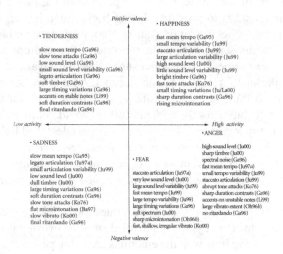

Fig. 1. Auditory cues

intended emotions is tempo, sound level, articulation and timbre. It is thus possible to define the emotion of a piece of music by analyzing these four cues.

Visual emotion cues: In the same way as the detection of emotion from sound, the detection of emotion from a musician's body movement relates to a set of cues. In a study from 2007, Dahl and Friberg [7] investigate the visual information provided by the performer. As described in the study paper: *"Musicians often make gestures and move their bodies expressing the musical intention. This visual information provides a channel of communication to the listener of its own, separated from the auditory signal. In order to explore to what extent emotional intentions can be conveyed through musicians' movements, subjects watched and rated silent video clips of musicians performing four different emotional intentions, Happy, Sad, Angry, and Fearful"*.

Besides rating how well the emotions were conveyed, the subjects were also asked to rate the movement they saw, based on the following four cues: Regularity, fluency, speed, amount: *"The assumption was that Amount would correspond to an overall measure of the physical magnitude of the movement patterns, Speed to the overall number of movement patterns per time unit, Fluency to the smoothness of movement patterns, and Regularity to the variation in movement patterns over the performance"*. The study in [7] ends by concluding that the emotions of sadness, happiness and anger was successfully conveyed through body movements only, while fear was not. It is also concluded that the cues mentioned above can be used to describe the different intended emotions.

Overview of the emotion cues: The auditory and visual cues used to convey the emotions of happiness, sadness and fear are summed up in Table 1.

Table 1. Auditory and visual cues

		Happiness	Sadness	Anger	Fear
Auditory cues	Tempo	Fast	Slow	Fast	Fast
	Sound level	High	Low	High	Very low
	Articulation	Staccato	Legato	Staccato	Staccato
	Timbre	Bright	Dull	Sharp	n/a
Visual cues	Regularity	Regular	Regular	Regular	n/a
	Fluency	In-between jerky and smooth	Smooth	Jerky	n/a
	Speed	Fast	Slow	Fast	n/a
	Amount	Medium	Small	Medium	n/a

3 Proposed Design

Having established the most important cues that are used to convey certain emotions, it is time to focus on how the intelligent system should detect and process these cues (which for sound is tempo, sound level, articulation and timbre and for body movement is regularity, fluency, speed and amount). Basically the system can be divided into three stages: Input, processing and output (see Fig. 2):

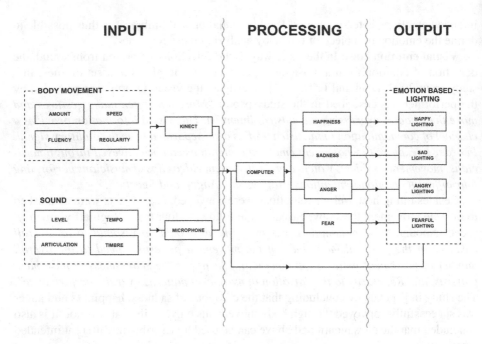

Fig. 2. System's flowchart

Input: The input stage deals with the cues described above. The visual cues are going to be detected via a Microsoft Xbox 360 Kinect camera (using the Processing library SimpleOpenNI). The advantages of using the Kinect over a regular camera is the use of infrared light. The sound is detected through a regular microphone.

Processing: In the stage of processing, the detected cues are fed into a piece of software where they are analyzed. Based on predefined values in the software, the system is able to decide if the cues together result in an emotion of happiness, sadness, anger or fear.

Output: The third stage of the system is the output of the lighting. The software contains different lighting designs that are developed specifically to the different detected emotions. E.g. if the emotion detected based on the cues is anger, then a lighting design that supports the emotion of anger is activated. The lighting design for each emotion is not static. The cues detected in the input stage are used to alter the lighting within certain boundaries for each emotion.

4 Proof of Concept Test

For the design testing, a simplified proof-of-concept version of the system is being used. That is to keep the number of variables low and thus keeping the number of possible errors as low as possible. If it is possible to make a system that works using only a couple of cues, then the system can be expanded to include all cues and emotions. To this goal, the possible emotions has been reduced to happiness and sadness. The reason for this

choice is the fact that they are the ones that consists of cues that are most different. Also, it seems to be the emotions that are the most basic to express and recognize [7]. In the input stage the cues have been reduced to the speed of the body and, level and tempo of the music. The speed of the body has been chosen because that it is the visual cue that differ the most between sadness and happiness. The level and tempo of the music have been chosen as they seem to be the most common and easiest recognizable cues.

So, how is lighting designed to support emotions of happiness and sadness respectively? As described earlier, the emotion in music can be described via sets of certain cues coming from both auditory and visual input. A set of cues can be defined for the lighting as well, that in the same way as with music, defines the intended emotion. Research has shown that the cues used for speech relates to the cues used in music: *"The results revealed a number of similarities in code usage. For example, vocal expression of sadness is associated with slow speech rate, low voice intensity, low intonation, and little high-frequency energy in the spectrum of the voice."* [6]. Also, a research study on dance, or people's movement to music, concludes that happy movements relates to high-dimensional movements, while sad movements is simple, low dimensional, long and smooth movements and covering little space [8]. Based on the mentioned research and the recurrence of almost identical emotion cues across disciplines, it is hypothesized that designing the lighting based on the same cues will make sure that it supports the intended emotions of the performance.

Light attributes: The cues used to define the emotion of the lighting are inspired by the most important auditory and visual cues, which is *level, tempo, articulation and timbre* and *amount, speed, fluency and regularity*. The ones used for the lighting are defined as: *Intensity, speed, fluency, regularity, hue, saturation and brightness*. The intensity relates to the brightness of the output. The speed defines how many changes, within a certain emotion, happens over a period of time. The fluency relates to how fluent the changes between different intensities and hues are within a certain emotion. The regularity relates to variation in patterns over the performance. Hue and saturation relates to the hue and saturation of the color of the lighting.

Happy lighting: The cues from previous research that relates to happy is defined as fast tempo, high level, staccato articulation, bright timbre, regular, somewhat jerky fluency and medium amount of movement. These cues have been used to define the cues for happy lighting shown in Table 2.

Table 2. Lighting cues

Emotion	Intensity	Speed	Fluency	Regularity	Hue	Saturation
Happiness	High	Fast	Somewhat jerky	Regular	Yellow	High
Sadness	Low	Slow	Smooth	Regular	Violet	Low

Sad lighting: As with the happy lighting, the cues for sad lighting has been defined inspired by the cues of the previous research. That is, slow tempo, low level, legato articulation, dull timbre, smooth fluency and small amount of movement. The cues defined for the sad lighting can be seen in Table 2.

The hue of the lighting has been inspired by a research study on how colors relates to music conveying different emotions [9]. Although the results are not very strong, the study concludes that the hue that relates the most to happiness is yellow and the one that relates most to sadness is violet.

Test: For comparison reasons the emotion based lighting will be tested against beat-synced lighting. As written in the introduction, one of the goals for the emotion-based lighting is to be an improvement to beat-synced lighting. To this goal, prior to the test the performer prepared two solo performances for a single snare drum. The two performances are exactly the same composition-wise and rhythmically. The difference is the fact that the first rhythm is played using the cues that relates to sadness and the second rhythm is played using the cues that relates to happiness. I.e. rhythm 1 is slow, low in volume and requires slow body movements, while rhythm 2 is fast, loud and uses fast body movements.

Findings: Figure 3 shows the results from the test. The orange dots represent the markings from audience 1 who were subject to the emotion-based lighting. The grey dots represent audience 2 who were subject to the beat-synced lighting. The top line shows the results for the first performed rhythm, the sad one, while the bottom line shows the performance of rhythm 2, the happy one.

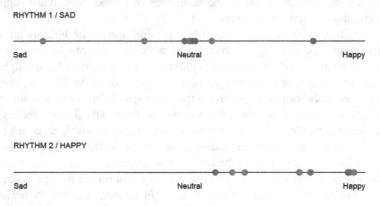

Fig. 3. Test results (Color figure online)

Although this test is based on a small sample size, it supports the idea that the emotion-based lighting in fact are better at conveying the intended emotion of what is being played and thus enhancing how well the emotions are being received by the audience compared to beat-synced lighting. The results show that the beat-synced lighting failed in conveying the emotion of sadness. One test subject even perceived the sad performance as being happy. However, the beat-synced lighting was as good as the emotion-based lighting at conveying happiness.

5 Conclusions

Through existing research on music and emotion and musicians body movements related to the emotion the want to convey, a set of cues to look and listen for was defined. This included amount, speed, fluency, and regularity for the visual and level, tempo, articulation, and timbre for the auditory. Using a microphone and a Kinect camera to detect these cues it was possible to create a system that is able to detect the intended emotion of what is being played - at least in a proof-of-concept version dealing with the emotions of happiness and sadness.

Specific lighting designs were developed to support the specific emotions and the system was able to change between and alter the lighting based on the incoming cues. It was tested how well the emotion-based lighting performed in enhancing the conveying of the intended emotions compared to beat-synced lighting. The results showed that the emotion-based lighting is promising.

References

1. Juslin, P., Laukka, P.: Communication of emotions in vocal expression and music performance: different channels, same code? Psychol. Bull. **129**(5), 770–814 (2003)
2. Trainor, L.J., Schmidt, L.A.: Processing emotions induced by music. In: The Cognitive Neuroscience of Music, pp. 310–324 (2003)
3. Lighting the Rock Concert Corporate Event. http://www.forbes.com/sites/ruthblatt/2014/08/25/lighting-the-rock-concert-corporate-event/#1dc48e2bf90e
4. Playing with the Spectacular Interactive Lighting. http://origin.www.futureoflight.philips.com/post/84508677106/playing-with-the-spectacular-interactive-lighting
5. Lighting the Rock Concert Corporate Event. http://www.forbes.com/sites/ruthblatt/2014/08/25/lighting-the-rock-concert-corporate-event/#2715e4857a0b6c165f59f90e
6. Juslin, P., Sloboda, J.: Music and Emotion, Theory and Research. Oxford Press, New York (2001)
7. Dahl, S., Friberg, A.: Visual perception of expressiveness in musicians' body movements. Music Percept. **24**(5), 433–454 (2007)
8. Burger, B., Saarikallio, S., Luck, G., Thompson, M.R., Toiviainen, P.: Emotions Move Us: Basic Emotions in Music Influence People's Movement to Music (2012)
9. Bresin, R.: Real-time visualization of musical expression. In: Proceedings of HUMAINE Workshop on From Signals to Signs of Emotion and Vice Versa', Santorini, Greece. Institute of Communication and Computer Systems, NTUAthens (2004)

Widening the Experience of Artistic Sketchbooks

Henning Christiansen$^{(\boxtimes)}$ and Bjørn Laursen

Roskilde University, Roskilde, Denmark
{henning,blaursen}@ruc.dk

Abstract. Artist's sketchbooks may provide important insights into the genesis of the finished works and may also contain artworks that are at least as interesting and sometimes even more fascinating and fresh. However, sketchbooks are delicate and problematic exhibits; displaying them in a showcase leaves at most two pages visible, and allowing visitors to handle the books does not make sense. This paper describes an interactive, virtual sketchbook technology intended for the display of books which, at the same time, is faithful to the original book and provides an enhanced spatial experience, a gigantic pocketbook which you may seem to enter spatially and bodily. The installation has been shown at The Italian Culture Institute in Copenhagen (2011), two public libraries (2012–13), two Danish art museums (2014), and the Book Fair in Bella Center, Copenhagen (2015).

Keywords: Interactive installation · Gigantic format · Bodily experience · Visuospatial innovation · Art exhibitions · Sketchbooks · Digital experience

1 Introduction

"Culture is habits" the Danish historian and Minister of Culture, Hartvig Frisch, claimed as the opening remark of his famous book "History of European Culture" [2]. What you experience meeting our (possibly) giant sized innovation, an up to four meters high interactive sketchbook, is a highly deliberate break of habits in dealing with books. From the dimensions of the book and the close distance to it, follows the fact that the field of viewing cannot be focused entirely simultaneusly, knowing that our sharp view only covers little of the entire field of vision in our horizontally oriented stereo view [3, p. 113 ff].

Different media represent different potentials for experiencing space [7]. Different media also offer different use of your body during spatial experience and familiarization. One of the greatest masters in relation to create fascination is the Danish poet Hans Christian Andersen. He very often used the parameter of size to provoke and engage our imagination. He often makes the diminutive gigantic and vice versa. An ordinary window frame can be transformed into a whole world or universe of its own. In the "The Tinder-Box", Andersen let no less than tree spatial monsters of dogs loose, the copper, the silver, and the gold protector. The size of the dogs grows bigger with the value of their protections,

© ICST Institute for Computer Sciences, Social Informatics and Telecommunications Engineering 2017
A.L. Brooks and E. Brooks (Eds.): ArtsIT/DLI 2016, LNICST 196, pp. 220–227, 2017.
DOI: 10.1007/978-3-319-55834-9_26

leading to their terrifying huge eyes. Humans in general and academics in particular pay little attention to the phenomenon of the common presence of their body as a basic precondition for our common and more specific behavior [8], a point of view that is sharply underlined by French phenomenologist philosopher Maurice Merleau-Ponty, who writes in "Phenomenology of Perception" [9]: "We must therefore avoid saying that our body is in space, or in time. It inhabits space and time" (p. 139). This "inhabitation" of space and time is central for understanding the experiencing person's interaction, responding to spatial signals and spaces and turning pages in an ongoing activity, getting access to the inside of the drawings, being intertwined with the life of the huge pages. "I am not in space and time, nor do I conceive space and time; I belong to them, my body combines with them and includes them. The scope of this inclusion is the measure of that of my existence" (p. 140). The experiencing person gets an opportunity to be included in an existential "being in the world" following his or her body's own concrete body-experience of being alive. As such, humans experience the surrounding world depending of the position of their body in exactly that world: "It is a space measured from me as point zero of the spatiality. I do not see the space from outside as an outer shell, but I experience it from inside, being surrounded by it. All in this world is not in front of me, but around me" [10, p. 41]. The bodily rooted phenomenon of "being inside" or "part of" the world being around us rather than in front of us is addressed spatially strongly in our interactive sketchbook project.

We describe and develop an interactive installation technology that appears as a huge book, of potentially unlimited size. It provides innovative and unseen opportunities for displaying artists' sketchbooks as part of art exhibitions, as well as a platform for innovative typologies of artworks.

Related Work and A Possible Pre-historic Connection. Museums of various kinds use increasingly interactive technology to attract a larger audience and to indicate a continued development of their exhibitions. Interactive installations may be artworks themselves or be vehicles for displaying existing art. A good systematic analysis of the potentials of the first category is found in Kwastek's recent book [5], and we find it also very useful for the second. At first glance, our installation may belong to the second kind but borders are crossed when we develop content, such as drawings, specifically for the installation. Our physical set-up, explained in Sect. 3, with two projectors pointing into a corner is very similar to that of [4], developed for gaming – for which our discussion of Maurice Merleau-Ponty also will apply; see [11].

The habit of depicting important objects in our surrounding world is universal for humans, as demonstrated so clearly by the cave painters. The Paleolitics', i.e., our cave painters', experiences inside the caves are interesting phenomena to bring forward in relation to experiences with a huge, virtual book. Certain spatial phenomena related to their being in the caves may foster comparative analyses of aspects of the two forms of performances taking place inside the caves and in our book installation. Caves are dark in general (also preferred for the present installation, but not total darkness) so the cave painters

themselves had to bring lights to be able to orient themselves, to work and create. The cave painters have been: "inside", simultaneously surrounded and bodily mobile, interactively occupied of the substance of the rockwall of chalk they scratched in, drew and painted on [6]. To specify present-day perceptions, we point at three typical different ways of experiencing sketchbooks as phenomena. They are named according to the body position of the involved person.

- "Outside the sketchbook" has got the natural quality, like any other minor thing, that the book as handheld is an entity you can grip and in most cases turn pages in and, if you make drawing, visualize impressions in.
- "Towards the sketchbook". For many other media a raised body position is the most characteristic, looking at a stationary computer screen, TV or a film.
- "Inside the sketchbook". The dimension of size is highly important here and that your bodily position is quite close to the depictions. Figure 1 shows a sketch of one of the dimensions of being inside the book.

Fig. 1. An oversize book installation may materialize the sense of being inside the book, transforming Hans Christian Andersen's imaginations into spatial perceptions. The biggest version of our Viskbook installation is H = 4.2 m, W = 2 × 3.2 m. (Drawing: B.Laursen)

2 Sketchbooks, What and Why

For the artist, a sketchbook may always be at hand, using it as a medium for collecting immediate perceptions and ideas, it can preserve a figurative freshness that is often difficult to transfer in the studio later. It is a flexible, semantic memory media combining multiple elaborated sketches, notes of impressions etc.

For the interested audience, sketchbooks are a wonderful source for meeting and experiencing the creation process for the completed and perhaps famous paintings. It provides also original insights into the artist's life and life time, which in turn deepens the general understanding of the artist's œvre.

However these books are rarely opened and almost never displayed for the audience. Tragically many sketchbooks reside in the eternal darkness of collections in safety boxes. The Viskbook installation makes it possible and easy to exhibit these books, giving the audience access to their complete contents. All over the world, we find this problem, and we see a large potential and upcoming demand for satisfactory solutions.

3 The Viskbook Technology

Our proposal for a technology that fulfils this purpose is the Viskbook[1] installation, which can be easily adapted to different contents and different sizes. The primary design goal has been to create a convincing illusion of an oversize book having a natural interaction of turning the pages in the book. In other words, even based on computer technology, it should not be experienced as a "computer installation", which means that help text, navigation tools, intelligent autonomy or the like are totally banished.

In order to make the installation accessible for a wide range of budgets and to make it easy to set up and take down, we have aimed at using payable and replaceable standard components, and minimize the physical requirements concerning the room and possible furniture. The standard set-up of a Viskbook fits into a corner in a room where two white-painted walls meet, typically but not necessarily in an angle of 90°; alternatively two pieces of chipboard can be fitted to form a corner; see Fig. 2. Two projectors are used, one placed at each edge, shooting at the opposite wall. The projectors need to be of the so-called short-throw type in order to produce a sufficiently wide angle, and they can be hidden by a screen as shown. The unavoidable geometric distortion is corrected by software. The figure shows also the typical position of a spectator, waving his or her hand in one or the other direction to turn a page, thus being able to go through the pages from one end to another or go a bit back and forth. Not shown in the figure are two loudspeakers behind the screens also hiding the projectors; in the basic version of Viskbook, sound is only used to produce a discrete "flap" sound when a page has been turned. In order to strengthen the illusion of the book as physical object, we use a 3D engine developed for computer games to obtain an effect as if the page is arching through the space in front of the book;

[1] http://viskbook.com.

Fig. 2. A sketch of the Viskbook installation seem from above. (Drawing: B. Laursen)

Fig. 3. The 3D effect used in Viskbook when a page is turned. (Photo: H. Christiansen)

see Fig. 3. The choice of sensor for recognition of gestures for turning pages is not essential; the figure shows a Kinect sensor (developed by Microsoft for their Xbox 360 play station), but other devices have also been used. A standard laptop computer with two video outputs is sufficient to run the entire installation.

Technical Observations. From a technical point of view, the design principles seem robust and do their job. More specifically, we noticed the following.

– The 3D effect associated with the turning of a page is very convincing. The spatial design, using a real corner as opposed to a flat screen, gives a significant amplification of the computer generated and normally flat "3D images".
– Although we have made no comparative studies, it is our clear impression that the simple sound effect (the "flap") adds a lot to the feeling of materiality.
– This arrangement of the projectors with crossing beams shot into a corner eliminates completely any problems with shadows, that typically appear in installations using front-projection.
– A Kinect sensor located as shown in Fig. 3 is difficult to calibrate so it perfectly fits all spectators (of different heights);[2] we are currently developing more reliable solutions with other sorts of sensors.
– The installation scales immediately to larger sizes; heights up to 4 metres have been tested in our laboratory. It will be a manageable software development task to scale to very large sizes with several synchronized projectors for each of the two pages. The real problem here will be fixing of the projectors and finding a suitable location for such an installation.
– A portable version of the Viskbook prepared in the lab can be set up and calibrated in a few hours, making it interesting also for fairs and other events.

Possible Extensions. The Viskbook technology as described above has been optimized for giving a faithful and respectful illusion of a given book. However, the technology provides a potential of going beyond what we normally expect from something that we designate "a book". The following ideas have been tested in our laboratory.

– Animated pages; e.g., a video or a drawing extended with cartoon-like effects.
– Content may be different sorts of images; we experienced that drawings are the most robust concerning the lighting condition and limited resolution of projectors, while photos and reproductions of paintings require more care.
– Adding real sound associated to the images in the book may be used without destroying the illusion of a material book.
– Cheating with the content of the book, so, e.g., going one page forth and one back again may yield a different view.
– Allowing spectators to manipulate the book content.

Using real sound has been tested in exhibitions with good results, while the others still need practical experimentation to prove their relevance. Obviously the use of such effects should be made with care, as on one hand maintain a believable materiality and on the other create interestingly enhanced experiences.

[2] Skeletal tracking (see https://en.wikipedia.org/wiki/Kinect) is avoided as the involved "exercises" for calibrating to each user would destroy the naturalness of using the installation as a book.

4 Experiences and Conclusions

The Viskbook has been shown publicly at the following events.

- Roskilde City Public Library, Denmark, May 8–mid June 2013. "Italian Drawings" by Bjørn Laursen; a virtual sketchbook composed of drawings from different cities in Italy: Rome, Naples, Venice and Florence.
- Istituto Italiano di Cultura di Copenaghen, November 22–December 20, 2013. "Italian Drawings" as above.
- Roskilde University Library, Denmark, September 1–30, 2014. "Italian Drawings" as above.
- Nivaagaard Art Museum and Øregaard Art Museum, Denmark. Viskbooks in two coordinated exhibitions showing comprehensive collections of Martinus Rørbye's work (Danish Golden Age painter, 1803–1852).
- National Libraries Cooperation Fair, November 4–7, 2015, Bella Center, Copenhagen.

At the Rørbye exhibitions [1], our installations displayed two specific sketchbooks, integrated as elements in larger exhibitions. This confirmed our hypotheses about a strong interest among the audience to discover the complex and varied content of the sketchbooks, and it complemented well the static exhibiting of authentic the works; see Fig. 4. We experienced also that the presence of an interactive installation created new social interactions among the visitors, guiding each other in its use, leading to conversations about what was seen in the

Fig. 4. A Viskbook installation in the Martinus Rørbye exhibition at Nivaagaard. The photo is taken during the exhibition, and shows how the installation creates a special attention and at the same time is an integral part of the exhibition. (Photo: H. Christiansen)

book. In one exhibition a one-line instruction was given as part of the curator's introduction to the sketchbook; in the other, there were no instructions, but a circular marking on the floor indicating a recommended position for browsing the book. The pattern of use were the same in both cases: the visitors found out themselves. Focusing the sensor on the natural (and marked) position of the visitor "in control" of the book reduced confusion to a minumum in case of several visitors watching the book. We learned also that an ultimate robustness of the interaction is essential (as opposed to the "95% performance" of that version).

The Italian Drawings exhibitions displayed virtual books composed from several actual sketchbooks, selected in order to produce strong coherence. The location in rooms not dedicated to exhibition exposed that conditions of light were critical for the visual contrast and overall experience of the installation.

In all cases, we experienced a very positive interest for this type of installation, and further research may show whether this is due to novelty value only or true qualitative enhancements. As it appears, a more systematic evaluation of the approach is still to be done.

Acknowledgement. This work is supported by the Strategic Research Initiative: Designing Human Technologies and the Experience Lab at Roskilde University. Special thanks to our developer Steffen Engler Thorlund, Mads Folmer, Remzi Ates Gürsimsek and numerous other people at Roskilde and the institutions listed above.

References

1. von Folsach, B., Søndergaard, S.M. (eds.) Martinus Rørbye. Det nære og det fjerne. Øregaard Museum, Hellerup & Nivaagaards Malerisamling, Nivå (2014)
2. Frisch, H.: Europas Kulturhistorie, vol. 1. Henrik Koppels Forlag, Copenhagen (1928)
3. Gibson, J.J.: The Ecological Approach to Visual Perception. Lawrence Erlbaum Associates, London (1986)
4. Jacobson, J., Lewis, M.: Game Engine Virtual Reality with CaveUT. In: IEEE Computer, pp. 79–82 (2005)
5. Kwastek, K.: Aesthetics of Interaction in Digital Art. MIT Press, Cambridge (2013)
6. Laursen, B.: Paleolithic Cave paintings, Mental Imagery and Depiction. A Critique of John Halversons article "Paleolithic Art and Cognition". Venus-Report 19. Aarhus (1993)
7. Laursen, B., Bøgh Andersen, P.: Drawing and programming. In: Bøgh Andersen, P., Holmqvist, B., Jensen, J.F. (eds.) The Computer as Medium, pp. 236–262. Cambridge University Press, New York (1993)
8. Laursen, B.: Paris in the Body - The Embodment of Paris. CVC Roskilde University, Roskilde (2003)
9. Merleau-Ponty, M.: Phénoménologie de la perception, Gallimard, Paris (1945). Eng. trans. by Smith, C.: Phenomenology of Perception, Routledge, London (1962)
10. Merleau-Ponty, M.: L'Œil et l'esprit. Gallimard, Paris (1961)
11. Sommerseth, H.: Gamic realism: player, perception and action in video game play. In: Proceedings of DiGRA 2007 Conference, pp. 765–768 (2007)

Considerations and Methods for Usability Testing with Children

Malene Hjortboe Andersen, Md. Saifuddin Khalid[✉], and Eva Irene Brooks

Department and Learning and Philosophy, Faculty of Humanities, Aalborg University,
Kroghstræde 3, 9220 Aalborg, Denmark
malenehjortboe@gmail.com, professorkhalid@gmail.com,
eb@learning.aau.dk

Abstract. In this paper, the authors draw on methods used in the field of inter-action design, emphasizing a user-centred design approach including methods such as usability testing, design metaphors, interview with users, video observations, focus groups, and think aloud sessions. However, a challenge of these methods is they are designed for adults and are not necessarily appropriate to investigations including children. The guiding questions for this systematic literature review are (1) the motivation for conducting usability tests with children, and (2) the kind of methodological, practical, and ethical considerations that should be considered when involving children in usability studies. Preferred Reporting Items for Systematic Reviews and Meta-Analyses (PRISMA) checklist and PRISMA flow diagram are applied in order to assure the quality of the process of this investigation. Nine articles are analyzed and then synthesized by applying the constant comparative method. The synthesis of the literature review is based on the identified thematic priorities, which are categorized as follows: (1) the motivation for involving children as test persons in design processes, (2) defini-tions of usability, (3) practical considerations, (4) methodological considerations, and (5) ethical considerations.

Keywords: Child-computer interaction · Usability testing · Usability evaluation · Usability testing methods

1 Introduction

In this paper, the authors will draw on methods used in the field of interaction design [1], emphasizing a user-centered design approach including methods such as usability testing, design metaphors, interview with users, video observations, focus groups, and think aloud sessions (c.f. [2, 3]).However, a challenge of these methods is that they are designed for adults and are not necessarily appropriate to investigations including chil-dren [4]. The needs, skills, terminologies, and desires of children are essentially different from those of adults (cf. [5]). In their studies, Read and Markopoulos [6] and Marko-poulos and Bekker [7] highlight that current literature seldom focuses on children. At the same time, research, as well as industry, target children as a user group or as consumers, resulting in an increased need to consider the context and inquiries that are

© ICST Institute for Computer Sciences, Social Informatics and Telecommunications Engineering 2017
A.L. Brooks and E. Brooks (Eds.): ArtsIT/DLI 2016, LNICST 196, pp. 228–238, 2017.
DOI: 10.1007/978-3-319-55834-9_27

unique to the field of child-computer interaction. This paper will try to meet some of these challenges.

When including children in usability studies, Druin [5] differs between four roles the children can employ: user, tester, informant, and design partner. The main difference is the distribution of power between the children and the researchers. The first two terms, Druin [8] defines as reactive participants, including methods such as children observing other children [5], play sessions [9], and post-task interviews [22]. The last two terms, informant and design partner, Druin [8] classifies as participative users. Here, the design inquiries include methods such as cooperative low-tech prototyping [8], drawings [10], and technology immersion [5].

The overarching goal of the research was to establish an overview of usability studies carried out including children. For the literature review, the guiding questions related to (1) the motivation for conducting usability tests with children, and (2) the kind of methodological, practical, and ethical considerations that should be considered when involving children in usability studies.

2 Methods

In this study, Preferred Reporting Items for Systematic Reviews and Meta-Analyses (PRISMA) checklist and PRISMA flow diagram [11] are applied in order to assure the quality of the process of this investigation. The checklist is applied as guidance to ensure that the study includes the central areas of the systematic literature review. The flow diagram is used to document the study searches, the search results, and inclusion and exclusion criteria.

The searches are conducted in the Educational Resources Information Center (ERIC) and Scopus databases. Different combinations of the following keywords and synonyms are applied: *usability testing*, *usability evaluation*, *children*, *interaction design*, *methods*, and *guidelines*. It is identified that the keyword *children* returns more relevant results than the use of *school students* or *primary school*. The searches are restricted to only English and peer-reviewed articles.

Figure 1 illustrates the research methodology, including searches, screenings, as well as inclusion and exclusion process. The figure is based on the PRISMA flow diagram [11], which includes four stages: identification, screening, eligibility, and included. In the *identification* phase, the search in the databases resulted in a total of 105 articles. During the *screening*, 80 articles were excluded while studying the titles, abstracts, and keywords of the 105 articles. The exclusion criteria were as follows: an article is excluded if (1) the article is not about children aged 5–17 years of age, or (2) the primary focus of the article is on usability tests of a specific product, and not on the methods or considerations focusing on the involvement of children in the testing process. In the *eligibility* phase, the full-text of each of the 25 articles was read, and 16 articles were excluded by applying the two exclusion criteria. Also, it is noteworthy that 5 of the 16 excluded articles were written by the same authors, and the content of the articles was similar. Ideally, those five articles should have been included as they cannot be rejected according to the rejection rule. Eventually, a total

of 9 articles has been included in the qualitative analysis and synthesis. The selected nine articles are published between 1997 and 2015.

Fig. 1. PRISMA flow diagram [11]

The nine articles are analyzed and then synthesized by applying "the constant comparative method" [12]. The method is applied to create an overview of the key themes that appear in the selected literature. It is an iterative process, where the relevant themes of the individual articles are identified, and used to analyze the subsequent articles. The process is as follows: the first article is read, and relevant themes highlighted and, then, the next article is read applying the same themes and identifying more themes. A table is made to record and summarize the themes identified in each of the articles (see Table 1). If one or more of the themes in an article matches with previously recorded themes, then a check mark is placed on the table. If a subsequent article's theme does not match with any of the existing themes, then a new theme is added. This process is repeated until the analysis does not result in any relevant new themes.

Table 1. Overview of articles and identified themes

Publication year	1997	2002	2003	2005	2008	2012	2013	2014	2015
Authors	Hanna, L. Risden, K., and Alexander, K.J.	Druin, A.	Markopoulos, P., Bekker, M.	Als, B.S., Jensen, J.J., Skov, M.B	Read, J.C., Markopoulos, P.	Rounding, K.,Tee,K., Wu, X.,Guo, C.,Tse, E.	Khanum, M.A., Trivedi, M.C	Read, J.C., Fitton, D., Horton, M.	Read, J.
Country	USA	USA	Netherlands	Denmark	England	England	India	England	England
Article type & Themes	J	J	J	C	C	C	C	C	J
The motivation to do usability testing with children	X	X			X	X	X		
Necessity of child-friendly environment	X	X		X					
The duration of the test should be considered	X		X	X					X
Children will be recruited from the age group	X	X		X					
The child must sit with an adult during the test	X	X						X	
Definition of usability			X	X				X	
Comparison of think aloud and constant comparative			X	X				X	
Children should be recruited based on language skills						X		X	X
Children must cooperate in pairs						X	X	X	X
Children should know the purpose of the test						X		X	X
Children should be thanked for participating in the test						X		X	X
Natural surroundings give the best results							X		X

3 Qualitative Analysis and Synthesis

The synthesis of the literature review is based on the identified thematic priorities (see Table 1), which are categorized as follows: (1) the motivation for involving children as test persons in design processes, (2) definitions of usability, (3) practical considerations, (4) methodological considerations, and (5) ethical considerations.

3.1 The Motivation to Involve Children as Testers in Design Processes

The child's role as a test person was first discussed in the literature of the late 1980s and early 1990s by Allison Druin [13]. The discussion was particularly relevant in

connection Seymour Papert's research group, who developed the *Logo* programming language: "It may well have been Papert and his colleagues' deeply held belief in children as builders, scientists, and learners that led to the early inclusion of children in the technology design process" [5]. The research group placed great emphasis on the involvement of children as test persons in the design processes. This resulted in a discovery of numerous problems, which adult test persons would never have been able to address [5]. Several large companies followed and since then it became common for manufacturers and designers to recruit children for testing [5].

The motivation for including children in the design process has increased as children have been savvy users of digital devices such as computers, phones, tablets and game consoles [5, 14]. *"Children are fast becoming tomorrow's power-users of everything from the Internet to multimedia authoring tools"* [5]. In this context, it has been essential to address how children can be included in the design of new technologies and at the same time which differences there is between involving children and adults as test persons.

Research within the child computer interaction community (CCI) has shown that there is an immense difference between the evaluations of designs tested by adults and the ones including children [7]. Children can be considered as a separate group with its culture, norms and complexities [5]. *"Children are not miniature adults, but they have their own set of preferences, perception, style, likes, and dislikes. When designing technology for children their preferences should be taken into account."* [14] Many designers often have their assumption about children or include personal experience of being a child [5]. These personal assumptions are not enough to represent today's children: *"Children are very different from adults — they have developing motor skills, limited reach, short attention spans, limited exposure to traditional user interfaces and social protocols."* [13] One central motivation to include children in a design process is that *"Children are extremely honest in their feedback and comments concerning technology [...]"* [5].

Druin identified "four main roles that children can play in the technology design process: *user, tester,* the *informant* and *design partner*" [5]. Each of the four roles are based on three underlying dimensions: (1) relationship to adults (which are indirect, including feedback, dialogue, and elaboration); (2) relationship to technology (which concern ideas, prototypes and products); and (3) goals for the inquiry (which include developing educational theory, questioning impact of technology, and improved usability/design) [5]. The motivation of recent child interaction design literature contributes to the understanding and the application of the four roles of children and the three dimensions in the design process.

3.2 Definitions of Usability

Usability testing is one of the disciplines that takes into account the preferences of children [7, 14]. Usability testing has been studied and used for many years, and the overall aim is to *"identify some of the key interaction problems in user interfaces"* [15] Today, it is common that users, first of all, check how easy it is to understand product functionalities. This indicates that users have become more aware of the products' usability [14]. *"Usability is most*

often defined as the ease of use and acceptability of a system for a particular class of users carrying out specific tasks in a specific environment. Ease of use affects the user's performance and their satisfaction while acceptability affects whether the product is used" [14, 16].

Usability testing can take the form of many different methods; the most common is a so-called think-aloud test [7]. According to Khanum and Trivedi [14], it is best to conduct usability testing in the early design stages, since it is central to disclose any problems or so-called 'bugs' early.

In usability tests with children, Markopoulos and Bekker [7] address the lack of a common definition of the term usability, and states: *"At present we are conducting various studies to determine appropriate evaluation criteria for interactive products for children, as how to test not only for how usable a product is found but, also, how much fun children experience while interacting with it"* [14]. Markopoulos and Bekker [7] also points out that there can be substantial differences in the purposes of the tests, depending on whether test persons are adults or children. The next section will focus on this adaptation.

3.3 Considerations

There is an extensive difference between testing with children and testing with adults: *"Working with children to evaluate interfaces requires that some adaptations be made to techniques traditionally used with adults"* [13]. Many of the selected articles are concerned with how this adaptation can take place and make more suggestions about considerations the researcher should be informed beforehand. *"There are practical concerns around arranging studies and recruiting children, there are methodological concerns in terms of ensuring that children can contribute in meaningful ways, and there are ethical concerns around the meaning of the children's participation."* [17] Based on this and the focus of the research question, this section is divided into three sub-sections: practical considerations, methodological considerations, and ethical considerations.

3.3.1 Practical Considerations

In 1997, Hanna *et al.* set some guidelines for usability testing with children, based on their work as usability engineers at Microsoft [18]. The proposed guidelines offer practical advice on how a researcher can set up a child-friendly testing environment and schedule usability tests in laboratories with children. These guidelines are categorized according to a four-phase test facilitation process: set-up and planning, introduction, during the test, and finishing up [18]. Many of these guidelines became important for design testing and evaluation with children. Several of the studies, particularly [5, 15], have applied the guidelines developed by Hanna and her colleagues.

Markopoulos and Bekker [7] question some of the advice or guidelines described by Hanna *et al.* [18]. Hanna *et al.* categorize children into three age groups related to their behavior during a test; preschool (2–5 years), elementary school (6–10 years) and middle-school (11–14 year). Hanna *et al.* experienced that children under 12 years of age are not able to think aloud. However, Markopoulos and Bekker experienced that

"*Some children may not be used to speaking up to adults and may be less likely to report usability problems. Extroversion and verbalization skills are thus important variables to control.*" [7]. Moreover, [18] states that children can concentrate for about 30 min, but [7] experiences that children (9–12 years of age) can enjoy longer sessions (45 min or more). Furthermore, [7] discusses the characteristics of children that impact the usability test. These are, capacity and inclination to verbalize, capability to concentrate, children's motivation, ability to adjust to strange environments and surroundings, trustworthiness of self-report, ability for abstract and logical thinking, monitoring progress towards a goal, gender differences, knowledge of language and concepts, and knowledge and skills about computer and interactive systems' use. These characteristics of children are important practical considerations for usability tests involving children.

"*If time stood still, and technology and children never changed, the original work by Hanna, Risden et al. would no doubt still be as valid now as it was then. But as we all know, nothing stays the same, and in the dynamic area of interactive technology and children, change is inevitable and rapid.*" [6]. For example, many new technologies cannot be tested in so-called usability labs, because technologies are becoming more mobile, and interactive [6]. Today, it is more customary to conduct testing in a child's contexts and make so-called *field visits*, which, compared to lab-based tests, provide better and more useful results as the children can express themselves more freely in their natural environment [14]. Existing guidelines targeting usability testing with children need some makeover: "*The original guidelines are essentially still highly relevant because, after all, a child is still a child. However, there are three areas where it appears, in the light of the changing times, that some adjustment is needed: these are timing, screening, and participation. Also, as there is now new knowledge about interactive technology and children, there are some additional guidelines to be aware of. In the original work, the researchers held usability tests between 30 min and an hour long. In our experience, and that of many others, this now seems rather liberal. Maybe children have shorter attention spans than they used to, but modern young children can often concentrate for only very short periods—as short as 10 min—and even older children find sessions beyond 30 min problematic.*" [6]. Many such considerations are also essential when testing with adults since they also have a need for security and tendency to lose concentration during the process.

3.3.2 Methodological Considerations

Usability testing includes various methods [7, 14]. Some of the methods involving children in interaction design are the verbalization methods (including think-aloud, picture cards method, active intervention, post-task interview, robotic intervention, constructive interaction, and peer tutoring), the wizard of oz method, survey methods, diaries, and inspection methods (including Nielsen's usability heuristics, problem reporting, heuristics for evaluating fun, games and websites, persona-based evaluation, software engineering with enterprise models (SEEM method) [19]. Think aloud is a common method; however, "children below the age of 12 are likely to be unable to think aloud" [7].

Several studies have focused on examining ways that provide the best results when testing usability with children [15]. Researchers have measured, among other issues, how many problems various methods have caused. "*[The] practices vary from simply asking*

children what was successful and what not, or asking what were the 'bugs' of the software tested, to analyzing the stories children make with a storytelling program." [7]. The think-aloud test is the most widely used method [15]. The differences between think-aloud and constructive interaction, the two variations, is that think-aloud involves only one test person whereas constructive interaction involves two test persons who need work together to solve different problems by using an interactive system [14]. Studies showed that constructive interaction is the variation that identifies the most problems [14]. It is, however, important to consider the process of selecting the participants: "Constructive interaction with pairs of children knowing each other identified more problems (on all severities) and specifically more critical problems." [15].

Nowadays, children collaborate online for academic activities and games; the methods applied for the evaluations of interactive technology should take account of children exploring interactive systems beyond the restrictions of locations and time [6].

Children are becoming independent and gaining increasing autonomy in accessing, personalizing and owning interactive digital systems. So, there is the transformation of power, confidence, motivation and feeling of comfort. Previously, the participation of a teacher or a parent was identified as "comfortable" during tests with children [18]. About a decade later, it is claimed that such a guideline for methods does not apply anymore; children can independently explore technology [6]. Read points out that it is the location of the test and the children's age and language development that should determine which methods the researcher chooses [17].

3.3.3 Ethical Considerations

The ethical considerations in testing usability appear to be pioneered by and emphasized in the articles contributed by Read [6, 17, 20]. The articles address the following issue: "In the IDC [Interaction Design and Children] literature very few researchers have documented how they have concerned themselves with the rights and feelings of children within the context of research using participatory design." [20]. Furthermore, it is importance to acknowledge the children for their participation and tell them what their participation has contributed to. This is first and foremost because children, as well as anyone else, have a right to know the purpose of their involvement. Read and Marko-poulos "suggests an approach in which the research team deliberately and critically examine why they are engaging with children and then ensure that the children have as much knowledge as possible in order to decide whether or not to participate." [20, 21] Children should, therefore, be informed about how their ideas will be used and what happens if some of their ideas contribute to the success of the company or the investi-gation. Another reason for why it is important to inform children about the purpose of their participation is that "It is generally considered that the more meaningful partici-pation is for children the more beneficial the activity is across all aspects" [20].

Read [17] emphasizes that it can be difficult for researchers to practice ethical considerations related to involving children in a design process. The author underlines the importance of making clear that the children understand the reason for their partic-ipation in a test, "because if the things cannot be reasonably justified, the evaluation should not take place."[17]. Read [17] suggests that "Children should be able to use

methods they can relate to and understand so their contributions can be meaningful to them as well as to the adult evaluator."

4 Discussion and Conclusion

The overarching goal of this paper was to establish an overview of usability studies carried out targeting the inclusion of children. The questions guiding the literature review concerned the *motivation* for conducting usability tests with children and, also, the kind of *methodological, practical,* and *ethical* considerations that should be considered when involving children in usability studies. The information was provided through a literature search process, which was challenging in terms of finding the correct combination of keywords. Optimally, the investigation should enable a search based on different age groups, but this was found difficult, for example, when applying search phrases such as "primary school children," the hits were either irrelevant or too few. However, as keywords such as "primary schools" or "elementary school" are not universally uniform, the authors suggest that in the child interaction design discipline age groups, e.g. 3–5, 5–12, 13–18, should be included as past of keywords in scientific publications. [3] highlight the issue of considering children's developmental needs when they are included in the design process. In addition, we suggest that this should include needs related to children's cognitive as well as social, emotional, and motor abilities. This kind of considerations respect and value children's different need for support and scaffolding [3]. Furthermore, [3] state that teenager "differ enough from children developmentally that design with teenagers should be considered separately from that of children." Thus, it should be emphasized that the outcome of the current literature review has identified that the children that have been included in the different studies are grouped into *teenagers* (13–18 years of age) and children younger than teenagers (5–12 years of age) by child-computer interaction researchers [3, 22].

It is notable that not many studies from the literature review include younger children as a participant group in usability inquiries. [23] carried out a study on digital playful learning, including 55 children, 3 to 5 years-of-age in an early years educational setting. The authors investigated different methods developed for children, but not necessarily for young children. The method they applied was the Cooperative Inquiry, among others the Bags of Stuff technique [24] and the Mixing Ideas technique [25]. The results suggested that when working with younger children, it is necessary to make efforts to understand the children and their conceptual framework before engaging in design activities. Furthermore, the findings highlighted that young children need support in their creative expression.

Children have their standards and strong opinions, which means that adult assumptions are not sufficient when developing interaction designs for children. Accordingly, several of the authors of the reviewed articles consider an adaptation of the techniques traditionally used in usability testing with adults important. This includes guidelines for the settings, how to divide the children in testing situations, and the duration of the test. In the same way, many of these guidelines also apply to testing with adults, in particular regarding parameters such as concentration, language skills and comfort. Nevertheless, although

recommendations apply to, age wise, a broad range of participants, there are inherent differences. For example, children's attention span is most often shorter compared to adults' and would, therefore, require breaks more frequently than an adult participant. Furthermore, when testing with children, a special focus on the ethical considerations since, for example, children can have a hard time understanding why they are participating in the test, and they can become upset during the performance of the test.

The findings from the literature review suggest that when working with children, preparations have to be carefully considered to engage children in a usability test situation. Creating a common ground is an essential factor the communication between the participant and the researcher, and setting the right ethical frame for the sessions can strengthen the quality of the design test situations.

References

1. Zimmerman, J., Forlizzi, J., Evenson, S.: Research through design as a method for interaction design research in HCI. In: Proceedings of the SIGCHI Conference on Human Factors in Computing Systems, pp. 493–502. ACM, New York (2007)
2. Sharp, H., Rogers, Y., Preece, J.: Interaction Design: Beyond Human-Computer Interaction. Wiley, Chichester (2007)
3. Fails, J.A., Guha, M.L., Druin, A.: Methods and techniques for involving children in the design of new technology for children. Found. Trends® Hum. Comput. Interact. 6(2), 85–166 (2012)
4. Read, J.C., Markopoulos, P.: Child–computer interaction. Int. J. Child-Comput. Interact. 1(1), 2–6 (2013)
5. Druin, A.: The role of children in the design of new technology. Behav. Inf. Technol. 21(1), 1–25 (2002)
6. Read, J.C., Markopoulos, P.: Understanding children's interactions: evaluating children's interactive products. Interactions 15(6), 26–29 (2008)
7. Markopoulos, P., Bekker, M.: On the assessment of usability testing methods for children. Interact. Comput. 15(2), 227–243 (2003)
8. Druin, A.: Cooperative inquiry: developing new technologies for children with children. In: Proceedings of the SIGCHI Conference on Human Factors in Computing Systems, pp. 592–599. ACM, New York (1999)
9. Marco, J., Cerezo, E., Baldassarri, S., Mazzone, E., Read, J.C.: Bringing tabletop technologies to kindergarten children. In: Proceedings of the 23rd British HCI Group Annual Conference on People and Computers: Celebrating People and Technology, pp. 103–111. British Computer Society, Swinton (2009)
10. Veale, A.: Creative methodologies in participatory research with children. In: Greene, S., Hogan, D. (eds.) Researching Children's Experience: Approaches and Methods, pp. 253–272. SAGE, London (2005)
11. Moher, D., Liberati, A., Tetzlaff, J., Altman, D.G.: Preferred reporting items for systematic reviews and meta-analyses: the PRISMA statement. Ann. Intern. Med. 151(4), 264–269 (2009)
12. Glaser, B.G.: The constant comparative method of qualitative analysis. Soc. Probl. 12, 436–445 (1965)
13. Rounding, K., Tee, K., Wu, X., Guo, C., Tse, E.: Evaluating interfaces with children. Pers. Ubiquit. Comput. 17(8), 1663–1666 (2012)

14. Khanum, M.A., Trivedi, M.C.: Exploring verbalization and collaboration during usability evaluation with children in context. IJCSI Int. J. Comput. Sci. Issues **10**, 485–491 (2013)
15. Als, B.S., Jensen, J.J., Skov, M.B.: Comparison of think-aloud and constructive interaction in usability testing with children. In: Proceedings of the 2005 Conference on Interaction Design and Children, pp. 9–16. ACM, New York (2005)
16. Tasos, S.: Integrating Usability Engineering for Designing the Web Experience: Methodologies and Principles: Methodologies and Principles. IGI Global, Hershey (2010)
17. Read, J.: Children as participants in design and evaluation. Interactions **22**(2), 64–66 (2015)
18. Hanna, L., Risden, K., Alexander, K.: Guidelines for usability testing with children. Interactions **4**, 9–14 (1997)
19. Markopoulos, P., Read, J.C., MacFarlane, S., Hoysniemi, J.: Evaluating Children's Interactive Products: Principles and Practices for Interaction Designers. Morgan Kaufmann, San Franscisco (2008)
20. Read, J.C., Fitton, D., Horton, M.: Giving ideas an equal chance: inclusion and representation in participatory design with children. In: Proceedings of the 2014 Conference on Interaction Design and Children, pp. 105–114. ACM, New York (2014)
21. Read, J.C., Horton, M., Sim, G., Gregory, P., Fitton, D., Cassidy, B.: CHECk: a tool to inform and encourage ethical practice in participatory design with children. In: CHI 2013 Extended Abstracts on Human Factors in Computing Systems, pp. 187–192. ACM, New York (2013)
22. Iversen, O.S., Smith, R.C.: Scandinavian participatory design: dialogic curation with teenagers. In: Proceedings of the 11th International Conference on Interaction Design and Children, pp. 106–115. ACM, New York (2012)
23. Borum, N., Brooks, E.P., Brooks, A.L.: Designing with young children: lessons learned from a co-creation of a technology-enhanced playful learning environment. In: Marcus, A. (ed.) DUXU 2015. LNCS, vol. 9188, pp. 142–152. Springer, Heidelberg (2015). doi: 10.1007/978-3-319-20889-3_14
24. Fails, J.A., Druin, A., Bederson, B.B., Weeks, A., Rose, A.: A child's mobile digital library: collaboration, community, and change. In: Druin, A. (ed.) Mobile Technology for Children: Designing for Interaction and Learning. Morgan Kaufmann Publishers, Burlington (2009)
25. Guha, M. L., Druin, A., Chipman, G., Fails, J. A., Simms, S., Farber, A.: Mixing ideas: a new technique for working with children as design partners. In: Proceedings of Interaction Design and Children 2004: Building a Community, pp. 35–42 (2004)

An Adaptation Framework for Turning Real Life Events into Games: The Design Process of the Refugee Game

Sacha Kjærhus Therkildsen, Nanna Cassøe Bunkenborg, and Lasse Juel Larsen(✉)

University of Southern Denmark, Campusvej 55, Odense, Denmark
ljl@sdu.dk

Abstract. Many games are inspired by real life events. The presented adaptation framework is based on the design of a board game with a companion app that addresses the Syrian refugee crisis. The aim of the game is to allow players to simulate the experience of being a Syrian refugee traveling through Europe. We applied an agile development method and participatory design to achieve our ambition. In conclusion we found that turning real life events into board games can be advanced by the following game design adaptation framework, which balances four interrelated layers: (1) real life events (game fiction), (2) game system (formal game elements), (3) movement system (game mechanisms), and (4) meaning (player choice) which prioritise game over story.

Keywords: Game design · Agile development · Board game · Real life events

1 Introduction

The field of game design has attracted many different genres and approaches to game creation [1–4]. Fewer have dealt with the design of board games, whether the interest is in Ameritrash or Eurogames [5], even though it is an area of growing design interest. Fewer still are concerned with researching adaptive design strategies for turning real life events into board games.

This brings us to the topic of this article: creating a board game against the backdrop of the current refugee crisis in Europe with a companion app run on a mobile device. In this paper the term 'board game' refers to games that include either a board or tiled playing field, as opposed to open world, 'non-tiled' tabletop games.

The refugee crisis is all over the news. We hear, see and read about refugees escaping the war in Syria in search for a better place to live. Most governments are discussing what to do with the vast numbers of fugitives and how to provide shelter; others are discussing how to keep them from crossing their borders and entering their countries. The intensity of the debate has risen with the swelling number of refugees.

The question addressed here is how to create a game around such a serious topic. Especially a game promoting the experience of being a refugee, even if done in order to inform players about some of the experiences refugees encounter. We wanted to communicate the situations and choices refugees face on their long journey in simulated forms of play, including real events from the refugees' real world and from the ensuing political debate.

© ICST Institute for Computer Sciences, Social Informatics and Telecommunications Engineering 2017
A.L. Brooks and E. Brooks (Eds.): ArtsIT/DLI 2016, LNICST 196, pp. 239–247, 2017.
DOI: 10.1007/978-3-319-55834-9_28

Initial considerations quickly turned into discussions about which aspects of the refugee experience would be best suited for inclusion in a game. It became clear that it was by no means easy to determine what to include and exclude. The design process later revealed an adaptive framework, which could guide this complex question.

Instead of trying to solve this question, we focused on the game format. We chose the board game format over a traditional video game to meet our aim of maximizing player-to-player interaction, discussion [6, 7], and immersion [8] with subsequent reflections and insights on the current refugee crisis.

Making a game that adequately addresses such a sensitive subject requires not only a firm grasp of the *game's fiction* (understood as its theme or semantics), but also a clear conception of *formal game elements* [2], if how to distil an gripping [10] movement system through the game space [9]. Such a system was later referred to as *game mechanisms* [1, 11] and meaning understood as *player choices* [12], since it is important not only to create choice in games, but also to differentiate between here and now choices and those that are to do with establishing longer-term player strategies.

Furthermore, how do you create a board game about a sensitive subject like refugees from Syria that will be interesting to play and generate insight without forcing a specific political or ethical perspective on its players? A board game that is not unintentionally provocative or outright offensive [13], yet still fun and enjoyable to play [14] in a family setting. Choosing the Syrian refugee crisis is in itself bordering on the offensive, but it was a risk we were willing to take in our effort to create an interesting and different board game.

The adoption of a game design stance that might be seen as offensive is generally either overlooked or unintentionally misused in efforts to create interesting games [15–18].

To reach our ambition we used an adapted agile development process [19, 20], because it allowed us to move back and forth in the design process and make rapid changes without having to begin again [21].

The following sections will elaborate on our adapted agile methods, and demonstrate how it was used, and why it was usable in this particular context. It will also present results from our game tests. Following this will we outline a game design framework balancing *game world fiction* [22, 23], *formal game elements* [2], *game mechanism* [1] and *player choice* [24] to promote a player experience that would approximate to the chosen topic.

2 Methods

In order to develop the *Refugee Game* we started out by defining the overall development method we were going to apply. Given the uncertainty regarding the final form of this project, we decided to use an agile development method. This enabled us to make rapid prototypes for testing out different approaches without fully committing to anything before we had analysed and further tested new design choices to see whether they propelled the underlying game concept or not. In this project we did not commit to one particular method within the range of accessible agile development processes, instead we followed the general philosophy in a revised and simpler format (Fig. 1). We adopted an

object-oriented approach in a small team to benefit from quick iterations with internal and external play tests. Some of these took the form of participatory design sessions [25, 26], which are effective early phases of the design process, when ideas are less constrained by existing codes or other infrastructures [27].

Fig. 1. Adapted iterative process

In addition to this, we approached prototypes as a form of communication tool between the team members themselves [28]. By this I mean that all ideas were developed as paper prototypes to be tested and experienced instead of regressing to verbal discussions, which run the risk of prematurely dismissing essential formal game elements [29] such as game procedures [2] – understood as who is doing what in which order – or game mechanisms [1] – understood as core actions unfolded with core purpose.

As a result of this constraining approach we needed to limit each prototype to include only essential elements in order to prevent the workload from becoming overwhelming and to be able to respond appropriately to game design changes. We did this by filtrating our prototypes [30] to narrow down our focus on interaction and functionality (and on a small scale, appearance) and keeping the scope of the prototypes limited to the particular game elements, mechanisms or choices that we were exploring.

Once we found the right game elements and mechanisms, we could progress and expand our scope to include further aspects of the game without falling prey to feature creep [1]. This is where we began to deviate from the 'standard' game development method. Nevertheless, we found ourselves facing the problem of working with real life ethical dilemmas especially how to convey them in a game format. We handled this challenge in three steps.

First, we approached the subject as if it was a regular game designed from a story, but we quickly discovered that this was not just another fictional story that we could shape, form and expand on as we saw fit. Reality dictated that we had to stay true to the experiences of refugees. To fully grasp the situation of refugees, we researched their situation by talking with volunteers at train stations as well as interviewing refugees in trains from Germany travelling towards Copenhagen (and, incidentally, Sweden).

Second, we tried to distil game elements (number of players and their relationship, objectives, procedures, rules, resources, conflicts and quantifiable outcomes [2, 3, 29, 31, 32] and design game mechanisms (actions with core purposes) to fit the contextual frame. We explored both the competitive and co-operative possibilities these entailed as a part of a family friendly setup using a complex set of resources such as morale and money made tangible by dice or cards.

Third, drawing inspiration from games like [33–35], we explored movement systems for traversing the game space and investigated the spatial layout and possible routes from Syria to the chosen final objective, Sweden (See Fig. 2).

Fig. 2. Prototypes of traversing the game space.

Traversing the game space in an interesting way, taking player experience, procedures, and challenges into consideration, made it possible to establish a consistent movement system where players move from one place (country) to the next facing ever-changing obstacles. This approach concluded in creating a spatial game space based on a revised geographical version Europe. The movement system was partly inspired by [36–38] (See Fig. 3.), all games with clear, known and recognizable game mechanisms for moving through the game space.

Fig. 3. Movement system for traversing the game space.

Having found the mechanism supporting movement through the game space, we began developing supporting mechanisms that delivered and expanded the core mechanism [1], making our game unique and not just a collection of well-known mechanisms dressed in new clothes. These mechanisms were discussed not only from the point of view of providing interesting choices [39] or for the sake of interesting gameplay [40], but also as being representations of actual real world events. A supporting mechanism would be discarded if it did not add depth and complexity or have plausible reference to a real life event (the game fiction). The issue arose, for example, in asking whether a player should be returned home if another landed on the same space. In the current context this would translate into deporting one refugee because another occupied the same space. We decided against such a supporting mechanism since it would not make sense that when two refugees meet one should be deported.

2.1 Findings

The Refugee Game underwent several qualitative user tests during its iterations, most notably two external tests. One took place immediately after an internal test, used to determine whether or not the intended game experience was achieved.

The participants consisted of four people (the game allows for four players) two male and two female between 20–30 years. All of them were ethnic Danes. They were instructed in the overall rules of the game and were allowed to ask clarifying questions on rules and cards. We tested for overall game coherency, meaning and choice as well as players perception of how the game handled the sensitive game world fiction. From their feedback and by observing play we recorded the following results:

(a) All players immediately recognized the theme of the game, two players felt uncomfortable with the theme prior to starting the game, but doubts were erased as the game proceeded. All players recognized the movement system from its game ancestors, but they did not feel that its reuse lacked foundation or was inappropriate for the topic. The game quickly opened up possibilities for becoming a game a family could play together.

(b) Players became immersed in the play and the simulation of controlling a family of refugees. They rejoiced when two or more game pieces 'met' on the board, and would at times purposely make inferior game progression choices in order to have their pieces meet up, despite this not being to any advantage in the game. Pieces owned by other players were viewed as an amalgam of competitor and fellow-traveller [41, 42]. The element of competition included did not seem to bother the players. This particular issue had been a subject of discussion during the design process, as we found the idea of having simulated refugees competing against each other both distasteful and unrealistic. For the same reason we placed less focus on rules that allowed players to manipulate an opponent's game pieces and on failing to attain their goal [43].

(c) The companion app controlled global game changes, which could turn events upside-down after each turn. As intended, this introduced both fun and frustration. Players would plan series of good choices to advance towards the game goal, only to find that external events forced their hands and made life either harder or easier. The aim was to approximate game world fiction, game mechanisms, and the choices confronting players in the volatile experience of being a refugee.

(d) The companion app served to make global game state changes each turn. It changed the values and meaning of cards already dealt, so that a card's initial value (e.g. to move 4 spaces ahead) was suddenly reversed. Now the player would move backward if that card were played. Such changes were accompanied by text highlighting the shortage of food or sudden border control. All were accepted as a simulation of real world changes and therefore seen to be in compliance with game world fiction.

(e) Still the game needed tweaking as regards its supporting movement mechanisms. To increase correlation between the world events and game world fiction, we decided to change terminology by renaming moves like *shortcuts* and *detours* with *being smuggled closer to the boarder* or *being exposed, and/or deported*. Changing

terminology enhanced the experience of being a refugee fleeing war. These changes accelerated immersion [8, 44] and enhanced meaning of player choices.

3 Discussion

This project set out to turn real life events into a board game. In the present case we investigated the possibilities of opening the refugee experience to the players in a way that was neither politically loaded nor satirical. We wanted to translate real world events into game fiction, bringing them as close to each other as possible.

The main challenge was how to convert a sensitive real life subject as truthfully as possible while still ensuring that the game was fun and interesting.

We found that it is not advisable to design a game from a storyline. Instead focus should be on the story's context or frame. We have termed the context 'game world fiction'. The benefit of such an approach is that designers can decide which real life events to choose from when adapting them to a game world. We found that the selection process benefitted from being performed on the basis of formal game elements. This enabled correlation between real life events and game objects, between their values and behaviours. Included in this are rules, objects, challenges, conflicts and goals. Designers could be tempted to include too many real life aspects. That is not advisable, since raising levels of complexity negatively impacts players' experience of the game instance [45]. It enhances increases the risk of creating a game that is either frustrating or boring, placing it well along the negative axes of experiencing flow [46].

Since being a refugee is about moving from one place to the next an interesting *movement mechanisms* was needed, and especially one supporting the game world fiction and aligned with player choices in relation to formal game elements. Drafting movement mechanisms carry an inherent danger of diluting the game world fiction by reducing it to a game that would just as well have fitted a scenario of backpacking through Europe. To avoid this pitfall we had to underscore game world fiction in every aspect of the game. Correlating formal game elements and movement mechanisms with the terminology of the game world fiction. Such correlation increased symmetry between expression of the game world and real life events.

In the *Refugee Game* we established symmetry between specific game elements such as player cards and game world fiction to place emphasis on player choice. A player could be dealt an *equipment card* giving them wealth (enabling payment of human smugglers) or an *action card* allowing them to move on contact with helpful volunteer groups instead of waiting for the right dice roll (border control). Equipment and action cards are impacted either positively or negatively at the beginning for each turn by *global event cards* (managed by the companion app). Global event cards reversing equipment and action card values underscored the changes that refugees' experiences. Furthermore some countries are more or less hostile towards refugees, making them either easier or harder pass through (e.g. lower/higher risks of *detours/being discovered,* and *being deported*). All this mirrors the current state among European countries – and at the same time highlights player choices by intensifying uncertainty and fun, since player choices are an important part of playing games. The framework involves meaningful player

choices to balance unpredictability and control. Game states change, and the player navigates with a sensation of influencing the current, but also of influencing subsequent game states. The adaptive framework therefore places importance on an oscillation between players feeling more or less in control of actions and their consequences, yet still facing an unpredictable next turn.

4 Conclusion

In this article we have proposed an adaptive design framework approach of turning real life events into board games. The design framework is distilled from a game design process executed using agile development methods. This allowed for rapid iterations, evaluations, redesign and further testing without starting from scratch. Using prototypes as a communication tool, both internally in the team and externally with testers, made it possible to show and explain our ideas and test them before prematurely discarding them. By conducting ethnographic field research [47] and interviewing volunteers, we made sure that portrayed game world events came as close to the real-life refugee scenario as possible.

We found that game designing based on the refugees' expanded stories constricted the game design process. It was necessary to separate the particular refugee storyline from the general situation or context. Converting the general aspects of a situation established the first layer of our proposed design framework, namely to turn real life events into a game. We have termed it 'game world fiction'. The second layer involves determining how and which real life aspects to select and convert to the game. We found that this is best done using formal game elements. The third layer concerns mechanisms, especially movement dynamics through the game space, while the fourth layer highlights player choices in relation to game world fiction, formal game elements and movement mechanisms, all in place to promote a desired player experience.

Together these four interrelated layers establish a design framework of turning. It is not restricted to the particular case of adapting the Syrian refugee crisis to a game. Instead, we believe, it can act as a generic design framework for turning any real life event into an entertaining and thought-provoking game.

References

1. Burgun, K.: Clockwork Game Design. Focal Press Taylor & Francis Group, Burlington (2015)
2. Fullerton, T.: Game Design Workshop – A Playcentric Approach to Creating Innovative Games. Morgan Kaufmann Publishers, Burlington (2008)
3. Schell, J.: The Art of Game Design – A Book of Lenses. CRC Press, Boca Raton (2008)
4. Larsen, L.J., Majgaard, G.: Expanding the game design space – teaching computer game design in higher education. Des. Learn. 8(1), 13–22 (2016). doi:10.16993/dfl.68
5. Burgun, K.: Game Design Theory – A New Philosophy for Understanding Games. CRC Press, Boca Raton (2012)
6. Jakobsen, M.: Playing with the rules: social and cultural aspects of game rules in a console game club. In: Proceedings of DiGRA Conference on Situated Play (2007)

7. Real, P.: Seriously - Boardgames? Yes, Seriously. African American Intellectual History Society, AAIHS (2015). http://aaihs.org/seriously-boardgames-yes-seriously/. Accessed 22 Jan 2016
8. Murray, J.: Hamlet on the Holodeck – The Future of Narrative in Cyperspace. The MIT Press, Cambridge (1997)
9. Aarseth, E. Allegories of space – the question of space in computer games. In: Eskelinen, M., Koskimaa, R. (eds.) Cybertext Yearbook. Gummerus Printing (2000)
10. Larsen, L.J.: Objects of desire: a reading of the reward system in world of warcraft. Eludamos. J. Comput. Game Cult. 6(1), 15–24 (2012)
11. Sicart, M.: Defining game mechanics. In: Game Studies (2008). http://gamestudies.org/0802/articles/sicart. Accessed 22 Jan 2016
12. Salen, K., Zimmerman, E.: Rules of Play – Game Design Fundamentals. The MIT Press, Cambridge (2004)
13. Wilson, D., Sicart, M.: Now it's personal: on abusive game design. In: Futureplay 2010 Proceedings of the International Academic Conference on the Future of Game Design and Technology, pp. 40–47 (2010). http://dl.acm.org/citation.cfm?id=1920785&dl=ACM&coll=DL&CFID=516385488&CFTOKEN=39932089. Accessed 22 Jan 2016
14. Koster, R.: Theory of Fun for Game Design. Paraglyph Press, Scottsdale (2004)
15. Battlefield 1942 (2004, Digital Illusions)
16. Battlefield: Vietnam (2004, Digital Illusions Creative Entertainment)
17. Call of Duty (2003, Infinity Ward; 2005, Treyarch; 2006, Sledgehammer Games)
18. DayZ (2013, Bohemia Interactive)
19. Sutherland, J.: Agile development: lessons learned from the first scrum. Cutter Agile Project Manage. Advisory Serv. Executive Update 5(20), 1–4 (2004)
20. Schwaber, K., Sutherland, J.: SCRUM. Scrum.org (2010). http://www.evolvebeyond.com/site/wp-content/uploads/2014/05/Scrum-Guide-1.pdf. Accessed 22 Jan 2016
21. Royce, W.: Managing the development of large software systems. Reprinted from Proceedings, IEEE WESCON (1970). http://www.serena.com/docs/agile/papers/Managing-The-Development-of-Large-Software-Systems.pdf. Accessed 22 Jan 2016
22. Klastrup, L., Tosca, S.: Transmedial worlds – rethinking cyberworld design. In: International Conference on Cyberworlds, pp. 409–416 (2004). DOI:10.1109/CW.2004.67
23. Juul, J.: Half-real – Video Games between Real Rules and Fictional Worlds. The MIT Press, Cambridge (2005)
24. Fullerton, T., Swain, C., Hoffman, S.: Improving Player Choices in Gamasutra (2004). http://www.gamasutra.com/view/feature/130452/improving_player_choices.php. Accessed 22 Jan 2016
25. Boess, S., Pasman, G., Mulder, I.: Seeing things differently: prototyping for interaction and participation. In: Proceedings of DeSForM 2010: Design and Semantics of Form and Movement, pp. 85–97 (2010)
26. Brandt, E.: Designing exploratory design games: a framework for participation in participatory design. In: Proceedings of PDC, pp. 57–66 (2006)
27. Gaffney, G.: Participatory design workshops (1999). http://infodesign.com.au/wp-content/uploads/ParticipatoryDesign.pdf. Accessed 22 Jan 2016
28. Manker, J.: Design scape – a suggested game design prototyping process tool. Eludamos 6(1) (2012). http://www.eludamos.org/index.php/eludamos/article/view/vol6no1-8/6-1-8-html. Accessed 22 Jan 2016

29. Costikyan, G.: I have no words & I must design: toward a critical vocabulary for games. In: Proceedings of Computer Games and Digital Cultures Conference. Tampere University Press (2002)
30. Youn-Kyung, L., Stolterman, E., Tenenberg, J.: The anatomy of prototypes: prototypes as filters, prototypes as manifestations of design ideas. ACM Trans. Comput. Hum. Interact. **15**(2) (2008)
31. McGonigal, J.: Reality is Broken – Why Games Make Us Better and How They Can Change the World. Jonathan Cape, London (2011)
32. Juul, J.: The game, the player, the world: looking for a heart of gameness. In: 2003 Level Up: Digital Games Research Conference Proceedings, Utrecht University (2003). http://www.jesperjuul.net/text/gameplayerworld/. Accessed 22 Jan 2016
33. Forbidden Desert (2013, Matt Leacock)
34. Pandemic (2008, Matt Leacock)
35. The Star of Africa (1951, Kari Mannerla)
36. Ludo (1896)
37. Partners (1998, Thomas Bisgaard)
38. Snakes & Ladders (1943)
39. Meier, S.: Sid Meier on how to see games as sets of interesting decisions in Gamasutra (2012). http://www.gamasutra.com/view/news/164869/GDC_2012_Sid_Meier_on_how_to_see_games_as_sets_of_interesting_decisions.php. Accessed 22 Jan 2016
40. Walter, B.K.: Playing and gaming: reflections and classifications in game studies. Int. J. Comput. Game Res. **3**(1) (2003). http://www.gamestudies.org/0301/walther/. Accessed 22 Jan 2016
41. Hunicke, R., Leblanc, M., Zubek, R.: MDA: A Formal Approach to Game Design and Game Research (2004). http://www.cs.northwestern.edu/~hunicke/MDA.pdf. Accessed 24 Jan 2016
42. Zagal, P.J., Rick, J., Hsi, I.: Collaborative games: lessons learned from board games. Simul. Gaming **37**(1), 24–40. Sage Publications (2006)
43. Juul, J.: The Art of Failure – An Essay on the Pain of Playing Video Games. Playful Thinking Series. The MIT Press, Cambridge (2013)
44. Calleja, G.: Revising immersion: a conceptual model for the analysis of digital game involvement. In: Proceedings of DiGRA Conference on Situated Play (2007). http://www.digra.org/wp-content/uploads/digital-library/07312.10496.pdf. Accessed 22 Jan 2016
45. Montola, M., Stenros, J., Waern, A. (eds.): Games and Pervasive Games in Pervasive Games Theory and Design. Morgan Kaufmann, Amsterdam (2009)
46. Csikszentmihalyi, M.: Beyond Boredom and Anxiety – Experiencing Flow in Work and Play. Jossey-Bass Publishers, San Francisco (2000)
47. Dourish, P.: Implications for Design. In: Proceedings of the SIGCHI Conference on Human Factors in Computing Systems, CHI 2006, pp. 541–550 (2006)

Emotion Index of Cover Song Music Video Clips Based on Facial Expression Recognition

Georgios Kavalakis[1], Nikolaos Vidakis[1],
and Georgios Triantafyllidis[2(✉)]

[1] Informatics and Multimedia Department, TEI of Crete, Heraklion, Greece
gkavalakis@gmail.com, nv@ie.teicrete.gr
[2] Medialogy Section, ADMT, Aalborg University Copenhagen,
Copenhagen, Denmark
gt@create.aau.dk

Abstract. This paper presents a scheme of creating an emotion index of cover song music video clips by recognizing and classifying facial expressions of the artist in the video. More specifically, it fuses effective and robust algorithms which are employed for expression recognition, along with the use of a neural network system using the features extracted by the SIFT algorithm. Also we support the need of this fusion of different expression recognition algorithms, because of the way that emotions are linked to facial expressions in music video clips.

Keywords: Facial expression recognition · SIFT · Cover song video clips

1 Introduction

Human expression recognition is a fundamental problem in computer vision attracting great interest from the research community over the last years. Human expressions involve facial expressions, gestures, voices, etc. In this work, we will focus on the facial expression recognition which is the task of automatically identifying and classifying expressions in an image or video sequence. This is still a difficult task for computer vision to perform, although humans recognize facial expressions without effort or delay.

It is also known that music is a basic way of expressing human emotions. But there is somehow a rather different way of face expressing emotions in music performances and in music video clips compared to the same emotions in everyday life. When someone is singing or playing music, he/she is usually more expressive and also may employ different or more intense or even new expressions for specific emotions. For example, a singer looking down usually indicates a sad expression, while this not always true in everyday life expressions. In this context, this paper considers a specific and interesting case of facial expressions recognition: recognition in music video clips of cover songs, aiming at producing an emotion index, labelling the video clip.

The proposed scheme employs already known and used methods of classifying emotions such as the Logistic Regression (LogReg) [1], the Classification and Regression Trees (CR-tree) [2], Linear discriminant analysis (LDA) [3], k-Nearest

© ICST Institute for Computer Sciences, Social Informatics and Telecommunications Engineering 2017
A.L. Brooks and E. Brooks (Eds.): ArtsIT/DLI 2016, LNICST 196, pp. 248–255, 2017.
DOI: 10.1007/978-3-319-55834-9_29

neighbour (k-NN) [4] and Quadratic discriminant analysis (QDA) [5]. The paper also suggests the use of SIFT feature extraction algorithm [6] for emotion classification. SIFT is an algorithm in computer vision that detects and describes local features in images. In this context, for any face in an image, interesting points can be extracted to provide a "feature description" of the face. This description can then be used to recognize the facial emotions in the image with a use of a neural network.

Before processing the facial expressions recognition, an algorithm for face detection should be employed, in order to detect faces that will be evaluated accordingly. However, detecting faces in music video clips is also a challenging task. Face position, lighting, occlusions, video quality are factors that affect the face detection performance.

Fig. 1. General scheme

For the facial expression recognition task, we employ a novel scheme with a fusion decision system for each detected face in the music performance. More specifically, it fuses the aforementioned expression recognition techniques for getting a more reliable final decision regarding the emotion index. This fusion of such techniques improves the efficiency of the system, since the facial expressions during performing music may be different or even more difficult to be classified compared to the everyday expressions, because of the way that emotions are linked to facial expressions while performing music.

After this short introduction the rest of the paper is organized as follows: In the following section, we present the methodology and the algorithms of the proposed system. Then, the experimental results for the case of cover song music video clips are presented and finally the conclusions and future work are drawn.

2 Methodology

The program's input is a music video clip of a cover song. The general scheme is illustrated in Fig. 1. A group of frames is selected (e.g. 5 frames per second) and processed with the face detection algorithm. If the detected face is considered as acceptable (see next section for more details) for the expression analysis, this face image is stored for further processing. This includes the expression analysis which fuses different methods and produces a decision for that face image. This decision is an emotion index. If the detected face is not acceptable or there is not any detected face, the algorithm checks the next group of frames until it finds an acceptable face image for processing.

2.1 Face Detection

The first step of the proposed scheme is the detection of faces within the video frames of a musical video clips. A critical issue is the question if the detected faces are suitable for further (expression) analysis. So it is essential that the basic features on the faces (i.e. two eyes and mouth) should be detected, helping in extracting information. In this context, the face detection algorithm of [7] was employed, which uses a cascaded classifier. In this technique of face detection, we also added the constraint of detecting the two eyes and the mouth, since these are the main features which export the information for the facial expression. Once we detect the two eyes and the mouth, this face image is accepted and we proceed to the next step of the expression recognition.

2.2 Expression Recognition

The facial expression recognition has been a subject of research in the computer science for a long time and there is a lot of research on this area. However, the classification rules are somehow different in recognizing expressions of an artist in a music video clip, since an artist playing music or singing a song, presents specific facial expressions, according to his/her emotions, which may differ in a way from the everyday expressions. This fact makes the expression recognition even harder and proves the correctness of the fusion approach which is suggested in this paper. Some more details about the algorithms we used for expression recognition:

- **Logistic Regression (LogReg)** [1]: The logistic regression analysis offers an elegant possibility of examining the influence of several (of quantitative or qualitative) arguments or "factors of risk". The idea of the logistic regression is based on the conception that the probability of an event with an involution model can be functionally described. The influence of the arguments can be modelled directly. A further advantage is that these variables can be usually transferred in their original form to the model. Besides, only the involution coefficients must become estimated, which reduces the number of necessary statistic tests.
- **Classification and Regression Trees (CR-Tree or CART)** [2]: The CR-Tree decision tree is a binary recursive partitioning procedure capable of processing continuous and nominal attributes as targets and predictors. Data are handled in their raw form; no binning is required or recommended. Beginning in the root node, the data are split into two children, and each of the children is in turn split into grandchildren. Trees are grown to a maximal size without the use of a stopping rule; essentially the tree-growing process stops when no further splits are possible due to lack of data. The maximal-sized tree is then pruned back to the root (essentially split by split) via the novel method of cost-complexity pruning. The next split to be pruned is the one contributing least to the overall performance of the tree on training data (and more than one split may be removed at a time). The CR-Tree mechanism is intended to produce not one tree, but a sequence of nested pruned trees, each of which is a candidate to be the optimal tree.

- **Linear discriminant analysis (LDA)** [3]: Linear Discriminant Analysis (LDA) is a method of finding a linear combination of variables which best separates two or more classes. In itself LDA is not a classification algorithm, although it makes use of class labels. However, the LDA result is mostly used as part of a linear classifier. The other alternative use is making a dimension reduction before using nonlinear classification algorithms.

- **k-Nearest neighbour (k-NN)** [4]: is a method for classifying objects based on closest training examples in the feature space. k-NN is a type of instance-based learning, or lazy learning where the function is only approximated locally and all computation is deferred until classification. The k-nearest neighbour algorithm is amongst the simplest of all machine learning algorithms: an object is classified by a majority vote of its neighbours, with the object being assigned to the class most common amongst its k nearest neighbours (k is a positive integer, typically small). If k = 1, then the object is simply assigned to the class of its nearest neighbour.

- **Quadratic discriminant analysis (QDA)** [5]: is one of the most commonly used nonlinear techniques for pattern classification. In the QDA framework, the class conditional distribution is assumed to be Gaussian, however, with an allowance for different covariance matrices. In such cases, a more complex quadratic boundary can be formed. It is therefore reasonable to believe that QDA better fits the real data structure. However, due to the fact that more free parameters are to be estimated (C covariance matrices, where C denotes the number of classes) compared to those in an LDA-based solution (1 covariance matrix), QDA is more susceptible to the so-called small sample size (SSS) problem where the number of training samples is smaller or comparable to the dimensionality of the sample space.

- **Scale-invariant feature transform (SIFT)** [6]: is an algorithm in computer vision to detect and describe local features in images. The algorithm was published by David Lowe in 1999 and computes scale-space extrema of the space Laplacian, and then samples for each one of these extrema a square image patch. SIFT method is actually proposing descriptors that are invariant to image translations and rotations, to scale changes (blur), and robust to illumination changes. It is also surprisingly robust to large enough orientation changes of the viewpoint (up to 60 degrees). The initial goal of the SIFT method is to compare two images (or two image parts) that can be deduced from each other (or from a common one) by a rotation, a translation, and a zoom [8]. The method turned out to be also robust to large enough changes in view point angle, which explains its success also in object recognition [9]. So, the proposed scheme employs the SIFT method for expression recognition since the SIFT feature keypoints are highly distinctive, in the sense that a single feature can be correctly matched with high probability against a large database of features from many images. Therefore, we actually build a neural network and train it by using as input the SIFT feature keypoints of several face images and as output the respective emotion. Regarding this SIFT-based neural network, there is a problem that there are many feature keypoints which are not associated to the expressions, but only with the face characteristics. In this context, the efficient choice of the face regions

is critical. To solve this problem, we may perform a SIFT-based neural network only to the eyes region (SIFT top) and to the mouth region (SIFT down), since these regions are greatly affected by facial expressions (Fig. 2).

Fig. 2. SIFT features keypoints

The general facial expression flowchart is depicted in Fig. 3. Each one of the faces which were detected in the face detection part of the proposed scheme is analysed by using all six algorithms presented above. These outcomes are fused to result the final decision for the expression recognition of the specific face image which was analysed. Next, we apply the same algorithm to other detected faces and we finally produce the emotion index of the whole video. For simplicity, we have chosen to use the same weight in all six methods.

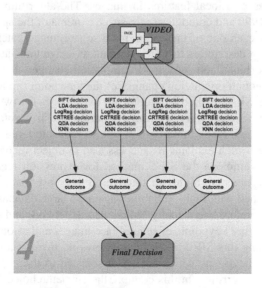

Fig. 3. Emotion recognition analysis

3 Experimental Results

Figure 4 depicts a screenshot of the interface (which is still in a beta version). The user may select the music video clip that will be processed for the facial expression recognition. The interface has been designed in such a way where there is a window playing the video clip, while the faces detected to be suitable for the expression analysis are shown below this video window. The right panel of the interface presents the results (in our proof of concept experiment we have chosen to use on the happy and sad emotions) obtained from each face image according to each algorithm.

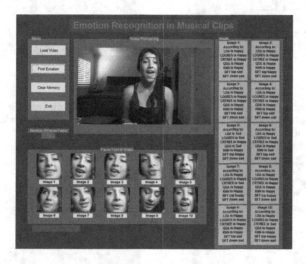

Fig. 4. Program's Interface

So taking into consideration the output of each algorithm, we can reach to a final emotion expression decision for each face image (see Fig. 3). Then, considering these decisions, we can draw a degree (index) of the emotion (e.g. happiness or sadness) for each video (based on the average values and rounded in tens).

In our experiments we used 4 randomly selected cover song video clips from YouTube. We applied the suggested scheme and concluded to an overall index regarding the emotion of happiness. Results are shown in Table 1. Results greater than 70% indicate a happy song, lower than 30% indicate a sad song, while results around 50% indicate a rather neutral song.

Table 1. Emotion (happiness) index on four YouTube cover song videos

Cover Song 1: Song Title: I am yours
www.youtube.com/watch?v=dQz0U6LV-ME
Happiness Index: 90%

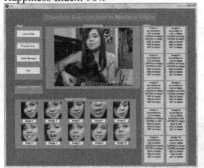

Cover Song 2: Song Title: Just the way you are
www.youtube.com/watch?v=dW6VGm3I8jY
Happiness Index: 80%

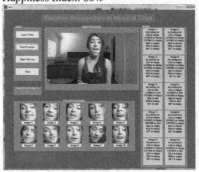

Cover Song 3: Song Title: Creep
www.youtube.com/watch?v=Ph1GaDwdecI
Happiness Index: 30%

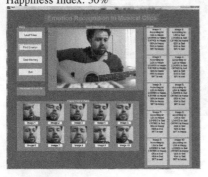

Cover Song 4: Song Title: The writer
www.youtube.com/watch?v=92dxTXL46h4
Happiness Index: 60%

4 Conclusion and Future Work

Automatic emotion labelling of music video clips based on the facial expression recognition is a challenging task, but also a very useful tool. There are internet services offering huge collections of music video clips that may use such methods for classifying the videos in a data base accordingly. Also users may use the proposed scheme for organizing and sorting their personal collections of music video clips. In this way and depending on the user's mood a music player may automatically choose the right music video clip for playing.

In this context, this paper presents a preliminary study of creating an emotion index of cover song video clips by recognizing facial expressions. Improvements, such as more effective segmentation of areas such as the mouth and the eyes and the selection of proper feature keypoints may produce more accurate SIFT-based neural network's

decisions. Also, the creation of a more effective data base is one of our priorities, aiming to facial expression recognition methods to produce better results. Another direction of future work is the weight-based fusion of the results. Finally, the range of the emotions that can be recognized from the system is about to grow and cover a more realistic range of emotions of a music video clip.

References

1. Agresti, A.: Categorical DATA Analysis. Wiley, New York (1990)
2. Steinberg, D., Colla, P.: CART™ Interface and Documentation. Salford Systems, San Diego (1997)
3. Balakrishnama, S., Ganapathiraju, A.: Linear Discriminant Analysis - A Brief Tutorial. Mississippi State Univ., Starkville (1998)
4. Hall, P., Park, B.U., Samworth, R.J.: Choice of neighbor order in nearest-neighbor classification. Annal. Stat. **36**, 2135–2152 (2008)
5. Wang, J., Plataniotis, K.N., Lu, J., Venetsanopoulos, A.N.: Kernel quadratic discriminant analysis for small sample size problem. Pattern Recogn. **41**(5), 1528–1538 (2008)
6. Lowe D.G.: Distinctive image features from scale-invariant keypoints. Int. J. Comput. Vis. **60**, 91–110 (2004)
7. Kienzle, W., Bakir, G., Franz, M., Scholkopf, B.: Face detection - efficient and rank deficient. In: Advances in Neural Information Processing Systems 17, pp. 673–680 (2005)
8. Foo, J.J., Sinha, R.: Pruning SIFT for scalable near-duplicate image matching. In: Proceedings of the Eighteenth Conference on Australasian Database, vol. 63, pp 63–71 (2007)
9. Moreels P., Perona P.: Common-frame model for object recognition. In: Advances in Neural Information Processing Systems, pp. 953–960 (2004)

The Opportunities of Applying the 360° Video Technology to the Presentation of Cultural Events

Nikolay Borisov[1,2], Artem Smolin[1,2], Denis Stolyarov[1,2(✉)], Pavel Shcherbakov[1,2], and Vasiliy Trushin[1,2]

[1] St. Petersburg National Research University of Information Technologies, Mechanics and Optics, Saint Petersburg, Russia
denis1900@mail.ru
[2] Saint Petersburg State University, Saint Petersburg, Russia

Abstract. The opportunities of applying virtual reality technologies to the presentation of cultural events (musical concerts, city excursions, theatrical performances, and others) in virtual reality devices are described in this work. Challenges that appear during shooting video 360° and their solutions are analyzed. The experience of shooting more than 50 different videos is generalized. The opportunities of further development of practice described within the frames of the International Technology Cluster "Infocommunication and Optical Technologies in Culture and Arts" are analyzed. The example of realization interactivity in video 360° connected to the virtual reconstruction is described.

Keywords: Virtual reality · Multimedia technologies · Interactivity · Video 360°

1 Introduction

At the present time virtual reality technologies and their applications have developed intensively [1]. Using these technologies for Arts and Culture [2] allows for a wide variety of opportunities due to providing the user with the effect of presence in the very center of cultural events. One of the most prospective approaches of creating content for virtual reality systems is the 360° Video Technology [3]. This technology allows the creation of panoramic videos with different grades of interactivity where the users changes an angle shot (a camera angle) of the video accordingly to their desire. The video can be viewed through virtual reality headsets (for example, Oculus Rift [4]) as well as on a smartphone, via a special app when the user rotates the video "around himself" by moving his head (Fig. 1) or turning a smartphone. The video can be watched on computers also. In this case, the user manages the foreshortening by using a mouse or a keyboard.

Many big companies (Facebook, Nokia, Samsung, Google and others) develop video cameras for shooting video 360°, virtual reality garnitures for different smartphones and personal computers as well as audio recording devices that provide the binaural sound and the realization of the technology Multimedia 360°.

© ICST Institute for Computer Sciences, Social Informatics and Telecommunications Engineering 2017
A.L. Brooks and E. Brooks (Eds.): ArtsIT/DLI 2016, LNICST 196, pp. 256–263, 2017.
DOI: 10.1007/978-3-319-55834-9_30

Fig. 1. Watching 360° through garniture Samsung Gear VR

Using the 360° Video Technology is actual especially viable in the field of education. The interaction with the user is realized in interactive video 360°. This is the reason why this method can be widely applied to education of experts in different fields, where presence in the center of actions is necessary for gain the experience. The 360° Video Technology allows for analyzing of teamwork during solving different tasks that leads to enhance the quality of the educational process.

The panoramic video plays an important role for preservation and provision of access to cultural heritage. The technology provides the unique opportunity to see not only closed for public access archives of museums but also reconstructed historical monuments that were destroyed by time or circumstances (3D virtual reconstruction). Moreover, virtual reality provides disabled people a unique chance for exploring to different parts of the planet.

As for entertainment in the field of video 360°, viewers can visit biggest cultural festivals, be on stage near favorite musicians or watch a theatrical performance from the royal lodge.

The project of development and applying of the 360° Video Technology to culture and arts has been realized in the Center for Design and Multimedia of ITMO University [5]. Certain results that are necessary for creating high-quality content for virtual reality were achieved within the frames of the project, starting with original devices for filming video 360° and recording audio to software for special task solutions in this field [5, 6].

2 The 360° Video Technology

At present video cameras for filming video 360° are only being developed. However, it is possible to use regular video cameras with special equipment and software for this purpose.

One of the outstanding examples of this approach is the project 360Heros (http://www.360heros.com/) that offers special rigs (video gears) for GoPro cameras HERO 4. The amount of cameras dependent on the tasks in the rig is from 6 to 14 (the stereo version). After a shooting video streams are combined into one spherical video with the help of the special software (Fig. 2).

Fig. 2. Mono (on the left) and stereo (on the right) rigs for GoPro HERO 4

Moreover, several big IT-companies and electronic manufacturers have announced their own fully-automated solutions for shooting content for virtual reality – Google Jump + GoPro Odyssey (https://gopro.com/odyssey), Samsung Beyond (http://think-tankteam.info/beyond/), Nokia Ozo (https://ozo.nokia.com/) (Fig. 3).

Fig. 3. Nokia OZO (on the left) and Samsung Project Beyond (on the right)

The team of project "video360production.com" films 360° videos with the help of its own invention – the camera 360°. This camera provides spherical quality up to 24 K and creates several video streams that are afterwards combined into one panoramic video with the help of a special sequence of algorithms developed by programmers. This

approach provides a high quality product decreasing parallax errors in panoramic videos that is a complex issue to resolve. In the field of video content for virtual reality, "stitching" quality is the most challenging feature to maintain with the only help of the software. Often parallax errors can be eliminated only during the postproduction.

The team of project "video360production.com" unites experts from two fields - engineering (engineers, programmers, hardware and software experts) and art (stage directors, videographers). While one part of the team develops solutions for maintaining a high quality of video 360, the other part provides a creative approach to every case during the film production. It means that the employees of the Center for Design and Multimedia do not use only the unique equipment and software but also a unique approach for every video shooting depending on a set of factors such as interior, exterior, weather, season, time of day and people in a shot.

Video 360° is a new and upcoming trend that doesn't have any standard direction. It gives a wide variety of opportunities for new ideas and methods. The effect of full immersion is achieved due to the camera 360° that shoots everything happening around with the help of several lenses. However, it causes some challenges – for instance, a vast majority of film editing rules and film grammar do not exist in video 360 (for example, screen direction). The main distinction of video 360° in virtual reality glasses is the fact that the audience has the opportunity to look in any direction "around itself" which means that the producer will give an opportunity of dynamic choice of viewing angle without focusing the viewer on a specific part of the screen.

One of the solutions is a detailed scriptwriting with special attention to changes of paradigm – 3D filming. Every video project requires not only a standard preparing (such as setting up lights, choosing the best camera angle, creating a scenario and a composition) but also individual approaches (unique for every case camera mounts, binaural audio recorders, and special ideas for video 360°). For instance, for videos of musical concerts, the recorded production sound track from a camera or stereo microphones is often combined with other elements such as effects or noise of the audience in order to reach full immersion into a video story.

The team has filmed more than 50 different events for virtual reality glasses such as concerts, musical festivals, excursions in historical places, performances in theaters, different cultural events and technological processes. One example is the video 360° of a jazz concert (Fig. 4) [5, 7].

During the shooting of this concert, there were about 20 musicians with musical instruments on stage at the same time which leads to some difficulties with the camera installation. It was necessary to find a place where the camera angle was good enough but the device did not disturb musicians and moreover didn't attract the attention of the audience. The camera was placed in front of the first row of musicians among other equipment. The final product provides musicians with a great opportunity to see not only how they play and analyze their locations with musical instruments on stage but also the reaction of the audience. Viewers are able to view in detail each of the musicians and enjoy the atmosphere created by a classical orchestra with the help of this video.

Fig. 4. Jazz Philharmonic Orchestra – 360° video

There were other difficulties during the filming of a concert of the Russian group "Picnic". It was in a dark music hall with bright spotlight. These conditions are far from being ideal. Even with a usual professional video camera it is quite challenging to make the color depth transmission realistic. Partly this problem can be overcome by using special lens filters that enhance colors. In addition the team worked with foreign groups too: HIM, D12, Skindred, GusGus, Hollywood Undead, etc.

The videos of musical shows in the format of 360° have a huge advantage over standard recordings because the viewer has full independence and freedom over what to look at – to observe the genius playing of a guitarist, to admire the singer or to see the concert with the "eyes" of the musicians, turning his back to the stage and watch the reaction of the audience.

To achieve the effect of the full immersion a high-quality image and a "live" sound are required. There is no denying the fact that the "technical" sound on stage is far from what is heard in the hall. Sound engineers combined the sound of a stereo microphone with studio recording. As a result, the quality of audio is rather high but the recording does not lose its liveliness, which means that while watching the recording, you can hear the audience sing.

Furthermore, the project video360production works with leading St. Petersburg theatres. For instance, a number of plays and musical performances in Mariinsky and Alexandrinsky Theater were filmed. Videos of historical attractions in the city and excursions to museums provide a unique opportunity for users to see the main sights of the city at any time. As for the Museum of Anthropology and Ethnography that is one of the biggest museums in Saint Petersburg, a hall with the Greater Academic Globe, a diplomatic gift to Peter I on the Holstein Duke Carl Friedrich during the Northern War, was filmed before closing for reconstruction (Fig. 5) [8]. Consequently, now it is the only chance to visit this hall. In addition, the tour was filmed during the excursion on the rivers and canals of St. Petersburg (Fig. 6) [5, 9, 10].

Fig. 5. Filming of the Greater Academic Globe in the format of video 360°

Fig. 6. Filming of excursion of the rivers and canals in the format of video 360°

3 Interactivity in the Format of Video 360°

Despite the fact that watching video 360° through various virtual reality headsets provides high-quality immersion into video content, the next step is adding different interactive elements to the video 360°.

These elements can include the following:

- Active tags within the virtual space for the movement along different paths previously filmed as the video 360°;
- Different additional content (images, videos, hyperlinks, etc.) - the function PiP ("Picture-in-picture");
- Switching from video 360° to the simulated 3D reconstructed reality.

On the basis of the system Unity3D, the interactive tour of Korela Fortress Museum was realized as video 360° [11]. This panoramic video excursion with interactive control elements was developed for watching though virtual reality headset Oculus Rift.

Interactive communication allows selecting the route: at certain points (forks) the user is given the opportunity to select the desired continuation of the tour or go back (Fig. 7). The user can point at the interactive elements by turning the head, which is monitored by a gyroscope in Oculus Rift. By keeping a look at the selected item for a few seconds, the user activates this element and the respective segment of video 360° plays. In order to increase the visibility of interactive, the circular progress bar appears when the user looks at the interactive elements.

Fig. 7. Interactive map of Korela Fortress Museum

There is a professional tour guide who describes exhibits when the user "moves" along the path in the forward direction. As for the reverse direction, there is no guide in order not to repeat the same information twice. The user can skip a part of the video by using a keyboard or with the help of an interactive element if desired.

The second form of interactivity is the possibility to switch the video 360° to a virtual three-dimensional reconstruction of the fortress. The reconstruction of the fortress Korela was performed within the project "Multimedia information system "The ancient fortress of North-West"" [12, 13]. There is an interactive element in fixed points of the video-excursion which can be activated by the user in order to switch to the 3D reconstruction. The user can "move" freely inside the virtual 3D reconstruction due to using the functions provided by Unity3D. There are the luminous portals at the points where the virtual reconstruction coincides with the real filmed places. Going into this portal, the user returns to the respective point of the video excursion.

4 Conclusion

Multimedia Technology 360° is a new and perspective technological direction, which allows the creation of high quality innovative content for virtual reality in all areas of human activity (culture, arts, education, science, public administration, etc.).

As for the perspective of the entertainment industry, especially the creation of feature films as the video 360°, a number of new approaches and methodologies of creative and technological processes are expected to be developed in order to provide the user deeper immersion into a video content at a new virtual and interactive level to have more holistic perception.

This work was partially financially supported by Government of the Russian Federation, Grant 074-U01.

This work was partially financially supported by Saint-Petersburg State University development program.

References

1. Frederick, P.: Brooks what's real about virtual reality? J. IEEE Comput. Graph. Appl. Arch. **19**(6), 16–27 (1999)
2. Magnenat-Thalmann, N., Papagiannakis, G.: Virtual worlds and augmented reality in cultural heritage applications. http://citeseerx.ist.psu.edu/viewdoc/summary?doi=10.1.1.106.9743
3. Technology of 360° Panorama Videos. http://www.360-degree-video.com/
4. Oculus Rift. https://www.oculus.com
5. Project Video360production. http://video360production.com
6. Centre for Design and Multimedia, ITMO University. http://cdm.ifmo.ru/
7. Jazz Philharmonic Orchestra. http://www.jporchestra.com/eng/
8. Great Gottorp Globe. http://www.kunstkamera.ru/en/museum_exhibitions/5floor/globe/
9. Borisov, N., Smolin, A., Stolyarov, D.: Multimedia 360° – new technology for arts and culture. In: EVA 2015 Saint Petersburg. Electronic Imaging & the Visual Arts International Conference, St. Petersburg, Conference Proceedings, 24–25 June 2015, pp. 18–31. SPb ITMO University (2015)
10. Borisov, N.V., Smolin, A.A., Stolyarov, D.A., Trushin, V.: Multimedia 360° technologies in art, culture and cultural heritage. In: SGEM International Multidisciplinary Scientific Conferences on Social Sciences and Arts, pp. 189–197 (2015)
11. Korela Fortress Museum. http://korelafortess.ru/
12. The multimedia information system «Ancient Fortresses of the Northwest of Russia». http://nwfortress.ifmo.ru/
13. Borisov, N., Smolin, A.: Virtual reconstruction of the ancient Russian fortress koporye. In: Proceedings of the Third International Conference Digital Presentation and Preservation of Cultural and Scientific Heritage – DIPP 2013, vol. III, Veliko Tarnovo, Bulgaria, 18–21 September 2013, pp. 147–152 (2013)

Learning Together Apart – The Impact on Participation When Using Dialogic Educational Technologies for Kids with Attention and Developmental Deficits

Elsebeth Korsgaard Sorensen[✉] and Hanne Voldborg Andersen

Department of Learning and Philosophy, Aalborg University, Kroghstraede 3,
9220 Aalborg Oest, Denmark
{elsebeth,voldborg}@learning.aau.dk

Abstract. This study reports on research into the impact of digital technological interventions for including kids with attention and developmental deficits into school class contexts. It describes, how the authors have approached the challenge of researching inclusion of kids with attention and developmental deficits for communication, collaboration and knowledge sharing. The analysis assesses the potential of interventions with digital technology for acting as stimulating enzymes for life and learning. On the basis of a thorough discussion of the findings, the authors assess the degree to which interventions with digital technologies, e.g. Virtual Learning Environments (VLEs), may promote inclusion through stimulating the participation in life and learning of kids with attention and developmental deficits.

Keywords: Inclusion · Learning · Digital technology · Attention deficit · Dialogue · Interaction · Collaboration · Communication · 21st century learning skills · Thrownness · Hin enkelte · Learning together apart · Building identity · Participation

1 Introduction

The challenge, imposed by the Danish government in 2012, of including a higher proportion of learners with special educational needs in mainstream schools, represents a complex situation for educators. Many teachers are bewildered in terms of how to meet this increased challenge of inclusion. Generally, they do not find themselves "properly dressed" - educationally or technologically.

On the positive note, research on the educational potential and affordances of digital technologies [1, 2] has identified the *communicative affordance* of digital technology and networks as a strong and promising resource for teachers to employ in learning designs, provided the teachers, pedagogically and technologically, are able to utilize it. Much research [3, 4] points to the potential of digital technologies for supporting some of the ideas of what has been named "21st century learning skills": Creativity and innovation; Critical thinking, Communication and Collaboration.

© ICST Institute for Computer Sciences, Social Informatics and Telecommunications Engineering 2017
A.L. Brooks and E. Brooks (Eds.): ArtsIT/DLI 2016, LNICST 196, pp. 264–271, 2017.
DOI: 10.1007/978-3-319-55834-9_31

The perspective of this study recognizes the potential of digital technological inventions to help teachers and learners with special needs to increase the feeling of *presence, participation and achievements* in teaching and learning processes [5] with focus on "Communication" and "Collaboration". These two modes involve a relation to other people and denote the idea that in order for a learning process to be of good *quality*, a learning process should incorporate - and utilize the digital technology to facilitate - these relations to the teacher and to other learners. In other words, the "glue" for these processes, namely *dialogue* and *interaction*, become central to the learning process. The dialogic affordances are prevailing in the set of reasons why digital technologies appear interesting as tools for helping the inclusion of a diversity of learners in mainstream schools. They offer a great potential in the hands of teachers as tools for helping the inclusion in mainstream classrooms of youngsters with developmental difficulties and difficulties in focusing attention [6].

Learners with attention and developmental disorders, such as e.g. Attention Deficit Hyperactivity Disorder (ADHD), Attention Deficit Disorders (ADD) and Autism Spectrum Disorders, are especially challenged, when it comes to *participating in processes of dialoguing and collaboration*. In general, the achievements of this group of learners are marked by low productivity, errors due to lack of procedures and a poor ability to organize [7].

In addition to general learning disabilities, the attention deficit expressed by insufficient memory, poor persistent focus and initiation ability might affect the ability of the focus learners *to participate* and contribute in collaborative knowledge construction and task solving (ibid.). Furthermore, potential hyperactivity and impulsivity may give rise to inappropriate behavior, disturbances and lower tolerance among the focus learners themselves and their peers [8].

In sum, there appear to be an extensive need for developing digitally based pedagogical methods to stimulate focus learners to co-enact, to dialogue and to collaborate and through these processes learn to fill in the role at school as a significant and valued *peer and participant* in processes of life and learning.

Section 2 of this paper outlines the analytical optic, on which the analysis of this piece of research is resting. Section 3 gives an account of the research design behind the study. It describes, how the authors have approached the challenge of researching the need of the focus group for communication, collaboration and knowledge sharing, and it assesses the potential of digital technology to act as a positive contributor in this respect. While Sect. 4 forms the forum for the actual analysis and the actual insight into data, Sect. 5 performs a more thorough discussion of the findings. Section 6 makes an attempt to assess the degree to which it appears possible to make conclusions on the basis of these findings.

2 Analytical Optic

In the following paragraphs the authors draw the contours of some of the underlying philosophic assumptions and theoretical *concepts of quality*, through which the authors try to capture and discuss the data and findings of this study in view of the challenge of inclusion.

2.1 Developing Identities Together Apart

Any individual human being is unique (an exception) and need space to develop as such. But at the same time, this unique human is preconditioned upon a condition of inescapable co-existence or "throwness" [9], in which *relations* with other people (social, communicative and otherwise) come into focus, in order for a human being to develop harmoniously throughout a lifelong learning process. Envisioning focus learners to become included as happy and well-functioning human beings as any world citizen ("dannelse"), the authors find the notion of "hin enkelte" [11] as one fruitful perspective of a focus learner: [(...) *in a certain understanding every human being constitutes an exception, and that it is true that every human being is the universally human and, in addition, an exception" (Kierkegaard, 1843)] (Our translation)*. Thus, a prosperous process of inclusion aligns with the notion of "a genuine learning process", which emphasize genuine learning as something, not only *meaningful* to the learner, but also *true* to the learner [12].

This view of a learner (i.e. a participant in a learning community) entails the idea of *identity through participation*, and implies that in every learning act and communication, the individual must arrive at *experiencing him or herself as something unique* - an exception. This means that all individuals are left, ultimately, with the important task of participating and, thus, working on the creation of their identity in "becoming themselves".

Thus, any pedagogical approach and use of technology must necessarily employ the digital technologies in ways being concerned with personal growth and a confirmation of the value of "hin enkelte" [11]. At the same time, the digital technologies and interventions must be employed to promote a learner experience of inclusion, and a feeling of being recognized as a valuable participating and contributing member of a group of peers sharing an inescapable context of mutual collaboration, dialogue and collaborative knowledge building (CKB) - in a spirit and context of "learning together apart"[1] [13].

2.2 Developing Participation and Empowerment

Language use and collaborative dialogue (CKB) are widely acknowledged as fruitful pedagogical elements in a prosperous learning process. Both our natural language and any dialogue unfolding around an issue may be viewed as "media" for learning. They underpin the double optic of the ying-yang relationship between "hin enkelte" (individual) and "co-existence" (collaborative) in the learning process. Instead of aiming at making learners reproduce knowledge (traditional pedagogy), the CKB process allows for participation in a continuous "construction of NEW knowledge" [14] through dialectical pending between involvement and reflection [10].

[1] This term was first coined by Dr. Tony Kaye, in Kaye, A. W. (1992). Learning Together Apart. Heidelberg:Springer. The meaning of the term has been slightly altered in the present context to cover the combination of "learning intra-personally" and "learning inter-personally" (with peers).

Dialogue is considered vital for *learner empowerment* to be cultivated. Employing dialogue in a learning process is widely recognized as a fruitful method for the individual learner to be joining and participating the choir adding voice to the polyphonic symphony of the classroom [15, 16]. The *teacher is the key and pedagogic architect* of creating the polyphonic classroom [16] and for making diversity and variation resources among students, in the "symphony of learning" unfolding in an including classroom.

To become *included and (co-)exist* in a global world calls for abilities and competencies to respectfully negotiate diversities and invite compromises - competencies to dialogue with others, while respecting the voice and the value of the argument. Thus, while the making ("Bildung") of democratically oriented global citizens takes its point of departure already in the implementation of educational digital methodology, it plays a significant role in the education and self-understanding of the global citizen, as it promotes ... *learning to dialogue* [17].

Teaching for growth in a digital 21st century context is envisioned to include two overall societal needs related to two overall pedagogical focuses: (1) supporting the *individual aspect of learning,* and (2) supporting the *co-existential aspect of learning.* Thus, teachers' pedagogies, when using digital technologies and technological interventions for inclusion, must include pedagogical methods that support:

- development of *an individual learner identity* (i.e. "hin enkelte")
- initiative and *ownership* of the individual learner
- co-construction of *new and (to the learner) true knowledge* [12]
- *visibility and respect* for *participation/contribution* to the community
- *collaborative knowledge building dialogue (CKB)* [1]

How can technology and technological interventions be utilised to enhance this approach with our focus learners? In which situations does it occur in the case study?

3 Research Design

This piece of research is one of the outcomes from a wider research design [7, 18, 19]. "Ididakt is an iterative and explorative qualitative research project, where data is collected in a real school context. It is a case study in the frame of Action Research (AR) and Educational Design Research (EDR) [20] using a hermeneutical, phenomenological interpretation of data. It is crucial for our data collection, that the unfolding research process goes hand in hand with the involved teachers' work and interventions into the field of study, so the process becomes a learning endeavour in terms of learning how to work with SEN learners and integrating ICT in the classroom" [18].

"Therefore, we designed this study using an AR/EDR approach, where the researchers are included as participants – and professional dialog partners and facilitators of the transformation processes – at the schools involved: 11 schools where 46 teachers in 26 classes have experimented with and examined the impact of including ICT facilitated interventions with more than 500 learners aged 6 to 16 years – including 56 learners with extensive developmental or attention deficit disorders (focus learners). We are studying the problem in its real life context: the mainstream classroom, where

the borders between phenomenon and context are unclear. We have collected data from teachers' statements at seminars, in research blogs, from interviews, and from surveys and observations in the classroom, and we analyse and compare the data in a data triangulation" [7].

4 Analysis and Findings

During the project work 16 out of 26 classes (62%) in 8 out of 11 schools (73%) with Google Apps for Education (GAfE) as Virtual Learning Environment (VLE). We are to some extend able to observe, where and how this technology is utilised to enhance the focus points above, and which impact the use of the VLE has to our focus learners. As a part of our analysis, the eight schools are divided into three categories compared to the learners' experiences as respectively expert, competent or novice when using the GAfE technology.

4.1 The Expert Level (Two Classes - 11% of the Schools)

Students at one of the schools mastered GAfE at a high level and employed the VLE in almost all learning activities. Both teachers and learners were experts, when it came to applying the technology. We observed a pedagogically and technologically powerful team of teachers, who in two years had developed a teaching and learning practise for using GAfE as VLE in two classes in level 6th grade. We noticed on-going pedagogical meta-reflections about the value of this technology for focus learners.

The same school utilised Google Websites as a shared digital academic portfolio. Each subject had its own website, and the full academic repertoire over time was compiled here. This was the place where focus learners found texts, tasks set by the teachers, learner assignments, information, analysis models etc. As a main rule, each learner had access to everybody's assignments and notes. The learners had a school account at GAfE containing mailbox, calendar, drive etc., but apart from that they used many online tools (e.g. mindmeister, quizlet, padlet) to complement the Google applications (docs, sheets, slides etc.).

In this pedagogical setting we were witnessing that focus learners were part of a *shared knowledge building* community, where learners were *dialoguing* about academic topics. All learners' *participation and contributions* were *visible and operationalized* in the design at the Google site and the structures at the Google Drive. Learners were *collaborating* in their problem solving; they were inspired of each other's work and discussed possible solutions of their tasks. The Google Site and Drive may be interpreted as reifications of the knowledge they had *jointly* created. It appeared an externalised part of the learners' academic *identity*, and the focus learners expressed *ownership* to their own as well as to the entries of their peers. Furthermore, in addition to this shared open portfolio, each learner had an individual portfolio, where he/she summed up his/her own 'view of the case' – or his/her own *"true knowledge"*; e.g. in math at their 'word of wisdom site' or in linguistics at their 'concept understanding site'.

Focus learners found much help in this pedagogical design. They were supported in *participating* via the *visible* structure, the *jointly generated content* and the *collaboration with peers*. Insecure focus learners retrieved inspiration, certainty and affirmation at the VLE. We observed, how focus learners felt proud of the shared products – even though their participation in the task solving, in fact, had been peripheral. But we observed, too, how the focus learners may feel so vulnerable or have so much to offer in the task solving processes (e.g. due to developmental delay) that it becomes difficult for them to participate, openly and equally.

4.2 The Competent Level (4 Classes - 33% of the Schools)

For the students at three schools GAfE is well known, and they use the VLE for many of their learning activities. Both teachers and learners are competent and apply technology fluently. We have observed a team of teachers that – to some degree – mastered the technology and were accustomed to using it with their students in, respectively, two classes in 2^{nd} grade and two classes in 6^{th} grade. We only noticed few pedagogical meta-reflections on the value of this technology for learners with special educational needs.

These schools primarily utilised Google Drive and Google applications as management tool in the learning processes. The teachers established folders for each subject and sub-folders for the topics, in which files related to the task solving were shared. Focus learners received files in writing protected folders and copied them to their own drive. They collaborated on Google applications (docs, sheets, slides, hangout) during their task solving. One of the schools started using Google Classroom as a compiling VLE.

In this pedagogical setting we noticed that learners had opportunity to *collaborate* and *foster new knowledge*, primarily, through shared writing processes in Google Applications. It happened mostly at task level and in the form of occasionally *shared knowledge building*; only one of the schools attempted to *organize and visualise* the academic content and the learners' contributions in Google Classroom. The *participation* was more individualised, and the *digital dialogue* took place between teacher and each learner, rather than in an open *shared dialogue* among all learners. The *shared writing processes* were aiding focus learners. They were supported in keeping attention and be aware in the task solving process by *dialoguing and collaborating* with peers. Finally, we noticed, how this pedagogical design demanded a clear and visible distribution of roles in the work-sharing processes (as e.g. Collaborative Learning (CL) methods), to avoid focus learners leaving the work to their peers.

4.3 The Novice Level (10 Classes - 56% of the Schools)

GAfE was unknown to the students at the last five schools, but they started using it in the project in some of their learning activities. The learners were novices, while the teachers ranged from novice to expert. There were two different teams of teachers. At one of the schools (three classes in 3^{rd} grade) teachers were experts, given that they had previous experiences with using GAfE as a VLE. At four schools teachers had to pick up digital skills simultaneously to putting the technology in operation in two classes in

1st grade, one class in 4th, two classes in 7th grade and two classes in 10th grade. We noticed incipient pedagogical meta-reflections concerning the value of this technology for learners with special educational needs.

These schools started using Google Drive and Google applications as tools for learning. The teacher gained experiences in creating and sharing folders and stumbled in general over some difficulties related to fostering an appropriate structure for the learners (with the exception of one school). The learners collaborated in Google applications (docs, sheets, slides, calendar) and learned how to use assistive technologies (text to speech) at GAfE. One school tried out Google+ as a social learning environment.

5 Discussion

In this pedagogical setting we noticed how easily focus learners fell short, when the virtual learning environments were lacking intentional management and structure. But at the same time we observed, how teachers at expert level were able to facilitate academic and work-related success for both focus learners and peers, due to the fact that they used their knowledge about GAfE to introduce and scaffold learners in relation to the technology in a well-arranged step-by-step pedagogical approach.

Focus learners need visual support systems to remember how to navigate in a new online universe. It is necessary to produce recognisable structures across subjects and to stimulate focus learners in growing accustomed to the VLE. We have observed, how focus learners' participation in production and dialogue increase considerably, when they are working with digital templates (e.g. Google Docs or Slides), which guide them through the task solving processes.

6 Conclusion

This paper has addressed the impact of digital technology and technological interventions for including kids with attention and developmental deficits into school class contexts. It has described, how the authors have approached the challenge of researching inclusion of kids with attention and developmental deficits for communication, collaboration and knowledge sharing. On the basis of a thorough analysis of the findings, the authors have discussed how technology and technological interventions promote inclusion through stimulating participation, digital dialogue, and collaborative knowledge building of NEW knowledge, primarily through shared writing processes in Virtual Learning Environments.

The major finding of the study suggests that *teachers and the degree of their pedagogical and technological insights and competences* appear to be the key to inclusion of focus learners. It also uncovers that many teachers need more educational support and competence development. – But to receive more educational support and learning for themselves, they need to be given sufficient space and time to participate and learn together through participating in collaborative knowledge building dialogue. As for our focus learners, it counts for the learning of the teachers that the quality of their learning process will increase through collaborative knowledge building in a setting of "learning together apart".

References

1. Sorensen, E.K.: Dialogues in networks. In Andersen, P.B., Holmqvist, B., Jensen, J.F. (eds.) The Computer as Medium, pp. 389–421. Cambridge University Press, Cambridge (1993)
2. Sorensen, E.K., Takle, E.S., Taber, M.R., Fils, D.: CSCL: structuring the past, present and future through virtual portfolios. In: Dirckinck-Holmfeld, L., Fibiger, B. (eds.) Learning in Virtual Environments. Samfundslitteratur, Frederiksberg (2002)
3. Weigel, V.B.: Deep Learning for a Digital Age: Technology's Untapped Potential to Enrich Higher Education. Jossey-Bass, San Francisco (2002)
4. Dalsgaard, C., Sorensen, E.K.: A Typology for Web 2.03. In: Proceedings of European Conference on E-Learning (ECEL 2008), pp. s.272–s.279 (2008)
5. Ainschow, M., Booth, T.: Index for inclusion developing learning and participation in schools. http://www.eenet.org.uk/resources/docs/Index%20English.pdf. Accessed 15 Aug 2015
6. Andersen, H.V.: Supporting inclusion of learners with attention deficit hyperactivity disorder in sound-field-amplification-systems. In: Sorensen, E.K., Szucs, A., Khalid, S. (eds.) Proceedings of the 1st D4|Learning International Conference: Innovations in Digital Learning for Inclusion, pp. 1–8. Aalborg Universitetsforlag (2015)
7. DuPaul, G.J., Stoner, G.: ADHD in the Schools: Assessment and Intervention Strategies, 2nd edn. Guilford Press, New York (2003)
8. Almer, G.M., Sneum, M.M.: ADHD - Fra barndom til voksenalder (1. udgave, 2. oplag). Frydenlund, København (2009)
9. Heidegger, M.: Sein und Zeit. Max Niemeyer Verlag, Tübingen (1986)
10. Kierkegaard, S.A.: Enten - Eller. Gyldendahl (1843)
11. Colaizzi, P.F.: Learning and existence. In: Valle, R., King, M. (eds.) Existential-phenomenological alternatives for psychology, pp. 119–135. Oxford University Press, New York (1978)
12. Kaye, A.R.: Learning together apart. In: Kaye, A.R. (ed.) Collaborative Learning Through Computer Conferencing. Springer, NY (1992)
13. Darsoe, L.: Innovationspaedagogik. Samfundslitteratur, Copenhagen (2011)
14. Ó Murchú, D., Sorensen, E.K.: Online master communities of practice: collaborative learning in an intercultural perspective. Eur. J. Open Distance Learn. 2004/I, 1–9 (2004) (Peer Reviewed)
15. Dysthe, O.: The multivoiced classroom. Interactions of writing and classroom dialogue. Written Commun. 13(3), 385–425 (1996)
16. Sorensen, E.K.: Fostering intercultural collaborative learning (i-CSCL) through problem orientation methodology (POPP) and social media. Published in METJ (2012)
17. Andersen, H.V., Sorensen, E.K.: Technology as a vehicle for inclusion of learners with attention deficits in mainstream schools. In: Expanding Learning Scenarios - Opening Out the Educational Landscape, pp. 720–730. European Distance and E-Learning Network (EDEN), Barcelona (2015)
18. Sorensen, E.K., Andersen, H.V., Grum, H.: Intercultural Dialogic eLearning: a tool for fostering shared understanding and sustainable competence development in practices of inclusion. In: Herrington, J., Couros, A., Irvine, V. (eds.) Proceedings of World Conference on Educational Multimedia, Hypermedia and Telecommunications 2013, pp. 389–397. AACE - Association for the Advancement of Computing in Education (2013)
19. Jungk, R., Müllert, N.R.: Håndbog i fremtidsværksteder. Politisk revy, Copenhagen (1989)
20. McKenney, S., Reeves, T.C.: Conducting Educational Design Research. Routledge, NY (2012)

Learning by Designing Interview Methods in Special Education

Lise Jönsson[✉]

VIA Kultur & Pædagogik, Center for forskning og udvikling, VIA Pædagogik & Samfund,
VIA University College, Ceresbyen 24, 8000 Aarhus C, Denmark
lhjo@via.dk

Abstract. With the current emphasis on innovation and research in higher education, this paper proposes design-based research as base for a teaching approach to enhance the learning environment of university college students. The paper depicts how students, professors, professional educationalists, and people with learning disabilities worked together to develop five new visual and digital methods for interviewing in special education. Thereby not only enhancing the students' competences, knowledge and proficiency in innovation and research, but also proposing a new teaching paradigm for university colleges and providing new tools for communication in special education.

Keywords: Design-based research · Learning by designing · Higher education

1 Introduction

University colleges in Denmark provide higher professional education. Programs lead to bachelor's degrees in areas such as social education, teacher education, social work and nursing and include internships/placements, thus, integrating theory and practice.

Regulated by execute order from the Ministry of Higher Education and Science, programs were recently changed from myriad parallel modules to short singular modules with particular emphasis on innovation, research and cooperation with practice. These changes were implemented in order to boost education to a higher level of academia, to innovate new practice-oriented products and services, and to make education flexible [1].

Such structural and curricula changes call for a new learning environment. An environment that raises the following research question: *What characterizes a teaching approach that has the potential to enhance students' research and innovative competences, knowledge, and proficiency whilst being embedded in practice?*

By taking point of departure in design-based research (cf. [2]), the paper proposes a comprehensive teaching approach. Thus, bridging the gap in literature and meeting a current need for clear guidelines in how to incorporate innovative approaches in teaching and learning [3]. As way of example, the paper uses a module in a social education

© ICST Institute for Computer Sciences, Social Informatics and Telecommunications Engineering 2017
A.L. Brooks and E. Brooks (Eds.): ArtsIT/DLI 2016, LNICST 196, pp. 272–279, 2017.
DOI: 10.1007/978-3-319-55834-9_32

program[1] and gives valuable insights into how students, professors, professional educationalists, and people with learning disabilities[2] worked together in a design process. The paper shows that not only did this collaborating design process enhance students' research and innovation competences, knowledge and proficiency, and gave way for a new teaching approach, it also resulted in five new visual and digital interview methods for interviewing in special education.

2 Design-Based Research as a New Teaching Approach

Design-based research (DBR) emerged in the 1990s [4, 5] as an educational technology in an attempt to enhance teaching and learning within the social constructivist learning paradigm [2]. DBR is a comprehensive approach, which retrieves data by designing, refining, and testing a design focusing on either education, learning, and/or didactics [6] and which can '…account for and potentially impact learning and teaching in naturalistic settings' [7]. DBR is characterized by the close collaboration with practice throughout the design process and, thus, offers an approach which combines theory and practice. In DBR students become active learners and are 'learning by designing' [8] through hands-on experience with e.g. creativity [3] and mathematics [4, 9]. Building on this, the proposition will show how DBR is adaptable to a university college setting with emphasis on students' competences, knowledge, and proficiency within innovation and research, whilst at the same time addressing a current need in practice by creating an adaptable solution.

Table 1. Teaching approach

	Phase 1	Phase 2	Phase 3	Phase 4
People with learning disabilities			Co-designing the prototype	
Students		Designing the first prototype	Designing + testing the prototype	Refining prototype Presentations Writing chapter
Professional educationalists	Experiencing a need for new interview methods		Expert group Mentoring	Expert group Mentoring First feed-back on methods
Professors	Identifying a need for new interview methods	Teaching Supervision	Teaching Supervision	Teaching Supervision

[1] The program provides qualifications for working with development and care assignments among children, young people and adults with reduced psychological or physical capacities.

[2] In this research, people with learning disabilities are limited to people in need of care by professional educationalists, i.e. people with downs syndrome, mental retardation, autism etc.

The model presented above (Table 1) is adapted from Thomas Reeves (2006). Reeves' original design model depicts four phases. In phase 1, researchers and practitioners analyze practical problems in order to put forward the research objective. Phase 2 focuses on the development of solutions using existing design principles and innovations, whereas phase 3 is an iterative cycle of testing and refinement of the solution in practice. Phase 4 produces design principles and focuses on the implementation of the solution [2].

This research proposition follows Reeves design model, yet elaborates the model by proving details about the particular roles of students, professors, professional educationalists, and people with disabilities (Table 1), and by presenting the cycle of testing and reflection/refinement (Fig. 1). The adapted model is explained below.

Fig. 1. Iterative test cycle for each interview method

Phase 1: Identifying the Need for New Interview Methods in Special Education.
The first indications of a need for new interview methods in special education were brought to light with teaching interview methods in a social education program. In social education, interviewing is a crucial part of gaining insight into the thoughts and feelings of the target group. From that, professionals can adjust and accommodate the appropriate pedagogical and educational measures to the individual. Yet, very few publications focus on interviewing in special education and even less address or describe the particularities regarding people with learning disabilities [10, 11].

The lack of literature mirrored the lack of concrete methods in practice. This was recognized on a university college meeting with representatives from professional educationalists working in special education. Professional educationalists argued that people with learning disabilities have difficulties in communicating their ideas due to poor language, cognitive, and motor skills, which often leave the professional educationalists as the decision makers for people with learning disabilities. Thus, although professionals already use different communication techniques, they identified a need for a more systematic approach, where people with learning disabilities are able to communicate their perception of life.

From the above, it is clear that the need for new interview methods in special education was identified in both academia and in practice. To address this gap, seven professional educationalists joined an expert group. The expert group was to work with two university college professors (the author included) in order to identify which interview methods to design and refine for use in special education.

Visual and digital techniques are often used in special education settings for communication and documentation purposes. For example, drawings are used to illustrate the structure of the day for the autistic and pictures are taken to document a holiday as a reminder for people with a lack of memory. These experiences from practice and the fact that visual and digital methods in research often prove beneficial when working with children and others who may have verbal limitations, let to the decision that all interview methods were to be either visual, digital or both. Drawing on experiences in both special education and in academia, five visual and digital interview methods were chosen, namely: (a) Photography, (b) Film, (c) Scrapbook, (d) Digital storytelling and (e) Talking-mats[3].

Phase 2: Developing New Interview Methods. Twenty university college students from the social education program joined the research in phase 2 as part of a five-week module focusing on research and developmental projects. The first part of phase 2 focused on academia and provided knowledge of DBR, the history of participation and decision making among people with learning disabilities, and ethnographic interviewing with particular emphasis on special education. Students were also introduced to visual and digital methods. In groups of four, students worked with a particular method and designed their first solution, i.e. prototype, by combining their knowledge of education and methods. University college professors supervised this latter part of the phase.

Phase 3: Iterative Cycle of Testing and Refinements of Interview Methods. The third phase consisted of an iterative cycle of testing and refinements - starting with test 1 (see Fig. 1). For testing, each group split into pairs allowing each group to carry out two tests in each test cycle, thus, doubling the amount of data[4].

Interviews were carried out in care facilities, either at the work place or in the homes of people with learning disabilities. All interviews focused on the lawful right to participation and decision making in one's life, yet the main focus of the interview was for students to pay attention to the target group's needs and the potential to use the method as a way of communication. This potential was monitored by the use of notes and by video filming.

After test 1, students returned to university college for reflection and refinement. The pairs rejoined their methods group and a lecture on analysis served as a springboard for this next stage of the design process. Each group analyzed their videos and discussed similarities and differences between the two interviews by paying careful attention to the flow of the interview, language, body language, and the influence of e.g. time and setting. Overall, the method's ability to work as a tool of communication was scrutinized and sequences of particular interest and concern was presented to the expert group of professional educationalists. Professional educationalists and students then discussed the findings and worked together – along with input from university college professors - in order to refine the methods. For

[3] Talking mats involves the use of a mat and picture communication symbols. People communicate answers by placing a picture beneath a happy, neutral or angry smiley.

[4] Two interviewers instead of four also limited the amount of stress for the interviewee.

example, the group of students using photography as a method of interviewing first disregarded people with learning disabilities as photographers, yet encouraged interviewees to take pictures in the refinement of the method as it became clear from watching the video and from the discussion with the expert group that this was certainly an option. In this way, people with learning disabilities also became co-designers of the prototypes, as they informed the design process during the interview.

In test 2, the refined prototype was tested again. Tests were carried out with new interviewees so that prior knowledge of the method did not influence the interview. This interview was analyzed, reflected on and refined into a prototype for test 3. After test 3, the interview data from all six interviews were analyzed and discussed in each group. Again, the expert group mentored the students along with the professors. The process ended with a refinement of the prototype into a new interview method.

Phase 4: Reflections on New Methods for Interviewing in Special Education.
Throughout the design process students reflected upon the applicability of the interview method. In phase 4, these reflections were explored even further as each group of four presented their method on two occasions. First, the interview method was presented to the other four groups, the expert group and the university college professors. At the presentation, each group reflected on the design process, the interview method as well as its potentials and limitations. This allowed a discussion of the particular method and its applicability in special education, which also served as the first feedback to the expert group. The second presentation was carried out at a peer conference. The conference functioned as a "show and tell," in which students explained and demonstrated the method to their peers enrolled in parallel module projects - and to students and visitors at the university college on that particular day.

Presentations, along with the work and reflections carried out throughout the design process, laid the foundation for a forthcoming book on the subject of interviewing in special education. In more detail, students were instructed in writing and supervised intensively during a two-week writing period. These efforts resulted in five methods chapters focusing on interviewing with the use of photography, film, scrapbook, digital storytelling, and talking mats. The chapters will be published together with writings on DBR, the history of decision making among people with learning disabilities as well as an introduction to interviewing in special education [12].

In addition, students will visit the involved care facilities. These visits have a dual purpose. On one hand, the visits focus on sharing the knowledge and discussing the implementation of the method with the professional educationalists. On the other, the visits serve as a way to give back and thanking the people with learning disabilities. As will be demonstrated in the findings below, the visual and digital methods proved highly effective tools of communication. This meant that students connected well with the interviewees, and thus, were asked to come back by professional educationalists and people with learning disabilities alike.

3 Findings

Drawing on the design process presented in this paper as well as observations, informal conversations, and semi-structured interviewing [13], findings show that students were 'learning by designing' during the module. By applying knowledge from lectures on DBR, the history of participation and decision making among people with learning disabilities, ethnographic interviewing, visual and digital methods as well as analysis and writing, the students were able to design, test and refine the interview methods. Thus, allowing them to both learn and develop the profession.

Students' competences, knowledge, and proficiency in innovation and research were demonstrated vividly and visibly in the presentations and by their ability to write a chapter for a book on visual and digital methods in special education. Additionally, when asking students about their learning outcome, they spoke enthusiastically about the design process and highlighted the possibilities to do further testing and refinement in their upcoming internship/placement:

Sophie: *It's gonna be interesting if you can refine it even further. Maybe come up with*
 new ideas.
Mary: *Exactly, we can do some testing.*
Sophie: *There's great potential.*
Mary: *Definitely. And I really think the possibility to learn these kinds of things is so*
 cool; to test these things because we can use this in the future.[5]

As stated in the interview excerpt above, students expressed great interest in further advancing interviewing in special education. Although some students were more reluctant and unsure of themselves as interviewers due to lack of experience, it was apparent that all students agreed to have gained competences, knowledge, and proficiency in innovation and research, thus, enabling them to test and refine work related issues in future careers.

When asked for further details about their learning outcome, students praised the close relation with practice. The fact that they were designing new interview methods because of an actual need was highly motivating for them and linked their studies to the profession. Furthermore, the collaboration with practice played an important part in students' learning. The mentoring from the expert group and the openness and willingness from the interviewed people with learning disabilities were highly appreciated and both groups were seen as significant partners.

Indeed, cooperation had a significant impact on students' learning as well as on the professional educationalists and the people with learning disabilities involved. Although a bit embarrassed by being referred to as experts, the professional educationalists embraced their role as mentors and used their expertise in the design process. They spoke highly of a fruitful design process and saw themselves and the people with learning disabilities as co-designers of the five interview methods. The professional educationalists in particular appreciated the diversity of the methods. By referring to individuals in their care facilities, they were able to identify and match which method would aid communication with whom

[5] Names are kept anonymous. Statements are translated from Danish to English.

and highlighted how people with learning disabilities were able to voice their thoughts and feelings:

Nina: *The citizen is talking: "This is where I am and this is what I would like to develop."* *We are no longer the interpreters.*

The professional educationalists, as seen above, saw the methods as tools of communication that would support people with learning disabilities to keep focus and enable professional educationalists to listen. The methods, they argued, would provide professional educationalists with insights and understandings, instead of leaving them to rely on their own interpretations of people with learning disabilities' needs. They supported this argument by referring to interviewees who used the methods to become decision makers in their own life. In regards to talking mats, for example, a man was able to communicate his lack of privacy in his own home by the use of smileys and another man was able to communicate how he wanted his flat decorated for Christmas by the use of digital storytelling. The latter even taught his peers how to co-produce small films expressing thoughts and feelings about everyday life.

Now, considering the above, it is clear that the teaching approach, presented in this paper, has the potential as a new teaching paradigm for university colleges. The teaching approach, built on the principles of DBR, is characterized by being experimental, collaborative as well as theoretically and practically sound. Not only does the teaching approach successfully enhance students' competences, knowledge, and proficiency in innovation and research, it is also highly embedded in practice by addressing a current need and creating an adaptable solution. In summary, combining theory and practice; the focal point of university college education.

4 Conclusions

This paper proposes a new teaching approach to enhance the learning environment of university college students. By adapting DBR to a university college setting, it depicts how students gained competences, knowledge, and proficiency in innovation and research throughout a design process focusing on developing new visual and digital interview methods in special education. This was illustrated in students' presentations and methods chapters as well as in their statements about further testing and refinement of interview methods in special education.

The proposition also demonstrates how a teaching approach embedded in practice affects the profession involved and ensures an adaptable solution. Testing the prototypes in care facilities enabled students to explore the interview methods in real life situations while people with learning disabilities were able to inform the refinement of the method during the test cycle (seen in Fig. 1). Acting as an expert group, the professional educationalists also took part in the design process and allowed practice-oriented solutions that promote people with learning disabilities to become decision makers in their own life.

Being characterized as experimental, collaborative as well as theoretically and practically sound, the teaching approach presented in this paper is capable to serve as a model for university college teaching in innovation and research. Although the model seems

flexible and adjustable to time scales and students' levels in academia and practice (e.g. project management skills, experience with target group etc.) further testing of the model is needed in order to grasp the full potential as a new teaching paradigm. Consequently, the future research plan involves, in conjunction with dissemination in various academic outlets, initiating dialogue between academia, practitioners and students in order to validate the proposition and support theory building. In particular, further attention could be paid to the establishment of the appropriate DBR mindset for designing, refining and testing the solution.

References

1. Uddannelses- og Forskningsministeriet. http://ufm.dk/publikationer/2012/filer-2012/stoerre-sammenhaeng-i-det-videregaaende-uddannelsessystem.pdf
2. Reeves, T.: Design research from a technology perspective. In: van den Akker, J., Gravemeijer, K., McKenney, S., Nieveen, N. (eds.) Educational Design Research, pp. 86–109. Routledge, London (2006)
3. Wood, D., Bilsborow, C.: "I Am Not a Person with a Creative Mind": facilitating creativity in the undergraduate curriculum through a design-based research approach. Electron. J. e-Learning 12(1), 111–125 (2014)
4. Brown, A.L.: Design experiments: theoretical and methodological challenges in creating complex interventions in classroom settings. J. Learn. Sci. 2, 141–178 (1992)
5. van den Akker, J.: Principles and methods of development research. In: van den Akker, J., Nieveen, N., Branch, R.M., Gustafson, K.L., Plomp, T. (eds.) Design Methodology and Developmental Research in Education and Training, pp. 1–14. Kluwer Academic Publishers, The Netherlands (1999)
6. Christensen, O., Gynther, K., Petersen, T.B.: Design-Based Research – introduktion til en forskningsmetode i udvikling af nye E-læringskoncepter og didaktisk design medieret af digitale teknologier. Læring & Medier (LOM) – no. 9 (2012)
7. Barab, S., Squire, K.: Design-based research: Putting a stake in the ground. J. Learn. Sci. 13(1), 1–14 (2004)
8. Hmelo, C.E., Holton, D.L., Kolodner, J.L.: Designing to learn about complex systems. J. Learn. Sci. 9(3), 247–298 (2000)
9. Gravemeijer, K., Cobb, P.: Design research from a learning design perspective In: van den Akker, J., Gravemeijer, K., McKenney, S., Nieveen, N. (eds.) Educational Design Research, pp. 45–85. Routledge, London (2006)
10. Beail, N., Williams, K.: Using qualitative methods in research with people who have intellectual disabilities. J. Appl. Res. Intellect. Disabil. 27(2), 85–96 (2014)
11. Aldridge, J.: Picture this: the use of participatory photographic research methods with people with learning disabilities. Disabil. Soc. 22(1), 1–17 (2007)
12. Jönsson, L. (ed.): Visuelle og digitale metoder - på det sociale område. Frydenlund Academic (2017, in Press)
13. Kvale, S., Brinkmann, S.: InterView. København, Hans Reitzels Forlag (2011)

Powerlessness or Omnipotence – the Impact of Structuring Technologies in Learning Processes for Children with Attention and Developmental Deficits

Hanne Voldborg Andersen[(✉)] and Elsebeth Korsgaard Sorensen

Department of Learning and Philosophy, Aalborg University, Aalborg, Denmark
{Voldborg,Elsebeth}@learning.aau.dk

Abstract. Schoolwork of learners with developmental and attention deficits is often characterised by low productivity, many errors due to carelessness or inattention and poor organisational ability. Focus learners have difficulties performing at the same level as their peers. This paper addresses the challenges and investigates the potential of technologies for creating and facilitating environments, where learners are well-supported with respect to overviewing, structuring and planning tasks, evaluating and adjusting participation and management of time.

Keywords: Inclusion · Learning · Digital technology · Attention deficit · Structure and overview

1 Introduction

Individuals with Attention and Developmental Disorders (focus learners) as e.g. Attention Deficit Hyperactivity Disorder (ADHD) are challenged in life and learning, because of the core symptoms of their diagnosis [1]: The attention deficit reveals through poor memory, attention and persistence, while hyperactivity or impulsivity manifest itself in restlessness, behaviour problems, emotional vulnerability or social problems [1].

The schoolwork of learners with ADHD is often characterised by low productivity, many errors due to carelessness or inattention and poor organisational ability [2]. The focus learners have difficulties performing at the same level as their peers [3, 4]. Due to lacking memory and attention, it appears difficult for them independently to command and cope with what to do, how to do, when to do, where to do, with whom to do, for how long to do etc. They attain lower scores and poorer grades and are at a high risk for dropping out of school [5], the reason why teachers and researchers worldwide are searching for new methods to facilitate inclusion in the sense of increasing presence, participation and achievements for this particular group of learners.

Furthermore, the perspective of ADHD in adulthood shows continuing challenges for focus learners in relation to structuring and planning tasks, evaluating and adjusting their own behaviour, reactions, intuition and management of time etc. This affects them socially and in family, educational or working life [1]. It should be an overall concern for professionals to provide this group of learners with assistive tools and supportive

© ICST Institute for Computer Sciences, Social Informatics and Telecommunications Engineering 2017
A.L. Brooks and E. Brooks (Eds.): ArtsIT/DLI 2016, LNICST 196, pp. 280–288, 2017.
DOI: 10.1007/978-3-319-55834-9_33

structures, to bring them overview and help them remain on track in changing this unfavourable future perspective. Research shows us that *"when students with ADHD are taught planning skills and strategies, and provided proper support and guidance, they can use a plan effectively and use strategies. This, in turn, can improve their academic performance"* [6].

Using technologies for *shielding and focusing* seems fruitful in helping focus learners join and participate more attended, smoothly and quietly in the classroom [7], but also technologies for *structuring and overviewing* has proved valuable tools for SEN learners to physically join and participate in educational activities in the classroom [8].

This paper addresses the challenges of creating and facilitating a learning environment, in which focus learners are supported in relation to overviewing, structuring and planning tasks, evaluating and adjusting participation and management of time and, finally, examining the digital potential for these processes. Section 2 of the paper outlines the theoretical perspective on which the research is resting. Section 3 gives an account of the research design behind the study, while Sect. 4 forms the forum for the actual analysis and insight into data. A more thorough discussion of the findings occur in Sect. 5 and, finally, Sect. 6 makes an attempt to assess the degree to which it is possible to make conclusions on the basis of these findings.

2 Theoretical Perspective

The learning process can be seen as a personal formation, where learners learn both to understand the world and them selves. Kohut [9] offers us in his object-relation theory an understanding of, what is at risk in these processes. Teachers appear emphatic reflecting and idealizing self-objects, who lead learners through a staged self-development process initiated by sufficient frustration. The self, in this process, will oscillate between two emotional conditions – powerlessness (to be nothing) and omnipotence (to be able to everything, grandiosity). Omnipotence increases learners' willingness to deal with things. Powerlessness causes learners to search for protection and confirmation.

If the stages are experienced positively, the learner will develop a robust/solid self, which make him/her able to assess opportunities in the world. If necessary frustration turns into invincible frustrations, narcissistic infringement occurs [9], which makes the self-developmental processes impossible. Invincible frustration leaves the self in a depressive emptiness and feeling of being abandoned – or chooses other environments for reflection – as e.g. gangs, religious sects, etc. [9].

Learning can be seen to happen in the ideal tension field between reflection and idealization [9]. To change the learning and life perspective for focus learners it will be necessary that they meet a reflecting and understanding environment at school, where the level of frustration is adjusted to the learners' zone of approximate development – and the learner experience more omnipotent and less powerless.

This resonance in the reflecting and understanding environment is only a necessary base; it is not on its own enough to increase self-development and learning [9]. The constructive frustration brings something new to light, while missing or destructive confrontation decreases or hinders the learner's development. The ideal learning

environment is one, in which the teacher has reduced the threat against the learner to a minimum and facilitated different views on the case [10].

Technology is widely recognised as valuable tools for people with special educational needs [11, 12]. Technology, however, may be used in many perspectives and with different functional roles. From a Persuasive Technology point of view [13], technology may function as a *tool* to increase capability, a *medium* to provide experience or a *social actor* to create relationships [13 p. 25]. Assistive Technologies (AT) may be used to train or rehearse something, or assist or enable learning [14]. When using Assistive Technologies the idea is not to fix or cure the disability [14], but to enhance quality of life, accentuate strength and enable expression of abilities [15].

For focus learners challenged when structuring and planning tasks, and when evaluating and adjusting own behaviour or reactions, intuition and management of time - it could be fruitful to utilise the persuasive potential in Technology as a Tool for "change attitudes or behaviours or both by making desired outcomes easier to achieve" [13]. But it is possible to bring the seven types of Persuasive Technology Tools [13]: reduction, tunnelling, tailoring, suggesting, self-monitoring, surveillance and conditioning into play in a real world school practice? And how might Persuasive Technology Tools in the hand of teachers and learners assist, motivate and enable the presence, participation and achievements of focus learners at school? Using this lens the authors examine, to what extent technology may assist teachers to create more ideal learning environments by reducing the threat of focus learners and enable them to participate in learning. In which ways may technology increase resonance and constructive confrontation, facilitate necessary frustration and optimise learning? How may technology help enhancing the learners' feeling of omnipotence, reduce powerlessness and minimize invincible frustration?

3 Research Design

This piece of research is one of the outcomes from a wider iterative and explorative qualitative research design, Ididakt, carried out 2013–2016 by the authors of this paper [16, 17]. Ididakt is a case study framed by Action Research (AR) [18, 19] and educational Design Research (EDR) [20] and data is collected in a real school context. EDR is a *"genre of research, in which the iterative development of solutions to practical and complex educational problems also provides the context for empirical investigations, which yields theoretical understanding that can inform the work of others"* [20 p. 7].

The authors/researchers were included as professional dialog partners and facilitators in the transformations processes at 11 schools, where 46 teachers have been inspired to experiment with and examine the impacts of using ICT facilitated interventions in their teaching practises in 26 classes. More than 500 learners aged 6 to 16 years are included in the project – among them 56 learners with extensive developmental or attention deficit disorders (focus learners). *"It is crucial for our data collection, that the unfolding research process goes hand in hand with the involved teachers' work and interventions into the field of study, so the process becomes a learning endeavour in terms of learning how to work with SEN learners and integrating ICT in the classroom"* [21]. The empirical data set consists of teachers'

statements at seminars, in interviews or at a research blog, from surveys, interviews with school leaders or students and from classroom observations. All in all a rich data set, which were analysed in a hermeneutical, phenomenological perspective.

4 Analysis and Findings

Technologies used for helping focus learners structuring and overviewing the day appear in Table 1. From various interventions the authors have identified the most valuable tools for structuring and overviewing the school day and task solving as constituted by Virtual Learning Environments (VLE), Timers, Calendars, Visualisations and Templates.

Table 1. Technology used for structuring and overviewing the learning processes.

Technology used in	Number of schools	Per cent of schools
Templates	10	91%
Skole-Intra	9	82%
Visualisation	8	73%
Google Apps for Education (GAfE)	7	64%
Timer	5	45%
MobilizeMe/Planet	2	18%
Office 365	1	9%
Meebook	1	9%

4.1 Virtual Learning Environments (VLEs)

The schools have used four different types of VLEs: Skole-Intra, Meebook, Google Apps for Education (GAfE) and Office 365. In the VLEs teachers compile and structure all materials for a subject, a course or a task in an online resource, which always appear accessible for the students. The VLE serves as a shared curriculum or portfolio reflecting what is processed and learned, and it contains information, instructions, guidance, links, assignments, calendar, checkboxes, shared files and folders etc. Learners and teachers communicate in multiple modes with each other, and it is easy for teachers to differentiate content, explanations and tasks. Use of VLEs seems to foster a visible and shared frame for the academic work, which reduces complexity for the learners in offering suggestions for what to do, and help them keep on track. The VLE enables self-monitoring and surveillance of the progression, and content can easily be tailored to the specific individual needs of focus learners.

The VLE is very helpful for learners with lacking memory and attention, as it helps them to cope more independently with what to do, how to do, when to do, where to do, with whom to do something, for how long to do something: *"It works well for all students. L. (Focus learner, girl in 6*th *grade) benefits from reading the writings of her peers. It helps her getting started and gives her ideas for her writing."* (Teacher, School B).

Teachers describe how the VLE - specifically amongst the oldest group of focus learners - scaffolds the learning process and helps them participate and contribute more

autonomously in the classroom. In one young class, the teacher says that the VLE is more useful for peers. Nonetheless, it reduces the teacher tasks and leaves more time for focus learners.

Skole-Intra and Meebook are resources developed for education. They are easy to use and offer the teachers a fixed structure. GAfE and Office365 are generic tools, where the teachers must create a useful structure by themselves. It requires time, pedagogical visions and technological skills, but offers then a flexible and dynamic user interface, which easier can be adjusted different needs. The effect of VLEs seems dependent of the teachers' knowledge and competences for using the resource.

The VLEs seem to be valuable tools for classroom management. It is evident that a deliberated, structured use of VLEs enhances the learners' feeling of omnipotens. It might, though, be caused by the fact that use of VLEs also makes teachers' preparation and teaching more visible and structured. In contrast, if the VLEs not are well-structured and considered for the needs of focus learners, it would – similarly to a real world setting - still be difficult for them to navigate and overview what to do.

4.2 Timers

Five schools have used Time-timers in the classroom for structuring time, when focus learners participate in classroom activities and task solving. A time-timer is a visual watch, which in a simple, graphical way reflect the remaining time. The time-timer has proved a very strong tool for enhancing the focus learners' attention and persistence. The ability for self-monitoring time seems to be essential for most focus learners. The teachers notice more omnipotence and less stress and invincible frustration, when focus learners are able to measure the time left on a given task: *"The two persistent children (focus learners) worked autonomously in almost four hours, only because of the time managed and adjusted agenda. It was wonderful to se them work without constantly needing to be next to them – while at the same time they felt, that they had performed and contributed well. They went home happy, for sure, from school that day"* (Teacher, School D). Some of the schools tested online timers. They observed, that animated watches as e.g. bombs who blast, when time is up, are too disturbing for the focus learners' attention to tasks.

4.3 Calendars

Two schools tested assistive calendar applications (MobilizeMe and Planet) for planning and structuring the day for focus learners. The applications offered caregivers (parents, teachers, pedagogues, etc.) a shared calendar, in which they are able to collaborate, communicate and create a detailed day plan with text, pictograms and pictures. The focus learner finds the calendar at his iPad or mobile, where he follows the plan and with checkmarks illustrates, what is already done. The applications provide all types of persuasive technology tools (reduction, tunnelling, tailoring, suggestion, self-monitoring, surveillance and conditioning), and are used successfully in many schools for Special Educational Needs. The focus learners find the applications: *"I use Planet every day... I have an alarm for getting up. I use a program for the day, so I can see, what I*

need to do. Find cloth, take my medicine, prepare my lunch, brush my teeth, be ready for and go to school... If I didn't get notifications I wouldn't do my homework..." (Focus learner, girl in 8th grade) Nevertheless, it seems to be difficult to implement specific assistive tools in a mainstream educational setting. *"We do not use MobilizeMe, because the daily investment of time will not measure up to the possible outcome."* (Teacher, School C). It might be easier to provide such solutions to the focus learners, if the calendar tool was a part of the general VLE for all learners in the class.

4.4 Visualisations

As a supplement to digital structuring tools most schools have used various visualisations in the classroom to help the focus learners remember what was said and how to do. It might be day plan documents, posters with written expectations to learners' attitude and behaviour in the classroom, visible learning goals, collaboration groups or just notes at the board. We have observed, that quiet often focus learners seek information in these visualisations and use them to navigate in a school day. Even though learners have access to the same information online, it seems important to remember, that they might still need this "off-line" messages in the classroom.

4.5 Templates

Digital templates for structuring tasks have appeared successful tools in the project. At ten schools teachers observed that templates enhanced focus learners' capability for task solving and production. *"I have done experiences with writing templates, when my class was writing book reviews. I saw B. (focus learner, boy in 4th grade) autonomously make his assignment and within the deadline. I saw he worked systematically by means of the template. It is the very first time ever, I have witnessed him carry out a task in the school by himself."* (Teacher, School F). The templates can support learners with poor organisational ability to perform at the same level as their peers.

4.6 Other Interventions

Teachers in the project have made a variety of other interventions adjusted to the specific needs of their focus learners. From those, we found the following very fruitful:

1. Cancel morning hymn for focus learners and use this time to give him/her individual instructions about the day plan. Teachers observed a much more participating, calm and contributing learner for the rest of the day.
2. Adjust the homework to the focus learners' capability. Teachers observed less stress and invincible frustration.
3. Use of alarm and notifications at the iPad. Teachers observed that the focus learners remember their homework and arrive at school on time.
4. Use of video instructions. The teachers observed that the focus learners watch the video as many times as necessary to understand what to do.

5. Use of assessment and evaluation tools. The teachers observed enhanced awareness and understanding in focus learners about their own role in learning processes.

5 Discussion

There is little access to technology in the classroom of the younger learners. Not being a daily working tool, it spoils the teachers' possibilities for taking advantage of the potential in structuring and planning technologies.

It is evident that use of digital structuring tools has a positive impact when it comes to the focus learners participation and contribution in the learning processes. We have seen, how their memory, attention and persistence have been improved, as has the growing productivity of the focus learners. However, the technologies are not able to foster such changes on their own. They must be used in the hand of an intentional teacher, who uses his/her pedagogical imagination [22] to adjust the technologies and the structures according to the special needs of the focus learners. The technologies must be used as tools to increase capability, as mediums to provide experiences, and as social actors to foster the building of relationships. We might cite with [13] in stating that it is not enough with Persuasive Technologies. And then add: They must be used in a Persuasive Pedagogical setting.

In our earlier research we have promoted a five type intervention model for use of including technologies, where technologies for *structuring & overviewing* is one of the types among *shielding & focussing*, *differentiating & understanding*, *producing & disseminating* and *dialoguing & collaborating*. In an attempt to rank the five intervention types we have found that structuring and shielding tools are assistive technologies, which compensate for the focus learners' disabilities and enable them to become ready for – and join - the learning process, while the differentiating, producing and dialoguing tools are utilities directed towards the learning process.

6 Conclusion

This paper have examined and discussed the extent to which technology may assist teachers in creating a more ideal learning environment for learners with attention and developmental deficits. It seems evident, that digital tools, which provide possibilities for reduction, tunnelling, tailoring, suggestion, self-monitoring, surveillance and conditioning, are, in fact, able to assist, motivate and enable focus learners presence, participation and achievements at school.

We have identified well-structured Virtual Learning Environments (VLE), digital templates and timers as specific valuable tool for enhancing the focus learners' ability to become ready to learn, join and remain within the learning processes. We have further realised that visualisations in the classroom, notifications, video instructions, assessment and evaluations tools help focus learners to navigate, remember, become aware and understand their own role in the classroom.

Using structuring technologies in a reflecting and understanding environment in the school, it seems possible to reduce invincible frustration and increase resonance and

constructive confrontation in the zone for proximate development, in which the focus learners experience more omnipotence than powerlessness. Finally, we consider technologies for structuring and overviewing as basic assistive tool for equalizing the learning possibilities of the focus learners in an inclusive school setting.

References

1. Almer, G.M., Sneum, M.M.: ADHD - Fra barndom til voksenalder (1. udgave, 2. oplag). Frydenlund, København (2009)
2. Steiner, N.J., Sheldrick, R.C., Frenette, E.C., Rene, K.M., Perrin, E.C.: Classroom behavior of participants with ADHD compared with peers: influence of teaching format and grade level. J. Appl. Sch. Psychol. **30**(3), 209–222 (2014)
3. Barkley, R.A.: Attention Deficit Hyperactivity Disorder: A Handbook for Diagnosis and Treatment, 2nd edn. Guilford, New York (1998)
4. DuPaul, G.J., Stoner, G.: ADHD in the Schools: Assessment and Intervention Strategies, 2nd edn. Guilford Press, New York (2003)
5. DuPaul, G.J., Weyandt, L.L., Janusis, G.M.: ADHD in the classroom: effective intervention strategies. Theory Into Pract. **50**(1), 35–42 (2011)
6. Johnson, J., Reid, R.: Overcoming executive function deficits with students with ADHD. Theory into Pract. **50**(1), 61–67 (2011)
7. Andersen, H.V.: Supporting inclusion of learners with attention-deficit/hyperactivity disorder in sound-field-amplification-systems. In: Proceedings of the 1st D4Learning International Conference Innovations in Digital Learning for Inclusion, pp. 1–8. Aalborg University Press, Aalborg (2015)
8. Sorensen, E.K., Andersen, H.V.: Amplifying the process of inclusion through a genuine marriage between pedagogy and technology. In: Proceedings of the EDEN International Conference held in Budapest, 15–17 June 2016
9. Kohut, H.: Selvets Psykologi. Hans Reitzel, Copenhagen (1990)
10. Rogers, C.R., Freiberg, H.J.: Freedom to Learn, 3rd edn. Merrill, Maxwell Macmillan Canada, Maxwell Macmillan International, New York, Toronto, New York (1994)
11. Waller, T., Watkins, A.: Information and Communication Technology for Inclusion. Research Literature Review. European Agency for Development in Special Needs Education, Brussels (2013)
12. McKnight, L., Davies, C.: Current perspectives on assistive learning technologies. University of Oxford, The Kellogg College Center for Research into Assistive Learning Technologies (2012)
13. Fogg, B.J.: Persuasive Technology: Using Computers to Change What We Think and Do. Morgan Kaufmann Publishers, Amsterdam, Boston (2003)
14. Abbott, C.: Defining assistive technologies - a discussion. J. Assistive Technol. **1**(1), 6–9 (2007)
15. Raskind, M.H.: Assistive technology for adults with learning disabilities: a rationale for use. In: Learning Disabilities in Adulthood: Persisting Problems and Evolving Issues, pp. 152–162. Andover Medical, Stoneham, MA (1994)
16. Andersen, H.V., Sorensen, E.K.: Empowering teachers and their practices of inclusion through digital dialogic negotiation of meaning in learning communities of practice. In: Proceedings of World Conference on Educational Multimedia, Hypermedia and Telecommunications 2016, Held in Vancouver. AACE, CA, 28–30 June 2016

17. Sorensen, E.K., Andersen, H.V., Grum, H.: Intercultural dialogic eLearning: a tool for fostering shared understanding and sustainable competence development in practices of inclusion. In: Proceedings of World Conference on Educational Multimedia, Hypermedia and Telecommunications 2013, pp. 389–397. AACE, Victoria, Vancouver Island (2013)
18. Duus, G., Husted, M., Kildedal, K., Laursen, E.: Aktionsforskning: en grundbog. In: Tofteng, D. (ed.). Samfundslitteratur, Frederiksberg (2012)
19. Jungk, R., Müllert, N.R.: Håndbog i fremtidsværksteder. Politisk revy, Kbh. (1989)
20. McKenney, S., Reeves, T.: Conducting Educational Design Research. Routledge, New York (2012)
21. Andersen, H.V., Sorensen, E.K.: Technology as a vehicle for inclusion of learners with attention deficits in mainstream schools. In: Proceedings of the European Distance and E-Learning Network 2015 Annual Conference Barcelona, 9–12 June 2015, pp. 720–730 (2015)
22. Skovsmose, O., Borba, B.: Research methodology and critical mathematics education. In: Valero, P., Zevenbergen R. (eds.) Researching the Social-Political Dimensions of Mathematical Education: Issues of Power in Theory and Methodology, pp. 207–226. Kluwer Academic Publishers (2004)

Pyramid Algorithm Framework for Real-Time Image Effects in Game Engines

Adrià Arbués Sangüesa[1], Andreea-Daniela Ene[1], Nicolai Krogh Jørgensen[1],
Christian Aagaard Larsen[1], Daniel Michelsanti[1(✉)], and Martin Kraus[2]

[1] School of Information and Communication Technology, Aalborg University,
Selma Lagerløfs Vej 300, 9220 Aalborg Øst, Denmark
{aarbue15,aene15,njarge12,cala10,dmiche15}@student.aau.dk
[2] Department of Architecture, Design, and Media Technology, Aalborg University,
Rendsburggade 14, 9000 Aalborg, Denmark
martin@create.aau.dk

Abstract. Pyramid methods are useful for certain image processing techniques due to their linear time complexity. Implementing them using compute shaders provides a basis for rendering image effects with reduced impact on performance compared to conventional methods. Although pyramid methods are used in the game industry, they are not easily accessible to all developers because many game engines do not include built-in support. We present a framework for a popular game engine that allows users to take advantage of pyramid methods for developing image effects. In order to evaluate the performance and to demonstrate the framework, a few image effects were implemented. These effects were compared to built-in effects of the same game engine. The results showed that the built-in image effects performed slightly better. The performance of our framework could potentially be improved through optimisation, mainly on the GPU.

Keywords: Pyramid methods · Image effects · Depth of field · Blur · Bloom · Game engine · Texture lookup · Compute shader

1 Introduction

Pyramid methods have many applications within the image processing field. These methods are named pyramidal because they are based on the construction of a scale space of filtered levels of different resolutions of an image. From this pyramid structure, image effects can be generated through the use of filters and other image-based computations.

This paper is focused on creating a framework that allows users to develop image effects based on pyramid methods. The framework is implemented in the popular game engine Unity [1], but could ideally be implemented in any game engine that supports rendering to textures. Unity provides its own built-in image effects which are generally based on convolution methods using regular shaders. These are compared with the implemented image effects in terms of visual quality and performance.

© ICST Institute for Computer Sciences, Social Informatics and Telecommunications Engineering 2017
A.L. Brooks and E. Brooks (Eds.): ArtsIT/DLI 2016, LNICST 196, pp. 289–296, 2017.
DOI: 10.1007/978-3-319-55834-9_34

We opted for using the free version of Unity because it is a widely used game engine that supplies functionality, which made the implementation and use of the framework easier to manage. Moreover, render to texture was recently added to the free version of the engine (Unity 5.0) enabling the users of this version to use pyramidal image effects. However, currently there is no built-in support for pyramid methods using render to texture functionality, which is the motivation behind implementing the framework.

In order to evaluate the performance of the framework, some image effects have been implemented: blur, depth-of-field, and bloom. The performance was evaluated by comparing the visual quality of the effects to the built-in image effects of Unity. This comparison is a subjective assessment based on side-by-side comparisons. At the same time, the effects were compared in terms of metrics such as memory, GPU, and CPU usage.

This paper has the following structure: in Sect. 2 the state of the art is detailed, explaining various pyramid algorithms that have been proposed in the past; then, in Sect. 3, the framework is explained, and in Sect. 4 several image effects are illustrated. Later on, in Sect. 5, the results are shown, and, after that, they are discussed in Sect. 6. Finally, conclusions are drawn and future work is suggested in Sects. 7 and 8.

2 Previous Work

The pyramid algorithm was proposed by Burt [2] who also showed its advantageous complexity compared to the Fast Fourier Transform (FFT) techniques for blurring. For this reason, pyramid images were used in many computer graphics applications. An example is the work of Kraus and Stengert [3] who applied GPU-based pyramid methods for blurring in their algorithm for depth-of-field rendering.

Fig. 1. The dotted lines represent the boundaries of the coarse level pixels, while the grey ones represent the boundaries of the fine level pixels. The grey dots represent the center of the pixels in the current level, while the black ones represent the positions of the bilinear texture lookups for analysis (a, b and c) and synthesis (d). (a) 2×2 analysis box filter using a single bilinear texture lookup. (b) 4×4 analysis box filter averaging the results of four bilinear texture lookups. (c) Biquadratic B-spline analysis filter averaging the results of four bilinear texture lookups. (d) Biquadratic B-spline synthesis filter using four bilinear lookups.

Image blurring with pyramidal methods consists of two steps: analysis and synthesis. In the first one, a pyramid is generated by iteratively downsampling the filtered image by a factor of two in each dimension. In the second step, a level of the analysis pyramid is chosen, based on the desired blur width, and the image is upsampled through a synthesis filter until reaching the original dimensions.

As illustrated by Kraus and Stengert [4], many pyramid filters based on bilinear interpolation may be used for both analysis and synthesis. Although the users of our framework may implement their own filters, we decided to provide three different analysis filters (2×2 box filter, 4×4 box filter, and biquadratic B-spline) and one synthesis filter (biquadratic B-spline). Figure 1 shows how the mentioned filters are implemented through bilinear texture lookups.

3 Framework

The implemented framework aims at supporting developers in creating pyramid-based image effects. The framework is intended for experienced and advanced users of Unity3D with the assumption that users have some level of shader programming experience. At the same time, the framework supplies a few ready-to-go image effects in order to demonstrate its use as well as to help less experienced programmers.

As mentioned, the framework uses compute shaders to perform all the image processing and to produce the image effects.

The implemented framework takes over a lot of the management required to instantiate and maintain frame buffer objects, implemented as render textures in Unity. These textures are ARGB32 textures when running Unity in gamma space; in linear space they are floating point textures because of color quantisation issues due to gamma correction and these are, of course, more expensive. Moreover, the framework provides access to methods that analyse and synthesise an image. Each image is sampled to a new texture with the nearest power of two (PoT) resolution and stored in a list. The general procedure of the framework is shown in Fig. 2.

Creating an instance of the framework exposes all the functionality of it to the image effect the developer wants to create. This step also generates the

Fig. 2. Steps performed by the framework.

analysis pyramid based on the constructor that is used to generate the instance. The analysis pyramid is generated by taking an image in native resolution and downsampling it into a new texture with the nearest lower PoT resolution or copying it into a higher PoT resolution, depending on user preferences. The image is offset from the edge of the PoT texture and clamped to the edge by copying the edge pixels. This texture is then analysed using one of the analysis kernels described in Sect. 2.

Once the analysis pyramid has been computed, the users can generate one or more synthesis pyramids depending on their need. These pyramids can be generated through different constructors specifying source and, optionally, target levels or resolutions. The pyramid is generated using the specified synthesis filter described in Sect. 2. At this point, users can implement their desired image effects using the provided pyramids and once completed, the image will be converted back to a native resolution image.

The idea behind the framework is that it stores the pyramids allowing users access from anywhere in any script by name or resolution. Simultaneously, it ensures that the users are not able to generate duplicate pyramids. The framework consists of one class which handles the creation of all the textures needed for the pyramids as well as the dispatching of the compute shader. The compute shader then handles the transfer of pixel data between textures and the computation of effects. Another important feature of the framework is that it supports custom kernel creation, meaning that users are able to specify a kernel of the size they desire.

4 Applications of the Framework

The following sections present the three image effects provided with our framework, namely blur, depth of field, and bloom (Fig. 3).

4.1 Blur

The blur effect is meant to obscure details in an image by averaging pixels over a larger area. Using pyramids, the blur effect can be obtained by applying analysis

Fig. 3. The three image effects implemented using the framework, compared with the original image (a): blur (b), depth of field (c), and bloom (d).

and synthesis steps to an image. The results may change based on the number of levels of the generated pyramid and the kernels used to analyse and synthesise.

Our framework not only allows three different analysis filters and one synthesis filter (see Sect. 2 for details), but it also supplies support for custom kernels as mentioned in Sect. 3.

4.2 Depth of Field

Depth of field is defined as the difference between the nearest and the farthest planes between which pixels in an image appear sharp. Generally, pixels are considered sharp when they are in a position where the circle of confusion is not distinguishable from a point. Further explanations can be found in the work of Demers [5].

Using the framework described in Sect. 3 a simulation of depth of field was implemented. It is important to point out that this effect is not a physically accurate implementation of depth of field, but rather an approximation that exposes simple attributes which allow for modification of the effect.

The effect was implemented using the Reverse-Mapped Z-Buffer approach [5] by generating an analysis pyramid, with the framework, and using this to derive different amounts of blur. Each level of blur was derived by synthesising from lower levels of the analysis pyramid. In our effect, three blur widths were used.

From these three levels of blur, as well as the depth texture, depth of field was simulated based on the specified parameters of the effect (see Fig. 4). For each pixel in the image, its depth is looked up in the depth texture. Based on the depth, the pixel color is linearly interpolated from two textures. This happens for all pixels where the depth is within the A regions. In Fig. 4 this interpolation is expressed through the grey gradient. The rest of the image is copied either from the original image (in focus) or the maximum blur texture.

4.3 Bloom

Bloom is an effect generated by producing fringes of light extending from bright areas of an image. It produces an imaging artifact also seen in real world cameras, where bright light bleeds to nearby areas on a film.

Fig. 4. Parameters of the implemented depth of field effect. FD: distance from camera to focus plane; FS: distance from focus plane to start of blur; A: distance over which the blur will gradually increase; FCP: far clipping plane.

Implementing this effect using the framework, as previously described, is achieved by taking the source texture and locating all the bright areas. They are located by taking the average value of the three color channels for each pixel and checking whether it is above a user-specified threshold. In this case the pixel is copied to a bloom texture, otherwise it is set to black. The bloom texture is then sampled to a lower PoT texture and synthesised based on the desired bloom strength. This synthesised texture is then combined with the source texture using the following formula:

$$z = 1 - (1 - x)(1 - y)$$

where x, y, and z represent a pixel of the original image, of the blurred image after bright colors extraction, and of the resulting image respectively.

5 Results

The framework and its effects were tested on a Lenovo Y-50 laptop with a Nvidia GeForce 860 m graphics card and an Intel Core i7 4710HQ 2.5 GHz processor with 16 GB of RAM running in full HD resolution (1920 × 1080) in gamma space.

All the results are gathered over 1000 frames while skipping the first 60 frames as these could potentially cause anomalies in the performance. From this, the average time used per frame can be calculated as well as the processing time of the framework. The image effects are also compared to the built-in counterparts in terms of visual quality through side-by-side comparisons.

In Fig. 5, the average processing time and the average frame time of the results are displayed, along with the memory usage of the framework and of the built-in effects in Unity.

To clarify, *Only Blit* is the Unity scene running with just a texture being blitted to the screen and this is logged to see what the basic cost of the scene is. *Framework* is the framework running without applying any image effect but simply computing one analysis pyramid and one synthesis pyramid. The rest are the built-in image effects of Unity compared to the image effects implemented with our pyramid framework.

Performance of the Framework (ms)	Dark grey (CPU)	Light grey (frame)	VRAM Usage (MB)	
Only Blit	0,01	9,697	Only Blit	299
Framework	0,238	11,186	Framework	326
Unity Blur	0,073	10,415	Unity Blur	309
Pyramid Blur	0,245	12,498	Pyramid Blur	350
Unity DOF	0,043	13,909	Unity DOF	299
Pyramid DOF	0,274	17,988	Pyramid DOF	395
Unity Bloom	0,076	10,197	Unity Bloom	301
Pyramid Bloom	0,242	13,888	Pyramid Bloom	351

Fig. 5. Graphs showing the performance of the framework (left) and the total video memory usage on the graphics card when running the image effects. For the graph on the left, the dark grey bars represent the average CPU time in milliseconds as a part of the average frame time (light grey bars).

Looking at the average frame time from only blitting to running the framework (downsampling to 32 × 32 pixels), it can be seen that the basic cost of the framework is around 1.5 ms. For each of the image effect comparisons the framework performs slightly slower, where the biggest difference is in the bloom effect where the framework had the relatively worst performance. For the average processing time, the framework is fairly consistent; note that the depth of field effect is slower due to the creation of more synthesis lists.

Regarding the video memory usage, it can be seen that while the built-in effects barely use any additional memory, the framework footprint is directly tied to the amount of textures needed for each effect, as well as how many times the source texture is analysed and synthesised. Again, the depth of field effect is the most expensive effect, also due to the additional textures created.

Visually, the implemented image effects look relatively similar to the built-in image effects. However, as the procedure is different from one another (*i.e.* the built-in effects have more adjustable parameters), there are visible differences, especially in the bloom image effect.

6 Discussion

As the built-in effects of Unity are heavily optimised for the engine, we did not expect the image effects implemented with our framework to outperform them. This also proved to be the case as displayed in Fig. 5 where every effect was slower both on the CPU and the GPU. However, the current framework has room for improvement as it is a work in progress.

Although results are averaged over 1000 frames, they have some inaccuracy due to how Unity handles multithreading. Running two tests in a row could produce significantly different results, especially for the processing time, whereas average frame time generally stayed the same. The test would have to be iterated multiple times in order to get more accurate results. However, for the purpose of doing this initial testing of the framework, the collected results give an adequate representation of the performance.

Figure 5 shows, that the framework uses significantly more processing time than the built-in Unity effects due to the generation of the pyramids. However, when comparing this to the average frame time, it is an insignificant contribution to the overall performance cost. This in turn tells that the main performance bottleneck is the GPU implementation.

As it has been established that the framework's CPU cost is not a major factor of the performance, it would most likely be possible to optimise the framework by moving some logic and calculations from the GPU to the CPU side wherever possible.

As expected, the video memory usage of the framework is higher compared to the built-in effects. This is due to the use of multiple textures of different resolutions for the analysis and synthesis pyramids.

7 Conclusions

A pyramid algorithm framework capable of performing real-time image effects by using compute shaders in Unity has been developed. The framework is implemented based on previous work within the field and has functionality to support implementation of custom kernels. We showed how the framework performs by implementing certain image effects and compare them to their built-in counterpart in Unity. The performance was slightly worse than the built-in effects, an expected result considering that the framework is a work in progress.

8 Future Work

The performance of the framework could be improved in various ways. As mentioned earlier, the performance bottleneck is the GPU. The compute shader used by the framework applies many logic operations, such as branching logic, which could potentially lower the performance quite significantly. To avoid this, some of the kernels used in the computer shader would have to be split into separate kernels and dispatched appropriately from the CPU.

Moreover, the framework should supply some support for creating textures in order to make texture generation easier for the users. Currently, textures are made manually for each image effect. When implementing multiple image effects, some memory usage could be avoided by handling the textures in the framework instead of each image effect separately.

References

1. Unity Manual. http://docs.unity3d.com/Manual/UnityManualRestructured.html. Accessed Sept 2015
2. Burt, P.J.: Fast filter transform for image processing. Comput. Graph. Image Process. **16**(1), 20–51 (1981)
3. Kraus, M., Strengert, M.: Depth-of-field rendering by pyramidal image processing. In: Computer Graphics Forum, vol. 26. No. 3. Blackwell Publishing Ltd. (2007)
4. Kraus, M., Strengert, M.: Pyramid filters based on bilinear interpolation. In: GRAPP (GM/R), pp. 21–28 (2007)
5. Demers, J.: Depth of field: a survey of techniques. In: GPU Gems: Programming Techniques, Tips, and Tricks for Real-time Graphics, Chap. 23, pp. 375–390. Addison-Wesley Professional (2004)

Introducing the Tripartite Digitization Model for Engaging with the Intangible Cultural Heritage of the City

Matthias Rehm$^{(\boxtimes)}$ and Kasper Rodil

Department of Architecture, Design, and Media Technology,
Aalborg University, Aalborg, Denmark
{matthias,kr}@create.aau.dk

Abstract. In this paper we investigate the notion of intangible cultural heritage as a driver for smart city learning applications. To this end, we shortly explore the notion of intangible heritage before presenting the tripartite digitization model that was originally developed for indigenous cultural heritage but can equally be applied to the smart city context. We then discuss parts of the model making use of a specific case study aiming at re-creating places in the city.

1 Introduction

The paper departs from the new research direction of smart city learning that adds a new human-centered perspective to the so far functionalist vision of smart cities. The smart city learning approach does not address learning only as a way to train an adequate human capital but instead envisions learning as one of the driving forces of the smartness and well-being of a community. Unavoidably the underlying and ubiquitous techno-ecosystems - whose embedded intelligence, sensitivity and responsiveness surround the individuals - challenge the future of learning and call for a redefinition of spaces, contents, processes, skills and assessment approaches (e.g. [3,7]).

In this conceptual paper we focus on a specific aspect of the definition of the urban space as a room for practices that shape the meaning of these places. We call this the intangible cultural heritage of the city. This is meant in contrast to usually addressed cultural heritage in the form of buildings/architecture and artworks in the urban space. Instead, we focus on practices of everyday living and experiences that shape our meaning of urban places. This is in line with Dourish' distinction between space and place, where place denotes meaning making by everyday social practices in given spaces (e.g. [6]). According to Dourish modern ICT like ubiquitous WIFI connectivity and related technologies allow for "re-encountering" known spaces and thus allow for re-creating places.

In line with this idea, we first present the tripartite digitization model (TDM) for intangible cultural heritage (ICH), then we exemplify its potential and some of its aspects with a case study that allows for re-encountering urban spaces.

© ICST Institute for Computer Sciences, Social Informatics and Telecommunications Engineering 2017
A.L. Brooks and E. Brooks (Eds.): ArtsIT/DLI 2016, LNICST 196, pp. 297–304, 2017.
DOI: 10.1007/978-3-319-55834-9_35

2 Intangible Cultural Heritage

In contrast to tangible cultural heritage (buildings, sites etc.), intangible cultural heritage focuses on cultural practices. The intangible cultural heritage of the city can thus be seen as something constituted by the inhabitants of the city in their daily living routines, giving meaning to places found in the city. This "meaning making" is subject to constant changes, some subtle, some more drastic (e.g. structural changes when a city loses its industrial traditions). For this special session we invite contributions that focus on how this intangible heritage of the city (and thus its inhabitants) can be captured, represented, and disseminated in order to learn about (historical or modern) practices in relation to the actual urban scape.

Usually, the notion of intangible cultural heritage is tightly connected to indigenous cultures and the preservation and archiving of their practices (see [14]) as laid out in the UNESCO Convention for the safeguarding of the intangible cultural heritage [18]. Tailored to indigenous cultures, the convention distinguishes five domains of intangible cultural heritage:

A. Oral traditions and expressions, including language as a vehicle of the intangible cultural heritage
B. Performing arts
C. Social practices, rituals and festive events
D. Knowledge and practices concerning nature and the universe
E. Traditional craftsmanship

Without belittling the importance of safeguarding indigenous cultural practices, intangible cultural heritage is also relevant in changing urban landscapes, where especially the domains C and D are interesting avenues for exploration of the concept. The scope of this domains would necessarily be less broad when applied to the urban space, e.g. D would be rephrased to "Knowledge and practices concerning the city and its surroundings". Figure 1 represents in a stylized way the change that happened in the city in our case study, that was (as many European cities) subject to a radical structural change from industrial town

Fig. 1. The changing spaces of Aalborg over time affect the places created by interaction with the residents.

Fig. 2. The tripartite digitization model (TDM).

(harbour, petro-chemical industry) to a town of knowledge (university, colleges, etc.). In relation to the topic of smart city learning, it is our conviction that the urban space itself can become the playground for experiencing such changing social practices.

2.1 The Tripartite Digitization Model

Although originally proposed for the digitization of indigenous intangible culture heritage [14], the tripartite digitization model (TDM) is equally relevant for other types of intangible (and tangible) cultural heritage. Figure 2 highlights the main components of the TDM. Starting point and one of the crucial aspects of the model is its embedding in a co-creation line of thought, i.e. especially in relation to intangible heritage, the community members/knowledge holders have to become pivotal in all digitization endeavors if meaningful application should emerge. This is deeply rooted in the Scandinavian HCI tradition of participatory design of information systems (e.g. [15]). The TDM is a structuring tool as well as a tool to guide work in the area of heritage and learning and focuses on the three aspects of capturing, representing, and disseminating information. Each part of the model is associated to specific questions that have to be answered for each ICH project and can be used as a descriptive tool to identify the underlying features of each project. Here we present some of the challenging questions that will also structure the presentation of the two case studies in later sections:

– Capture:
 C1 Where does this data come from (archives, user-generated,...)?
 C2 How subjective should/could this data be?
 C3 Should it be captured in situ (and by whom: experts vs laymen)?

- Representation:
 R1 How can data about social practices be represented?
 R2 How can ontologies be useful for representing the data?
 R3 What is the relation between the data and the learning goal (dissemination)?
- Dissemination:
 D1 Which kind of technologies can be exploited?
 D2 What is the relation between place, content, and technology?
 D3 How can success be measured in such a setting?

Additionally, the model asks more theoretical questions that are related to the whole field of digitizing ICH, e.g. C: Which kind of data is relevant for capturing social practices related to urban places?; R: What could be standards for representing ICH data?; D: Which types of dissemination exist (and to what purpose)? How is the relation between C, R, and D?

What is apparent from a recent review of 10 years of research in the field of intangible cultural heritage [14] is a lack of methodological rigor in regard to these questions and an obvious lack of work on representation of data, which makes it nearly impossible to use the collected data in other forms than archival.

3 School Boys' Rebellion: Learning About Intangible Cultural Heritage

In 1941, a group of teenage school boys formed one of the first resistance groups against the German occupation. They sabotaged the German forces and were captured at last, but remained active even from out of the arrest. One of them became a journalist after the war and wrote several books about the time of the "school boys rebellion". This can be seen as a classical eyewitness account of specific of a dramatic intangible cultural heritage of Aalborg municipality. It served us as the data source from which to construct a smart city learning application that encourages the user to seek out pivotal locations of the historic events and listen to the first hand accounts of this eyewitness in place.[1] Thus, the target group for this application is quite broad, including tourists visiting the city as well as residents that would like to know more about the city they are living in.

From a theoretical point of view the general idea behind the application is based on experiential learning [9]. Earlier, we have shown how this paradigm can be utilized in a virtual learning environment for increasing knowledge and skills about culture-specific gestures [13]. In a city environment instead, place and space become the most important features (first and foremost due to travel times for the experience). Again from a theoretical point of view, the application exploits the spatial situation model and the induced spatial presence [21] to capture this effect.

[1] Download "Skoledrengenes Oprør" on Google Play (only in Danish).

Fig. 3. Map showing where in Aalborg stories about the Churchill-Club can be found.

Figure 3 left shows the features and context of the application. The different location around the city that have been selected as content are depicted in Fig. 3 right (above). And the start location (the school boys old dormitory) is shown in Fig. 3 right (below).

In order to support the user in creating a story-based SSM and to contribute to the resulting spatial presence, the visual cues as well as the audio cues have been designed with the historical context in mind. Additionally, to allow the user to experience the urban space more fully, it was decided to discard navigation between story location by maps and instead use a combination of sound beacons and directional sound [20] relying on the GPS and gyroscope information in the smart-phone. This means that when the user points his smart-phone in the direction of a story segment, a sound beacon becomes audible that is related to the location (e.g. church bells for a cloister). In other direction, only static can be heard. Thus, the user searches story segments by scanning in a 360° radius around him and when he finds another segment, he can decide to start walking towards it. Once the user reaches the location, the story becomes available for listening.

Results concerning the user test can be found in [4]. In general, results show that users were eager to explore the city to find the different story elements and they were highly immersed in the narratives on location. They were also able to successfully use the sonic navigation method introduced with the application and could easily find the points of interest.

In the following, we analyze the application in relation to the TDM and the questions we raised in the previous section.

3.1 Capture

C1. Where Does the Data Come From? The primary source is the eye witness accounts of one of the members of the resistance group that have been published after the war and that have been collected in one volume [12]. Additionally, other sources in relation to the specific time in general and the Churchill club in particular have been integrated [1,10].

C2. How Subjective is this Data? Most of the data used in this application are eyewitness accounts from members of the Churchill club. Moreover, other eyewitness accounts from the same time (occupation of Denmark during World War II) have been consulted for cross checks. It would of course be preferable to integrate other sources as well like news reports from the time. Additionally, the format of the app would allow for experiencing subjective experiences of these historic events. It could for instance be very interesting to integrate stories from other groups, e.g. German soldiers or laymen of the Churchill club members.

C3. Was it Captured In-Situ (and by Whom)? In this case the data was not captured by the research team. Instead, the sources have been analyzed in regard to three distinct features that would benefit the dissemination:

1. stories had to be evenly distributed around the city;
2. locations had to be "there" (at least in some way, i.e. not completely destroyed) to create more spatial presence;
3. a coherent (and "interesting") story should emerge across different locations in the city.

3.2 Representation

R1. How is the Data Represented? Similar to other projects in the ICH domain, the representation of the data is the least thought through part of this project. The main data are the stories that have been created based on the original eyewitness accounts. For the dissemination part those have been represented in archival form, i.e. as a data base of audio recordings, which have been tagged with GPS coordinates.

R2. Could Ontologies Be Useful for Representing the Data? Several papers have suggested the use of ontologies for cultural data [2] or for data related to social practices around intangible cultural heritage (e.g. [16,17]). In case of the Churchill club, ontologies for representing stories and narratives could be helpful (e.g. [5,11]) but have not been explored so far. In combination with ontologies for location-based interactions (e.g. [8]) this could be a useful way to ensure coherence of story fragments that can be distributed across the city.

R3. What is the Relation Between the Data and the Learning Goal (dissemination)? For this project there is a one to one relation between location and story data that is used for dissemination purposes.

3.3 Dissemination

D1. Which Kind of Technologies Have Been Exploited? The project makes use of standard smart-phones with active location sensors (GPS, WIFI access points, UMTS access points). Additionally, sound-based navigation has been developed.

D2. What is the Relation Between Place, Content, and Technology? The story content is directly linked to the locations that are encountered in the city. Moreover, in order to facilitate active exploration of the city, no map navigation was realized. Instead the aforementioned sound-based navigation is used to ensure exploration possibilities of the urban space and avoid fixation to a map.

D3. How is Success Defined and Measured? In our case, measurements included interviews as well as a measurement of spatial presence in relation to the SSM [21]. A standard spatial presence questionnaire was used [19].

4 Conclusion

The paper presented the tripartite digitization model for intangible cultural heritage and used it as an analytical tool for an example project that focuses on the dissemination of a specific type intangible heritage, namely eye witness accounts that have been turned into a coherent distributed storyline, which can be discovered by exploring the urban scape.

This work is situated at the intersection of research in the preservation and dissemination of intangible cultural heritage (e.g. [14]) and research on smart city learning (e.g. [7]). We have presented the TDM as a viable analytical tool for research in these areas. Further development of the model is currently focused on establishing best practice guidelines for the different challenges encountered in the digitization of intangible cultural heritage. We have already shown that the representation of data in this domain is the weakest link in projects related to intangible cultural heritage. The presented example application in this paper is no exception in this respect. In order to further applications relating to the awareness and dissemination of intangible cultural heritage, this is one of key areas that needs to be addressed.

Acknowledgements. We would like to thank Mathias Damgaard, Emil Byskov and Seth van Hejster for implementing the application described in this paper.

References

1. Anekdoter fra Besttelsestiden. http://www.seniormaksten.dk/11743590. Accessed 26 Mar 2015
2. Blanchard, E.G., Mizoguchi, R., Lajoie, S.P.: Structuring the cultural domain with an upper ontology of culture. In: Blanchard, E.G., Allard, D., (eds.) Handbook of Research on Culturally-Aware Information Technology: Perspectives and Models, pp. 179–212. IGI Global, Hershey (2010)

3. Christopoulou, E., Ringas, D.: Learning activities in a sociable smart city. Interact. Des. Archit. J. IxD&A **17**, 29–42 (2013)
4. Damgaard, M., Nielsen, E., van Heijster, S., Rodil, K., Rehm, M.: Preserving heritage through technology in a city undergoing change. In: Culture and Computing, pp. 183–186. IEEE Computer Society Press (2015)
5. Damiano, R., Lieto, A.: Ontological representations of narratives: a case study on stories and actions. In: Workshop on Computational Models of Narrative, pp. 76–93 (2013)
6. Dourish, P.: Re-Space-ing: place and space ten years on. In: CSCW 2006. ACM Press (2006)
7. Giovannella, C., Iosue, A., Tancredi, A., Cicola, F., Camusi, A., Moggio, F., Baraniello, V., Carcone, S., Coco, S.: Scenarios for active learning in smart territories. Interact. Des. Archit. J. IxD&A **16**, 7–16 (2013)
8. Kauppinen, T., Henriksson, R., Sinkkilä, R., Lindroos, R., Väätäinen, J., Hyvönen, E.: Ontology-based disambiguation of spatiotemporal locations. In: Proceedings of the 1st International Workshop on Identity and Reference on the Semantic Web (IRSW) (2008)
9. Kolb, D.A.: Experiential Learning: Experience as the Source of Learning and Development. Prentice Hall, Englewood Cliffs (1984)
10. Laursen, P.: Churchill-klubben som Eigil Foxberg oplevede den. GP-Tryk (1987)
11. Faith Lawrence, K., Jewell, M.O., Rissen, P.: OntoMedia: telling stories to your computer. In: First International AMICUS Workshop on Automated Motif Discovery in Cultural Heritage and Scientific Communication Texts (2010)
12. Pedersen, K.: Bogen om Churchill Klubben. Lindhardt og Ringhof (2005)
13. Rehm, M., Leichtenstern, K.: Gesture-based mobile training of intercultural behavior. Multimed. Syst. **18**(1), 33–51 (2012)
14. Rodil, K., Rehm, M.: A decade later: looking at the past while sketching the future of ICH through the tripartite digitisation model. Int. J. Intangible Cult. Herit. **10**, 45–58 (2015)
15. Simonsen, J., Robertson, T., (eds): Routledge International Handbook of Participatory Design. Routledge, London (2013)
16. Stanley, R., Astudillo, H.: Ontology and semantic wiki for an intangible cultural heritage inventory. In: Computing Conference (CLEI), pp. 1–12. IEEE Computer Society (2013)
17. Tan, G., Hao, T., Zhong, Z.: A knowledge modeling framework for intangible cultural heritage based on ontology. In: Knowledge Acquisition and Modeling, pp. 304–307. IEEE Computer Society (2009)
18. UNESCO. The UNESCO convention for the safeguarding of the intangible cultural heritage (2003)
19. Vorderer, P., Wirth, W., Gouveia, F.R., Biocca, F., Saari, T., Jaencke, L., Boecking, S., Schramm, H., Gysbers, A., Hartmann, T., Klimmt, C., Laarni, J., Ravaja, N., Sacau, A., Baumgartner, T., Jaencke, P.: Mec spatial presence uestionnaire (mec-spq). Report to the European Community, Project Presence: MEC (IST- 2001-37661) (2004)
20. Walker, B.N., Lindsay, J.: Navigation performance with a virtual auditory display: effects of beacon sound, capture radius, and practice. Hum. Factors **48**(2), 265–278 (2006)
21. Wirth, W., Hartmann, T., Böcking, S., Vorderer, P., Klimmt, C., Schramm, H., Saari, T., Laarni, J., Ravaja, N., Gouveia, F.R., Biocca, F., Sacau, A., Jäncke, L., Baumgartner, T., Jäncke, P.: A process model of the formation of spatial presence experiences. Media Psychol. **9**(3), 493–525 (2007)

Aesthetic Computing for Representation of the Computing Process and Expansion of Perceptual Dimensions: Cases for Art, Education, and Interfaces

Myounghoon Jeon[✉]

Mind Music Machine Lab, Michigan Technological University, 1400 Townsend Drive,
Houghton, MI 49931, USA
mjeon@mtu.edu

Abstract. With the advances of technologies, the application of computing to aesthetics has rapidly increased. However, little effort has been put to apply aesthetics to computing. Aesthetic Computing is an attempt to fill that research gap. The present paper revisits and elaborates its concept, and highlights "embodiment" as a new format of representation of Aesthetic Computing. The present paper also describes how embodiment can provide more opportunities for accessibility and personalization of computing across different projects – art, STEAM education, and in-vehicle interfaces. Finally, more aesthetic components in Aesthetic Computing are discussed for future research.

Keywords: Aesthetic computing · Embodiment · Representation · Robot actors project · Sonification · STEAM education

1 Introduction

Art and technology have a similar origin and until 17th century, they were not differentiated from each other (e.g., the Latin word, "ars" was not distinguished from crafts or sciences). Since then, they seem to be separated from one another (e.g., with an emphasis on aesthetics in Romanticism). However, with the rapid technological advancement, art and technology seem to be *re*integrated. For example, the application of computing to aesthetics (and "art and design") has proliferated. On the contrary, until recently, relatively little research has been done about the effects of aesthetics on computing. Aesthetic Computing started with such a converse attempt to fill that research gap. In 2003, Researchers in the Dagstuhl Workshop[1] on Aesthetic Computing defined it as "the application of art theory and practice to computing" [1]. The present paper introduces and refines the concept and approach of Aesthetic Computing and then, describes case studies on how aesthetic theory and practice can affect the computing professionals and

[1] The Dagsthul Seminar is one of the prestigious academic workshops in computing. The seminars discuss an established field within computer science or sometimes establish new directions by bringing together separate fields or scientific disciplines.

© ICST Institute for Computer Sciences, Social Informatics and Telecommunications Engineering 2017
A.L. Brooks and E. Brooks (Eds.): ArtsIT/DLI 2016, LNICST 196, pp. 305–313, 2017.
DOI: 10.1007/978-3-319-55834-9_36

their practice, and other stakeholders, including artists, students, and system users with a focus on its representation and implications.

2 Aesthetic Computing and Its Extended Definition

Researchers in the Dagstuhl Workshop identified the benefits of the application of aesthetics to computing as follows [1]: (1) Exploring more creative and innovative *media* for software and mathematical structures; (2) Making computing more *accessible* to various people so that they can understand the concept of computing and utilize it; which leads to (3) promoting *personalization and customization* of computing structures at individual and group levels. The application of aesthetics to computing has brought about new media for computing and mathematical representations. Here, the new media refer to "representation" of the computing process and its structure. Representation of the system does not serve just as an information format, but plays a crucial role to process, encode, and understand the information [2]. For example, music notation composed of special rules and symbols is certainly a big barrier for people to learn music because it requires special training. Likewise, computer programs have traditionally been presented in conventional text-based notation and mathematical structures have been presented in complicated numbers and symbols. This is inherently a difficult representation format for human to process. Inventing graphic user interfaces (GUIs) was a step towards embodiment [3] of computing. The evolution from command line interfaces (CLIs: e.g., DOS) to GUIs (e.g., Windows) has made a big distinction in the computing history. For the last decade, we have witnessed a new wave, called "tangible user interfaces (TUIs)". It is premised on embodied interaction [4], which is strongly affected by embodied cognition [5]. Embodied cognition/interaction negates Descartes' mind-body dualism. In this new paradigm, not only our "brain (mind)" or "eyes and hands" (as part of body for computing with GUIs), but also our entire body is offered special functions for further computing interactions. Based on this embodiment notion, computer programming or mathematical structuring can be acquired through perceiving, planning, and performing actions with the body, which is the traditional area of art. However, as the researchers in the Dagstuhl Workshop already pointed out, this re-presentation does not need to compromise the goal of abstraction of computing and mathematics [1].

As much as GUIs have made computing accessible or more than that, embodiment of computing has been popularizing the concept of computing to lay persons and even children (e.g., use of sensors such as Arduino, little Bits, etc.). Consequently, this pervasiveness of computing will lead to easy personalization and customization because anyone will be able to program their own software and hardware ultimately. This means that computing can finally become closer to the fundamental meaning of art, "making special" [6]. In this stage, computing professionals will gain flexibility in aesthetics as well as associated psychological attributes such as comprehension and motivation. Artists will attain the benefits associated with computational thinking and its underlying mathematical structures [3]. Lay persons will obtain a tool box to make their own special art work. From this integrated view, Aesthetic Computing can be largely *re*defined to include reciprocal interactions between aesthetics and computing, instead of one way

effect. In other words, computing, which is enriched by aesthetic theory and practice, will again facilitate the formation of new art and design activities, by providing a raw medium or the subject material for art [3] and thus, expand people's perceptual dimensions [the original meaning of aesthetics is "the study of our *perception* of the whole environment", 7][2] (Fig. 1).

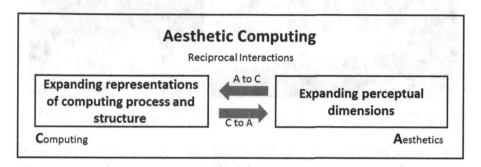

Fig. 1. A conceptual diagram of reciprocal interactions between computing and aesthetics.

3 Case I: Aesthetic Computing for Arts

The first case is to provide a platform for performing arts. The immersive Interactive Sonification Platform (iISoP) project focuses on making a design research platform for researchers and artists to use visualization and sonification in a 3D virtual environment [9]. Current projects include a performing artist's embodied drawings, big virtual instruments (Fig. 2 left), dancer-sonification (Fig. 2 right), and children-puppy interactions. The iISoP project uses motion capture data via a Vicon tracking system. This allows users to utilize their entire body as a controller. The motion capture data are mapped onto either visual or auditory displays in many-to-many mappings. To illustrate, the ultimate goal of dancer-sonification is to have dancers improvise music and visuals by their dance. This project adopted emotions and affect as the medium of communication between gestures and sounds. To maximize affective gesture expression, expert dancers have been recruited to dance, move, and gesture inside the iISoP system while being given both visual and auditory outputs in real time. Affective gesturing is analyzed using Laban Movement Analysis and sonified based on the mapping algorithm [10]. For the recognition of these affective states, personal space and movement effort are interpreted by the Vicon tracking system and utilized by the visualization and sonification algorithms. An example of the sonification logic would be that high effort and high personal space (e.g., content) results in raising the octave of the audio output, changing to an instrument with a brighter timbre and increasing volume and speed at which the notes are played. This fusion of different genres of arts

[2] Note that Aesthetic Computing is different from Perceptual Computing [8], which specifically refers to a methodology which is used to develop an interactive device that can help people make subjective judgments by propagating random and linguistic uncertainties, using fuzzy logic.

gathers norms and rules of each genre, and thus, contributes to creating a new convergent process as well as a divergent process.

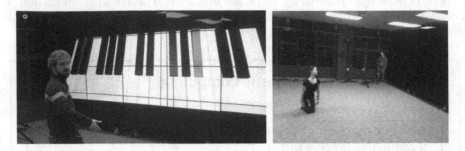

Fig. 2. Big virtual instruments project (left) and dancer-sonification project (right).

Our current research focus is on "how to make the motion-sound mapping process more *accessible* to diverse populations". For efficient motion-sound mappings in this process, the Interactive Sonification Markup Language (ISML) has been developed [11]. The primary goal of ISML was to enable researchers with non-programming background (e.g., cognitive scientists, artists, musicians, etc.) to configure mappings in an easy way. The ISML platform allowed researchers to create items that had both conditions and actions. However, even though ISML provides users with a text-based document and web-based GUI, it still has a number of issues to be called an accessible system (e.g., requiring manual adjustments, offline manipulations, separate audio program, lacking of data feedback, etc.). To solve these issues, the Musical Utility Software for Interactive Creations (M.U.S.I.C.) platform was created. It serves as an interactive programming platform for the iISoP to increase the robustness and usability of the entire system. Note that the representation of the MUSIC software is visually provided as respective gesture, movement, and location events in a 3D space, rather than the text-based document. As a result, both usability and accessibility of the platform have increased. In addition, a mobile application version of the iISoP system is being developed using portable sensors, such as LEAP motion and Myo, and a projector-based display beyond the Vicon tracking system and the display wall.

The children-puppy interaction project is about how technology expands the *subject* of art. Since 1960s' happening [12], integrating audience into the artwork as a key *part* has been a crucial milestone in art. With the technological help, we can also facilitate this collaboration, by making audience a more active subject of arts. Children (with sensors attached to their body) play fetch with a puppy (with sensors attached to the body) inside the iISoP system. Children try to control the puppy, but the puppy also has their own intentionality. Based on the specific mapping parameters, visual and auditory outputs are displayed to represent the current position and kinetic characteristics of all players (children and puppy). A number of questions are raised in this situation, including "intentionality", "agent of composition", "quality of work", which might not be promptly answered, but gives a clue to the next iteration of the project and Aesthetic Computing per se.

4 Case II: Aesthetic Computing for "STEAM" Education

The trend to integrate art and science is also pervasive in formal education. STEM (Science, Technology, Engineering, and Math) education is evolving into STEAM (Science, Technology, Engineering, *Art*, and Math) movement by adding art and design to the equation (e.g., http://stemtosteam.org). We have also tried to develop STEAM education programs, specifically, for underrepresented students in a rural area, including female students, students from low income families, and students with various disabilities. For example, we have developed an interactive musical robot for children with autism spectrum disorders (Fig. 3 left). Fairly recently, we have been developing a new afterschool program with a local elementary school entitled, "Making Live Theatre with Multiple Robots as Actors" (Fig. 3 right).

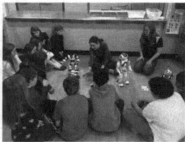

Fig. 3. Musical robots for children with autism spectrum disorders project (left) and making live theatre with multiple robots as actors project (right).

There have been some "Robot Actors" projects over the world [13, 14], but those are not specifically for education purpose for children. The existing projects aim to facilitate artistic performance and use this performance as a useful stepping stone for robotics research and further, as a platform for social futurology research. For example, Ishiguro and Hirata have tried to naturally depict in-house family situations where they are worried about socio-cultural issues in near future, by playing theatre with robots [13]. This type of experiment can vary, by having robots play different roles of a "robot", "human", or "animal". Based on various roles robots play and the storylines, theatre can also serve as a parable about human existence.

In our case, through making this live theatre play, students are expected to learn and ponder about (1) technology and engineering: planning, controlling robots, and pseudo coding; (2) art and design: writing, stage designing, preparing music and sound effects; (3) collaboration: discussing, negotiating, role allocating, casting, promoting, etc.; and (4) co-existence with robots: being exposed to philosophical and ethical questions (e.g., the roles and limitations of robots in the community).

In this project, we suggest that students can go beyond the limited role of passive learners and explore a more constructive and interactive role [15] just as in the children-puppy interaction project within the iISoP system. We attempt to incorporate interactive

activities in this multimodal learning environment, by allowing students to interact with multiple robots and peers, and make their own creative work (i.e., live theatre).

We use multiple robots with various types and different capabilities in the afterschool program. Robots have sensors, and they are programmable and communicable. Again, the core research question is about "representation" of computing; how to provide "computational thinking" experience to young students. We utilize the existing robot simulators and software development kits (SDK). In addition to traditional story-boarding procedures used both in script development and interface design, we are devising tangible elements for students to iteratively refine their storytelling ideas. For example, students have created their own robot model using Play-Doh. Note that we attempt to have students create and implement their ideas by an event-based approach (e.g., touching the robot's back can generate the next action) rather than the paper and pencil-based text diagram. While the actual coding is performed separately by experienced programmers (graduate and undergraduate students), rehearsals with both the programmers and students present allow for interactive debugging of readily observable problems, potentially including deliberate bugs for this purpose. This embodiment of computing process makes even 5–8 year old children experience the concept of computing. Of course, each team creates their own unique story. That provides an opportunity to compare their output with peer groups' performance, which fulfill another purpose of interactive learning.

We believe that this afterschool activity allows students to learn technology, art, and design in an integrated way. We are seeking more methods to evaluate the effectiveness of this learning activity with teachers, but it seems clear that Aesthetic Computing has helped us glean some hints about where to go in STEAM education.

5 Case III: Aesthetic Computing for In-Vehicle Interfaces

Aesthetic Computing can lead to *usable* outcomes or not [3] if we are based on narrowly defined "usability". The third case is about in-vehicle interfaces for which usability and safety are critical components. Given that vision is heavily occupied during drive, research on in-vehicle use of auditory displays and sonification has been intensively conducted [for review, see 16]. In addition to the traditional collision warning sounds, and voice and beeps for personal navigation devices, we have devised more dynamic in-vehicle sonification systems. For example, we design fuel efficiency sonification based on real-time driving performance data (Fig. 4 left). Speech-based auditory displays have also been prototyped for eco-friendly driving; the system offered spoken alerts and advice to improve fuel economy [17]. Speech provides an advantage in that the intended message requires no explanation and the system does not require a learning phase. However, speech might interfere with concurrent conversation and create annoyance in the form of a virtual backseat driver. Therefore, an alternative approach can be use of sonification [21]. We have developed software that can extract all the driving performance data (speed, lane deviation, torque, steering wheel angle, pedal pressure, crash, etc.) from our simulator (NADS MniSim). All these data can be mapped onto sonification parameters. This project can easily be extended to a higher level, e.g., nearby

traffic sonification based on collective big traffic data [18]. With this system, drivers can aurally monitor nearby traffic situations in real-time. Recently, research on connected vehicles has proliferated and big data from those vehicles have high potential to be used to manage traffic flow. Thanks to autonomous vehicles, drivers' overall tasks and work-load might decrease in future, but simultaneously their controllability and situation awareness could also decrease. This type of sonification can enhance drivers' controll-ability, situation awareness, risk perception, and subjective satisfaction; it can also reduce driver workload. For example, we can create a new radio channel, dedicated to real-time traffic sonification based on nearby traffic data (e.g., overall speed, flow in each lane, accidents, etc.). If well implemented, traffic sonification can yield comparable trust level and driving performance as speech-based traffic broadcasting, while it can unob-trusively increase drivers' situation awareness and engagement with driving, which will lead to road safety. By all means, the design principles of sonification should be seriously considered for this implementation, not to annoy drivers.

Fig. 4. Driving data-based sonification project (left) and sonically-enhanced in-vehicle gesture interaction project (right).

Another driving project is the sonically-enhanced in-vehicle gesture project. We investigate how auditory displays can improve in-vehicle gesture interactions. Just as in the driving sonification project, there is a clear goal, "safety" and "usability" in this project. However, we still want to design more aesthetic interactions [19] in addition to usable interfaces in both cases. With electric vehicles and autonomous vehicles being pervasive, this type of multimodal in-vehicle interaction is expected to improve driver situation awareness, user experience, and road safety even more. Our research program seeks to provide evidence for the best use of auditory displays and sonification in the vehicle context by investigating appropriate representation formats, considering customization and aesthetics.

6 Conclusion and Future Works

Fishwick [3] proposed three broad topics of aesthetics: modality, culture, and quality. Among these, the present paper mainly focuses on *modality* (or representation). The direction of personalization can easily lead to *cultural* considerations. Multiple styles and philosophies in different cultures can be applied to computing. Indeed, in the HCI and design communities (e.g., CHI, HCII, Design Principles and Practices Conferences),

more culture-specific sessions have recently appeared. Aesthetic qualities, such as mimesis, symmetry, complexity, parsimony, minimalism, and beauty can also be transferred to computing. However, it might not imply direct translation. Since a number of new technologies and styles have appeared in media arts, considerable new analysis frameworks have also appeared in recent aesthetic theory (e.g., biocybernetics [20]). Thus, with more cautious consideration, we need to ponder how we can enhance *quality* of computing while we make it more *accessible*.

References

1. Shem-Shaul, N.B., et al.: Aesthetic computing manifesto. Leonardo **36**(4), 255–256 (2003)
2. Marr, D.: Vision: A Computational Approach. Freeman & Co., San Francisco (1982)
3. Fishwick, P.A.: Aesthetic Computing. MIT Press, Cambridge (2008)
4. Marshall, P., Antle, A., van Den Hoven, E., Rogers, Y.: Special Issue on the Theory and Practice of Embodied Interaction in HCI and Interaction Design. ACM Trans. Comput. Hum. Interact. **20**(1), 1:1–1:3 (2013)
5. Anderson, M.L.: Embodied cognition: a field guide. Artif. Intell. **149**, 91–130 (2003)
6. Dissanayake, E.: Retrospective on homo aestheticus. J. Canad. Assoc. Curric. Stud. **1**(2), 7–11 (2003)
7. Bolter, J.D., Engberg, M., MacIntyre, B.: Media studies, mobile augmented reality, and interaction design. Interaction **20**(1), 36–45 (2013)
8. Mendel, J., Wu, D.: Perceptual Computing: Aiding People in Making Subjective Judgments, vol. 13. Wiley, New York (2010)
9. Jeon, M., Smith, Michael, T., Walker, James, W., Kuhl, S.A.: Constructing the immersive interactive sonification platform (iISoP). In: Streitz, N., Markopoulos, P. (eds.) DAPI 2014. LNCS, vol. 8530, pp. 337–348. Springer, Heidelberg (2014). doi: 10.1007/978-3-319-07788-8_32
10. Camurri, A., Lagerlöf, I., Volpe, G.: Recognizing emotion from dance movement: comparison of spectator recognition and automated techniques. Int. J. Hum. Comput. Stud. **59**(1), 213–225 (2003)
11. Walker, J., Smith, Michael, T., Jeon, M.: Interactive sonification markup language (ISML) for efficient motion-sound mappings. In: Kurosu, M. (ed.) HCI 2015. LNCS, vol. 9170, pp. 385–394. Springer, Heidelberg (2015). doi:10.1007/978-3-319-20916-6_36
12. Carvalho, R.: The magical features of immersive audiovisual environments. Interaction **20**(5), 32–37 (2013)
13. Paré, Z.: Robot actors: theatre for robot engineering. In: Ehwa Institute for Humanities Science & LABEX Arts-H2H Laboratory (eds.) Theatres du Posthumain, pp. 143–162. Arcarnet, Seoul (2015)
14. Bruce, A., Knight, J., Listopad, S., Magerko, B., Nourbakhash, I.R.: Robot improv: using drama to create believable agents. In: Proceedings of the IEEE International Conference on Robotics and Automation, vol. 4, pp. 4002–4008 (2000)
15. Chi, M.T.H.: Active-constructive-interactive: a conceptual framework for differentiating learning activities. Topics Cognit. Sci. **1**, 73–105 (2009)
16. Nees, M.A., Walker, B.N.: Auditory interfaces and sonification. In: Stephanidis, C. (ed.) The Universal Access Handbook, pp. 507–521. Lawrence Erlbaum Associates, New York (2009)

17. Meschtscherjakov, A., Wilfinger, D., Scherndl, T., Tscheligi, M.: Acceptance of future persuasive in-car interfaces towards a more economic driving behaviour. In: Proceedings of the 1st International Conference on Automotive User Interfaces and Interactive Vehicular Applications. ACM Press (2009)

18. Riener, A., Jeon, M. Ferscha, A.: Human-car confluence: socially-inspired driving mechanisms. In: Gaggioli, A., (ed.) Human-Computer Confluence: Advancing Our Understanding of the Emerging Symbiotic Relation between Humans and Computing Devices (in press)

19. Lim, Y.-K., Stolterman, E., Jung, H., Donaldson, J.: Interaction gestalt and the design of aesthetic interactions. In: Proceedings of the Conference on Designing Pleasurable Products and Interfaces, Helsinki, Finland, 22–25 August (2007)

20. Mitchell, W.J.T.: The work of art in the age of biocybernetic reproduction. Modernism/modernity **10**(3), 481–500 (2003)

21. Jeon, M.: Advanced vehicle sonification applications. In: Adjunct Proceedings of the 6th International Conference on Automotive User Interfaces and Interactive Vehicular Applications, pp. 1–5. ACM Press (2009)

AcuTable: A Touch-Enabled, Actuated Tangible User Interface

Simon Dibbern, Kasper Vestergaard Rasmussen, Daniel Ortiz-Arroyo, and Michael Boelstoft Holte$^{(\boxtimes)}$

Aalborg University Esbjerg, Niels Bohrs Vej 8, 6700 Esbjerg, Denmark
{sdibbe11,kvra11}@student.aau.dk, {do,mbh}@create.aau.dk

Abstract. In this paper we describe AcuTable, a new tangible user interface. AcuTable is a shapeable surface that employs capacitive touch sensors. The goal of AcuTable was to enable the exploration of the capabilities of such haptic interface and its applications. We describe its design and implementation details, together with its strengths, limitations, and possible future applications.

Keywords: Tangible user interface · Adaptive interface · Actuated surface · Haptic feedback

1 Introduction

Tangible User Interfaces (TUI) are used in a wide variety of modern day appliances, from ticketing machines and information kiosks [1], to music instruments [2] and cars [4]. TUIs differ from standard graphical user interfaces (GUI), as they are developed specifically to perform tasks by touch and manipulation. Humans have highly sophisticated skills for sensing and manipulating the physical environment. However, these skills are rarely used in the interaction with the digital world [5]. This issue has been partially addressed by mobile devices with the wide availability of 2D touch screens for human-computer interaction [5]. Recently, new 3D touch interfaces such as in the iPhone 6s indicate that this type of TUIs may be introduced in other computer devices in a near future.

In contrast to traditional mouse-keyboard based GUIs, TUIs allow users to manipulate information in 2D or 3D by incorporating haptic feedback. A haptic interface creates haptic sensations on skin and muscles. Compared to other types of feedback, such as auditory or visual sensations, haptic feedback is rarely utilised to an equal extent.

TUIs have been applied in multiple applications in different domains, but one significant aspect of these interfaces is in facilitating people suffering from visual impairment. It allows for use of computer systems in a more effective way, since the haptic sensations add an additional way of interacting [1].

In this paper we describe the *AcuTable*, a haptic TUI. We have built a prototype of this TUI to explore its possibilities and part of its design space.

© ICST Institute for Computer Sciences, Social Informatics and Telecommunications Engineering 2017
A.L. Brooks and E. Brooks (Eds.): ArtsIT/DLI 2016, LNICST 196, pp. 314–321, 2017.
DOI: 10.1007/978-3-319-55834-9_37

This paper describes a summary of related work, the *AcuTable* in detail followed by a discussion on the strengths, limitations and applications of *AcuTable*. Finally, it presents some conclusions.

2 Related Work

A wide variety of research work has been carried out in the field of tangible user interfaces (TUI) in last decade.

TUIs that have been reported in the literature, vary from the actuated surface *FEELEX* [1] to electronic music instruments such as *ReacTable* [2].

Shaer and Hornecker [3] describe the possibility of a collaborative interaction with other users, as one of the key strengths of TUIs. An example of this is the tangible electronic musical instrument *ReacTable* [2], a system with a round shape that allows having several users at the same time. Shaer and Hornecker state that the way we interact with a TUI is similar to how we use our body. Our bodies are developed for physical interaction and it is natural for us to use our arms and hands without thinking about their placement in the physical world. Users come in direct contact with a TUI-based system without having to think about how to use it [5].

On the other hand, TUIs have their own limitations. Ulmer and Ishii in [6] describe the balance that must exist between physical and digital representations, as one of main challenges in using TUIs. Scalability is also a problem in TUIs, since the primary interaction happens when users are touching a surface. Hence, TUI's size matters since if it is too big, the interface will be perceived as "bulky" by users, decreasing their level of interaction. Additionally, TUIs are also versatility-wise limited [3], as most systems are often created for one specific purpose. In contrast to a GUI, TUIs cannot just be easily transformed into something new, and the creator or user does not have the ability to undo his/her actions. Additionally, TUIs require users to use their body and depending on the size and weight of the system, this might be tiresome or difficult.

Iwata et al. [1] analyse TUIs physical design and its possible application scenarios. These authors created two prototype artefacts that combine haptic and visual sensations in a single interface. Their project *FEELEX* consists of a rubber flexible screen, actuated by a matrix of motors. Each actuator is equipped with a force sensor which senses the pressure applied to the surface by the user's hand. In an alternative prototype, the motor's power consumption is measured to estimate the load. The load value is increased when external pressure is applied to the surface (e.g. a hand pushing onto it).

In [1] it is argued, that resolution and speed of the actuation are vital for an optimal perception of the haptic feedback that the system may provide. This research found that a maximum stroke rate of 7 Hz with a length of 18 mm was sufficient for optimal perception. Resulting from these studies, a group of possible applications of haptic interfaces was compiled. Among these applications are: their use in medical equipment, for 3D modelling, as an enhancement to current touch-screen technology, and finally as interactive art.

3 AcuTable: A Programmable, Adaptive Interface

The systems described in previous section are creative and work well. However, *AcuTable* has different goals. One goal is to enhancing the adaptability aspect of the interactive surface by introducing a greater haptic sensation. At the same time, *AcuTable* allowed us to explore the design space of TUIs by experimenting with different materials and techniques in its construction.

Figure 1 shows a block diagram of *AcuTable's* main components. The system is comprised of three major parts: the surface with servo-motors and touch-sensing electrodes, the touch sensing processing system, and the servo motor control system. The surface consists of several layers of foam which can be shaped by the user or the system itself at same time, to produce haptic feedback. A matrix of motors located underneath the surface allows the programmatic control of deformation in the foam. In order to utilise the surface as touch-input, self-capacitive touch sensors were used. A computer and two microprocessors control the motors and sensors.

Fig. 1. Block diagram of *AcuTable*

3.1 The Foam Compound

AcuTable's surface is composed of several layers of foam which when compressed subsequently return to its original state. Different kinds of foam were combined in order to obtain the optimal, mechanical properties for the application. These include the ability to be shaped by the motors in the desired way, additionally to the rebound speed and resolution of the actuation. *AcuTable's* surface consists of 2/3 soft foam (17 kPa rated) and 1/3, harder, cold-foam (30 kPa rated) on top. This allows for easy compression of the compound and at the same time, to achieve an even distribution of the force along the surface. In order to further enhance the even distribution and resolution, facets are distributed along the surface (Figs. 2 and 3). These facets provide a more "fluid" sensation of the surface's movement, compensating for the relatively sparse grid of servo motors [7].

Fig. 2. The 1.5 mm thin facets are situated in between two layers of flexible cloth.

Fig. 3. The facets embedded in the surface. Two points are pulled down by the servos.

Finally, nylon strings attached to the facets through the foam, allow the mechanical connection to the servo-motors.

3.2 Servo-motors

To compress the surface, the servos wind and unwind the strings attached to the facets. The servos are interconnected in modular rows that can be removed from the system and serviced individually. The motors and pulleys attached to each, are designed to provide the exact amount of force and movement required, in order to actuate the surface. A force of 1.5 kg of pulling strength produces 20 mm of movement. A total of 46 servos are arranged in 7 rows to form a triangular tessellation.

3.3 Touch

A capacitive surface, composed of a two-dimensional grid of electrodes, [8] was designed as the input to the system. By measuring and analysing the capacitive properties of the electrodes in the surface, the computational system can determine the three-dimensional position of a human hand or finger on and over the grid. The electrodes are 5 thin strips of aluminium along each axis, and are located below the foam compound. For determining the correct characteristics of these, some tests were performed, whose results are shown in Fig. 4.

3.4 Programmatic Control

Four individual software applications running independently enable *AcuTable* to perform all tasks required to function properly. The software running on a microcontroller attached to the touch sensing electrodes, measures their capacitive characteristics. It performs 6000 readings per seconds which are filtered using an integration filter with 60 cycles. Furthermore, it performs calibration in 2 s intervals and normalisation of the

Electrode Material Capacitive Response Characteristics (mV)

■ Through Foam ■ Through Compressed Foam

	5mm Copper Strip	Thick 5mm Copper Strip	5mm Aluminium Strip	20mm Aluminium Strip	Copper Thread	Copper String	Aluminium String
Through Foam	4.88	19.53	29.30	19.53	43.95	4.88	14.65
Through Compressed Foam	73.24	78.13	107.42	117.19	87.89	34.18	83.01

Fig. 4. Different types of electrodes tested on the particular setup. The voltages represent the discharge of the electrodes after a given time subsequent to charging the electrode.

readings [9]. A script written in Matlab receives those values through a serial connection. In order to retrieve coordinates from the readings, the position is interpolated as described by O'Conner in [9]. Coordinate filtering is subsequently performed using a rolling average with a 4:1 ratio. The resulting values are broadcasted to a sketch written in Processing. Processing allowed the rapid implementation of several application scenarios. The outcome of this is a map representing the deformation of the surface. The microcontroller connected to the servos receives packages of positional data from the Processing sketch through a serial connection and subsequently generates the electronic signals that control all servo-motors. The full system running can be seen in Fig. 5.

Fig. 5. A user interacting with the system. Matlab signal processing is visualised to the left. The Processing sketch is on the top-right.

4 AcuTable Strengths, Limitations and Applications

4.1 Strengths and Limitations

Similarly to the TUI described by Shaer and Hornecker [3], we found that our system has its own strengths and limitations. The system itself is fairly easy to use, and allows the collaborative interaction of several users at the same time. This is because the system has a near-square shape, so users can stand at each side of the table. As described previously, TUIs often lack malleability, making it hard to give them a new purpose. Contrarily, *AcuTable's* surface allows to adapt its affordances dynamically.

Table 1. List of general strengths and limitation of select TUIs.

AcuTable	ReacTable	Project FEELEX
Strengths		
Easy to use and requires no tools or intrusive devices	Visual and auditory feedback	Robust construction
Size and shape offers collaborative interaction	Size and shape offers collaborative interaction	Surface optimized for projection mapping
Dynamic surface		Dynamic surface
Safe to use		Safe to use
Limitations		
Limited malleability, thus limiting number of potential purposes	Lack of malleability, thus limiting number of potential purposes	Limited malleability, thus limiting number of potential purposes
Large number of noisy actuators. Strings can unhinge from servos	Requires skill to use	Physical representation of objects is limited
Physical representation of objects is limited	Objects used with the system can be a potential danger hazard	
Latency of up to 1 s	Utilises additional devices for interaction	

AcuTable does not require any tools or intrusive devices in order to be operated by the user. This has positive impacts in relation to usability and safety aspects. However, a major disadvantage of *AcuTable* is the complex nature of the implementation in the current prototype. In this implementation, it requires a large number of servos and is relatively susceptible to be used wrongly. Given that the system uses strings to pull on the surface, the strings may unhinge themselves from the pulleys when the servos release strings too rapidly or the user interferes with this action by pushing onto the surface simultaneously. This may cause that parts of the surface could be unmovable. Furthermore, the system is limited in the range of objects it can represent as it cannot represent complex geometric shapes, and will always be shaped with a slope, and not free flowing, like a computer-generated 3D object. Complex, three-dimensional objects are hard to

visualise, especially when featuring hard edges. The system is mostly restricted to representing textures of surfaces.

The touch system allows for a rough approximation of the user's hand, but not for recognition of gestures or for mapping it to a virtual cursor on a computer system. Also, the considerable latency of about one second before a touch is recognised by the computer presents some limitations to the naturalness of the interaction. This is mainly due to the fact, that the signal has to stabilise before it could be recognised. This is partially due to the fact that the electrodes have to sense touch through three centimetres of foam.

For a greater understanding of the difference in systems, Table 1 below show a short list of strengths and limitations are listed.

4.2 Application Scenarios

Adaptable interface. The surface of the *AcuTable* allows it to adapt in some ways, as long as the constraints of the surface are not challenged. Like a touch-screen can dynamically change its visual interface in order to afford the right tools for the current task, the *AcuTable* can change its haptic properties. This just-in-time-affordance opens up for a great amount of possibilities in regards to user experience and productivity. As described by Iwata et al. [1], touch-screens are used in a wide variety of modern day appliances such as automatic-teller machines and ticketing machines. Though intuitive, touch-screens lack haptics feedback. A solution for a touch-screen would be a mapped projection of a visual user interface. The user would be able to see and feel the interface.

Art installation. Projection mapping can be used to manipulate a projected landscape or shape of any kind for the purpose of encouraging playful behaviour.

Music manipulation. The *AcuTable*, with its adaptable interface, can be used as a means to manipulate a piece of music. By using the touch capabilities of the surface, the user can change both the pitch and tempo individually, or together. Both pitch and tempo have its own axis respectively, with pitch being on the x axis, ranging from low pitch to high pitch, and tempo being on the z axis, ranging from slow tempo to high tempo. By varying the intensity of the actuation in accordance to the beat of the music, the user can haptically sense it.

5 Conclusions

In this paper the *AcuTable* TUI has been introduced. The concept of such a new interactive interface has been discussed in relation to relevant, related work. The developed prototype demonstrates the idea of haptic feedback in touch systems and allowed us to explore the design space of the system and the capabilities of the techniques involved. The use of foam as the main material for the surface worked as expected. However, the material introduced some challenges in detecting the changes in capacitance when the surface was pressed by a user.

The use of servomotors presented an accessible and cheap way of actuating the surface with the required force and desired speed. However, the noise generated by these motors turned out to be a downside. Additionally, the shapes generated by *AcuTable* are rather limited, as it cannot represent complex, free floating 3D objects or steep slopes. Finally, the current prototype will present some challenges regarding its fabrication and maintenance.

Future work will include a new design for the pulleys, a different capacitive touch solution and the use of a single, more powerful microcontroller for the servo-motors and touch sensing processing.

References

1. Iwata, H., Yano, H., Nakaizumi, F., Kawamura, R.: Project FEELEX: adding haptic surface to graphics. In: Proceedings of the 28th Annual Conference on Computer Graphics and Interactive Techniques, pp. 469–476. ACM (2001)
2. Jorda, S., Kaltenbrunner, M., Geiger, G., Bencina, R.: The ReacTable. In: Proceedings of the International Computer Music Conference, Barcelona, Spain, pp. 579–582 (2005)
3. Shaer, O., Hornecker, E.: Tangible user interfaces: past, present and future directions. Found. Trends Hum. Comput. Interact. 3(1–2), 4–137 (2010)
4. Designaffairs.com. Case-Studies - Designaffairs: Brand Shaping Products (2015). http://www.designaffairs.com/nc/en/projects/case-studies/case/haptic-touch-1.html. Accessed 11 Mar 2015
5. Ishii, H., Ulmer, B.: Tangible user interfaces. In: Jacko, J. (ed.) The Human-Computer Interaction Handbook: Fundamentals, Evolving Technologies, and Emerging Applications, 3rd edn, pp. 465–490. CRC Press, New York (2012)
6. Ulmer, B., Ishii, H.: Emerging frameworks for tangible user interfaces. IBM Syst. J. 39(3–4), 915–931 (2000). IBM
7. Goulthorpe, M., Burry, M., Dunlop, G.: Aegis Hyposurface: the bordering of university and practice. In: Proceedings of the 11th International Conference of the Association for Computer Aided Design in Architecture, Buffalo, New York, pp. 34–349 (2001)
8. Walker, G.: Fundamentals of projected-capacitive touch technology. In: SID Display Week 2014, San Diego (2014)
9. O'Connor, T.: mTouch™ Projected Capacitive Touch Screen Sensing Theory of Operation (2010)

Author Index